Olympus® PEN E-PL1

FOR

DUMMIES®

Olympus® PEN E-PL1
FOR
DUMMIES®

by Julie Adair King

WILEY

Wiley Publishing, Inc.

Olympus® PEN E-PL1 For Dummies®

Published by
Wiley Publishing, Inc.
111 River Street
Hoboken, NJ 07030-5774

www.wiley.com

Copyright © 2010 by Wiley Publishing, Inc., Indianapolis, Indiana

Published by Wiley Publishing, Inc., Indianapolis, Indiana

Published simultaneously in Canada

No part of this publication may be reproduced, stored in a retrieval system or transmitted in any form or by any means, electronic, mechanical, photocopying, recording, scanning or otherwise, except as permitted under Sections 107 or 108 of the 1976 United States Copyright Act, without either the prior written permission of the Publisher, or authorization through payment of the appropriate per-copy fee to the Copyright Clearance Center, 222 Rosewood Drive, Danvers, MA 01923, (978) 750-8400, fax (978) 646-8600. Requests to the Publisher for permission should be addressed to the Permissions Department, John Wiley & Sons, Inc., 111 River Street, Hoboken, NJ 07030, (201) 748-6011, fax (201) 748-6008, or online at http://www.wiley.com/go/permissions.

Trademarks: Wiley, the Wiley Publishing logo, For Dummies, the Dummies Man logo, A Reference for the Rest of Us!, The Dummies Way, Dummies Daily, The Fun and Easy Way, Dummies.com, Making Everything Easier, and related trade dress are trademarks or registered trademarks of John Wiley & Sons, Inc. and/or its affiliates in the United States and other countries, and may not be used without written permission. Olympus is a registered trademark of Olympus Corporation. All other trademarks are the property of their respective owners. Wiley Publishing, Inc. is not associated with any product or vendor mentioned in this book.

For general information on our other products and services, please contact our Customer Care Department within the U.S. at 877-762-2974, outside the U.S. at 317-572-3993, or fax 317-572-4002.

For technical support, please visit www.wiley.com/techsupport.

Wiley also publishes its books in a variety of electronic formats. Some content that appears in print may not be available in electronic books.

Library of Congress Control Number: 2010929737

ISBN: 978-0-470-87950-4

Manufactured in the United States of America

10 9 8 7 6 5 4 3 2 1

WILEY

About the Author

Julie Adair King is the author of many books about digital photography and imaging, including the best-selling *Digital Photography For Dummies*. Her most recent titles include a series of *For Dummies* guides to popular digital SLR cameras, including the *Canon EOS Rebel T2i/550D, T1i/500D, XSi/450D, XS/1000D,* and *XTi/400D,* and *Nikon D5000, D3000, D300s, D90, D60,* and *D40/D40x*. Other works include *Digital Photography Before & After Makeovers, Digital Photo Projects For Dummies, Julie King's Everyday Photoshop For Photographers, Julie King's Everyday Photoshop Elements,* and *Shoot Like a Pro!: Digital Photography Techniques*. When not writing, King teaches digital photography at such locations as the Palm Beach Photographic Centre. A graduate of Purdue University, she resides in Indianapolis, Indiana.

Author's Acknowledgments

I am deeply grateful for the chance to work once again with the wonderful publishing team at John Wiley and Sons. Kim Darosett, Steve Hayes, Jen Riggs, and Katie Crocker are just some of the talented editors and designers who helped make this book possible.

Special thanks also go to Chuck Pace, who brought a wealth of photography knowledge (and sense of humor) to his technical review of my work. And finally, I am indebted to Sally Smith Clemens and Richard Pelkowski at Olympus, who so graciously contributed hour upon hour of expertise and support to this project.

Publisher's Acknowledgments

We're proud of this book; please send us your comments at http://dummies.custhelp.com. For other comments, please contact our Customer Care Department within the U.S. at 877-762-2974, outside the U.S. at 317-572-3993, or fax 317-572-4002.

Some of the people who helped bring this book to market include the following:

Acquisitions and Editorial

Project Editor: Kim Darosett

Executive Editor: Steven Hayes

Copy Editor: Jennifer Riggs

Technical Editor: Chuck Pace

Editorial Manager: Leah Cameron

Editorial Assistant: Amanda Graham

Sr. Editorial Assistant: Cherie Case

Cartoons: Rich Tennant
(www.the5thwave.com)

Composition Services

Project Coordinator: Katherine Crocker

Layout and Graphics: Kelly Kijovsky

Proofreaders: Susan Hobbs,
Lauren Mandelbaum

Indexer: Steve Rath

Publishing and Editorial for Technology Dummies

Richard Swadley, Vice President and Executive Group Publisher

Andy Cummings, Vice President and Publisher

Mary Bednarek, Executive Acquisitions Director

Mary C. Corder, Editorial Director

Publishing for Consumer Dummies

Diane Graves Steele, Vice President and Publisher

Composition Services

Debbie Stailey, Director of Composition Services

Contents at a Glance

Table of Contents

Introduction

*I*n 1959, Olympus revolutionized photography by introducing the first PEN, an ingenious marriage of single-lens reflex (SLR) and point-and-shoot camera designs. Offering the same interchangeable lens flexibility as an SLR model, but in a lightweight, compact body, the PEN lived up to the promise of its name: a camera that offered the features demanded by serious photographers yet was as easy to carry around as a pen.

Today, the PEN E-PL1 offers the same best-of-both-worlds approach to digital photographers. Like the original PEN, the E-PL1 packs a ton of photographic punch into a sleek, stylish package that doesn't break your back (or your wallet, for that matter).

The E-PL1 is so feature-packed, in fact, that it can be a challenge to sort out everything, especially if you're new to digital photography. In fact, if you're like many people, you may be so overwhelmed by all the controls on your camera that you haven't yet ventured beyond fully automatic picture-taking mode. And that's a shame because it's sort of like buying a Porsche and never actually taking it on the road.

Therein lies the point of *Olympus PEN E-PL1 For Dummies.* Through this book, you can discover not just what each bell and whistle on your camera does, but also when, where, why, and how to put it to best use. Unlike many photography books, this one doesn't require any previous knowledge of photography or digital imaging to make sense of things. In classic *For Dummies* style, everything is explained in easy-to-understand language, with lots of illustrations to help clear up any confusion.

In short, what you have in your hands is the paperback version of an in-depth photography workshop tailored specifically to your Olympus picture-taking powerhouse. Whether your interests lie in taking family photos, exploring nature and travel photography, or snapping product shots for your business, you'll get the information you need to capture the images you envision.

A Quick Look at What's Ahead

This book is organized into four parts, each devoted to a different aspect of using your camera. Although chapters flow in a sequence that's designed to take you from absolute beginner to experienced user, I also tried to make each chapter as self-standing as possible so that you can explore the topics that interest you in any order you please.

Here's a brief preview of each part:

- ☛ **Part I: Fast Track to Super Snaps:** Part I contains three chapters to help you get up and running with your E-PL1. Chapter 1 offers a tour of the external controls on your camera, shows you how to navigate camera menus to access internal options, and walks you through initial camera setup and customization steps. Chapter 2 explains basic picture-taking options, such as shutter-release mode and image quality settings, and Chapter 3 shows you how to use the camera's most automatic modes, iAuto and SCN (scene). Chapter 3 also shows you how to record high-definition movies.

- ☛ **Part II: Working with Picture Files:** This part offers two chapters, both dedicated to after-the-shot topics. Chapter 4 explains how to review your pictures on the camera monitor, delete unwanted images, and protect your favorites from accidental erasure. Chapter 5 guides you through the process of downloading pictures to your computer, preparing photos for printing or online sharing, and connecting your camera to a television for large-screen picture playback.

- ☛ **Part III: Taking Creative Control:** Chapters in this part help you unleash the full creative power of your camera by moving into the advanced shooting modes (P, A, S, and M). Chapter 6 covers the critical topic of exposure, and Chapter 7 explains how to manipulate focus and color. Chapter 8 summarizes all the techniques explained in earlier chapters, providing a quick-reference guide to the camera settings and shooting strategies that produce the best results for portraits, action shots, landscape scenes, and close-ups.

- ☛ **Part IV: The Part of Tens:** In famous _For Dummies_ tradition, the book concludes with two "top ten" lists containing additional bits of information and advice. Chapter 9 covers ten features geared to your fun and creative side, including the ART shooting mode and in-camera picture-editing tools. Chapter 10 wraps things up by detailing some camera features that, although not found on most "Top Ten Reasons I Bought My PEN E-PL1" lists, are nonetheless interesting, useful on occasion, or a bit of both.

Icons and Other Stuff to Note

If this isn't your first _For Dummies_ book, you may be familiar with the large, round icons that decorate its margins. If not, here's your very own icon-decoder ring:

✔ I apply this icon either to introduce information that's especially worth storing in your brain's long-term memory or to remind you of a fact that may have been displaced from that memory by some other pressing fact.

✔ When you see this icon, look alive. It indicates a potential danger zone that can result in much wailing and teeth-gnashing if ignored.

✔ Lots of information in this book is of a technical nature — digital photography is a technical animal, after all. But if I present a detail that is useful mainly for impressing your technology-geek friends, I mark it with this icon.

✔ A Tip icon flags information that will save you time, effort, money, or some other valuable resource, including your sanity.

Additionally, I need to point out a few other details that will help you use this book:

✔ **Other margin art:** Replicas of some of your camera's buttons and onscreen graphics also appear in the margins of some paragraphs and in some tables. I include these to provide a quick reminder of the appearance of the button or option being discussed.

✔ **Software menu commands:** In sections that cover software, a series of words connected by an arrow indicates commands that you choose from the program menus. For example, if a step tells you to "Choose File⇨Print," click the File menu to unfurl it and then click the Print command on the menu.

✔ **Camera firmware:** *Firmware* is the internal software that controls many of your camera's operations. The E-PL1 uses two pieces of firmware, one for the camera body and one for the lens. This book was written using version 1.1 of the body firmware and 1.0 of the lens firmware, which were the most current at the time of publication.

Occasionally, Olympus releases firmware updates, and it's a good idea to check the Olympus Web site (www.olympus.com) periodically to find out whether any updates are available. (Chapter 1 tells you how to determine which firmware version your camera is running.)

✔ **Online cheat sheet:** To download a handy, tuck-in-your-camera bag reference guide to some of your camera's controls, visit the following Web address: www.dummies.com/cheatsheet/olympuspenepl1.

Practice, Be Patient, and Have Fun!

To wrap up this preamble, I want to stress that if you initially think that digital photography is too confusing or too technical for you, you're in very good company. *Everyone* finds this stuff a little mind-boggling at first. So take it slowly, experimenting with just one or two new camera settings or techniques at first. Then, each time you go on a photo outing, make it a point to add one or two more shooting skills to your repertoire.

I know that it's hard to believe when you're just starting out, but it really won't be long before everything starts to come together. With some time, patience, and practice, you'll soon wield your camera like a pro, dialing in the necessary settings to capture your creative vision almost instinctively.

So without further ado, I invite you to grab your camera, a cup of whatever it is you prefer to sip while you read, and start exploring the rest of this book. Your PEN E-PL1 is the perfect partner for your photographic journey, and I thank you for allowing me, through this book, to serve as your tour guide.

Part I
Fast Track to Super Snaps

Making sense of all the controls on your PEN E-PL1 isn't something you can do in an afternoon — heck, in a week, or maybe even a month. But that doesn't mean that you can't take great pictures today. By using your camera's point-and-shoot automatic modes, you can capture terrific images with very little effort. All you do is compose the scene, and the camera takes care of almost everything else.

This part shows you how to take best advantage of your camera's automatic features and also addresses some basic setup steps, such as adjusting the viewfinder to your eyesight and getting familiar with the camera menus and buttons. In addition, chapters in this part explain how to obtain the very best picture quality, whether you shoot in an automatic or manual mode, and how to use your camera's movie-making features.

Getting the Lay of the Land

At first glance, the Olympus PEN E-PL1 could easily be mistaken for just another digital point-and-shoot camera. But don't be fooled by your camera's diminutive size or the simplicity of its outward design: Under that small, sexy exterior lies a lot of photographic muscle.

This chapter covers the basics you need to start enjoying all the E-PL1 has to offer, introducing you to its external features, showing you how to work with interchangeable lenses, and explaining how to navigate menus and select camera settings. In addition, the last part of the chapter details options that enable you to customize basic camera operations.

Taking a Quick Tour

If you've used a digital camera before, some external controls on the E-PL1 may be familiar to you. The button that you press to erase pictures, for example, is marked with the universal delete symbol — a trash can. But some features are unique to the E-PL1, so the next three sections provide an overview of the function of each external control. (I discuss these controls in more detail later in this book.)

Topside controls

As shown in Figure 1-1, the top of the camera sports a couple features:

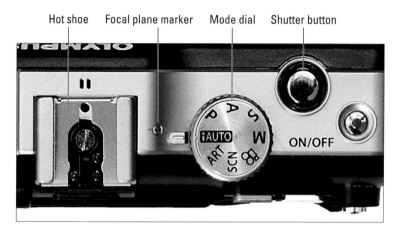

Figure 1-1: Use the Mode dial to choose a basic exposure mode.

- ✒ **Power button:** I won't insult your intelligence by telling you what this button does. But see the section "Exploring setup options on the Custom menu," near the end of this chapter, to find out about the Sleep setting. That setting enables you to specify how quickly you want the camera to automatically shut off to save battery power.

- ✒ **Shutter button:** I'm sure you also figured out this one. But see Chapter 2 to find out how to specify whether you want the camera to record a single shot, a continuous series of shots, or a self-timer shot each time you press the button.

- ✒ **Mode dial:** You select the shooting mode, or exposure mode, via this dial. Chapter 3 explains the simplest, most automatic modes — iAuto and Scene (SCN) — as well as Movie mode. Chapters 6 and 7 cover the more advanced photography modes (P, S, A, and M). For help with ART mode, check out Chapter 9.

- ✒ **Flash hot shoe:** *Hot shoe* is the traditional photography term for "contact on top of the camera for mounting an external flash." But on the E-PL1, the electrical contacts on the hot shoe also enable the camera to communicate with the optional electronic viewfinder. See the upcoming sidebar "Awesome add-on: The VF-2 electronic viewfinder," later in this chapter, for some additional information.

✔ **Focal plane marker:** See that little circle with the line through it, between the Mode dial and the hot shoe? That line represents the plane at which the lens focuses light onto the *image sensor* (the element that replaces film in a digital camera). If you ever need to know the exact distance between your subject and the camera, basing the measurement on this mark produces a more accurate camera-to-subject distance than using the end of the lens or some other external point on the camera body as your reference point.

Back-of-the-camera controls

Traveling over the top of the camera to its back, you see the controls labeled in Figure 1-2. The following list introduces you to each item:

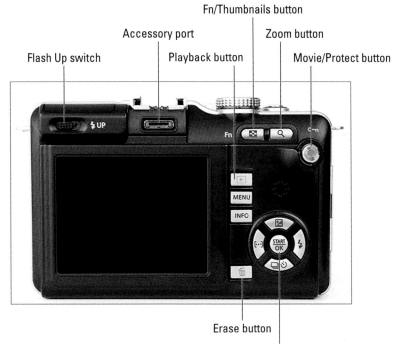

Figure 1-2: Use the Start/OK button and surrounding arrow keys to navigate menus and adjust picture-taking settings.

✔ **Flash Up switch:** To raise the built-in flash, slide this switch to the right and release it. Chapter 3 introduces you to flash; Chapter 6 gets into more advanced flash features. (To close the flash, just press its top gently down.)

✔ **Accessory port:** If you buy the optional electronic viewfinder (a choice I highly recommend), it attaches into this slot. See the upcoming sidebar "Awesome add-on: The VF-2 electronic viewfinder" for more details. The port also enables you to attach an optional stereo microphone.

Fn ▓ ✔ **Fn (Function)/Thumbnails button:** This button performs a different function depending on whether you're shooting pictures or reviewing them in playback mode:

- *Shooting function:* By default, pressing this button during shooting toggles the Face Detection feature on and off. (Chapter 2 introduces you to Face Detection.) But you can set the button to perform a variety of other functions instead (see Chapter 10).

- *Playback function:* During playback, pressing the button cycles the display from single-image view to thumbnails view to calendar view. See Chapter 4 for playback details.

To save time and space, I refer to this button simply as the Fn button from this point forward.

🔍 ✔ **Zoom button:** As on most digital cameras, pressing this button during playback magnifies the image. But here's a twist: On the E-PL1, you can also magnify the live view during shooting, which can be helpful for fine-tuning focus. See the later section "Zooming the live display" in this chapter for details.

✔ **Movie/Protect button:** As indicated by its name, this button also accomplishes a different act depending on whether you're shooting or reviewing pictures:

- *Shooting mode:* By default, this button is used for one-button movie recording. Press the button to start recording, and press again to stop. Chapter 3 explains the art of E-PL1 movie making.

- *Playback mode:* Note the little blue key directly above the button. That symbol indicates that during playback, you press the button to "lock" the picture file and protect it from accidental erasure. Chapter 4 has details. (As a reminder of the button's playback function, the key is blue, just like the symbol on the Playback button.)

You can change the shooting function of the Movie button, just as you can assign a different task to the Fn button. Chapter 10 provides details.

 ✔ **Playback button:** Press this button to set the camera to playback mode. See Chapter 4 for all the ways you can customize the playback display.

✔ **Menu button:** Press this button to access camera menus; see the section "Ordering from Camera Menus" for the fine points you need to know about the process.

✔ **Info button:** Pressing this button changes the amount and type of data displayed on the monitor during shooting and playback. The upcoming section "Monitor Matters: Customizing the Shooting Display" explains how you can tweak the display in shooting mode; Chapter 4 covers playback display options. This button also comes into play for some other operations, such as changing the level of magnification when you zoom the display.

✔ **Start/OK button and arrow pad:** This collection of buttons is key to most operations on the camera.

After displaying menus, for example, use the arrow keys to select a menu item and then press the Start/OK button to select that item. You also use the Start/OK button during shooting to access control screens that enable you to quickly adjust picture-taking settings. And notice that each of the four arrow keys bears a label: The label tells you that you can press the button to directly access the function indicated by the label. For example, you can display flash settings by pressing the right-arrow key — the one sporting the lightning bolt, which is the universal symbol for flash.

To save time and space in this book, I refer to the Start/OK button as just OK (okay?). And I refer to the arrow keys by their position on the arrow pad — "press the right-arrow key, press the down-arrow key," and so on.

✔ **Erase button:** During playback, you can erase photos by pressing this button. Chapter 4 has details.

✔ **Speaker:** Finally, note the tiny holes just above the OK button/arrow key cluster. When you play movies or picture files that contain sound, the audio comes wafting through those holes, which lead to the internal speaker. (And yes, you read me correctly: You can annotate your still photos with audio notes; see Chapter 9 to find out how.)

And the rest . . .

Just for good measure, the following list details features found on the front, right side, and bottom of the camera:

✔ **Connection ports:** Under the flap on the right side of the camera, you find two ports that enable you to connect the camera to other devices, as shown in Figure 1-3. The USB/AV (Universal Serial Bus/Audio Video) port is for connecting the camera to a computer, printer, or standard definition television set. The HDMI (High-Definition Multimedia Interface) port enables you to connect the camera to an HD display for playback.

Cables for making the USB/AV connections ship with the camera. To make an HD connection, you must purchase an HD cable. (Chapter 4 has details about connecting to a television; Chapter 5 explains how to connect the camera to a computer for picture download.)

✔ **Battery/memory card chamber:** Open the cover on the bottom of the camera to access the chamber that holds both the battery and the memory card, as shown in Figure 1-4. The upcoming section "Working with Memory Cards" details installing and using memory cards.

To find out how to monitor the battery level, see the upcoming section "Monitor Matters: Customizing the Shooting Display." And see Chapter 10 for a menu option that controls how depleted you want the battery to become before the camera warns you that you're soon to be running on empty.

✔ **Tripod mount:** The little screw hole just next to the battery chamber is provided for mounting the camera on a tripod.

When the camera is mounted on a tripod, you can't access the battery chamber. Double-check that your battery is charged and your memory card is inserted before you connect the camera to the tripod.

✔ **Lens-release button:** Last but not least is the little silver button on the front of the camera, next to the lens. Press the button to disengage the lens from the lens mount before removing the lens. The following section discusses this and other lens-related information.

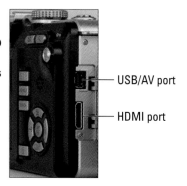

USB/AV port

HDMI port

Figure 1-3: Open the cover on the right side of the camera to reveal ports for connecting the camera to a computer or TV.

Battery release

Tripod mount Memory card

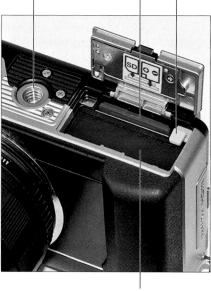

Battery

Figure 1-4: The battery and memory card share an apartment next to the tripod mount.

Working with Lenses

To take best advantage of the features of your E-PL1, match the camera body with a Micro Four Thirds lens. If you bought the E-PL1 kit, which includes the camera body plus the Olympus 14–42mm M.Zuiko Digital lens, you own this type of lens.

Micro Four Thirds refers to the camera design and technology that permits the E-PL1 to take such a small, lightweight form. If you're interested in the science and history of the Micro Four Thirds format, visit www.four-thirds.org, an Olympus educational Web site.

When dealing with lenses, the important point to know is that Micro Four Thirds lenses were designed specifically to partner with the E-PL1. Like the camera itself, these lenses are built to be as small and lightweight as possible, and they support the camera's entire range of features. (Note the *M* in M.Zuiko; it distinguishes Micro Four Thirds lenses from standard Zuiko lenses. As for *Zuiko?* It stems from two sources: an abbreviation created to refer to one of Olympus' original lens-manufacturing plants and a rough translation of the Chinese expression for "golden light." Won't you sound smart at the next meeting of the photo club!?)

At any rate, although you can mount other types of lenses on the camera, you need to purchase an adapter to do so. And with some lenses, you lose access to certain important camera features. For example, you can't use autofocusing with some lenses; you must focus manually. The Olympus Web site has details about lens options.

Because of those complications — and because covering all the variations involved with using your camera with different types of lenses is way, way beyond the page count this book allows — instructions in this book presume that you're using a Micro Four Thirds lens, and illustrations feature the 14–42mm Micro Four Thirds kit lens. If you use a different lens, check your lens manual for help with any questions that you can't sort out.

With that bit of business out of the way — okay, it's probably about two or three bits — the next sections explain the basics of working with a Micro Four Thirds lens.

Attaching and removing lenses

Follow these steps to attach a Micro Four Thirds lens to your camera:

1. **Turn off the camera.**

2. **Remove the cap that covers the lens mount on the front of the camera.**

3. **Remove the cap that covers the back of the lens.**

4. **Hold the lens in front of the camera so that the little red dot on the lens aligns with the matching dot on the camera body.**

 Official photography lingo uses the term *mounting index* instead of *little red dot.* Either way, you can see the markings in question in Figure 1-5.

 Again, the figure (and others in this book) shows you the E-PL1 with the Olympus 14–42mm M.Zuiko Digital lens. Assuming that you stick with Micro Four Thirds lenses, other lenses should work and look much the same, but if you have any questions, consult the lens manual.

Mounting index dots

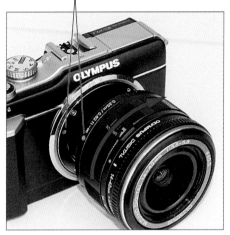

Figure 1-5: When attaching the lens, align the index markers as shown here.

5. **Keeping the dots aligned, position the lens on the camera's lens mount.**

6. **Turn the lens in a clockwise direction until the lens clicks into place.**

 In other words, turn the lens away from the shutter button side of the body, as indicated by the red arrow in the figure.

To detach a lens, take these steps:

1. **Turn off the camera.**

2. **Locate the lens-release button, labeled in Figure 1-6.**

3. **Press the button while turning the lens counterclockwise until the lens disengages from the lens mount.**

4. **After removing the lens, protect it by placing the rear protective cap onto the back of the lens.**

 If you aren't putting another lens on the camera, cover the lens mount with the protective cap that came with your camera, too.

Lens-release button

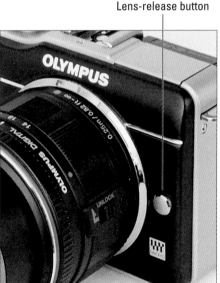

Figure 1-6: To disengage the lens, press this button.

Always attach and remove lenses in a clean environment to reduce the risk of getting dust, dirt, and other contaminants inside the camera or lens. For added safety, point the camera body slightly down when performing this maneuver; doing so helps prevent any flotsam in the air from being drawn into the camera by gravity.

Familiarizing yourself with the lens

The kit lens (and some other Micro Four Thirds lenses) sports the features shown in Figure 1-7. Get familiar with the following key components:

Focal length indicator Zoom barrel

Focusing ring Unlock switch

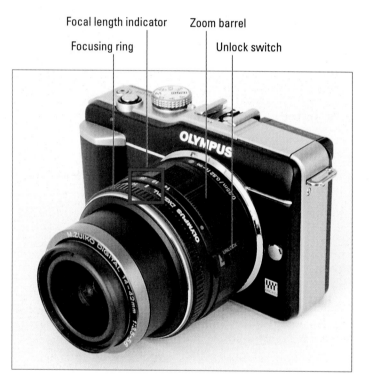

Figure 1-7: Get to know the functions of these lens features.

✏ **Zoom barrel:** If you own a zoom lens (such as the kit lens), zoom in and out by simply twisting the zoom barrel.

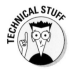

✏ **Focal length indicator:** Every lens can be characterized by its *focal length,* measured in millimeters. The focal length determines the *angle of view* (the area the lens can capture), the relative size of objects in the frame, and the *depth of field* (the distance over which objects remain sharply focused).

A zoom lens gives you access to a range of focal lengths — in the case of the kit lens, from 14mm to 42mm. At the edge of the zoom barrel, you see numbers representing various focal lengths within that range (refer to Figure 1-7). As you zoom in and out, you can determine the current focal length by looking at the position of the focal length indicator, labeled in Figure 1-7. For example, in the figure, the indicator shows that the lens is currently zoomed to a focal length of about 18mm.

Be sure to review Chapter 7 to discover how the results produced by a given focal length are different on a Micro Four Thirds camera than on a 35mm SLR camera.

✔ **Focusing ring:** Even the best autofocusing systems have trouble locking in on certain subjects — highly reflective objects and animals behind fences are two that come to mind. To save you the frustration of trying to autofocus in those tough shooting scenarios, your lens offers manual focusing.

Before you can focus manually, you must set the camera's AF (autofocus) mode to MF (manual focus) or S-AF+MF (single autofocus with manual override). Chapter 7 provides details on how to select this setting.

✔ **Unlock switch:** If you've worked with a zoom lens on an SLR, it may have had a Lock switch that enabled you to lock the lens at a specific focal length. The kit lens, on the other hand, has an Unlock switch. Hmm, what gives? A really cool retracting feature found on the kit lens and some other Micro Four Thirds lenses, that's what. Move your eyeballs to the following section to find out more.

Retracting and unlocking the lens

Some Micro Four Thirds lenses, including the kit lens, feature a nifty retracting feature. When you're not using the camera, you can retract the lens so that it takes up even less space in your camera bag than usual.

Check out Figure 1-8. The left side of the figure shows the smallest footprint of the lens at its unretracted position. On the right side of the figure, you see the reduced lens bulk you can accomplish by retracting the lens.

The key to the retracting feature is the Unlock switch on the zoom barrel. Try it out:

1. **Holding the lens by the zoom barrel, press and hold the Unlock switch forward.**

 Refer to Figure 1-8 for a look at the switch.

2. **Twist the zoom barrel counterclockwise until the lens is fully retracted.**

 Just to be clear: Twist the barrel toward the shutter button side of the camera.

3. **Release the Unlock switch.**

Unlock switch

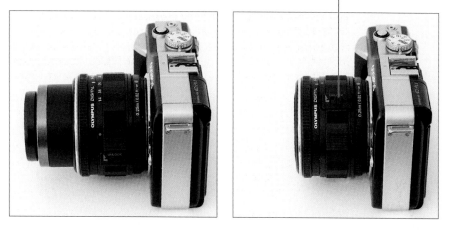

Figure 1-8: When you finish shooting, you can retract the lens to reduce the camera size even further.

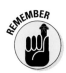

The next time you turn on the camera, the monitor displays the screen shown in Figure 1-9, telling you that the lens is locked. To unlock the lens, just twist the zoom barrel clockwise. You don't need to press the Unlock switch.

Working with Memory Cards

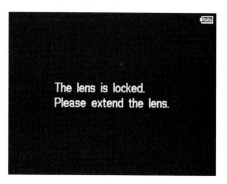

Figure 1-9: If the lens is retracted, this message appears when you turn on the camera.

Instead of recording images on film, digital cameras store pictures on *memory cards.* The E-PL1 uses a specific type of memory card — an *SD (Secure Digital) card* — as shown in Figure 1-10. You can also use the newer, high-capacity Secure Digital cards, labeled SDHC.

Safeguarding your memory cards — and the images you store on them — requires just a few precautions:

- ✔ **Handling cards:** Don't touch the gold contacts on the back of the card. (See the left card in Figure 1-10.) When cards aren't in use, store them in the protective cases they came in or in a memory card wallet. Keep cards away from extreme heat and cold as well.

🖚 **Locking cards:** The tiny switch on the side of the card, labeled *lock switch* in Figure 1-10, enables you to lock your card, which prevents any data from being erased or recorded to the card. Press the switch toward the bottom of the card to lock the card contents; press it toward the top of the card to unlock the data.

Chapter 4 shows you how to protect individual images on a card from accidental erasure by using the camera's picture-locking feature.

Don't touch Lock switch

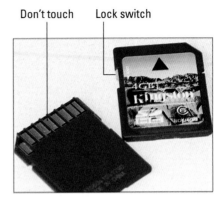

Figure 1-10: Avoid touching the gold contacts on the card.

🖚 **Inserting a card:** First, be sure that the camera is turned off. Then open the battery cover on the bottom of the camera — the card and the battery share this compartment. Put the card in the card slot with the label facing the front of the camera, as shown in Figure 1-11. Push the card into the slot until it clicks into place.

🖚 **Formatting a card:** The first time you use a new memory card or insert a card that's been used in other devices (such as an MP3 player), *format* it. Formatting ensures that the card is properly prepared to record your pictures.

Figure 1-11: Insert the card with the label facing the front of the camera.

Formatting erases *everything* on your memory card. So before you format, be sure that you copy any pictures or other data to your computer.

To format a memory card, display Shooting Menu 1 and select Card Setup, as shown on the left in Figure 1-12. Press OK to display the second screen in the figure. Then select Format and press OK again. On the confirmation screen that appears next, select Yes and press OK. (If you need help using menus, the upcoming section "Ordering from Camera Menus" explains all.)

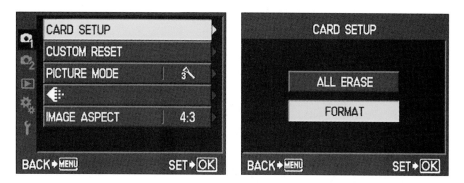

Figure 1-12: Format a memory card through the Card Setup option on Shooting Menu 1.

Some computer programs enable you to format cards as well, but it's not a good idea to go that route. Your camera is better equipped to optimally format cards.

📌 **Removing a card:** If you just took a picture, look for the memory card access icon, labeled in Figure 1-13, and wait until it disappears, indicating that the camera has finished recording the file to the card. Then turn off the camera, open the battery cover, depress the memory card slightly, and then let go. The card pops halfway out of the slot, enabling you to grab it by the tail and remove it.

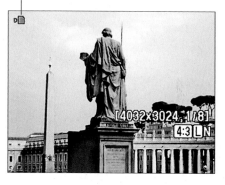

Memory card access symbol

Figure 1-13: Don't turn off the camera or remove the memory card until the card access icon disappears.

If you turn on the camera when no card is installed, a message appears on the monitor to remind you. If you have a card in the camera and you get these messages, try taking the card out and reinserting it. Also be sure that you haven't locked the card (using the card's lock switch).

⚠️ One side note on the issue of memory cards and file storage: Given that memory cards are getting cheaper and larger in capacity, you may be tempted to pick up an 8GB (gigabyte) or 16GB card thinking you can store a gazillion images on one card and not worry about running out of room. But memory cards are mechanical devices that are subject to failure, and if a large card fails, you lose lots of images. And putting aside the potential for card failure, it's darned easy to misplace those little guys. So I carry several 4GB SD cards in my camera bag instead of relying on one ginormous card. Although I hate to lose any images, I'd rather lose 4GB worth of pictures than 8 or 16GB.

Awesome add-on: The VF-2 electronic viewfinder

Micro Four Thirds cameras lack viewfinders — it's one main reason why the camera can be so small. If you miss having a viewfinder, you can purchase the Olympus VF-2, an electronic viewfinder that attaches to the camera via the accessory port just beneath the camera's hot shoe. You can rotate the viewfinder upward as much as 90 degrees to suit the viewing angle you need, as shown here.

In addition to its flexible neck, the VF-2 has other powers you don't get from a traditional, optical viewfinder. Simply put, the VF-2 can display anything that you can view in the monitor, including menus and camera settings. You also can use the viewfinder for picture playback — and the clarity of the playback display is really stunning.

There are a couple downsides: You can't use an external flash, which also requires the camera's hot shoe, at the same time as the viewfinder. (You can still use the built-in flash.)

The other issue is cost. At a suggested retail price of $280, the viewfinder isn't a casual investment. But I suspect that if you visit your local camera store to try it out, you'll have a hard time leaving without it.

As much as I love the viewfinder, it's an *optional* accessory, so the rest of this book assumes that you're working with the monitor only. But know that if you're using the viewfinder, everything works just the same way — you just see the menus, screens, and so forth in your viewfinder instead of on the monitor. For help attaching, removing, and adjusting the viewfinder display, see the camera manual and the instruction sheet that ships with the viewfinder. Also be aware that shortly after the E-PL1 came to market, Olympus released an update to the camera firmware (internal software) that enables some viewfinder features that aren't described in the manual; for details, visit the Olympus Web site (www.olympus.com).

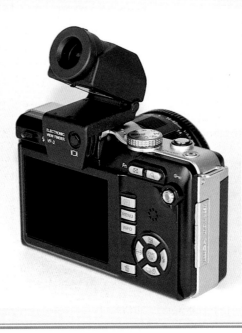

Ordering from Camera Menus

You access many of your camera's features via internal menus, which, conveniently enough, appear when you press the Menu button. Features are grouped into five menus, described briefly in Table 1-1.

Table 1-1		Menus
Symbol	*Open This Menu . . .*	*. . . To Access These Functions*
📷₁	Shooting 1	Memory card setup, picture quality, and a few other basic photography settings
📷₂	Shooting 2	Shutter-release mode, image stabilization, and additional photography settings
▶	Playback	Picture playback and editing features
⚙	Custom	Advanced photography and setup options
🔧	Setup	Basic camera customization options

One menu, the Custom menu, is hidden by default. That menu contains a slew of advanced photography and camera customization options that aren't of much interest to casual photographers, so Olympus chose to simplify the experience for those users. But you, of course, want to explore all your camera's features, so the upcoming list, which details the basics of working with menus, uses the task of turning on the Custom menu as an example.

Menu icons

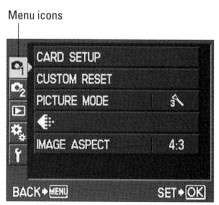

- **Display menus:** Press the Menu button. The monitor displays a screen similar to the one you see in Figure 1-14. Along the left side of the screen, you see icons representing the menus. (Again, the fourth icon, for the Custom menu, is hidden by default.) The highlighted menu is the active menu; options on that menu appear to the right. In the figure, Shooting Menu 1 is active, for example.

Figure 1-14: The fourth menu (Custom menu) is hidden by default.

✔ **Choose a different menu:** Press the up- or down-arrow keys to move the highlight over the menu. To access the option that enables the Custom menu, select the Setup menu, as shown on the left in Figure 1-15.

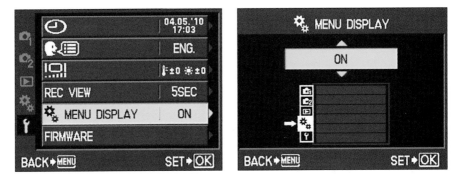

Figure 1-15: To display the hidden menu, choose this setting on the Setup menu.

✔ **Select a menu item:** Press the right-arrow key to jump from the menu icons to the options on the selected menu. Then press the up- or down-arrow key to move the highlight over the option you want to choose. To enable the Custom menu, choose Menu Display, as shown on the left in Figure 1-15. Press OK to display the screen that offers available settings for the menu item, as shown on the right in the figure.

Olympus aficionados often refer to the Custom menu as the *gear menu* because of the tiny gear symbols used to represent it. For the same reason, some people call the Setup menu the *wrench menu.* I use the official menu names, but you may encounter the unofficial lingo when visiting online camera forums and other photography sites.

✔ **Change the setting for the selected item:** After highlighting the option, you typically take one of two routes: Either press OK or press the right-arrow key.

How do you know which button to push? The camera reminds you by displaying symbols at the bottom of the menu screen. For example, in Figure 1-15, the symbols tell you to press the Menu button to go back one screen and to press the OK button to select the highlighted option. But in Figure 1-16, note the middle icon: It tells you that on this screen, you press the right-arrow key to access a secondary menu of options.

Figure 1-16: This icon tells you to press the right-arrow key to access a submenu.

How the various options appear varies depending on the menu item. Sometimes you see a screen that looks like the one on the right in Figure 1-15, with only the current setting displayed. For other menu items, you see a submenu listing all the available settings. Either way, press the arrow keys (up, down, right, left) to scroll through the various settings. When the setting you want is highlighted, press OK (or follow the prompts that appear at the bottom of the screen).

To turn on the Custom menu, for example, press the up- or down-arrow key to display On, as shown on the right in Figure 1-15, and then press OK.

✐ **Go back one screen:** Press the Menu button or the left-arrow key.

✐ **Exit the menus and return to shooting mode:** You can press the Menu button (you may need to press it several times to back out of all the screens). But a quicker option is to simply press the shutter button halfway and release it.

The Custom menu is divided into ten submenus that are assigned alphabetic labels (A, B, C, and so on). In this book, when I tell you to "choose Custom Menu A," I mean to open the Custom menu and then select the A submenu. In addition, some menu items are represented by symbols rather than text labels. For example, the option you use to set the camera's date and time is labeled with a little clock symbol. Because it's difficult to insert those symbols within the text here, I instead provide you with a text name for the symbol and, in most cases, label the menu in an accompanying figure.

Monitor Matters: Customizing the Shooting Display

When you're not using the menus or viewing your pictures in playback mode, the monitor displays some of the critical picture-taking settings, as shown in Figure 1-17. The type of data that appears depends on your exposure mode; the figure shows the display for the P exposure mode, explained in Chapter 6.

Later chapters detail each symbol; for now, just note the battery status icon in the top-right corner. The icon appears for a few seconds when you turn on the camera and then disappears to declutter the screen. If the

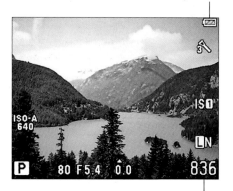

Battery status

Shots remaining

Figure 1-17: The battery status icon appears briefly when you turn on the camera and then disappears.

battery begins the run low, the icon appears half-full; if the battery is nearly depleted, the icon blinks red.

One other key item, the shots remaining value, appears in the lower-right corner of the display. This number tells you how many pictures will fit in the space remaining on your memory card. If the number is low, grab another card, visit Chapter 4 to find out how to erase some pictures, or pay a trip to Chapter 5 for details on how to download photos to your computer. Chapter 2 explains how your Image Quality settings affect the number of shots you can fit on a card. Chapter 3 explains how Movie Quality settings affect how many minutes of recordings will fit.

You're not limited to the display style shown in Figure 1-17, however. By pressing the Info button, you can add a histogram to the mix, as shown on the left in Figure 1-18. (If you're unfamiliar with histograms, Chapter 4 explains them.) Another press of the Info button clears all the data from the screen so that you see your subject only, as shown on the right in the figure.

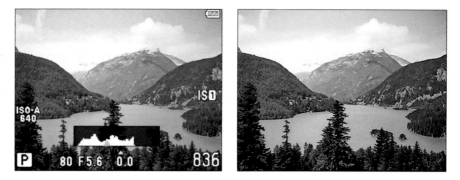

Figure 1-18: Press the Info button to switch between the initial data display and additional display modes.

If you don't care to see the two display modes shown in the figure, you can disable them. You can also access a couple other display modes that are turned off by default. The following section explains your options. Following that, you can discover some another neat trick for customizing the display — a feature that lets you magnify your view of the scene.

Enabling and disabling display styles

To control which display styles appear when you press the Info button, take these steps:

 1. **Select Custom Menu D, as shown on the left in Figure 1-19, and press OK.**

Figure 1-19: Choose which displays to enable through this option on Custom Menu D.

2. **Choose the Thumbnails/Info Setting option, as shown on the right in Figure 1-19, and press OK.**

You see the screen shown on the left in Figure 1-20.

Figure 1-20: You can control which of these five displays are enabled.

3. **Select LV-Info and then press OK.**

(The LV is a reference to _live view,_ which is what the monitor displays when you shoot with the E-PL1 — a live view of the scene before the lens.)

After you press OK, you see a list of display options that you can enable or disable, as shown on the right in Figure 1-20. In some shooting modes, not all display options are available; you can choose from all displays only in P, A, S, and M modes.

4. **Enable the display options you want to use; turn off the others.**

This screen requires that you press the right-arrow key after selecting an option. After pressing the right-arrow key, you see the screen where you can enable or disable the display.

Here's an overview of the five styles you can enable or disable. (You can't disable the default display style, which is the one shown in Figure 1-17.)

• *Displayed Grid:* Enabling this option adds gridlines to the screen, as shown in Figure 1-21. The grid is helpful for ensuring that the horizon line is level or in other cases where you want to compose the shot so that objects fall into some other precise alignment.

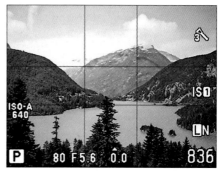

Figure 1-21: The grid display is helpful for checking that the horizon line is level.

To enable the grid, choose Displayed Grid, as shown on the left in Figure 1-22, and then press the right-arrow key. You then see a list of four grid styles, as shown on the right in Figure 1-22. Make your selection and press OK. To disable the grid display, return to the menu and choose Off.

Figure 1-22: You can choose from four grid styles.

• *Histogram:* Choose the menu item represented by the histogram symbol (refer to Figure 1-20) to enable or disable the histogram display. This display mode is enabled by default.

• *Highlight & Shadow:* This display alerts you to areas of the frame that may be seriously overexposed or underexposed at your current exposure settings. When you press the shutter button halfway, over-exposed areas are indicated by a red overlay, and underexposed

areas are indicated by a blue overlay. This display option is disabled by default and isn't available in ART or Movie mode.

- *Multi View:* This display option is available only when the Mode dial is set to P, A, S, or M. When you apply Exposure Compensation, an exposure adjustment covered in Chapter 6, or White Balance, a color setting discussed in Chapter 7, you can use this display mode to preview the effects of four settings at a time. Figure 1-23 shows an example of the Exposure Compensation preview. I leave this display at its default setting, Off, until I need it. That way, I don't have to press the Info button to cycle past it each time I want to change the display style.

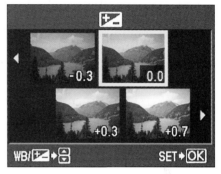

Figure 1-23: The Multi View display enables you to preview the effects of four Exposure Compensation settings side-by-side.

- *Image Only:* Enabled by default, this view eliminates all data from the screen. (Refer to the right side of Figure 1-18.) If you don't appreciate this view, set the option to Off.

5. After setting your display options, press OK to return to the main menu.

6. To return to shooting, press the shutter button halfway and release it.

After you set up the display styles you want to use, just keep pressing the Info button to cycle the monitor from one display to the next.

Zooming the live display

Most digital cameras, including the E-PL1, enable you to magnify an image during playback to take a close-up look at the photo. (Chapter 4 provides specifics.) But the E-PL1 adds a new trick to the zoom bag: In any shooting mode but Movie mode, you can zoom the live preview to check details in the scene or to ensure that focus is spot on. In fact, if you use autofocusing, you can press the shutter button halfway while the display is zoomed to focus on the object currently visible in the frame. (Chapter 7 provides details on focusing.)

To zoom the live preview, take these steps:

1. Press the Zoom button.

A green rectangle appears onscreen, as shown on the left in Figure 1-24.

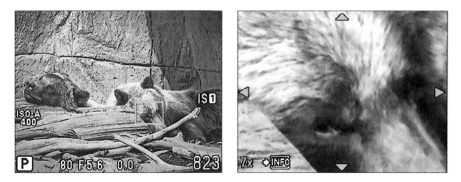

Figure 1-24: Press the Zoom button to magnify the display for a close-up look at your subject.

2. **Use the arrow keys to move the green rectangle over the area you want to inspect.**

3. **Press the Zoom button a second time.**

 The area under the green rectangle becomes magnified in the frame, and you see four little green triangles, as shown on the right in Figure 1-24.

 In the lower-right corner, a value appears to show the current magnification level. For example, a 7x magnification is active in Figure 1-24.

4. **Press the arrow keys to scroll the display to see other areas of the frame.**

5. **To change the magnification level, press the Info button, press the up- or down-arrow key to set the value, and press Info again.**

 After you press Info the first time, the magnification value becomes active, as shown in Figure 1-25.

Figure 1-25: Press the arrow keys to scroll the zoomed display; press the Info button to change the magnification level.

You can then press the up- or down-arrow key to select magnification values of 7x, 10x, and 14x magnification. Another press of the Info button deactivates the setting and returns you to zoom mode.

6. **To exit the magnified display, press OK.**

When you use this feature, understand that you're not actually zooming the lens — just magnifying the onscreen display, as you can do when reviewing your pictures in playback mode. You can take a picture with the display zoomed, but your photo will include everything within the frame and not just the magnified area.

Monitoring and Adjusting Photography Settings

You can adjust photography settings, such as aperture, shutter speed, and focusing method, in a variety of ways — some of which are fairly obvious, and some, not so much. Depending on the photography setting you want to change, you may be able to adjust it using one or all of the following options:

- **Menus:** Shooting Menus 1 and 2 contain the most basic picture-taking options, such as the Image Quality setting (resolution and file format, explained in Chapter 2). The Custom menu contains a plethora of advanced options that enable you to fine-tune color, focus, exposure, and more.

- **Live Control screen:** Through the Live Control screen, as shown on the left in Figure 1-26, you can scroll through a variety of settings, one by one, and then quickly adjust a setting by using the arrow keys. The next section provides details.

 By default, pressing OK displays the Live Control screen in all exposure modes except iAuto. In that mode, you instead see the Live Guide screens (see Chapter 3). However, you can enable the Live Control screen for iAuto mode if you prefer. See the next section for help.

Figure 1-26: The Live Control display (left) and Super Control Panel (right) enable you to adjust settings without digging through menus.

- **Super Control Panel:** Some photographers (including me) prefer to view all critical picture-taking settings together, as shown on the right in Figure 1-26. Olympus refers to this display as the Super Control Panel. As with the Live Control screen, use the arrow keys to select and adjust the available settings.

 The Super Control Panel is disabled by default, but you can enable it in addition to, or instead of, the Live Control screen. See the next section to find out how.

➤ **Camera buttons:** You can access a few settings directly by pressing the keys on the arrow pad. For example, pressing the right-arrow key brings up the screen through which you select flash settings. In most cases, the process from that point is the same as when you use the Live Control or Super Control Panel displays.

Instructions throughout the book mention all options that you can use for adjusting camera settings. But so that you don't have to wade through lots of step-by-step specifics on each page — "display the Live Control screen, press the up-arrow key to select the Flash setting, press the right- or left-arrow key to choose your option, press OK to return to shooting" — instructions and figures simply point you to where to find the setting being discussed. Ditto for menus: Instructions tell you to "adjust the setting via the AF Mode option on Custom Menu A" rather than stepping you through each button-press required to use the menus.

Your part in this *keep it quick and simple* plan involves familiarizing yourself with the process of using menus, the Live Control display, and Super Control Panel display. For the basics of using menus, see the section "Ordering from Camera Menus," earlier in this chapter. For details about enabling and using the Live Control screen and Super Control Panel, read on.

Setting your control screen preferences

By default, pressing OK during shooting produces one of two screens, depending on your exposure mode:

➤ **iAuto mode:** Pressing OK brings up the Live Guide screens, which help you manipulate aspects of your photo without having to know a thing about photography. Chapter 3 explains this feature.

➤ **All other modes:** You instead see the Live Control screen (refer to the left example in Figure 1-26).

For Movie mode, the Live Control screen is the only control screen available. But for iAuto mode, you can choose to enable or disable the Live Guide, Live Control, and Super Control Panel screens. For all other modes, you can enable or disable the Live Control and Super Control Panel features. And you can set up different preferences for different exposure modes as well.

To set up your control screen preferences, follow these steps:

1. Select Custom Menu D, as shown on the left in Figure 1-27, and press OK.

Don't see the menu? It's hidden by default; track back to the section "Ordering from Camera Menus" to find out how to bring it into view. That section also provides more specifics of using menus, if you need help.

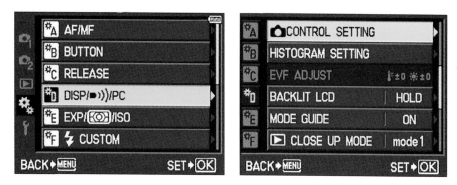

Figure 1-27: Enable the Super Control Panel through Custom Menu D.

2. **Press the up or down arrows to scroll the screen until you see the Control Setting option, as shown on the right in Figure 1-27.**

3. **Press OK.**

The screen shown on the left in Figure 1-28 appears, offering three options. You can set control screen preferences for three exposure modes or mode groups: iAuto; the advanced exposure modes (P/A/S/M); and the ART and Scene modes (ART/SCN). You can't adjust the control screen for Movie mode.

Figure 1-28: You can set different preferences for different shooting modes.

4. **To set preferences for iAuto mode, select the first option and press OK.**

The screen shown on the right in Figure 1-28 appears. Here, you can enable or disable each of the three possible control screens for iAuto mode: the Live Guide, Live Control, and Super Control Panel (abbreviated SCP in the menu).

5. **Select a display option and press the right-arrow key to display the screen where you can turn the option on or off. Make your selection and press OK.**

6. **Press the Menu button or left-arrow key to return to the main Control Setting screen (refer to the left screen in Figure 1-28).**

7. **Repeat Steps 4–6 for the second group of exposure modes (P, S, A, and M).**

8. **Go around the track once more to set your preferences for the remaining two modes (ART and SCN).**

9. **To exit the menus and return to shooting mode, press the shutter button halfway and then release it.**

Switching between control displays

Assuming that you enable more than one display for an exposure mode, you need to remember the following two techniques for displaying and switching them:

- **To display a control screen:** Press OK.
- **To toggle the display to the next control screen:** Press the Info button.

As you know if you explored the earlier section related to changing the shooting information displays, pressing the Info button also changes the amount and type of data that appears on the monitor when you're *not* trying to adjust settings. So remember the key: To switch to one of the control screens, press OK first and then press the Info button to change to a different control screen.

The next two sections explain how to actually make use of the Live Control and Super Control Panel displays. Again, Chapter 3 details the Live Guide display.

Adjusting settings via the Live Control display

The following steps walk you through the process of adjusting a picture setting via the Live Control display:

1. **Set the Mode dial on top of the camera to any setting except iAuto.**

 By default, the iAuto mode is linked to the Live Guide screens, covered in Chapter 3. If you prefer to work with the Live Control display, see the preceding section to find out how to enable it for iAuto mode.

2. **If you're currently viewing menus or have the camera set to playback mode, press the shutter button halfway to return to shooting mode.**

3. **Press OK.**

The Live Control screen becomes active, and you see a screen similar to the one in Figure 1-29. The relevant areas to note are

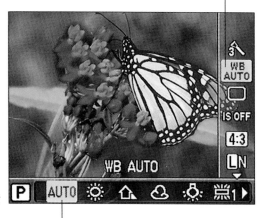

Selected option

Current setting

Figure 1-29: Press the up- or down-arrow keys to highlight the picture option you want to adjust; press the right- or left-arrow keys to select a setting.

- Icons running down the right side of the screen represent the picture options you can adjust, which vary depending on your shooting mode. You can control more settings in the P exposure mode, for example, than in the SCN (Scene) modes.

- The highlighted icon is the currently selected setting. In the figure, the White Balance setting is selected. (Don't worry — you'll come to recognize what all those icons mean after a few days of working with your camera. And if not, later chapters decode all the various symbols.)

- Settings available for the selected option appear in a row along the bottom of the screen. Again, the highlight indicates the current setting. In the figure, the Auto White Balance setting is selected. A text label above the icon strip offers a hint as to the actual name of the setting.

4. **Press the up- or down-arrow keys to select the camera option you want to adjust.**

As you do, the settings strip at the bottom of the screen updates to reflect possible settings for that option.

5. **Press the left- or right-arrow keys to select the setting you want to use.**

Just move the highlight over the setting.

And now for one of the really cool features of the E-PL1: As you select some settings, the monitor preview shows you the effects on the scene. One of those preview-enabled settings is the White Balance option, a color-related function you can explore in Chapter 7. For example, Figure 1-30 shows how changing the White Balance setting from the Auto setting used in Figure 1-29 to the Sunny setting affected the picture colors.

To take advantage of this live preview feature in some shooting modes, you must disable another option, Live View Boost. See the "Exploring setup options on the Custom menu" section later in this chapter for details.

6. **To adjust another picture-taking option, press the up- or down-arrow key to highlight its icon on the right side of the screen.**

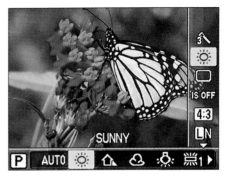

Then use the left- and right- arrow keys to select an option for that setting. And so on. And so on.

Figure 1-30: You can see how a change to the White Balance setting alters your photo in the live preview.

7. **To exit the Live Control screen and return to shooting, press the shutter button halfway.**

Using the Super Control Panel (SCP)

The Live Control screen enables you to concentrate on a single setting at a time. (Experimenting with just one setting on each photography outing is a great way to learn, by the way.) But as you advance in your photography knowledge, you'll figure out how to combine multiple settings to craft the picture that you have in mind. For example, you might use a particular exposure setting with a specific focusing setting to capture a waterfall and then dial in a totally different combination to photograph a child playing with a puppy.

When you're ready to consider all the critical photography settings as a unit, you may prefer to abandon the Live Control screen in favor of the Super Control Panel. Or you can enable both displays and then switch between them as needed.

Before you can use the Super Control Panel (abbreviated SCP in the camera screens and in some parts of the manual), you must enable it through Custom Menu D. Skim backward through this chapter, to the section "Setting your control screen preferences" to find out how.

After enabling the display, press OK to bring it to life. If one of the other control displays appears, press Info until you see the Super Control Panel, which looks like the screen shown on the left in Figure 1-31.

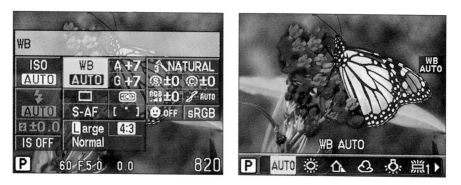

Figure 1-31: Use the arrow keys to select an option and then press OK to access available settings for that option.

Here's the lowdown on selecting and adjusting settings via the panel:

1. **Press the arrow keys (up, down, left, right) to move the highlight over the option that you want to adjust.**

 In Figure 1-31, the White Balance setting is selected. The icon represents the current setting for the option; in the figure, the display indicates that the White Balance option is set to Auto. For some options, a text label appears at the top of the panel — note the WB at the top of the screen in Figure 1-31. For others, you get just another icon (but in most cases, the icons are pretty easy to figure out).

2. **Press OK.**

 The control panel is replaced by a strip of icons representing the available settings at the bottom of the screen, as shown on the right in Figure 1-31. The screen is a modified version of the settings screen that appears in the Live Control display.

3. **Press the right- or left-arrow key to select the icon that represents the setting you want to use.**

 A text label above the icon strip identifies each setting.

4. **If you want to change another setting, press the Info button to return to the Super Control Panel.**

 Or just don't press any buttons for a second or two.

 When no buttons are pressed for a few seconds, the camera locks in the setting you just chose. Then it redisplays the Super Control Panel. The option you selected in Step 2 remains highlighted and shows your new setting.

5. **Repeat Steps 1–4 to adjust other settings.**

6. **To exit the panel and return to shooting, press the shutter button halfway.**

Reviewing Basic Setup Options

Your camera offers scads of options for customizing its performance — the display options covered earlier in this chapter represent just a few of the ways you can make your camera, well, *yours*.

Later chapters explain settings related to actual picture taking, such as those that affect flash behavior and autofocusing. The rest of this chapter details additional options related to initial camera setup, such as setting the date and time, adjusting monitor brightness, and the like.

Cruising the Setup menu

Start your camera customization by opening the Setup menu, as shown in Figure 1-32. As you can see, some menu items are represented just by icons rather than text labels. So for easy reference, I add my own text labels to those menu items in the figure.

Monitor brightness/color temperature

Language Date/Time

🕐	04.05.'10 17:22
👤📋	ENG.
🔲	F±0 ☀±0
REC VIEW	5SEC
⚙ MENU DISPLAY	ON
FIRMWARE	

BACK ➡ MENU SET ➡ OK

Custom Menu Display

Figure 1-32: Visit the Setup menu to set basic operational preferences.

✔ **Date and Time:** Select this option and press OK to display the screen where you can enter the current date and time. Press OK when you finish.

Taking this step is important because that information is recorded as part of the image file. In your photo browser, you can then see when you shot an image and, equally handy, search for images by the date they were taken.

✔ **Language:** This option determines the language of text on the camera monitor. Scrolling through this list is like a visit to the United Nations — you can choose from more than 30 languages. Make your selection and press OK to return to the Setup menu.

✓ **LCD Brightness and Color Temperature:** Choosing this option displays the screen shown on the left in Figure 1-33. As with most digital cameras, you can adjust the monitor brightness to suit the ambient light in which you're working. But you also can affect the monitor *color temperature*. Chapter 7 explains this term fully, but the short story is that you can set the monitor to make the colors appear warmer (more red) or cooler (more blue). This adjustment affects *only* how the monitor displays picture colors during playback, however. It's provided mainly so that when you connect the camera to a TV for playback, you have a way to tweak the display.

Brightness

Color temperature

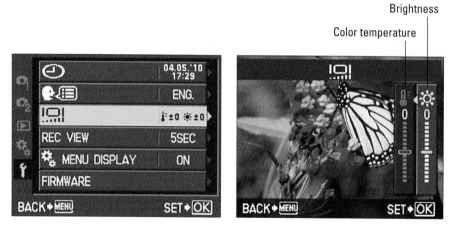

Figure 1-33: Adjustments to the monitor color temperature affect picture playback only.

To adjust the monitor, press the right- or left-arrow key to highlight the brightness scale or the color temperature scale, labeled in Figure 1-33. Press the up- or down-arrow key to set the level of adjustment and then press OK to return to the Setup menu.

I caution you against making either adjustment to your monitor on a regular basis, however, because it may influence your judgment of whether your picture's exposure or colors are off.

✓ **Rec View:** After you take a picture, the camera displays it for five seconds on the monitor. You can adjust this instant review period or disable it entirely; Chapter 4 discusses this and other playback options. The Rec View setting affects still photography only, so the menu option is disabled when the Mode dial is set to Movie.

✓ **Custom Menu Display:** Enabling this option brings the Custom menu out of hiding. See the earlier section "Ordering from Camera Menus" for details.

✔ **Firmware:** Select this option and press OK to view a screen that shows you what version of the camera *firmware,* or internal software, your camera is running. You see two separate firmware items, one related to the camera body and one to the lens. At the time of publication, the most current version of the body firmware is 1.1, and the lens firmware is version 1.0.

Keeping your camera firmware up-to-date is important, so visit the Olympus Web site (www.olympus.com) regularly to find out whether your camera sports the latest version. You can find detailed instructions on how to download and install any firmware updates on the site. Note that the update to the body firmware (from version 1.0 to version 1.1) is an important one: It improves autofocusing speed and enables additional display options related to the electronic viewfinder.

Exploring setup options on the Custom menu

Custom Menu D, visible in Figure 1-34, leads to three screens of options, all shown in Figure 1-35. The following list details just those options that affect basic camera operations; later chapters detail the features related to picture-taking or playback. (Check the index if you need help finding the section that describes a specific menu item.)

Figure 1-34: Custom Menu D contains some additional important camera setup options.

✔ **Sleep:** To help save battery power, the camera is set by default to turn itself off after one minute of inactivity. Through the Sleep option, you can vary this automatic shutdown interval to 3 minutes, 5 minutes, or 10 minutes. You also can completely disable the auto shutdown by selecting the Off setting.

✔ **Live View Boost:** If you turn on this feature, the camera automatically adjusts the brightness of the monitor according to changes in the ambient light. Sounds good, but here's a catch: Enabling Live View Boost prevents the live view from reflecting adjustments you make to exposure in some shooting modes. For that reason, I leave Live View Boost at its default setting, Off.

✔ **Thumbnail/Info Setting:** This menu item gives you access to options that control certain aspects of the shooting and playback displays. See the earlier section "Monitor Matters: Customizing the Shooting Display" for details about the shooting display; Chapter 4 covers playback display choices.

Figure 1-35: Press the up- or down-arrow key to scroll through the three screens of options.

✏ **Control Setting:** Use this option to enable or disable the Live Guide, Live Control, and Super Control Panel (SCP) displays. The earlier section "Monitoring and Adjusting Photography Settings" explains.

✏ **EVF Adjust:** If you attach the optional electronic viewfinder, you can use this feature to adjust the display brightness and color temperature. Otherwise it's dimmed in the menu and unavailable, as in Figure 1-35. Refer to my comments about the related control for adjusting the monitor, in the preceding section, to find out more about this setting and why I suggest you ignore it.

✏ **Backlit LCD:** By default, the monitor display dims slightly after an 8-second period of activity to save battery power. If you want to adjust this timing, visit this menu option. You can increase the automatic dimming delay to 30 seconds or one minute. Or you can disable the dimming feature entirely by choosing the Hold setting.

✔ **Mode Guide:** By default, the camera displays a message similar to the one you see in Figure 1-36 every time you change the camera Mode dial to a new setting. The idea is to provide you with a hint as to the purpose of the mode. You dismiss the screen by pressing the shutter button halfway.

The reminder screens are helpful when you're first exploring the camera, but after you understand what each mode does, you may prefer to disable them by setting the Mode Guide menu option to Off.

Figure 1-36: Press the shutter button halfway to dismiss these screens; set the Mode Guide option to Off to disable them altogether.

✔ **Beep:** When you use autofocusing and press the shutter button halfway, the camera emits a little beep to let you know that it was successful in locking focus. The option that controls the beep is indicated on the menu with a little speaker icon (refer to the third screen in Figure 1-35). To silence the beep, set this menu option to Off.

✔ **Volume:** This setting controls the default volume of the camera's internal speakers. (The circle of tiny holes on the camera back lead to that speaker.) When you play a movie, slide show, or still picture that has audio, you can adjust volume by pressing the up- or down-arrow key. See Chapter 4 for more about playback and slide shows; and see Chapter 9 to find out how to annotate a still photo with an audio clip.

Custom Menu H, as shown in Figure 1-37, contains one additional critical setup option, File Name. This option controls how file numbers are assigned to pictures. By default, the camera assigns each picture file a number — your first picture is P1000001.jpg, your second picture, P1000002.jpg, and so on. (Chapter 4 decodes the rest of the filename characters.) Even if you turn off the camera or replace the memory card, the camera remembers where the numbering scheme left off and assigns the next available number to your next picture. If you change the File Name option from the default setting,

G	QUICK ERASE	OFF
H	RAW+JPEG ERASE	RAW+JPG
I	FILE NAME	AUTO
J	EDIT FILENAME	
	PRIORITY SET	NO
	dpi SETTING	AUTO
BACK➔MENU		SET➔OK

Figure 1-37: Leave this option set to Auto so you don't wind up with multiple images that have the same filename.

Auto, to Off, the camera restarts the numbering sequence at P100001.jpg every time you insert a new memory card (or, if the card contains images, at the next available number). Obviously, that setup can lead to multiple pictures having the same file number, which can cause problems when you download the pictures to your computer. So keep this option set to Auto. See Chapter 10 for details on the related option, Edit Filename, which lets you customize the first few characters of filenames.

Restoring default settings

For the iAuto and SCN modes, the camera automatically restores the factory default settings for critical shooting options as soon as you choose a different shooting mode or turn off the camera. You can restore the defaults for other modes by setting the Mode dial to P, A, S, or M and then visiting Shooting Menu 1. Select Custom Reset, press OK, and then select Reset, as shown in Figure 1-38. Through this option, you can restore most — but not all — of the default picture-taking settings.

In either case, basic camera settings, such as those on the Custom menu or Setup menu, are unaffected. If you want to return all settings to their factory defaults, you need to go through each menu item individually. A chart in the back of the camera manual lists the default setting for each option.

Figure 1-38: To access the Custom Reset option, first set the Mode dial to P, A, S, or M.

Chapter 10 explains how to use the other to reset options, Reset 1 and Reset 2, to create and maintain your own set of camera defaults.

Choosing Basic Picture Settings

*E*very camera manufacturer strives to provide a good *out-of-box* experience — that is, to ensure that your first encounter with the camera is a happy one. To that end, the camera's *default* (initial) settings are carefully selected to make it as easy as possible for you to take a good picture the first time you press the shutter button.

On the E-PL1, the default settings ensure that the camera works about the same way as any automatic, point-and-shoot camera you may have used in the past: You frame the subject in the monitor, press the shutter button halfway to focus, and then press the button the rest of the way to take the shot.

Although you can get a good picture using the default settings in many cases, they're not designed to give you the optimal results in every shooting situation. Rather, they're established as a one-size-fits-all approach to using the camera. You may be able to use the defaults to take a decent portrait, for example, but will probably need to tweak a few settings to capture fast action. And adjusting a few options can also help you turn that decent portrait into a stunning one, too.

So that you can start fine-tuning camera settings to your subject, this chapter explains the most basic picture-taking options, such as the shutter-release mode, image aspect ratio, and the picture quality. They're not the sexiest or most exciting options to explore (don't think I didn't notice you stifling a yawn), but they make a big difference in how easily you can capture the photo you have in mind. You also need to understand this core group of camera settings to take best advantage of all the advanced color, focus, and exposure controls covered in Part III of the book.

Reviewing the Most Critical Options

Stage one of mastering your E-PL1 begins with getting familiar with the core set of picture options listed in Table 2-1. The table also shows you the default settings for each option along with the button or menu you use to adjust the setting. You also can adjust most settings via the Live Control or Super Control Panel displays; see Chapter 1 to find out how to enable those displays.

Note, though, that the defaults in Table 2-1 are specific to the advanced photography modes, represented by P, S, A, and M on the Mode dial, as shown in Figure 2-1. Your camera offers eight modes, described briefly in Table 2-2. You get seven still-photography modes plus Movie mode for recording digital movies. For still photography, the P/A/S/M modes are the only ones that give you full control over the core options.

Table 2-1	Default Picture Settings	
Option	**Defaults (P/A/S/M Modes)**	**How to Change It**
Shutter-release mode	Single Frame	Down-arrow key, Shooting Menu 2
Image Aspect	4:3	Shooting Menu 1
Image Stabilizer	Off	Shooting Menu 2
Face Detection	On	Fn button, Custom Menu D
Image Quality	L/N (Large Normal)	Shooting Menu 1
AF (autofocus) Mode	S-AF	Custom Menu A
AF Area	All Targets	Left-arrow key, Custom Menu A
White Balance	Auto	Custom Menu G
Picture Mode	3 (Natural)	Shooting Menu 1

Table 2-2	Shooting Modes
Mode	**Description**
iAuto	Automatic photography with a few options for tweaking focus, color, and exposure.
P	Programmed autoexposure; camera sets exposure by selecting aperture and shutter speed but gives you control over all other aspects of the picture.
A	Aperture-priority autoexposure; you select aperture, and the camera sets shutter speed to produce proper exposure. Full control over all other picture settings.
S	Shutter-priority autoexposure; you set shutter speed, and the camera selects proper aperture for good exposure. Full control over all other picture settings.
M	Manual exposure; you select both shutter speed and aperture. Full control over all other settings.
Movie	Movie-recording mode.
SCN	Scene mode; you select one of the scene types (Portrait, Landscape, and so on), and the camera does the rest. Little control over picture settings.
ART	Art Filter mode; you apply one of six special effects to either still photos or movies. For most options, offers same control over picture settings as P mode or Movie mode.

REMEMBER

The iAuto and SCN (Scene) modes are designed to provide almost-automatic photography and so give you access to only some of the settings. Default settings in some cases vary from those shown in Table 2-1. ART mode is sort of a hybrid mode: The camera operates much the same as it does in P mode, but enables you to preview and apply six special effects to the image. As for Movie mode, you don't actually have to set the dial to that mode to record a movie; by default, the Movie button is set to start and stop recording no matter what the shooting mode. But if you want to adjust recording settings, you need to set the Mode dial to Movie. You also can apply the ART effects to movies if you choose.

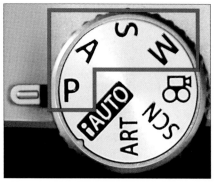

Figure 2-1: You get full control over the picture settings only in the P, A, S, and M shooting modes.

With that preamble out of the way, the rest of this chapter details how the first five options in Table 2-1 impact still photography with the E-PL1. As for the remaining options, Chapter 3 explains the settings available in the iAuto and SCN modes, and Part III covers the options available when you shoot in the P, S, A, and M modes. (If you're not ready to move into the advanced content in those chapters, just stick with the default settings listed in the table.)

Setting the Shutter-Release Mode

Your camera is set by default to record one picture each time you press the shutter button fully. But by changing the shutter-release mode, you can instead record a continuous series of shots with a single press of the button or take advantage of self-timer shooting.

To adjust the setting, use any of the following techniques:

✓ **Down-arrow key:** After you press the key, you're taken to a screen that looks like the one shown in Figure 2-2. Icons representing the settings appear at the bottom of the screen — notice that the label on the down-arrow key mimics those icons. Press the right- or left-arrow key to select the setting you want to use. (The upcoming list details exactly how each release mode works.) Then just press the shutter button halfway and release it to return to shooting.

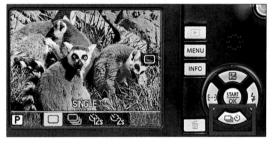

Figure 2-2: Pressing the down-arrow key is the fastest way to access the shutter-release settings.

✓ **Live Control or Super Control Panel display:** You also can access the release-mode setting through either of the control screens, as shown in Figure 2-3. See Chapter 1 for details on how to display and use the control screens.

✓ **Shooting Menu 2:** The release-mode setting lives at the top of the menu, as shown in Figure 2-4. If you go the menu route, remember that you have to press OK to lock in your new setting. If you simply exit the menus, the camera retains the previous setting.

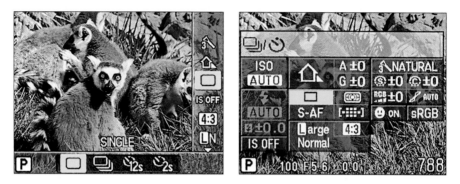

Figure 2-3: You also can adjust the release mode via the Live Control screen (left) or Super Control Panel (right).

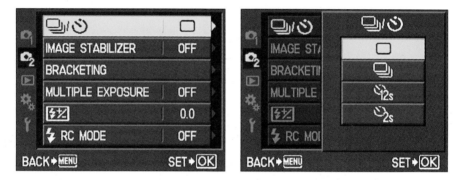

Figure 2-4: Shooting Menu 2 offers one more way to set the release mode.

The E-PL1 offers the following assortment of release-mode settings:

✔ **Single frame:** Record one shot each time you fully depress the shutter button. This setting is the default and is best for shooting portraits, landscapes, and other pictures that feature a stationary subject.

✔ **Sequential:** In this mode, designed for capturing action, the camera records a continuous series of pictures as long as you hold down the shutter button. (This release mode is often referred to as *burst mode* or *continuous capture mode*.) You can record approximately three pictures per second.

In Sequential mode, the camera uses the same exposure and White Balance settings for all frames in the series of shots. How the camera sets focus for each burst of images depends on the AF mode setting, which I detail in Chapter 7. In the default mode, S-AF (single autofocus), the camera sets focus when you press the shutter button halfway and then uses the same focus setting for the entire series of shots. If you instead set the AF mode to continuous autofocus (C-AF) or continuous

autofocus with subject tracking (C-AF+TR), focus is adjusted as needed between shots. In some cases, using continuous autofocusing can slow down the frames-per-second rate because of the time the camera needs to adjust focus.

In manual focus mode (MF), you can twist the focusing ring as needed during the burst capture (although you need to be pretty quick to keep pace with the three frames-per-second shot rate).

⊙12s ⎯ **12-Second Self-Timer:** Want to put yourself in the picture? Select this mode, press the shutter button, and run into the frame. As soon as you press the shutter button, a self-timer lamp on the front of the camera lights (see Figure 2-5). The light starts to blink about five seconds before the camera captures the image.

⊙2s ⎯ **2-Second Self-Timer:** In this mode, the camera captures the picture two seconds after you depress the shutter button. This release mode isn't designed for taking a picture of yourself — unless you're really, really fast. Instead, the setting is meant for times when you mount the camera on a tripod (or other steady surface) and you want to eliminate any chance that camera shake will blur the image. That may sound odd, but when you use a slow shutter speed (long exposure time), a long (tele-photo) lens, or shoot extreme close-ups, even the act of press-ing the shutter button can jar the

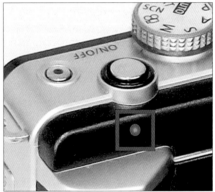

Figure 2-5: After the self-timer lamp starts blinking, you have about five seconds to perfect your pose.

camera enough to cause a slight blur. In any of these scenarios, select the 2-Second Self-Timer setting, depress the shutter button, and then take your hands off the camera until the picture is captured.

Again, whether you can select from all four modes depends on your shoot-ing mode. And in ART, P, A, S, and M modes, you get an additional option: Custom Menu E offers an Anti-Shock option, as shown in Figure 2-6. (The option is on the second screen of the menu; press the down arrow to scroll the display and reveal the screen.) The Anti-Shock feature enables you to set a specific delay between the time you press the shutter button and the time the shutter is released, no matter what shutter release mode you select. You can choose a range of delay times from 1/8 second all the way to 30 seconds.

If you enable the Anti-Shock feature, you see four additional shutter-release mode icons, one for each of the standard modes combined with the Anti-Shock delay, represented by the same little diamond symbol that appears in parentheses after Anti-Shock on the menu.

REMEMBER

Regardless of your shutter-release setting, remember that when you use the default AF (autofocus) mode, S-AF, the camera refuses to release the shutter button until focus is achieved. You can press that shutter button as long and hard as you want, but the camera just sits there and ignores you

Figure 2-6: You can use the Anti-Shock feature to set a specific delay between the time the shutter button is pressed and the shutter is released.

if it can't lock focus. You can adjust this behavior through the RLS Priority S setting on Custom Menu C; Chapter 7 tells the whole story.

Changing Picture Proportions (Image Aspect Ratio)

Your camera is set by default to record an image that has a 4:3 aspect ratio. This setting makes full use of the camera's image sensor and is the recommended option. However, depending on your shooting mode, you can use the Image Aspect option to capture pictures using one of three alternative aspect ratios:

- 📋 **3:2,** the same as a 35mm film negative and 4 x 6-inch print

- 📋 **16:9,** the same as a widescreen TV and most new computer monitors

- 📋 **6:6,** the same as most scrapbooks (which usually hold pages that are 12 x 12 inches)

TECHNICAL STUFF

How the camera arrives at these three alternative image proportions depends on the Image Quality setting, which determines whether the picture is saved in the JPEG file format or Raw format. (See the last few sections of this chapter for details on that setting.) Here's how your Image Quality choice relates to the Image Aspect setting:

✔ **JPEG:** The camera crops the photo to the selected aspect ratio before saving the file to the memory card.

✔ **Raw:** The image retains the same area that's captured at the 4:3 setting, but the file data includes the Image Aspect setting you selected. When you display the picture on the camera monitor, a white crop box indicates the image boundaries of the selected aspect ratio. If you use the in-camera Raw Data Edit feature to save a JPEG copy of the image, the copy is cropped automatically to those boundaries. You also can view the crop box and apply the crop via the Raw processing feature in the Olympus photo software. (Chapter 5 covers the topic of processing Raw images.)

I prefer to keep the Image Aspect option set to 4:3 so that the camera records the maximum image area. If I need a picture at one of the other aspect ratios, I can make a cropped copy using the in-camera cropping feature, which I cover in Chapter 9, or the cropping tools in my photo software.

I'm here to explain all your possibilities, however, so if you decide you have good reason to change the aspect ratio, you can do so in the following ways:

✔ **Shooting Menu 1:** Select Image Aspect, as shown on the left in Figure 2-7, and press OK to display the second screen in the figure. Press the up- or down-arrow key to adjust the setting. As you do, the list on the left side of the screen shows you how many pixels the image will contain at each of the available Image Quality settings. (Refer to the section "Choosing the Right Quality Settings," later in this chapter, for a primer on pixels.)

✔ **Live Control or Super Control Panel display:** Figure 2-8 shows you where the Image Aspect setting is located on each display. (Chapter 1 introduces you to these screens.) If you go this route, you don't see the pixel details that appear when you go through the menus.

Figure 2-7: When you select an aspect ratio other than 4:3, the pixel count of the image is reduced to fit the desired proportions.

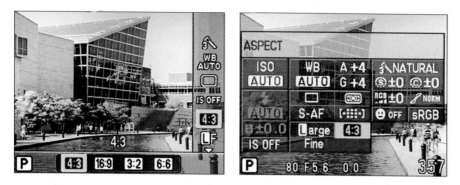

Figure 2-8: For a quicker way to adjust the aspect ratio, use the Live Control or Super Control Panel display.

If you select an aspect ratio other than 4:3, the live preview shows the image area that will be included in your cropped image. For example, Figure 2-9 shows how the monitor appears if you set the aspect ratio to 16:9. At any setting but 4:3, the Aspect Ratio setting remains onscreen as a reminder of the crop factor, as shown in the figure. When you reset the option to 4:3, the setting is no longer displayed.

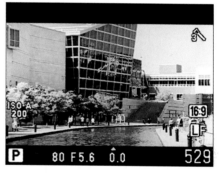

Figure 2-9: The live preview reflects your selected aspect ratio.

All these details apply only to still photography; for movies, the Movie Quality setting determines the aspect ratio. If you shoot a movie in high-definition (HD) format, the aspect ratio is 16:9. For SD (standard definition) recording, the normal 4:3 aspect ratio is used. See Chapter 3 to find out more about this and other movie options. In addition, the Panorama SCN mode, covered in Chapter 3, also limits you to the 16:9 aspect ratio.

Stabilizing Your Shots

Blurry photos can stem from poor focusing or, if the subject is moving, a slow shutter speed. Chapters 6 and 7 show you how to avoid those problems. But even if your focus and shutter speed are spot on, you need to watch out for a third cause of blur, camera shake. The slightest amount of camera movement during the exposure can blur the entire photo. To help alleviate the blurring caused by camera shake, you can enable *image stabilization*. This technology, built into the E-PL1, attempts to compensate for small amounts of camera shake that are common when photographers handhold their cameras and use a slow shutter speed, a lens with a long focal length, or both. Although

image stabilization can't work miracles, it does enable most people to capture sharper handheld shots in many situations than they otherwise could.

You have a choice of four stabilization settings, which you can control in all eight shooting modes, with one exception. If you use the Fireworks SCN mode, image stabilization is unavailable. Otherwise, you can choose from these settings:

- ✔ **Off:** When you use a tripod, image stabilization can have detrimental effects because the system may try to compensate for movement that isn't actually occurring. So select this setting (the default) for tripod shooting.

- ✔ **I.S. 1:** Choose this setting for normal handheld photography. The camera applies stabilization that compensates for both horizontal and vertical camera movement.

- ✔ **I.S. 2:** This setting is designed for times when you use an action-photography technique — *panning*. During the exposure, you *pan* (move) the camera to follow the subject. The result is that the subject remains sharp but the background dissolves into blurred horizontal or vertical lines, creating a heightened sense of motion.

 The I.S. 2 stabilization setting is designed for use when you pan in a horizontal direction, as you might when photographing a race car or cyclist. The camera then ignores horizontal camera movement and compensates only for vertical movement.

- ✔ **I.S. 3:** The opposite of I.S. 2, this setting compensates only for horizontal movement and is meant to provide stabilization for vertical panning. You might pan upward to capture a basketball player's jump toward the hoop, for example.

You can adjust the setting through Shooting Menu 2, as shown in Figure 2-10, or via the Live Control or Super Control Panel displays, as shown in Figure 2-11.

Figure 2-10: To enable stabilization, head for Shooting Menu 2.

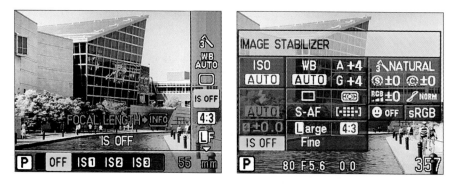

Figure 2-11: You can also adjust the setting via the Live Control screen (left) or Super Control Panel (right).

You may notice a slight camera vibration or additional mechanical sounds when you turn on the camera as it initializes the stabilization system. You may also be able to detect a slight sound or vibration as the system does its thing when you're taking pictures. Don't worry about either — they're normal.

Keep these additional details in mind to get best performance from the image stabilizer:

✓ **Registering a lens focal length:** The system needs to know the focal length of the lens to do its best work. When you use Micro Four Thirds lenses, the camera detects the focal length setting that produces optimum stabilizer results. The camera also can detect focal length of Four Thirds lenses, which you can mount with the use of an optional adapter. The focal length information is displayed at the bottom of the menu screen on the right in Figure 2-10 and in the lower-right corner of the Live Control display (left screen in Figure 2-11).

With other lenses, you need to *register* the lens — to enter the lens focal length, in plain terms. To take this step, use either of these techniques:

• *Shooting Menu 2:* Select Image Stabilizer and press OK to display the second screen shown in Figure 2-10. Then press the right-arrow key to display the screen shown on the left in Figure 2-12. Use the up- or down-arrow key to set the focal length and press OK. You can choose from focal lengths ranging from 8mm to 1000mm; select the one that most closely matches your lens.

• *Live Control or Super Control Panel display:* After you select the Image Stabilizer option and display the settings screen, press the Info button to activate the focal length value, as shown on the right in Figure 2-12. Press the up- or down-arrow key to adjust the

setting and press OK. (*Note:* When the Image Stabilizer option is active, you can't use the Info button to switch between the Live Control and Super Control Panel displays as you usually do because pressing the Info button just toggles the focal-length value on and off. So select any other option — White Balance, Face Detection, whatever — and then press Info to switch displays.)

✔ **Preventing dueling stabilization systems:** Most interchangeable-lens cameras don't offer built-in stabilization like the E-PL1. Instead, if you want to take advantage of the feature, you must buy (and pay extra for) a lens that offers it. If you own an image-stabilized lens and want to use it with your E-PL1, disable the feature either on the camera or the lens so that only one stabilization system is active. Otherwise, the two systems compete, leading to much electronic confusion and potentially blurry photos.

✔ **Shooting exposures longer than 2 seconds:** Image stabilization is automatically disabled when you choose a shutter speed longer than 2 seconds because that slow of a shutter speed calls for the use of a tripod. In fact, I recommend a tripod any time the shutter speed even approaches the one second mark. (Chapter 6 explains shutter speed.)

✔ **Avoiding overheating:** If the stabilizer icon in the Live Control or Super Control Panel display turns red, the camera is alerting you to two facts: First, the camera's internal temperature is reaching the danger zone. Second, the camera has deactivated the stabilizer feature in an attempt to try to reduce the operating temperature. Either way, you may want to power down the camera for a short while to let it return to normal temperatures. (If the IS symbol blinks, the camera is politely asking you to take it to a service shop to have the stabilizer system repaired.)

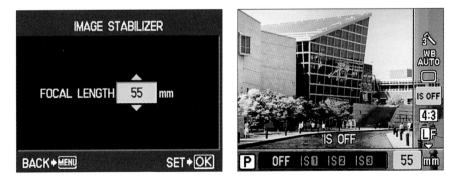

Figure 2-12: If you don't use a Micro Four Thirds or Four Thirds lens, register the lens focal length to help the stabilizer do its job.

Using Face Detection

A relatively new digital-camera feature, *Face Detection* enables the camera to automatically recognize faces and then adjust focus and exposure to suit those faces. When you enable the feature on the E-PL1, the camera immediately scans the frame looking for faces. Detected faces become surrounded by a white box, as shown in Figure 2-13. As you can see, the camera can sometimes recognize animal faces as well as human ones. Regardless of species, though, faces usually aren't recognized unless the eyes are looking directly into the lens. Additionally, Face Detection isn't available for movie recording on the E-PL1, and for Sequential shooting during still photography, Face Detection works only for the first shot in a series of images.

Face Detection on

Face Detection is a great feature when you're just getting started in photography. But after you get comfortable with the camera's focusing and exposure controls, choosing the right settings to properly expose and focus the face isn't that difficult, and having the little white frames popping up here and there can become a distraction.

Figure 2-13: A white frame indicates that Face Detection was successful.

You can't disable Face Detection in iAuto mode, and whether you have any control in SCN mode depends on which scene type you select. In ART, P, A, S, and M modes, you can turn the feature on or off according to your mood. Use these techniques:

Fn

- ✔ **Press the Fn button.** By default, the button is set to toggle Face Detection on and off in P, A, S, and M modes. The little face icon on the left side of the screen updates to reflect the current setting. When the feature is enabled, the icon looks like the one in Figure 2-13. When the feature is disabled, Off appears next to the icon.

 Chapter 10 shows you how to assign a different responsibility to the Fn button if you don't use Face Detection very often. You can't use the button for the Face Detection feature in ART mode.

- ✔ **Custom Menu D:** The Face Detection feature is considered a display option, so you access it via Custom Menu D, as shown in Figure 2-14.

- ✔ **Live Control or Super Control Panel displays:** As with most of the critical camera functions, you can enable Face Detection through both of these displays. Look for the little face icons, highlighted in Figure 2-15.

Figure 2-14: Custom Menu D holds the menu version of the Face Detection setting.

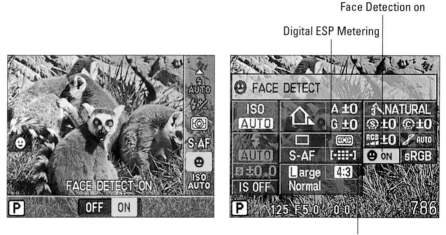

Figure 2-15: You must use these AF Area and Metering settings for Face Detection to work.

I need to alert you to two other settings related to Face Detection: If you want the camera to base exposure and focus on the faces, you must also use the following exposure and focus settings:

✔ **AF Area mode:** Select the All Targets option. In Single Target mode, focus is set on the object that falls under the focus point, regardless of whether that object has two eyes, a nose, and a mouth. The All Targets setting is the default; you can change it via Custom Menu A or the control displays. I labeled the icon that represents the correct setting in Figure 2-15. See Chapter 7 for more details about this option.

> ✔ **Metering mode:** This option determines what area of the frame the camera analyzes to select the proper exposure settings. Face Detection is paired with the default metering mode, Digital ESP metering. Chapter 6 covers metering modes and all other exposure-related options. If you want to check the setting now, look for it on Custom Menu E or either of the control displays. Digital ESP metering is the first metering option on the list of settings — the icon looks like the one labeled in Figure 2-15.

Choosing the Right Quality Settings

Almost every review of the E-PL1 contains glowing reports about the camera's top-notch picture quality. As you've no doubt discovered, those claims are true: This baby can create large, beautiful images.

Getting the maximum output from your camera, however, depends on choosing the correct Image Quality setting. This option determines two important aspects of your pictures: *resolution,* or pixel count; and *file format,* which refers to the type of computer file the camera uses to store your picture data. Resolution and file format together contribute to the overall quality of your photos, so understanding them is critical.

Why not just dial in the setting that produces the maximum quality level and be done with it? Well, that's the right choice for some photographers. But because choosing that maximum setting has some disadvantages, you may find that stepping down a notch or two on the quality scale is a better option, at least for some pictures.

To help you figure out which Image Quality setting meets your needs, the rest of this chapter explains exactly how resolution and file format affect your pictures. Just in case you're having quality problems related to other issues, though, the next section provides a handy quality-defect diagnosis guide. If you already know what setting you want to use and just need some help finding out how to select the option, skip to the very last section of the chapter. For details on setting the quality of movies, check out Chapter 3; the rest of this chapter relates only to still photography.

Diagnosing quality problems

When I use the term *picture quality,* I'm not talking about the composition, exposure, or other traditional characteristics of a photograph. Instead, I'm referring to how finely the image is rendered in the digital sense.

Figure 2-16 illustrates the concept: The first example is a high-quality image, with clear details and smooth color transitions. The other examples show five common digital-image defects.

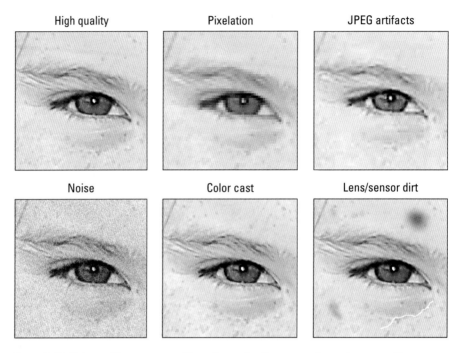

Figure 2-16: Refer to this symptom guide to determine the cause of poor image quality.

Each of these defects is related to a different issue, and only two are affected by the Image Quality setting. So if you aren't happy with what you see in your photos, compare them to those in the figure to properly diagnose the problem. Then try these remedies:

- **Pixelation:** When an image doesn't have enough *pixels* (the colored tiles used to create digital images), details aren't clear, and curved and diagonal lines appear jagged. The fix is to increase image resolution, which you do via the Image Quality setting. See the upcoming section, "Considering resolution: How many pixels are enough?" for details.

- **JPEG artifacts:** The "parquet tile" texture and random color defects that mar the third image in Figure 2-16 can occur in photos captured in the JPEG *(jay-peg)* file format, which is why these flaws are referred to as *JPEG artifacts.* This defect is also related to the Image Quality setting; see the "Understanding file type (JPEG or Raw)" section, later in this chapter, to find out more.

- **Noise:** This defect gives your image a speckled look, as shown in the lower-left example in Figure 2-16. Noise is most often related to a very long exposure time (that is, a very slow shutter speed) or to an exposure control called ISO Sensitivity, which you can explore in Chapter 6.

✓ **Color cast:** If your colors are seriously out of whack, as shown in the lower-middle example in the figure, try adjusting the camera's White Balance setting. Chapter 7 covers this control and other color issues.

✓ **Lens/sensor dirt:** A dirty lens is the first possible cause of the kind of defects you see in the last example in the figure. If cleaning your lens doesn't solve the problem, dust or dirt may have made its way onto the camera's image sensor. See the sidebar "Maintaining a pristine view," elsewhere in this chapter, for information on safe lens and sensor cleaning.

When diagnosing image problems, you may want to open the photos in your photo software and zoom in for a close-up inspection. Some defects, especially pixelation and JPEG artifacts, have a similar appearance until you see them at a magnified view.

I should also tell you that I used a little digital enhancement to exaggerate the flaws in my example images to make the symptoms easier to see. With the exception of an unwanted color cast or a big blob of lens or sensor dirt, these defects may not even be noticeable unless you print or view your image at a very large size. And the subject matter of your image may camouflage some flaws; most people probably wouldn't detect a little JPEG artifacting in a photograph of a densely wooded forest, for example.

In other words, don't let Figure 2-16 lead you to think that the E-PL1 is suspect in the image quality department. First, *any* digital camera can produce these defects under the right circumstances. Second, by following the guidelines in this chapter and the others mentioned in the preceding list, you can resolve any quality issues that you may encounter.

Considering resolution: How many pixels are enough?

To decide upon an Image Quality setting, the first decision you need to make is how many pixels you want your image to contain. *Pixels* are the little square tiles from which all digital images are made. You can see some pixels close up in the right image in Figure 2-17, which shows a greatly magnified view of the eye area in the left image.

Pixel is short for *picture element.* The number of pixels in an image is referred to as *resolution.* You can define resolution either in terms of the *pixel dimensions* — the number of horizontal pixels and vertical pixels — or total resolution, which you get by multiplying those two values. This number is usually stated in *megapixels,* or MP for short, with one megapixel equal to one million pixels. For example, the E-PL1 offers a maximum resolution of 4032 x 3024 pixels, which translates to approximately 12.2 megapixels.

Table 2-3 shows you the resolution settings available on the E-PL1. You can choose from three settings, Large (L), Middle (M), and Small (S). At the Large setting, your pictures always contain the maximum 12.2 megapixels. But for the Middle and Small settings, you can choose from three resolution options. In the table, the first pixel count listed for the Middle and Small settings represents the default. See the section "Selecting and customizing the Image Quality setting," in this chapter, for details on how to set the count you want to use for the Middle and Small resolution settings.

Figure 2-17: Pixels are the building blocks of digital photos.

Table 2-3	The Resolution Side of the Quality Settings	
Symbol	*Setting*	*Pixel Count (MP = Megapixels)*
L	Large	4032 x 3024 (12.2 MP)
M	Middle	3200 x 2400 (7.7 MP)
		2560 x 1920 (4.9 MP)
		1600 x 1200 (1.9 MP)
S	Small	1280 x 960 (1.2 MP)
		1024 x 768 (0.8 MP)
		640 x 480 (0.3 MP)

When mulling over resolution options, you need to consider three ways that pixel count affects your pictures:

✔ **Print size:** Pixel count determines the size at which you can produce a high-quality print. If you don't have enough pixels, your prints may exhibit the defects you see in the pixelation example in Figure 2-16, or worse, you may be able to see the individual pixels, as in the right example in Figure 2-17. Depending on your photo printer, you typically need anywhere from 200 to 300 pixels per linear inch, or *ppi,* of the print. To produce an 8 x 10 print at 200 ppi, for example, you need a pixel count of 1600 x 2000.

Even though many photo-editing programs enable you to add pixels to an existing image, doing so isn't a good idea. For reasons I won't bore you with, adding pixels — known as *upsampling* — doesn't enable you to successfully enlarge your photo. In fact, resampling typically makes matters worse. The printing discussion in Chapter 5 includes some example images that illustrate this issue.

✔ **Screen display size:** Resolution doesn't affect the quality of images viewed on a monitor, television, or other screen device the way it does for printed photos. Instead, resolution determines the *size* at which the image appears. This issue is one of the most misunderstood aspects of digital photography, so I explain it thoroughly in Chapter 5. For now, just know that you need *way* fewer pixels for onscreen photos than you do for printed photos. In fact, the smallest resolution setting available on your camera, 640 x 480 pixels, is plenty for e-mail sharing. At larger sizes, the recipient usually can't view the entire picture without scrolling the display.

✔ **File size:** Every additional pixel increases the amount of data required to create a digital picture file. So a higher-resolution image has a larger file size than a low-resolution image.

Large files present several problems:

- You can store fewer images on your memory card, on your computer's hard drive, and on removable storage media such as a CD-ROM.

- The camera needs more time to process and store the image data on the memory card after you press the shutter button. This extra time can hamper fast-action shooting.

- When you share photos online, larger files take longer to upload and download.

- When you edit your photos in your photo software, your computer needs more resources and time to process large files.

As you can see, resolution is a bit of a sticky wicket. What if you aren't sure how large you want to print your images? What if you want to print your photos *and* share them online?

I take the better-safe-than-sorry route, which leads to the following recommendations about which resolution settings to use:

- **Always shoot at a resolution suitable for print.** You then can create a low-resolution copy of the image for use online. In fact, your camera offers a built-in resizing option; Chapter 5 shows you how to use it.

- **For everyday snapshots, the default Middle (M) setting (3200 x 2400, or about 7.7 MP) is probably sufficient.** I find 12.2 MP, which is what you get from the Large setting, to be overkill for casual snapshots, which means that you're creating huge files for no good reason. So I stick with the largest Middle option unless I'm shooting critical images.

- **Jump to Large (12.2 MP) if you plan to crop your photos or make huge prints.** Always use the maximum resolution if you think you may want to crop your photo and enlarge the remaining image. For example, when I shot the photo in Figure 2-18, I wanted to fill the frame with the bee and its flowery perch, but I couldn't get close enough to do so. (Okay, okay, I was chicken and didn't *want* to get any closer.) So I kept my distance and took the picture at the Large setting, which enabled me to crop the photo and still have enough pixels left to produce a great print, as you see in Figure 2-19.

Figure 2-18: I couldn't get close enough to fill the frame with the bee and flower, so I captured the image at the highest resolution setting (Large).

Figure 2-19: A high-resolution original enabled me to crop the photo and still have plenty of pixels left to produce an excellent print.

✔ **Reduce resolution if shooting speed is paramount.** If you're shooting action and the shot-to-shot capture time is slower than you want — that is, the camera takes too long after you take one shot before it lets you take another — dialing down the resolution may help. Lower resolution produces smaller files, and the smaller the file, the less time the camera needs to record the image to your memory card. Also see Chapter 8 for other tips on action photography.

✔ **Reserve the Small (S) setting for casual shots that you plan to use only for e-mail sharing or simple "idea communication."** I set up my E-PL1 to record photos using the fewest possible pixels (640 x 480) at the Small setting. (Again, the upcoming section "Selecting and customizing the Image Quality setting" shows you how.) Then I use that setting exclusively for household information and other "throwaway" pictures. For example, I recently needed a new couch. I snapped a photo of my living room and then printed it to take with me to the furniture store so that I could give the salesperson an idea of my existing décor. I didn't need a high-quality print — a low-resolution draft on plain office paper was sufficient to communicate the idea. A 640-x-480-pixel photo also is plenty large enough if you want to share this type of image online. Remember, for onscreen use, resolution affects only display size, not picture quality.

In short, if you can get the job done with fewer pixels, go for it. Be careful, though — you never know when a picture that you *expect* not to print turns out so good that you really wish you could print an 8 x 10.

Understanding file type (JPEG or Raw)

In addition to establishing the resolution of your photos, the Image Quality setting determines the file format. The *file format* simply refers to the type of image file that the camera produces. The E-PL1 offers two file formats, JPEG and Raw, with a couple variations of each. The next sections explain the pros and cons of each setting.

Don't confuse *file format* with the Format option that you can access via the Card Setup item on Shooting Menu 1. That option erases all data on your memory card; see Chapter 1 for details.

JPEG: The imaging (and Web) standard

Pronounced *jay-peg*, this format is the default setting on your camera, as it is for most digital cameras. JPEG is popular for two main reasons:

- ✔ **Immediate usability:** JPEG is a longtime standard format for digital photos. All Web browsers and e-mail programs can display JPEG files, so you can share them online immediately after you shoot them. You also can get JPEG photos printed at any retail outlet, whether it's an online or local printer. Additionally, any program that has photo capabilities, from photo-editing programs to word-processing programs, can handle your files.

- ✔ **Small files:** JPEG files are smaller than Raw files. And smaller files mean that your pictures consume less room on your camera's memory card and in your computer's storage tank.

The downside — you knew there had to be one — is that JPEG creates smaller files by applying *lossy compression.* This process actually throws away some image data. Too much compression leads to the defects you see in the JPEG artifacts example in Figure 2-16, near the start of this Image Quality discussion.

On the E-PL1, you can choose from four levels of compression, which carry the labels Super Fine (SF), Fine (F), Normal (N), and Basic (B). However, before I explain what you can expect from each setting, I need to share one important detail about choosing those settings: The camera offers only four JPEG settings at a time, with each setting producing a different combination of resolution and compression level. The four default settings are Large/Fine,

Large/Normal, Middle/Normal, and Small/Normal. If those combinations don't suit you, can set up any four combinations you want. See "Selecting and customizing the Image Quality setting" section later in this chapter to find out how.

As for the compression half of the equation, the differences among the settings break down as follows:

- **Super Fine:** At this setting, the compression ratio is 1:2.7. In other words, the file size is about three times smaller than it would be if no compression were applied. At this low compression ratio, picture quality is excellent, and you shouldn't see many compression artifacts, if any.

- **Fine:** This setting notches the compression ratio up slightly, to 1:4. Still, you aren't likely to notice any compression defects unless you blow up the picture to a large size and look closely for problems.

- **Normal:** Switch to Normal, and the compression amount rises to 1:8. The chance of seeing some artifacting also rises, although again, for everyday pictures and images that you don't plan to enlarge past snapshot size, Normal delivers acceptable quality while significantly reducing file sizes.

- **Basic:** At this setting, you drop into the artifact danger zone. The compression ratio is 1:12, which is a fairly heavy amount of compression. Expect to see some damage to image details at this setting.

 Even the Basic setting doesn't result in anywhere near the level of artifacting that you see in my example in Figure 2-16, though. Again, that example is exaggerated to help you recognize artifacting defects and understand how they differ from other image-quality issues.

In fact, if you keep your image print or display size small, you aren't likely to notice a great deal of quality difference among the Super Fine, Fine, and Normal compression levels. The differences become apparent only when you greatly enlarge a photo.

Given that the differences among Super Fine, Fine, and Normal aren't all that easy to spot until you enlarge the photo, is it okay to shift to Normal and enjoy the benefits of smaller files? Well, only you can decide what level of quality your pictures demand. For most photographers, the added file sizes produced by the Super Fine setting aren't a huge concern, given that the prices of memory cards fall all the time. Long-term storage is more of an issue; the larger your files, the faster you fill your computer's hard drive and the more DVDs or CDs you need for archiving purposes. But in the end, I prefer to take the storage hit in exchange for the lower compression level of the Super Fine setting. You never know when a casual snapshot is going to be so great that you want to print or display it large enough that even minor quality loss becomes a concern. And of all the defects that you can correct in a photo editor, artifacting is one of the hardest to remove.

Preserving the quality of edited photos

If you retouch pictures in your photo software, don't save the altered images in the JPEG format. As explained in the section "JPEG: The imaging (and Web) standard," elsewhere in this chapter, JPEG creates smaller files by eliminating some image data, a process called *lossy compression*.

Every time you alter and save an image in the JPEG format, you apply another round of lossy compression. And with enough editing, saving, and compressing, you can eventually get to the level of image degradation shown in the JPEG example in Figure 2-16. (Simply opening and closing the file does no harm.)

Instead, always save your edited photos in a nondestructive format. TIFF, pronounced *tiff,* is a good choice and is a file-saving option available in most photo-editing programs. Should you want to share the edited image online, create a JPEG copy of the TIFF file when you finish making all your changes. That way, you always retain one copy of the photo at the original quality captured by the camera. You can read more about TIFF in Chapter 5, in the section related to processing Raw images. The same chapter explains how to create a JPEG copy of a photo for online sharing.

To make the best decision, do your own test shots, carefully inspect the results in your photo editor, and make your own judgment about what level of artifacting you can accept. Artifacting is often much easier to spot when you view images onscreen. Reproducing artifacting here in print is difficult because the printing press obscures some of the tiny defects caused by compression. Your inkjet prints are more likely to reveal these defects.

If you don't want *any* risk of artifacting, bypass JPEG altogether and change the file type to Raw (ORF). Or consider your other option, which is to record two versions of each file, one Raw and one JPEG. The next section offers details.

Raw (ORF): The purist's choice

The other picture-file type that you can create on your E-PL1 is *Camera Raw,* or just *Raw* (as in uncooked) for short.

Each manufacturer has its own flavor of Raw files; Olympus Raw files are *ORF* files. (The three letter code stands for *Olympus Raw Format* — hey, for once, an acronym that makes sense!) If you use a Windows computer, you see that three-letter designation at the end of your picture filenames.

Raw is popular with advanced photographers, for several reasons:

✔ **Greater creative control:** With JPEG, internal camera software tweaks your images, adjusting color, exposure, and sharpness as needed to produce the results that Olympus believes its customers prefer. (The exact processing that occurs depends in part on the Picture Mode setting, covered in Chapter 7.) With Raw, the camera simply records the original, unprocessed image data. The photographer then copies the image file to the computer and uses special software — a *raw converter* — to produce the actual image, making decisions about color, exposure, and so on at that point. The upshot is that "shooting Raw" enables you, not the camera, to have the final say on the visual characteristics of your image.

✔ **Higher bit depth:** *Bit depth* is a measure of how many distinct color values an image file can contain. JPEG files restrict you to 8 bits each for the red, blue, and green color components, or *channels,* that make up a digital image, for a total of 24 bits. That translates to roughly 16.7 million possible colors. On the E-PL1, a Raw file delivers a higher bit count, collecting 12 bits per channel, or a total of 36 bits. (Chapter 4 provides more information about the red-green-blue makeup of digital images.)

Although jumping from 8 to 12 bits per channel sounds like a huge difference, you may not really ever notice any difference in your photos — that 8-bit palette of 16.7 million values is more than enough for superb images. Where having the extra bits can come in handy is if you really need to adjust exposure, contrast, or color after the shot in your photo-editing program. In cases where you apply extreme adjustments, having the extra original bits sometimes helps avoid a problem known as *banding* or *posterization,* which creates abrupt color breaks where you should see smooth, seamless transitions. (A higher bit depth doesn't always prevent the problem, however, so don't expect miracles.)

✔ **Best picture quality:** Because Raw doesn't apply the destructive compression associated with JPEG, you don't run the risk of the artifacting that can occur with JPEG.

But of course, as with most things in life, Raw isn't without its disadvantages. To wit:

✔ **You can't do much with your pictures until you process them in a raw converter.** You can't share them online, for example, or put them into a text document or multimedia presentation. You can view and print them immediately if you use the Olympus-provided software, but most other photo programs require you to convert the Raw files to a standard format first. Ditto for retail-photo printing. So when you shoot Raw, you add to the time you must spend in front of the computer instead of behind the camera lens. Chapter 5 shows you how to process your Raw files using your Olympus software as well as the converter built into the camera.

✔ **Raw files are larger than JPEGs.** Unlike JPEGs, Raw doesn't apply lossy compression to shrink files. In addition, Raw files are always captured at the maximum resolution available on your camera, even if you don't really need all those pixels. For both reasons, Raw files are significantly larger than JPEGs, so they take up more room on your memory card and on your computer's hard drive or other picture-storage device.

Whether the upside of Raw outweighs the down is a decision that you need to ponder based on your photographic needs, your schedule, and your computer-comfort level. If you do decide to try Raw shooting, you can select from the following two Image Quality options:

✔ **Raw:** This setting produces a single Raw file at the maximum resolution (12.2 megapixels).

✔ **Raw+JPEG:** This setting produces two files: the standard Raw file plus a JPEG file. You can specify the resolution and compression you want for the JPEG file; Raw files are always captured at the maximum resolution. Either way, remember that creating two files for every image eats up substantially more memory card space than sticking with a single file. I leave it up to you to decide whether the pluses outweigh the minuses.

Selecting and customizing the Image Quality setting

Compared with understanding all the ramifications of the Image Quality setting, selecting the option you want to use is simple. Use any of these methods:

✔ **Shooting Menu 1:** Choose the menu option highlighted in Figure 2-20 and press OK to reveal the second screen in the figure. Highlight Still Picture and press the right-arrow key to reveal list of Image Quality settings. Make your choice and press OK again.

The little diamond symbol is the standard Olympus icon for the setting that controls resolution and file format. Its design is a reminder of the impact of your setting: The diamond represents a pixel on its side. Notice that the left side of the diamond is rendered smoothly, representing the high quality produced by lots of pixels and little or no JPEG compression. The other side looks blotchy, representing the lower quality that results from a smaller pixel count and higher amount of JPEG compression.

✔ **Live Control or Super Control Panel display:** You can also access the setting via the control screens, as shown in Figure 2-21.

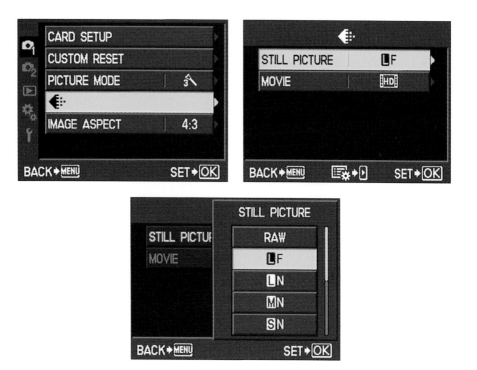

Figure 2-20: Follow this menu trail to change the Image Quality setting.

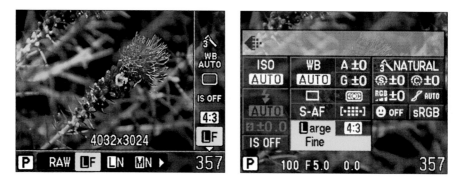

Figure 2-21: Or select the option via the Live Control or Super Control Panel display.

Maintaining a pristine view

Often lost in discussions of digital photo defects — compression artifacts, pixelation, and the like — is the impact of plain-old dust and dirt on picture quality. But no matter what camera settings you use, you aren't going to achieve great picture quality with a dirty lens. So clean your lens on a regular basis, using one of the specialized cloths and cleaning solutions made expressly for that purpose.

If you continue to notice random blobs or hair-like defects in your images (refer to the last example in Figure 2-16), you probably have a dirty *image sensor*. That's the part of your camera that does the actual image capture — the digital equivalent of a film negative, if you will.

Your camera performs an internal sensor cleaning every time you turn it on and off. Especially if you frequently change lenses in a dirty environment, however, this internal

cleaning mechanism may not be able to fully remove all specks from the sensor. In that case, you need a more thorough cleaning, which is done by actually opening the camera and using special sensor-cleaning tools. You can do this job yourself, but . . . I don't recommend it. An image sensor is pretty delicate, and you can easily damage it or other parts of your camera if you aren't careful. Instead, find a local camera store that offers this service. In my area (central Indiana), sensor cleaning costs about $30 to $50. If you bought your camera at a traditional camera store, the store may even provide free sensor cleaning as a way to keep your business.

One more cleaning tip: Never — and I mean *never* — try to clean any part of your camera using a can of compressed air. Doing so can not only damage the interior of your camera, blowing dust or dirt into areas where it can't be removed, but also, it can crack the monitor.

By default, you can choose from the following Image Quality settings:

- ✓ **Large/Fine, Large/Normal, Middle/Normal, and Small/Normal:** All these settings produce JPEG files. The first part of the setting name refers to the image resolution; the second, to the compression level.

- ✓ **Raw:** Raw files are always captured at the maximum resolution, and no compression is applied.

- ✓ **Raw+JPEG:** You can choose to record one Raw file and one JPEG file. You can choose from the four default resolution/compression combos for the JPEG file.

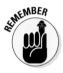

You aren't limited to the four resolution/compression combinations described in the preceding list, however. The camera can display only four JPEG combos, or *presets,* at a time, but you can modify those presets to use

whatever combination of resolution and compression you like. For the Middle and Small JPEG options, you also can modify the pixel count you get from each setting.

To customize the options, set the Mode dial to any setting except SCN. Then display Custom Menu G, highlighted in Figure 2-22. After selecting that menu and pressing OK, scroll down to the second page of the menu, as shown on the left in Figure 2-23. The controls for adjusting the Image Quality presets as well as the pixel count for the Middle and Small settings hang out together on this menu.

Figure 2-22: To begin customizing the JPEG settings, select Custom Menu G and press OK.

Figure 2-23: Choose the top option on this screen to modify the four JPEG presets.

✓ **Customizing the JPEG presets:** Choose the top option on the screen shown on the left in Figure 2-23 — the one marked with the little Image Quality symbol — and press OK to display the right screen in the figure. The settings in the figure represent the four default presets (Large/Fine, Large/Normal, Middle/Normal, and Small/Normal). To modify a preset, first press the right- or left-arrow key to highlight either the size or compression value. For example, in the figure, the size option for preset 1 is selected (L, for Large). Then press the up- or down-arrow key to adjust the setting. Keep pressing the right arrow to activate a value and then press up or down to change that value.

For the size value, you can select Large (L), Middle (M), or S (Small). The pixel count produced by the Middle and Small settings, however, depends on the option discussed in the next bullet point. For the compression value, you can select Super Fine (SF), Fine (F), Normal (N), or Basic (B).

✓ **Setting the Middle and Small pixel count:** By default, the Middle (M) size setting produces an image that contains 3200 x 2400 pixels, and the Small (S) setting delivers 1280 x 960 pixels. You can reduce the pixel count for either setting through the Pixel Count option on Custom Menu G, highlighted in the first screen in Figure 2-24. Select the option and press OK to display the second screen in the figure. Choose the setting you want to modify and press the right-arrow key to reveal the available pixel counts for that setting, as shown in the third figure. Press OK to finalize things or press the Menu button to go back one screen and adjust the other size setting.

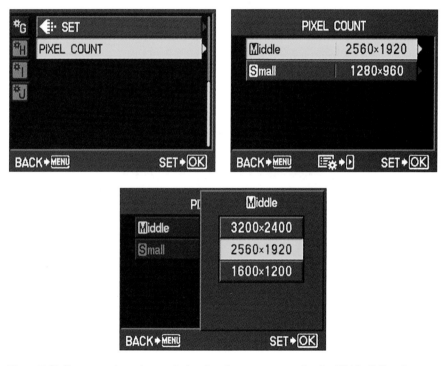

Figure 2-24: You can reduce the resolution that the camera uses for the Middle (M) and Small (S) JPEG settings.

Easy Breezy: Shooting in iAuto, Scene, and Movie Modes

*A*re you old enough to remember the Certs television commercials from the 1960s and '70s? "It's a candy mint!" declared one actor. "It's a breath mint!" argued another. Then a narrator declared the debate a tie and spoke the famous catchphrase: "It's two, two, two mints in one!"

Well, that's sort of how I see the PEN E-PL1. On one hand, it provides a full range of powerful controls, offering just about every feature a serious photographer could want. On the other, it also offers two "almost automatic" shooting modes, iAuto and SCN (Scene, if you can afford to buy a vowel), that enable people with absolutely no experience to capture beautiful images. "It's a sophisticated photographic tool!" "It's as simple as point-and-shoot!" "It's two, two, two cameras in one!"

Now, my guess is that you bought this book for help with your camera's advanced side, so that's what other chapters cover. This chapter, however, is devoted to your camera's point-and-shoot side, explaining how to get the best results from the iAuto and SCN modes. In addition, this chapter walks you through the steps involved in recording movies with your E-PL1 — a process that's about as close to point-and-shoot as movie making can be.

Going Fully Automatic with iAuto Mode

Officially, the *i* in iAuto stands for *intelligent*. When you set the Mode dial to iAuto, the camera's brain analyzes the subject and then automatically optimizes camera settings for the scene, leaving you free to concentrate solely on picture composition.

Taking a picture in iAuto mode involves just a handful of steps:

1. **Set the Mode dial to iAuto, as shown in Figure 3-1.**

2. **Frame the picture in the monitor.**

3. **Press and hold the shutter button halfway down to set focus and exposure.**

 When the camera establishes focus, it emits a tiny beep and displays a green focus light in the top-right corner of the display, as shown in Figure 3-2. In addition, a green square appears briefly to indicate the *focus target* — the area of the frame the camera used to establish focus. Typically, the camera locks onto the closest object in the scene, as it did for the example photo in the figure.

Figure 3-1: The iAuto mode lets you enjoy fully automatic photography or take more control through the Live Guide feature.

 Face Detection is enabled in iAuto mode, so if there are people in the scene, you also see the white face-detection frame on the monitor before and after the green focus target lights. See Chapter 2 for details about Face Detection. (You can't disable the feature in iAuto mode.) If the light is such that the camera can't select optimal exposure settings, the aperture and shutter speed values blink. I labeled these values in Figure 3-2; see Chapter 6 for a complete explanation. In dim lighting, try adding flash; in very bright light, you may need to move the subject into a shaded area.

Focus light

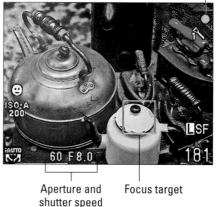

Aperture and shutter speed · Focus target

Figure 3-2: The green square indicates what the camera used as its focusing target.

4. **Press the button the rest of the way to take the shot.**

The picture appears on the monitor for a few seconds and then the camera returns to shooting mode.

If you're not happy with your picture, you may be able to tweak camera settings to produce a better result. The next two sections explain the options you can control in iAuto mode.

Adjusting picture settings in iAuto mode

Even in this simple shooting mode, you can adjust the following options:

✔ **Focusing mode (AF mode):** By default, the iAuto mode uses the S-AF mode, which locks focus when you press the shutter button halfway. To find out about the other focusing options, check out Chapter 7.

✔ **Focusing target (AF Target):** The E-PL1 has an 11-point autofocus system, which simply means that it can lock focus onto any of 11 points positioned throughout the frame. (You can see where the points are located in the focusing discussion in Chapter 7.) By default, the camera selects which of the 11 points to use when setting focus. If you have trouble getting focus to lock on your subject, see Chapter 7 to find out how to select a specific focus point or switch to manual focusing.

✔ **Shutter-release mode:** The default setting is the single-frame mode, which produces one picture for each press of the shutter button. You can change to sequential (burst mode) or self-timer shooting by following the steps laid out in Chapter 2.

✔ **Image Stabilizer (IS):** This feature helps ensure blur-free handheld shots. Select the I.S. 1 setting unless you're using a tripod, in which case, turn off stabilization. See Chapter 2 for more information about this feature.

✔ **Image Aspect:** This setting determines the picture proportions. In iAuto mode, the camera uses the standard 4:3 setting, which is the best for most photos. See Chapter 2 for information about the other aspect options (3:2, 16:9, and 6:6).

✔ **Image Quality:** This setting controls the resolution (pixel count) and file type (JPEG or Raw). Chapter 2 holds the secret to understanding this critical setting. But until you're in the mood to discover that secret, feel free to stick with the default setting (Large/Normal, or L/N), which gives you a good quality JPEG file at the camera's maximum resolution. *Note:* I said "good quality," not "best quality;" if you demand top quality, go ahead and check out Chapter 2 now. Or, for the top quality JPEG file option, choose Large/Super Fine (L/SF), as I did in Figure 3-2.

✔ **Flash:** Flash is set by default to Auto so that the flash fires if the camera thinks extra light is needed. But on the E-PL1, the flash doesn't pop up automatically from its bunker as it does on some cameras. You have to raise the flash unit by moving the Flash Up switch, shown in Figure 3-3, to the right.

Flash Up switch

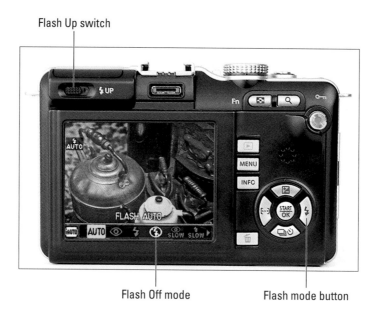

Flash Off mode Flash mode button

Figure 3-3: Even though the flash mode is set to Auto by default, you must manually raise the flash, or it won't fire.

To disable flash, you have two options. You can either close the built-in flash or press the right-arrow key to display the flash-settings screen shown in Figure 3-3. Press the right-arrow key to highlight the Flash Off symbol, also labeled in Figure 3-3, and then press OK or just give the shutter button a quick half-press and release it.

There is one critical hitch to know about using flash in iAuto mode: When the flash is enabled, you can't access the Live Guide feature, which enables you to easily tweak picture color, focus, and exposure. So if you want to take advantage of Live Guide, either close the flash or set the flash mode to Off.

Getting more creative with Live Guide

Chapters 6 and 7 help you understand all the photography fundamentals you need to know to fully manipulate focus, exposure, and color. But thanks to the Live Guide feature available in iAuto mode, you can start experimenting with those aspects of your pictures without needing to know a single photography term.

Live Guide gives you access to the following five options:

✏ **Change Color Saturation:** Use this option to make colors more or less intense.

✏ **Change Color Image:** Through this setting, you can make colors warmer, shifting them to the red-yellow-orange side of the color spectrum. Or you can go the other direction and make colors cooler, emphasizing blue and green tones.

✏ **Change Brightness:** This one does just what the name implies: It enables you to request a brighter or darker exposure than what the camera's autoexposure brain thinks is appropriate.

✏ **Blur Background:** This adjustment enables you to play with *depth of field,* or the distance over which objects in the scene remain sharply focused. You can choose to blur the background or keep both the subject and background sharp.

Blurring the background helps set the subject apart from its surroundings, especially when the subject and background are similar in color and brightness. As an example, see Figure 3-4. In the left image, the background foliage competes with the statue for the eye's attention. Softening the background focus in the right image enhances the visual importance of the statue because the eye is drawn naturally to the most sharply focused part of the scene.

Figure 3-4: The statue competes with the background in the original image (left); blurring the background helps restore visual emphasis to the statue (right).

✔ **Express Motions:** If you're shooting a moving subject, set this option to the Stop Motion setting to freeze the action, as shown in Figure 3-5, or to the Blurred Motion setting to intentionally blur the subject for special effect. You might want to choose the latter option when shooting a waterfall, for example, so the water takes on a misty look. Chapter 8 has an example of that effect.

Unfortunately, you can apply only a single Live Guide adjustment at a time. So you can't adjust depth of field and tweak color for the same picture, for example. Additionally, Live Guide isn't compatible with flash photography, so you have to choose between the two.

Figure 3-5: When shooting a moving subject, set the Express Motions option to the Stop Motion setting to freeze the action.

Despite those limitations, Live Guide gives you an easy way to start taking more control over your photos. Follow these steps to try out Live Guide:

1. Set the Mode dial to iAuto and disable flash.

Again, you can't use flash if you want to use Live Guide. (If you have a specific picture look in mind and you need flash, you may be able to get the results you want by using one of the scene modes, explained in the next section.)

2. Press OK.

By default, you see the screen shown in Figure 3-6. If you instead see the Live Control panel or Super Control Panel, press the Info button until the Live Guide appears. (See Chapter 1 to find out more about these different displays.)

On the right side of the screen, you see six icons. The first five represent the picture settings you can adjust, as labeled in Figure 3-6. The sixth icon represents shooting tips you can display; more about that feature in the bulleted list following these steps.

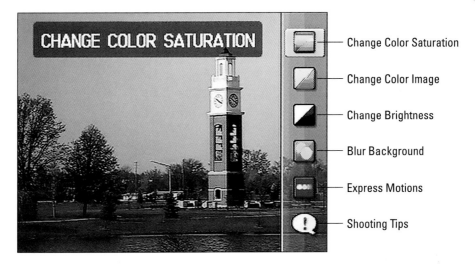

Change Color Saturation

Change Color Image

Change Brightness

Blur Background

Express Motions

Shooting Tips

Figure 3-6: Press OK to access the Live Guide and tweak color, focus, and exposure.

3. Highlight one of the picture-adjustment icons and press OK.

The initial Live Guide interface disappears, and you see a single vertical slider control onscreen. For example, Figure 3-7 shows the slider for the Change Color Saturation option. The middle of the bar represents the default setting.

4. Press the up- or down-arrow key to move the slider bar to indicate the amount and direction of the adjustment you want to make.

As you do, the picture onscreen updates to show you the effect of the change.

Adjustment slider

Figure 3-7: Press the up- or down-arrow key to move the slider along the adjustment scale.

If you decide you don't like the results of the adjustment, press the Menu button to exit the adjustment screen. Otherwise, move on to Step 5.

5. Press OK to return to shooting.

The name of the Live Guide adjustment appears in the lower-left corner of the screen, as shown in Figure 3-8. *Note:* Although the monitor no longer displays a preview of how your picture will be affected by the Blur Background or Express Motions adjustments, the final picture will use those settings.

CANCEL ➔ MENU 181

Figure 3-8: Press the Menu button to cancel the Live Guide adjustment.

6. Frame, focus, and shoot.

From this point on, everything works as I outline in the steps given in the preceding section for taking a picture in iAuto mode.

7. To disable the Live Guide adjustment, press the Menu button.

Here are a few other nuggets of information about Live Guide:

- **Getting a better Blur Background preview:** For this adjustment, you may want to set focus before you bring up the Live Guide. Just press the shutter button halfway to focus and then release it. With the subject in focus, you can get a better idea of how the various slider settings will affect the picture.

- **Displaying help screens:** Select the Shooting Tips icon (refer to Figure 3-6) and press OK to display tips on getting different kinds of shots, as shown in Figure 3-9. Use the up- or down-arrow keys to select a subject icon on the first screen and then press OK to display tips for that subject. Press the Menu button to exit the screens.

Figure 3-9: Selecting the Shooting Tips icon from the Live Guide menu leads to these advice screens.

✔ **Shooting in the Raw format:** Enabling Live Guide when the Image Quality option is set to Raw automatically changes the quality setting to Raw+LN (Large/Normal JPEG), so you get two copies of each picture. The Live Guide adjustment is made only to the JPEG copy. See Chapter 2 to fully understand the Image Quality setting.

✔ **Understanding the limitations of the exposure and focus adjustments:** The camera achieves background blur or sharpening by adjusting the aperture (f-stop) setting, which is an exposure control. To modify motion blur, the camera adjusts another exposure control, shutter speed. And when you employ the Change Brightness option, aperture and shutter speed may both be adjusted along with another exposure option, ISO.

How much change you can achieve through any of these Live Guide adjustments depends on the lighting conditions. In extreme lighting, the camera may not be able to manipulate the aperture, shutter speed, and ISO settings as needed to produce the desired Live Guide effect and still produce a good exposure. In addition, the range of f-stops available depends on your lens.

In dim lighting, the camera may need to select a very high ISO, which can cause the picture to appear grainy — or *noisy* — in proper digital photo lingo. Inadequate lighting also may require the camera to select a very slow shutter speed, which can lead to blurring if you handhold the camera, if your subject moves during the exposure, or both.

Chapter 6 helps you understand all these exposure issues and discusses how to control aperture, shutter speed, and ISO to deal with challenging lighting situations.

Taking Pictures in SCN (Scene) Mode

Most digital cameras and some film cameras offer *scene modes* that automatically select picture settings geared toward capturing specific types of photographs. For example, for photographing people, you can set the camera to Portrait scene mode, which selects picture options that deliver a classic portrait treatment, in which the subject is sharply focused but the background is blurry. And if you're trying to photograph action, select Sport mode, which tells the camera to select settings that freeze motion, much like you can do with the Express Motions option when you use the iAuto Live Guide feature.

Usually, scene modes also apply color, exposure, contrast, and sharpness adjustments to the picture according to the traditional characteristics of the scene type. Landscape scene mode typically results in more vibrant colors, especially in the blue-green range, for example, whereas Portrait mode typically produces a softer image with more natural tones.

On the E-PL1, you can choose from 19 scene modes when you set the Mode dial to SCN, as shown in Figure 3-10. The following section introduces you briefly to each mode; following that, you can find step-by-step instructions for selecting the scene type and taking a picture.

Before I shoo you off to either section, though, I want to offer a little advice: Although the scene modes can improve your chances of getting a good shot, they're not going to deliver great results all the time. Take Sport mode, for example. In bright lighting, the camera can usually freeze

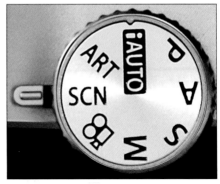

Figure 3-10: SCN mode gives you access to 19 automated shooting modes geared to different types of scenes.

action. But if you're trying to capture a softball game at dusk or an indoor volleyball match, your chances of success are much lower. In dim lighting, the camera has to use a slow shutter speed to properly expose the image, and a slow shutter speed causes moving subjects to appear blurry. (Chapter 6 explains shutter speed and other exposure technicalities.) That's not a fault of the Sport mode, per se — you face the same challenge with the Live Guide Express Motions feature or even if you switch to full manual control over shutter speed and other exposure settings.

I throw this wet blanket on the photography bonfire not to discourage you from trying the scene modes but to help manage your expectations. The scene modes are a great way to start taking control over your pictures, and if nothing else, they encourage you to think about the characteristics that go into different types of photos. But don't expect miracles, especially if the lighting conditions or subject matter is challenging.

There's also the whole notion of creative input to consider. Sure, most formal portraits feature a blurred background. But maybe you want to keep the background in focus because the setting is important to the story you're trying to tell — think of a shot of newlyweds standing in the front yard of their very first home, for example. The details of the yard and home likely will be just as important to the couple when they look back on that photo in years to come.

Long story short: Try out the scene modes and enjoy them while you're discovering more about photography. But if you're not happy with your results, don't just keep trying over and over with the same scene mode — you're not going to achieve anything different. Instead, step up to iAuto mode and experiment with the Live Guide adjustments that enable you to make a few creative calls about color, focus, and exposure. You could use the Live Guide Blur Background slider to the Sharp end to keep the newlywed's home in sharp focus, for example. Or, to really take the photographic reins, bypass

both modes and head for Part III of this book, where you can find out how to master the advanced exposure modes.

Checking out the scene(s)

You can choose from the following 19 scene modes:

✔ **Portrait:** Designed for shooting portraits at close to medium range, Portrait mode chooses settings that result in the classic portrait look, with the subject set against a softly focused background, as shown in Figure 3-11. Colors are adjusted to produce natural-looking skin tones.

How much background blurring depends on how far your subject is from the background — the greater the distance, the greater the blur. Lighting conditions also affect the extent of the background blur. Just as when you use the Blur Background feature of the iAuto Live Guide mode, the camera manipulates the *depth of field* (zone of sharp focus) in the photo by adjusting the aperture (f-stop) setting. Chapter 6 fully explains this issue, but the critical thing to know when you're using Portrait mode is that the range of f-stops the camera can select depends on your lens and the lighting conditions. In extremely bright lighting, the camera may need to *stop down the aperture* — select a higher f-stop number — to avoid overexposing the photo. And because the zone of sharp focus increases as you raise the f-stop setting, backgrounds may appear more sharply focused than they do in dimmer lighting.

Figure 3-11: Portrait mode produces soft backgrounds to help emphasize your subject.

The flash is set to Auto in Portrait mode, so it fires only if the camera thinks extra lighting is needed. That can be a hindrance for outdoor portraits on sunny days because a little flash helps reduce shadowing on the face but the camera doesn't see a need for additional light. To improve your outdoor portraits, switch to an advanced exposure mode and set the flash to Fill In mode. (Chapter 6 has details.) Also remember that even in Auto flash mode, you have to raise the flash if you want it to fire.

✔ **e-Portrait:** If you own a high-definition (HD) TV, you may have noticed that the facial lines, pores, and blemishes of your favorite stars are more apparent in HD than on your old, regular-def set. Suddenly, celebrities almost look like the rest of us, in fact. Well, the e-Portrait scene mode aims to correct that problem. After you take the shot, the camera applies a softening filter to minimize skin texture and help hide any flaws. The effect is the same one produced by the e-Portrait option on the JPEG Edit menu and the e-Portrait filter available in the Olympus software programs. Chapter 9 has an example.

I think the effect is a little overdone and gives the skin a sort of plastic look, so I prefer to do portrait retouching in my photo editor, where I have full control over any adjustments. However, because the e-Portrait mode actually creates two copies of your image, one with and one without the filter, there's no harm in experimenting. You need to know a couple of details, though:

- If the Image Quality option is set to one of the JPEG settings, such as Large/Normal (LN), you wind up with two JPEG images — the original and the filtered copy. If the Image Quality option is set to Raw+JPEG, the JPEG file gets the effect, and the Raw file is left untouched. And if the Image Quality setting is Raw only, the camera creates a JPEG image to use for the filtered copy. The e-Portrait JPEG file is created using the Medium/Fine Image Quality setting unless you originally used a lower Image Quality setting, such as Small/Normal, in which case the copy uses the lower setting as well. (See Chapter 2 for a complete explanation of all this Image Quality talk.)

- In addition, e-Portrait mode requires that the camera detect a face in the scene. So this mode works best for portraits that show the subject looking directly at the camera rather than posing in profile.

- When you take the picture in e-Portrait scene mode or apply it through the JPEG Edit option, you see a before-and-after view of your subject in the monitor at the end of the process. You can't cancel the application of the effect or adjust the intensity of the filter in either case, though.

✔ **Landscape:** In the time-honored tradition of landscape photography, this mode produces crisp images with vivid blues and greens to create that bold, vacation-magazine look (see Figure 3-12). The camera also tries to select a high f-stop setting because a higher f-stop extends depth of field, keeping both foreground and background objects as sharp as possible. Face Detection is disabled by default.

✔ **Landscape+Portrait:** This mode is designed to capture wide-angle photos that feature people set against a scenic backdrop. Blues and greens appear vivid, as they do in regular Landscape mode, but skin tones remain natural. Face Detection is enabled by default.

If the background is brighter than the people you're photographing, add flash to ensure that their faces are properly exposed. For very bright backgrounds, the camera may refuse to fire the flash, however; switch to one of the advanced shooting modes covered in Chapter 6 to take control of the flash.

Figure 3-12: Landscape mode features bold colors and a large zone of sharp focus (depth of field).

✔ **Sport:** Select this action to have a better chance of capturing a moving target without blur. The camera automatically selects the Sequential shutter-release mode (also known as continuous or burst mode) so that you can capture up to three frames per second with one press of the shutter button. (You can change to self-timer mode if you prefer, however.) In addition, the AF mode is set to continuous (C-AF) so that focus is continually adjusted up to the time you take the shot.

Even with all these action settings enabled, the camera may not be able to freeze action in dim lighting. Whether you can achieve the three frames per second rate also depends on the lighting conditions. And for reasons you can explore in Chapter 6, the camera typically can capture more frames per second when you use the single AF mode (S-AF) because it doesn't have to refocus between frames. You can't use that AF option in Sport mode, however.

✔ **Night Scene:** This setting uses a slow shutter speed to capture nighttime city scenes, such as the one in Figure 3-13. Because of the long exposure time, use a tripod to avoid camera shake, which can blur the picture, and turn off the Image Stabilizer feature, which can actually add blur for tripod shots. Note that even when the camera remains perfectly still, any moving objects in the scene appear blurry, as does the fountain water in this example.

✔ **Night+Portrait:**
In this mode,
the camera adds
flash and Face
Detection to the
Night Scene set-
tings. Because of
the slow shutter
speed, the back-
ground is more
visible than with
normal flash
because the
camera has time
to soak up some
of the ambient
lighting. Be sure
to raise the
flash — the
camera doesn't
do it for you.

Figure 3-13: To capture this kind of after-dark photo, use Night Scene and a tripod.

Also, use a tripod and ask the subject to stay completely still during the
exposure. (In other words, don't try this one with fidgety children.)

✔ **Children:** If you *do* want to photograph fidgety children — or fidgety
adults, for that matter — this mode can help. The Children mode
uses the same action-oriented settings as Sport mode, including the
Sequential shutter-release mode and continuous autofocus (C-AF),
although you can switch to self-timer release mode if you choose. Flash
is set to Auto mode, so the flash fires only in dim lighting. You have con-
trol over whether Face Detection is turned on or off.

✔ **High Key:** A *high-key* photo is dominated by white or very light areas,
such as a white china cup resting on a white doily in front of a sunny,
bright window. This mode helps ensure proper exposure for this type
of scene.

How does the name relate to the characteristics of the picture? Well,
photographers refer to the dominate tones — or brightness values — as
the *key tones.* In most photos, the *midtones,* or areas of medium bright-
ness, are the key tones. In a high-key image, the majority of tones are at
the high end of the brightness scale.

✔ **Low Key:** The opposite of a high-key photo, a *low-key* photo is domi-
nated by shadows. Use this mode to prevent the camera from brighten-
ing the scene too much and thereby losing the dark nature of the image.

- ✏ **DIS:** The name of this mode refers to *digital image stabilization.* Choosing this mode enables the camera to automatically increase ISO (light sensitivity) so that it can use a faster shutter speed, which in turn helps prevent blurring that can occur when you handhold the camera at slower shutter speeds. See Chapter 6 for a complete explanation of ISO and shutter speed.

- ✏ **Macro:** *Macro* is just a fancy word for *close-up.* In this mode, the camera intensifies color, contrast, and sharpness slightly. However, Macro mode doesn't enable you to focus at a closer distance on the E-PL1 as it does on some point-and-shoot cameras. The minimum focusing distance is determined by your lens. On the 14–42mm kit lens, for example, the minimum focusing distance is about 10 inches.

- ✏ **Nature Macro:** Try this mode when shooting close-ups of flowers, butterflies, and other small wonders of nature. This mode is very similar to Macro mode but boosts saturation, sharpness, and contrast slightly for a sharper, more dramatic look. Figure 3-14 shows the same flower shot in both modes to give you an idea of the difference between the two.

- ✏ **Candle:** This mode adjusts colors to compensate for the reddish cast of candlelight. Flash is disabled, and you can choose whether Face Detection is enabled. Shutter speed is reduced, so use a tripod to prevent image-blurring camera shake. For more about manipulating colors and dealing with different light sources, see the Chapter 7 section related to the White Balance control.

Macro mode Nature Macro mode

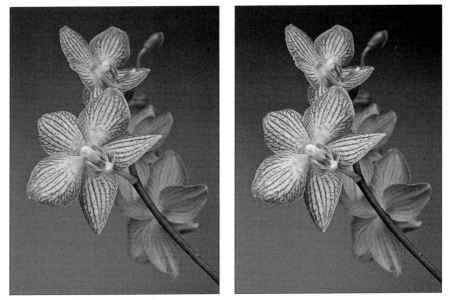

Figure 3-14: Nature Macro delivers a slightly more contrasty, sharper look than Macro.

✔ **Sunset:** Like Candle mode, Sunset mode tweaks colors to properly render sunset hues. This mode isn't good for shooting a portrait that uses the sunset as a backdrop, though. Flash is disabled, and without it, faces will be underexposed. Try Landscape+Portrait instead.

✔ **Documents:** Need to capture a picture of a diploma or some other printed document? Try this mode. But make sure that the document is well-lit because flash is disabled.

✔ **Panorama:** This mode assists you in capturing a series of images that can be joined into a panorama in your photo software. I stitched two images to create the panorama, as shown on the top in Figure 3-15, for example.

One key to a successful panorama is to frame each shot so that it includes some overlap from the previous frame. The overlap gives the panorama-stitching software the reference points it needs to join the two images seamlessly. In Panorama mode, the screen displays guide-lines to help you set up your shots to ensure this overlap, as shown in the lower row of Figure 3-15. You can press the up- or down-arrow key to switch the display from presenting vertical guides (for shooting horizon-tal panoramas) or horizontal guides (for shooting vertical panoramas). After your first shot, the camera reports the current frame number, as shown in the lower-right image in Figure 3-15. To keep depth of field con-sistent between shots, the camera also uses the same f-stop and focus-ing distance for each frame. A panorama series can include as many as ten frames. When you're done snapping your series of frames, press OK. You can then start another series of shots or choose a different scene mode.

A scene like the one in my example typically proves pretty easy to turn into a panoramic image. For scenes that contain lots of structures, moving subjects (such as people walking along a path), or extreme dif-ferences in brightness from one area to the next, things get a little trick-ier. You can find lots of good tutorials explaining how to deal with these and other panorama issues online; one place to start is the Olympus Web site (www.olympus.com), which shows how to shoot and stitch basic panoramas using Panorama mode and the Olympus photo software.

✔ **Fireworks:** To help you capture classic images of fireworks exploding in mid-air — well, at least, I hope they're in mid-air — this mode automati-cally adjusts white balance to maintain accurate colors. More important, Fireworks mode also selects a slow shutter speed so that you get those nice, trailing fingers of light in the sky. But you must do your part by stabilizing the camera on a tripod. At the slow shutter speed needed for this type of shot, handholding the camera inevitably results in camera shake and, thus, a blurry photo. And don't assume that the Image Stabilizer feature can do the job — not only would it not help during such a long exposure, but it's disabled in this mode.

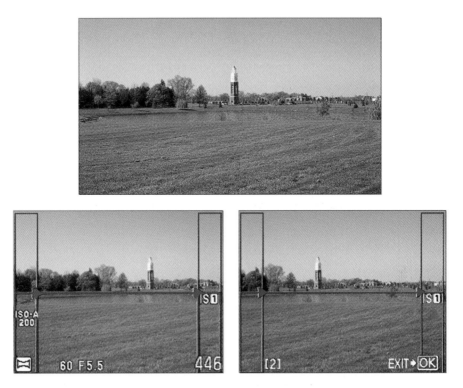

Figure 3-15: For a successful panorama, frame each image to include some overlap of the previous shot.

Fireworks mode also automatically sets the camera to manual focus (MF) mode. This choice makes good sense because no autofocus system can successfully lock onto fireworks. For best results, set focus at infinity. (To set this focus point, just aim the camera at a distant object and twist the focusing ring until the scene appears in focus.)

✓ **Beach & Snow:** The harsh lighting and bright backgrounds found at the beach or on the ski slopes can fool the camera's autoexposure system, causing the snow or sand to appear grayish and dull, and leaving people and other subjects underexposed. This mode prevents that issue by purposely amping up exposure a bit.

Like Sport mode, Beach & Snow mode is set to Sequential shutter-release mode (multiple images with one press of the shutter button) and continuous autofocus (C-AF). If you want to photograph a stationary subject, you can change the release mode to one of the self-timer settings, but you don't have control over the autofocus mode. You can choose to turn Face Detection on or off.

Taking a picture in SCN mode

The simplest way to take a picture in SCN mode is to follow these steps:

1. **Set the Mode dial to SCN.**

 By default, the monitor displays a menu screen similar to the one you see on the left side of Figure 3-16 as soon as you set the Mode dial to SCN.

2. **Select a scene mode.**

 On the left side of the screen, tiny icons represent each of the 19 scene modes. Press the up- or down-arrow key to scroll through the list of scene types. As you do, an example photograph appears to show you what type of subject the mode is designed to capture.

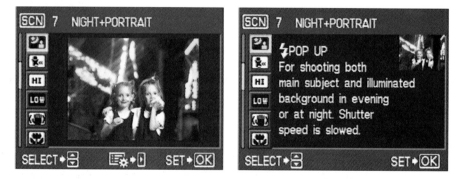

Figure 3-16: After selecting a scene mode, press the right-arrow key to display more information.

3. **Press the right-arrow key.**

 Now you see a screen that contains a description of the mode plus some tips for getting good results, as shown on the right in Figure 3-16. Some of the tip screens don't contain much information, but others, like the one in the figure, provide critical info — in this case, reminding you to raise the built-in flash.

4. **Press OK.**

 The scene menu disappears.

5. **For modes that allow flash, raise the flash unit.**

 The flash details work out as follows:

 • *Night Scene, Candle, Sunset, Document, Panorama, and Fireworks mode*: Flash is disabled. Even if you raise the flash, it won't fire when you take the picture.

- *Night Portrait mode:* The flash is set to Slow-sync with Red-Eye Reduction mode. This flash setting combines a slow shutter speed (long exposure time) with a feature designed to help prevent those glowing devil eyes in portraits. After you press the shutter button, the flash emits a brief burst of light designed to shrink the subject's pupils, which reduces the chances of red-eye. After the preflash, the flash fires again to illuminate the subject.

 The slow shutter speed enables the camera to soak up more ambient light so that less flash power is needed, resulting in softer, more flatting light on the subject. However, warn your subject to stay very still during the exposure and use a tripod to make sure that the camera also remains absolutely still. Any movement of the camera or subject can blur the photo. See Chapter 6 for more details about this flash mode.

- *All other modes:* The flash is set to Auto flash mode. If the camera thinks additional light is needed, the flash fires. Otherwise, the flash just sits there looking pretty.

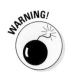

Again, the camera doesn't raise the flash unit for you even in the darkest of settings. You must handle that job by using the Flash Up switch on the back of the camera.

6. **Frame the shot.**

7. **For all modes except Fireworks, press and hold the shutter button halfway to set focus and initiate exposure metering.**

 How the camera sets focus depends on the scene mode:

 - *Sport, Child, and Beach & Snow modes:* The AF mode is set to continuous (C-AF). The camera locks focus on an initial target but then adjusts focus as needed up to the time you take the shot.

 - *All other modes:* The S-AF (single autofocus) mode is used. Focus is locked when you press the shutter button halfway.

 When the camera establishes focus, it signals you the same way it does in iAuto mode: You hear a beep and see the green focus light in the top-right corner of the display. In scene modes that use single autofocus, a green rectangle appears briefly to indicate the *focus target* — the area of the frame the camera used to establish focus. (Refer to Figure 3-2, earlier in this chapter.) Typically, the camera locks onto the closest object in the scene. In continuous autofocus mode, the camera doesn't display a focus target but instead keeps adjusting focus as needed to follow your subject.

 If Face Detection is enabled, you also see the white face-found frame as well. Chapter 2 tells you more about using Face Detection.

8. **For Fireworks mode, twist the focusing ring to set focus and then press and hold the shutter button halfway to initiate autoexposure metering.**

 Set the focus at the farthest possible distance (infinity).

9. Press the shutter button the rest of the way to take the picture.

In the Sport, Child, and Beach & Snow modes, the camera uses the Sequential shutter-release mode, recording as many as three frames per second for as long as you hold down the shutter button. In Panorama mode, you see the framing marks to help you line up your second shot, as explained earlier.

Here are a few other tips for taking advantage of SCN mode:

✓ **Using the Live Control display or Super Control Panel:** You also can select a scene mode by using either of the control displays. After you set the camera to SCN mode, press OK to exit the original menu screen and then press OK again. Now you can press the Info button to cycle from the menu screen to the Live Control screen, as shown in Figure 3-17; and to the Super Control Panel, as shown in Figure 3-18. (To use the Super Control Panel, you must enable it via Custom Menu D, as explained in Chapter 1.)

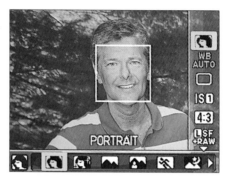

Figure 3-17: Settings that appear dimmed in the Live Control display are inaccessible in the selected Scene mode.

✓ **Adjusting basic picture settings:** Whether you can control the basic picture options described in Chapter 2 depends on the scene mode. The easiest way to see what options you can adjust is to use the Live Control or Super Control Panel displays. If an option is adjustable, it appears white in the displays. Otherwise, the option appears gray to indicate that it's off limits. Note, though, that the Flash Mode icon can be a fooler: If the flash isn't raised, the setting appears dimmed even if you can use flash. After you raise the flash, the setting turns white if the scene mode supports flash.

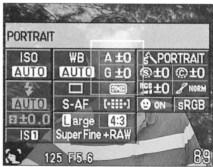

Figure 3-18: If you enable the Super Control Panel, you also can select a scene mode through that display.

Understanding focus factors

When you focus the lens, in either autofocus or manual focus mode, you determine only the point of sharpest focus. The distance to which the sharp focus zone extends from that point — the *depth of field* — depends in part on the *aperture setting,* or *f-stop,* which is an exposure control. Some of the camera's scene modes are designed to choose aperture settings that produce a certain depth of field.

The Portrait setting, for example, uses an aperture setting that shortens the depth of field so that background objects are softly focused — an artistic choice that most people prefer for portraits. On the flip side of the coin, the Landscape setting selects an aperture that produces a large depth of field so that both foreground and background objects appear sharp.

Another exposure-related control, *shutter speed,* plays a focus role when you photograph moving objects. Moving objects appear blurry at slow shutter speeds; at fast shutter speeds, they appear sharply focused. On your camera, Sport mode automatically selects a high shutter speed to help you "stop" action, producing blur-free shots of the subject.

A fast shutter speed can also help safeguard against allover blurring that results when the camera is moved during the exposure. The faster the shutter speed, the shorter the exposure time, which reduces the time that you need to keep the camera absolutely still. You can also improve your odds of shake-free shots in all scene modes, except Fireworks, by enabling the Image Stabilizer feature, introduced in Chapter 2. For Fireworks mode and other modes that use a very slow shutter speed, using a tripod is the best way to avoid camera shake. (Disable image stabilization when you use a tripod.)

In iAuto mode, you can use the Blur Background option to increase or decrease depth of field, and use the Express Motions option to increase or decrease the shutter speed. But in this mode or any of the scene modes, the range of f-stops and shutter speeds the camera can select depends on the lighting conditions. When you're shooting at night, for example, the camera may not be able to select a shutter speed fast enough to stop action even in Sport mode.

If you want more control over focus and depth of field, switch to an advanced exposure mode. Chapters 6 and 7 show you how to use those modes and explain all these concepts fully.

Becoming a Movie Mogul

During the long ago era known as my college days, part of my studies involved courses in filmmaking. Back then — more years in the past than I care to think about — creating even a short movie was backbreaking and time-consuming. You had to lug around a huge film camera, plus a second monster machine for recording audio. After you shot your masterpiece, you had to wait for the film to be developed and returned from the lab. Then, to turn the raw footage into something that might convince the professor to give you a passing grade, you spent hours in the post-production lab, carefully splicing film frames and audio tape to cut out any bloopers and make sure that the audio synced to the action.

It pains me to think of the many hours I spent learning those skills now that recording a movie, complete with audio, is as simple as pushing a single button on the E-PL1. In fact, Movie mode ranks right up there with iAuto and SCN modes for ease of use. The following section explains the process as it works when you stick with the default recording settings. Following that, you can find out about a few alternative recording options that you may want to explore.

For help playing movies, visit Chapter 4.

Shooting your first movie

The E-PL1 enables one-button movie recording: You can press the red Movie button, as shown on the left in Figure 3-19, to immediately start recording a high-definition movie with sound. You don't even have to set the Mode dial to the Movie setting — pressing the button starts movie recording no matter what the setting of the Mode dial.

Movie button

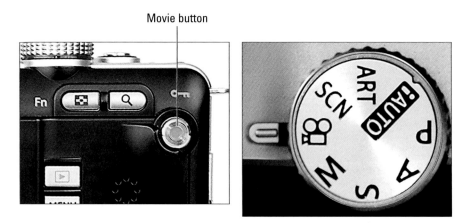

Figure 3-19: Pressing the Movie button begins movie recording in any shooting mode; selecting Movie mode lets you adjust recording settings.

To take full control over your movies, though, you do need to set the Mode dial to Movie, as shown on the right in the figure. The monitor then updates to show the movie-recording interface, as shown in Figure 3-20, with symbols representing the critical movie settings onscreen. The following section explains those settings and how to adjust them.

One critical detail to note now, though: The value in the lower-right corner represents the available recording time, in minutes and seconds. This value is determined by your movie quality settings and the amount of free space on your memory card. The maximum movie file size is 2GB, and the maximum

length at the default quality setting (high-definition) is seven minutes. (You can double the movie length if you shoot in standard definition.)

Follow these steps to record your movie:

Available recording time

Figure 3-20: You can view the remaining recording time in the lower-right corner of the screen.

1. **Frame the scene and set focus by pressing the shutter button halfway.**

 A green focus-target frame appears briefly, and the green focus light that normally appears during still photography appears in the upper-right corner of the monitor when focus is achieved.

2. **Release the shutter button.**

3. **To begin recording, press the Movie button.**

 A red recording light appears in the monitor, as shown in Figure 3-21. The card access light in the upper-left corner indicates that the movie file is being written to the memory card.

4. **To stop recording, press the Movie button again.**

Card access icon

Recording icon Time elapsed

Figure 3-21: The card access icon shows you that the camera is writing the movie file to the memory card.

That's the basic process; the following section explains some additional details about customizing your movie settings. First, though, a look at some technical details that may interest the movie geek in the crowd:

✔ **Recording format:** Movies are recorded in the AVI (Audio Video Interleaved) digital format. That means that you can play them with any computer software capable of working with AVI files. If you want to view your movies on a TV, you can connect the camera to the TV, as explained in Chapter 5. Or if you have the necessary computer software, you can convert the AVI file to a format that a standard DVD player can recognize and then burn the converted file to a DVD. You also can edit your movie in a program that can work with AVI files.

✔ **Maximum file size/movie length:** For the default, HD (high-definition) recording mode, the maximum length is seven minutes. If you reduce the recording quality to SD (standard definition), you can double the movie length to 14 minutes. In either case, the maximum file size is 2GB. However, there's nothing to stop you from simply starting a new recording when you reach the limit of your first one.

✔ **Frame rate:** The *frame rate* determines the smoothness of the playback. Whether you shoot in HD or SD, the frame rate is 30 frames per second, which is the standard frame rate for television-quality video.

If you take advantage of the movie shooting option that applies the art filters as you shoot, the frame rate can slow considerably, however. For more about this variable, see the "Shooting mode" bullet point in the next section.

✔ **Face Detection:** This feature isn't available for movie recording.

✔ **Heat safety:** All the electronics involved in movie recording cause the camera to heat up more than during still photography. If the camera believes that it's in danger of suffering heat stroke, it automatically shuts itself off to prevent permanent damage. Give the camera some time to cool off before you start shooting again.

✔ **Memory card speed:** SD and SDHC memory cards are assigned speed ratings that indicate how fast they can read and write data. For the best movie recording and playback performance, use memory cards that have a speed rating of 6, the maximum currently available.

Understanding and modifying movie settings

Because the whole point of the E-PL1 approach to recording movies is to make the process simple and painless, the camera doesn't bog you down with lots of obscure recording options that only a film major would understand. But you can adjust a couple recording settings, including the movie quality and whether sound is recorded.

In order to adjust settings before you begin recording, set the Mode dial to Movie. You then can check the status of the most critical settings by looking at the shooting information display, as shown in Figure 3-22. If you don't see the shooting data shown in

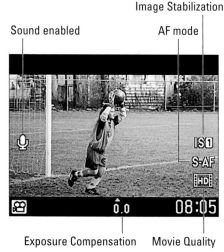

Figure 3-22: These symbols represent the most critical movie-recording settings.

the figure, press the Info button until it appears. (Chapter 1 explains how to modify the display.)

The following list offers a look at all the possible movie options. To adjust most settings, you can either use the menus or the Live Control display, the latter being the quickest option. The Super Control Panel isn't available for movie recording.

✔ **Record mode (Movie Quality):** You can stick with the default setting, which creates a movie that matches high-definition (HD) recording standards: 1280 x 720 pixels, with a screen format of 16:9. You also can lower the resolution to record a standard definition (SD) movie that has a size of 640 x 480 pixels and an aspect ratio of 4:3. You can make the call through the Live Control display, as shown in Figure 3-23, or via the Image Quality setting on Shooting Menu 1, as shown in Figure 3-24.

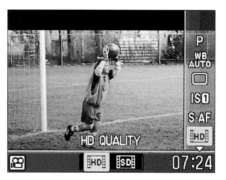

Figure 3-23: You can quickly adjust the recording quality through the Live Control display.

If you choose HD recording, the maximum movie length is 7 minutes; for SD movies, the maximum length is 14 minutes. Recording stops automatically when you reach the end of that limit. (You can always start a new movie after the camera finishes writing the current movie data to the memory card, however.)

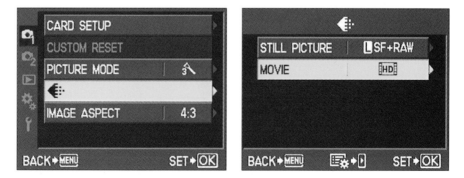

Figure 3-24: Shooting Menu 1 offers another way to set the movie quality.

Recording sound: The little microphone icon on the left side of the screen indicates that sound recording is enabled. To instead record a silent movie, use the Live Control display and select the microphone icon, as shown in Figure 3-25. You also can access the setting through Custom Menu I, as shown in Figure 3-26. When sound is disabled, the word Off appears next to the microphone icon in the information display.

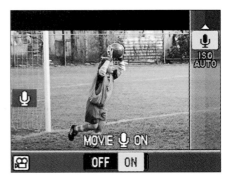

Figure 3-25: You can enable or disable sound through the Live Control display.

The camera's built-in microphone is located on top of the camera, just in front of the hot shoe, as shown in Figure 3-27. Make sure that you don't inadvertently cover the microphone with your finger. And keep in mind that anything *you* say is picked up by the mic along with any other audio present in the scene. I'm notorious for muttering various comments and "actor" instructions during my movies; I'm sure that one day film students everywhere will write papers about this aspect of my oeuvre.

Image stabilization: If you enable image stabilization, the camera enlarges the image slightly. Also, the only stabilization setting that is available is the normal, I.S. 1 setting. (You can select the I.S. 2 or I.S. 3 setting, but the camera ignores you and uses I.S. 1 anyway.) See Chapter 2 for more details about image stabilization; also, if you use a lens that has built-in image stabilization, turn off the feature either on the lens or on the camera so that only one system is in force.

As with still photography, you can adjust the IS setting via the Live Control panel or Shooting Menu 2.

Figure 3-26: Custom Menu I contains three movie-related settings.

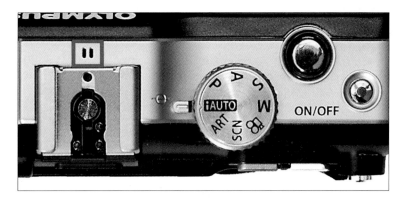

Figure 3-27: The microphone is located just in front of the flash hot shoe.

✓ **Autofocusing:** By default, the camera uses the single AF mode (S-AF), so focus is locked when you press the shutter button halfway. If you change the focus mode to continuous autofocus (C-AF), the camera attempts to adjust focus if you pan the camera or your subject moves. You also can use the continuous autofocus with subject tracking (C-AF+TR) option, which tells the camera to lock onto the subject when you press the shutter button halfway and then follow it as it moves through the frame. See Chapter 7 for the fine points of using both these continuous autofocusing options, including how to select the part of the frame you want the camera to use to set focus. *Note:* In either mode, the system sometimes lags a little or has to "hunt" to find the focus point, so you may notice the scene going in and out of focus during the movie. You also can sometimes hear the noise of the autofocusing mechanism in the sound recording.

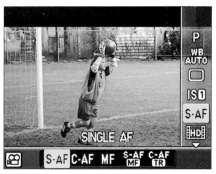

For better focusing results, set the camera to manual focusing (MF) and adjust focus as needed by twisting the focusing ring on the lens. With a little practice, you can figure out how to pan, focus, and zoom smoothly to create a more successful recording.

Select the focus mode through the Live Control screen, as shown in Figure 3-28, or via Custom Menu A, as shown in Figure 3-29.

Figure 3-28: Set the focus mode via this option on the Live Control display.

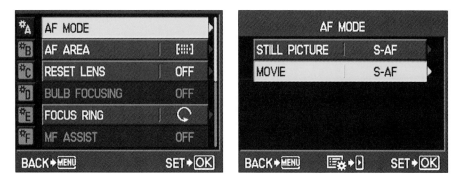

Figure 3-29: Custom Menu A also offers access to the movie focus mode setting.

✔ **Shooting mode:** Here's the one aspect of Movie mode that gets a little complex. You can choose from four movie-shooting modes: P, A, M, and ART. These modes correspond to the P, A, M, and ART settings on the Mode dial. The first three modes give you a choice of how you want the camera to handle exposure; the fourth enables you to apply special-effects art filters to the movie. Here's what you need to know:

- *P (programmed autoexposure):* The camera handles exposure for you, automatically selecting the right aperture, shutter speed, and ISO. This mode is the default.

- *A (aperture-priority autoexposure):* If you want to control depth of field, try this setting. As you do when taking still photos, you select the f-stop, and the camera selects the shutter speed and ISO to keep the scene well-exposed. Press the up-arrow key to activate the f-stop value and then press up or down to adjust it. (Chapter 6 has details.)

- *M (manual exposure):* In this mode, you set aperture, shutter speed, and ISO. You can select shutter speeds from 1/60 second to 1/2000 second and ISO values from 200 to 1600. The aperture range depends on your lens.

 For movie recording, shutter speed affects your results differently than for still recording. Shutter speed doesn't determine whether moving objects appear blurry — assuming that your focus is set correctly, subjects will be sharp even at a slow shutter speed because Movie mode records action at 30 frames per second. But shutter speed does impact the brightness of the scene. At 1/60 second, the scene will be brighter than at 1/2000 second. So you can modify the shutter speed to allow the use of the f-stop and ISO you have in mind.

- *ART1-ART6:* You also can record movies that take on the look of one of the art filters. For example, Art Filter 3 enables you to create a grainy black-and-white movie reminiscent of old film noire flicks. Chapter 9 gives you a look at the effects produced by all six filters.

Note a couple drawbacks: First, continuous autofocusing is limited for some of the filters, and using the Diorama filter (Art Filter 5) can confuse the camera's time-remaining calculator. (The movie appears to be recording at a slower than usual rate but plays back normally.) Finally, if you choose one of the art modes, the camera automatically handles all exposure decisions, as it does in P mode.

I suggest that you stick with the default, P mode, until you have your movie-recording skills down pat. When you're ready to experiment, you can change the setting through the Live Control screen, as shown in Figure 3-30, or through the Mode option on Custom Menu I (refer to the right screen in Figure 3-26).

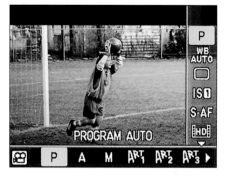

Figure 3-30: The Mode option lets you change how exposure is set or apply art filters to the movie.

✓ **Exposure Compensation:** If you set the camera to the P or A mode for movie recording, you can request a slightly brighter or darker picture through this option. To adjust the exposure, press the up-arrow key — the one marked with the plus/minus symbol. The Exposure Compensation setting then becomes highlighted, as shown on the left in Figure 3-31. Now press the left- or right-arrow key to adjust the setting. Raise the value for a brighter picture; lower it for a darker scene. You can see the effect of the adjustment on the monitor. Press OK to return to shooting.

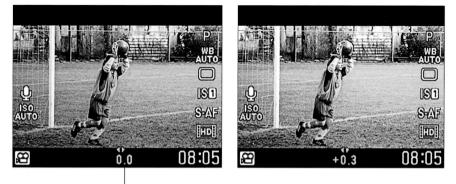

Exposure Compensation

Figure 3-31: Press the up-arrow key to access the Exposure Compensation setting; press right or left to adjust the value.

In M (manual exposure) mode, control brightness by adjusting the aperture, shutter speed, and ISO. Use the techniques outlined in Chapter 6 to adjust these settings.

✒ **Shutter-button movie recording and still-picture capture:** Through an option on Custom Menu B, you can set the Movie button to a function other than starting and stopping movie recording. (Chapter 10 shows you how.) If you take this step and don't assign the other programmable button, the Fn button, to the Movie function, you must set the Mode dial to Movie and use the shutter button to start and stop recording: Press halfway to set focus and then press the rest of the way to start recording. To stop recording, press down all the way again.

If you go for this button customization, you also can set the camera to record a still picture at the end of the recording. Enable this feature through the Movie+Still option on Custom Menu I (refer to the screen on the right in Figure 3-26).

While you're working with this book and figuring out the camera, I suggest that you stick with the default button functions. Otherwise, my instructions and those in the manual may not work as written.

Part II
Working with Picture Files

*y*ou have a memory card full of pictures. Now what? Now you turn to the first chapter in this part, Chapter 4, which explains all your camera's picture-playback features, including options that help you evaluate exposure, compare photos side-by-side, and zoom the display so that you can check small details. The same chapter shows you how to delete lousy pictures and protect great ones from accidental erasure.

When you're ready to move pictures from the camera to your computer, Chapter 5 shows you the best ways to get the job done. In addition, Chapter 5 offers step-by-step guidance on printing your pictures, preparing them for online sharing, and even viewing them on your television.

4

Playback Mode: Viewing, Protecting, and Erasing Pictures (And Movies)

*W*ithout question, my favorite thing about digital photography is being able to view my pictures on the camera monitor the instant after I shoot them. No more guessing whether I captured the image I wanted or whether I need to try again, as in the film era. And no more wasting money on developing and printing pictures that stink.

This chapter introduces you to all the playback features on the E-PL1, starting with ways to view still photos and winding up with a primer in playing movies. In addition, this chapter shows you how to erase pictures you don't like and how to protect the ones you love from being deleted accidentally. You also find out how to create an in-camera slide show and display your photos and movies on a television screen.

Customizing Playback Timing

You can control many aspects of picture playback, including what type of data appears with your pictures. Later sections explain all the possibilities. But first, be aware of the following two camera settings that affect when your pictures appear and for how long each image displays:

✔ **Adjust the timing of automatic camera shutoff.** By default, the E-PL1 saves battery power by turning itself off if one minute goes by without any activity. You can adjust the shutoff timing through the Sleep option on Custom Menu D, as shown in Figure 4-1. Options range from one minute to ten minutes to Off, which disables auto shutdown.

Figure 4-1: By default, the camera shuts down after one minute of inactivity; you can adjust the shutoff timing through this option.

✔ **Customize the instant review display.** After you shoot a picture, it appears automatically on the monitor for about five seconds. You can customize this behavior through the Rec View option on the Setup menu, as shown in Figure 4-2. Note that you can't access this menu item when the Mode dial is set to Movie.

Your options are as follows:

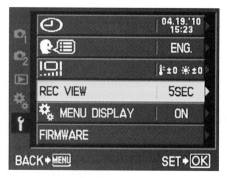

Figure 4-2: Head for the Setup menu to enable or disable instant review.

- *Adjust the length of the instant-review period.* You can choose a display period ranging from 1 second to 20 seconds.

- *Turn off instant review:* Select the Off setting to disable instant review. You can always press the Playback button at any time to view pictures when needed.

- *Shift from instant review to playback mode automatically:* The Rec View option also offers an Auto Playback setting. If you select this option, the camera automatically shifts to playback mode at the end of the instant review period. You then can inspect the picture using the playback zoom feature (explained later in this chapter), erase the picture, or perform other playback functions without pressing the Playback button.

You also have control over the shooting data that's displayed during the instant review period. The camera automatically uses the same display mode as you last used when you viewed pictures in playback mode. By default, you see the Simplified display mode, which shows you the picture plus a bit of file data, such as the date and time and Image Quality setting. For more on display modes, see the section "Viewing Picture Data," later in this chapter.

Viewing Images in Playback Mode

To review your photos, take these steps:

1. **Press the Playback button, labeled in Figure 4-3.**

 The monitor displays the last picture you took, along with some picture data. To find out how to interpret the picture information and specify what data you want to see, see the upcoming section "Viewing Picture Data." For now, just know that you can press the Info button to cycle between the various displays.

2. **To scroll through your pictures, press the right- or left-arrow key.**

3. **To return to picture-taking mode, press the Playback button again or press the shutter button halfway and then release it.**

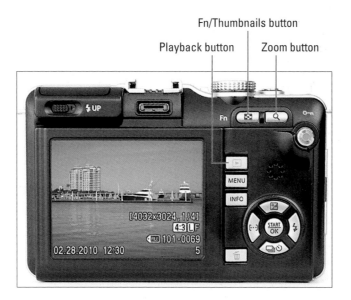

Figure 4-3: These buttons play a big role in picture playback.

These steps assume that the camera is currently set to display a single photo at a time, as shown in Figure 4-3. You can also display multiple small thumbnails views of your photos at a time, as I explain next.

Viewing multiple images at a time

Along with viewing images one at a time, you can switch to *index* or *thumbnails view,* which enables you to display 4, 9, 25, or 100 thumbnails at a time. You also can display thumbnails in calendar view, which groups images by date recorded. (Details about calendar view await in the next section.)

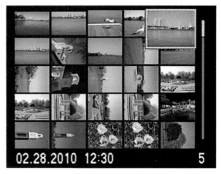

Figure 4-4: You can view up multiple thumbnails at a time.

By default, however, only the 25-thumbnails view, as shown in Figure 4-4, and calendar view are enabled. To specify which thumbnail displays you want to use, head for Custom Menu D. Choose the Info Setting option and press OK. You then see the screen shown on the left in Figure 4-5. Highlight the Thumbnails Setting option (the little grid represents thumbnails) and press OK again to bring up the second screen in the figure. Turn the views you want to use to On and set the others to Off. Press OK to exit the menu.

Figure 4-5: Follow this menu path to determine which thumbnails views are available.

After setting your thumbnail preferences, use these techniques to switch from single-image view to thumbnails view and navigate your photos:

 ✔ **Display thumbnails.** Press the Fn button, labeled in Figure 4-3 and shown in the margin, to cycle from single-picture view to thumbnails view. (Again, the icon on the button face looks a little like a batch of tiny thumbnails — well, if you squint and use your imagination, anyway.)

✔ **Increase the number of thumbnails.** Each time you press the Fn button, you increase the number of thumbnails, assuming that you enabled more than one thumbnails view. After you reach the final thumbnails view, another press of the button shifts the screen to calendar view.

✔ **Display fewer thumbnails.** From any thumbnail screen (except calendar view), you can reduce the number of images by pressing the Zoom button, also labeled in Figure 4-3. Each press takes you one step down the thumbnail-count ladder. (In calendar view, pressing the Zoom button displays the selected image in full-frame view; again, see the next section for details.)

✔ **Return to full-frame view.** Just keep pressing the Zoom button to cycle from thumbnails view to single-frame view. How many presses this takes depends on how many thumbnails views you enabled.

✔ **Scroll the display.** Press the up- or down-arrow keys.

✔ **Select an image.** To perform certain playback functions, such as deleting a photo or protecting it, you first need to select an image. A yellow box surrounds the currently selected image. For example in Figure 4-4, the upper-right photo is selected. To select a different image, just use the arrow keys to move the highlight box over the image.

Viewing pictures in calendar view

Fn ▦ This playback mode, as shown in Figure 4-6, helps you easily track down and view all pictures taken on a certain date. To shift from thumbnails view to calendar view, press the Fn button. You may need to press the button more than once to cycle through all the thumbnails views to get to calendar view.

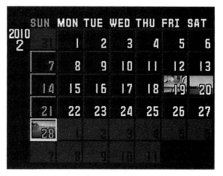

After getting to calendar view, use the arrow keys to move the yellow highlight box over the date and then press OK or the Zoom button to view the first picture shot on that day in single-image view.

Figure 4-6: Move the highlight box over a date and press OK to view pictures from that day.

Zooming in for a closer view

After displaying a photo in single-frame view, you can magnify it to get a close-up look at important details, such as whether someone's eyes are closed.

Additionally, you can choose from two zooming methods: Close Up Mode 1 and Mode 2. Figure 4-7 shows the setting that controls this option, found on Custom Menu D. What's the difference? *Mode 1,* the default setting, is the easiest and most intuitive to use; *Mode 2* is a little more complicated but offers some additional zooming functions. The next two sections explore both modes.

Either way, you can't zoom a movie; only still photos can be magnified.

Figure 4-7: This menu option determines the techniques you use to magnify a picture during playback.

Using Playback Close Up Mode 1

By default, the zoom system is set to Close Up Mode 1, as shown in Figure 4-7. To magnify pictures in this mode, use these techniques:

✓ **Zoom in:** Press the Zoom button. The display changes from full-frame view, as shown on the left in Figure 4-8, to a 2x magnification, as shown on the right. You can magnify the image to a maximum of 14 times its original display size. Just keep pressing the Zoom button until you reach the magnification you want. The current magnification value appears in the lower-left corner of the display, as shown on the right in Figure 4-8.

If the Face Detection option on Custom Menu D is enabled and the camera detects a face in the picture, it automatically centers the zoomed display on one of the faces, as it did in Figure 4-8. (Chapter 2 explains more about the Face Detection feature.) Otherwise, the display zooms to the center of the picture. The face-zooming feature doesn't work when the Mode dial is set to Movie, however, because Face Detection is disabled in that mode.

Figure 4-8: Press the Zoom button to magnify a photo.

Fn ⊞ ✔ **View another part of a magnified picture:** Just press the arrow keys to scroll the display.

✔ **Zoom out:** To zoom out to a reduced magnification, press the Fn button. You can also press OK to jump quickly to full-frame view.

Zooming in Close Up Mode 2

Mode 2 isn't quite as simple to use as Mode 1, but it offers three pretty useful advantages. In this mode, you can

✔ **Automatically inspect all faces in a portrait.** If the picture contains multiple faces, you can magnify one and then quickly jump to the next.

✔ **Easily inspect the same area in the next picture at the same magnification.** For example, if you capture three portraits of your subject, you can zoom in to check the eyes in the first image and then quickly jump to viewing the same area of the second shot at the same magnification.

✔ **Take advantage of the Light Box information display mode.** In this display mode, detailed later in this chapter, you can compare two pictures side-by-side and even zoom and scroll both views in tandem. Light Box viewing isn't available in Close Up Mode 1.

To zoom during picture playback in Close Up Mode 2, follow these steps:

1. **Press the Zoom button.**

 You see a green zoom frame, as shown in Figure 4-9. By default, the frame appears at the center of the image. But if the camera recognizes faces, it instead puts the zoom frame over one of them, as in the figure.

2. **Use the arrow keys to move the green frame over the area that you want to inspect.**

3. **To change the magnification level, press the Info button, press the up- or down-arrow key, and press Info again.**

Figure 4-9: To zoom using Close Up Mode 2, position the zoom frame over the area you want to inspect.

 As soon as you press the Info button, the magnification value, found in the lower-left corner of the screen, becomes active, as shown in Figure 4-10. Press the up-arrow key to raise the zoom level; press the down-arrow key to lower it. Be sure to press Info after you adjust the value to return to normal zoom viewing.

4. Press the Zoom button.

The area that was within the zoom frame appears at your selected magnification level, as shown on the left in Figure 4-11.

5. To jump from one face to the next in a portrait, press OK.

The next face appears at the same magnification level as the first, as shown on the right in Figure 4-11. Sometimes the camera doesn't correctly identify faces, however, especially if the picture shows the subject looking away from the lens or in profile.

Figure 4-10: Press the Info button and then press up or down to set the magnification level.

6. Use the arrow keys to scroll the display so that you can view other parts of the photo.

7. To check the same area of the next picture at the same magnification level, press the Zoom button and then press the right-arrow key.

Or to check the preceding photo, press the left-arrow key. Press the Zoom button once to display the green zoom frame on the new photo; press again to magnify the area in the frame. You can then scroll the display by using the arrow keys.

Fn 🔲 **8. To exit the zoomed view, press the Fn button.**

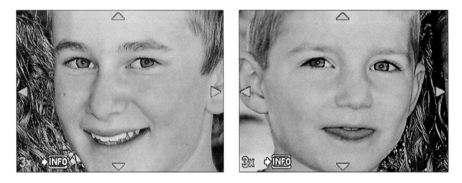

Figure 4-11: Press OK to jump from one face in portrait to another.

Rotating a photo

When you display a photo taken with a vertical orientation, it displays sideways on the monitor, as shown on the left side of Figure 4-12. You can apply an in-camera edit that rotates the photo to its correct orientation, after

which it appears as shown on the right side of the figure. You also can rotate photos 180 degrees to flip them vertically. Note, though, that if you apply the Protect option discussed later in the chapter, you can't rotate the photo (or make any other changes, for that matter). You can't rotate movies either.

Figure 4-12: Vertically oriented pictures normally appear sideways in the monitor (left); you can rotate them to their upright positions (right).

To rotate a photo, take these steps:

1. **Display the photo in single-image view and press OK.**

 For pictures taken in the Raw format, you see the screen shown on the left in Figure 4-13. For JPEG images, the JPEG Edit screen appears instead. Both screens include the Rotate option.

2. **Select Rotate and press OK.**

 Now you see the Rotate screen, featured on the right in Figure 4-13.

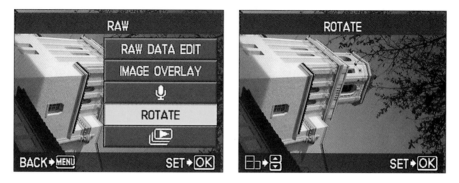

Figure 4-13: Press the up- or down-arrow keys to rotate the image in 90-degree increments.

3. **To rotate the image, press the up- or down-arrow key.**

 Each press rotates the image 90 degrees.

4. **Press OK.**

Viewing Picture Data

When you view photos in single-image view, you can choose from the following information display modes:

- **Image Only:** In this mode, you see no picture data, as shown on the left in Figure 4-14.

- **Simplified display:** This mode adds just a few bits of shooting information, including the image resolution, shooting date, and file number.

- **Overall display:** This mode provides the most complete shooting information, listing all the critical picture settings as well as two exposure-evaluation tools called histograms, as shown on the right in Figure 4-14. (The upcoming section "Overall display" explains how to read histograms.)

- **Histogram display:** In this mode, you see an enlarged brightness histogram that works similarly to the one you can display while shooting.

- **Highlight and Shadow display:** Overexposed and underexposed pixels blink red or blue in this display mode. These blinking alerts also appear in image thumbnails in Overall view mode.

- **Light Box display:** This mode enables you to compare two pictures side-by-side. However, this mode is available only if you set the Close Up Mode option on Custom Menu D to Mode 2.

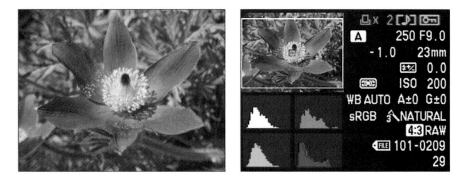

Figure 4-14: You can view your image without any data (left) or get a full report of camera settings (right).

Upcoming sections provide you with a decoder ring to the details you see in all the display modes except the Image Only mode, which I think speaks for itself. First, though, two important details to sort out:

✏ **To cycle from one display mode to the next:** Press the Info button.

✏ **To enable or disable display modes:** By default, only the first three modes in the preceding list are enabled, but you can turn on the other modes or disable any mode except Simplified mode. That mode is always part of the playback team.

To set your preferences, find your way to Custom Menu D and highlight the setting shown in Figure 4-15. Press OK and then select Playback Info, as shown on the left in Figure 4-16, and press OK again to see the list of display modes, as shown on the right. Turn each mode on or off as you see fit (press right to access the screen where you change the setting) and press OK. Remember, Light Box display is unavailable when the Close Up Mode option is set to the default, Mode 1. See the section "Zooming in for a closer view" for details.

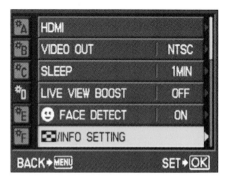

Figure 4-15: To enable the hidden display modes, start with this menu option.

For help understanding the onscreen data related to movie files, head to the section "Playing Movies," near the end of this chapter.

Figure 4-16: Select the Playback Info option and press OK to enable or disable individual display modes.

TIP

Decoding picture file and folder names

Picture filenames on the E-PL1 contain eight characters, which are based on the following scheme:

✔ The first character is either P or _ (underscore). P is used for pictures taken in the default color space, sRGB; the underscore is reserved for files taken in the Adobe RGB color space. (Chapter 7 explains the difference.)

✔ The second character indicates the month the picture was taken. For January through September, a number is used (1–9); for the remaining three months, a letter (A, B, or C).

✔ The next two digits indicate the day of the month.

✔ The next four digits are the unique number assigned to the photo, with the possibilities ranging from 0000 to 9999.

Files are organized into folders on the memory card, with possible folder names ranging from 100 to 999. Each folder can hold up to 9999 photos; when a folder is full, the camera creates a new folder and assigns it the next higher folder number.

By default, the camera continues the existing folder and filenaming scheme even if you take out one card and insert another so that you don't wind up with multiple pictures with the same file and folder numbers. You can change this behavior by changing the File Name option on Custom Menu H from Auto to Reset, after which the folder is reset to 100 and the file number is reset to 0001 each time you insert a memory card. (But I wouldn't take this step if I were you.)

During playback, you don't see the entire filename onscreen; instead, the camera displays the folder number and the last four digits of the filename (refer to Figure 4-17). After you transfer the pictures to your computer, you can see the actual filename in your photo browser.

Simplified display mode

In this display mode, the monitor always displays the following data, labeled in Figure 4-17:

✔ **Date and time:** In the lower-left corner, you see the date and time that you took the picture. Of course, the accuracy of this data depends on whether you set the camera's date and time values correctly, which you do via the Setup menu. Chapter 1 has details.

✔ **Image Quality:** Jumping to the right side of the screen, the first line of white data (labeled Resolution and compression in the figure) indicates details about the Image Quality setting, which you can read about in Chapter 2. The first pair of numbers represents the image pixel count (*resolution*). For pictures shot in the JPEG format, you also see the compression level you selected. For example, the compression level in the figure represents a 1:4 compression amount, which is how much is applied at the Fine quality setting.

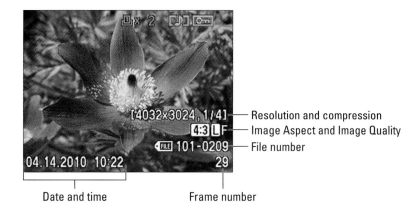

Resolution and compression
Image Aspect and Image Quality
File number

Date and time Frame number

Figure 4-17: In the Simplified display mode,
you can view these bits of data.

Just below the resolution and compression values, you see the actual
Image Quality setting — L/F, in the figure, Large (4032 x 3024 pixels)/Fine
(1:4 compression).

✔ **Aspect Ratio:** To the left of the Image Quality setting, you see the aspect
ratio of the picture. See Chapter 2 for information about selecting this
characteristic of your photo.

✔ **File number:** Here's the folder number and the last four digits of the
file number assigned to the picture. See the sidebar "Decoding picture
file and folder names" for some fine-point information about how the
camera assigns filenames and folder numbers.

✔ **Frame number:** This value tells you the frame number of the image with
respect to the total number of pictures on the memory card. For exam-
ple, the value in the figure indicates that the monitor is displaying the
29th picture on the card.

The remaining display items, labeled in Figure 4-18 and described in the fol-
lowing list, appear only if you apply certain playback and editing features:

✔ **DPOF Print Order Status:** Through the Playback menu Print Reservation
option (indicated on the menu with a little printer symbol), you can
select pictures for printing and set the number of prints per picture right
in the camera. You then can pop the memory card out of the camera
and into a printer memory card slot for direct printing. However, to take
advantage of this option, your printer must support the DPOF (Direct
Print Order Format) feature.

If you're interested in this feature, the camera manual provides step-by-
step instructions, but frankly, most printers that have card slots these
days let you set up the print order right on the printer. Some retail
printing labs can also read print-order data from a memory card, but

again, you also can use the in-store kiosks or online ordering forms to set up your print order. I bring up the whole issue now because if you do take advantage of DPOF, your print status appears during playback, as labeled in Figure 4-18. The printer symbol tells you the image is set for printing; the number tells you how many prints you ordered.

✓ **Sound Annotation:** Chapter 9 tells you about a camera feature that lets you annotate an image file with an audio clip. If you add voice comments to a picture, the little musical note icon appears in the playback display.

✓ **Protect Status:** The key icon indicates that you used the camera's file-protection feature to prevent the image from being erased when you use the camera's Erase function. See "Protecting Photos," later in this chapter, to find out more. (*Note:* Formatting your memory card, a topic discussed in Chapter 1, *does* erase even protected pictures.)

✓ **Aspect border:** If you set the Image Aspect setting to anything other than the default 4:3 *and* you shot the picture in the Raw format, a border appears to show you the area of the frame that will be retained when the picture is cropped to the chosen aspect ratio, as shown on the right in Figure 4-18. Note that the picture data shows that the aspect ratio is 4:3 regardless; that's because the cropping doesn't occur unless you process the picture using the in-camera Raw Data Edit feature, explained in Chapter 5, or choose the automatic crop option available in the Olympus software's raw converter. For JPEG photos, the picture is cropped to the selected aspect ratio at the time the picture is recorded to the memory card.

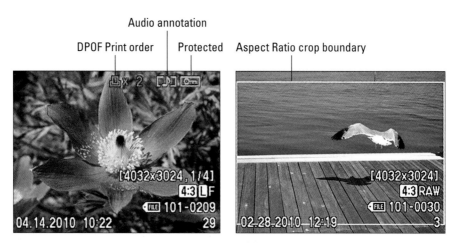

Figure 4-18: You see these screen notations only if the relevant feature was enabled when you took the picture.

Overall display

Overall display mode provides you with scads of shooting data plus two types of histograms, a brightness histogram and an RGB histogram, as shown in Figure 4-19. The next two sections explain what information you can glean from the histograms.

Image Aspect crop frame

Focus point

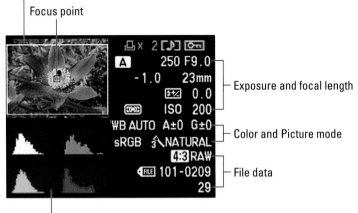

Exposure and focal length

Color and Picture mode

File data

Histograms

Figure 4-19: In Overall display mode, you can view the major camera settings you used to take the picture.

Along the top row of the display, you see the same colored symbols as in the Simplified display mode (refer to Figure 4-18). Again, this data appears only if you used the functions indicated by the symbols.

You also may see the following indicators in the image thumbnail:

- ✔ **Image Aspect crop frame:** The frame, labeled in Figure 4-19, appears if you took the picture in the Raw format and set the aspect ratio to any setting but 4:3. Chapter 2 explains file formats and aspect ratio options.

- ✔ **Red and blue blinking pixels:** Blinking red or blue areas in the image thumbnail indicate seriously overexposed or underexposed pixels, respectively. You can customize the brightness threshold that triggers "the blinkies" via the Histogram Setting on Custom Menu D; see the section "Highlight and Shadow display," later in this chapter, for details.

 ✔ **Focus point:** The green square indicates the focus point the camera used to set focus. However, the point appears only if the AF (autofocus) Mode was set to S-AF (single autofocus) or C-AF+TR (continuous autofocus with subject tracking) when you took the photo. Chapter 7 tells you more about the AF Mode setting and other focusing features.

To sort out the maze of other information, the following list breaks down things into the sections labeled in Figure 4-19:

 ✔ **Exposure and focal length settings:** This area shows the exposure settings labeled in Figure 4-20. You also can see the lens focal length. Chapter 6 explains exposure; Chapter 7 covers focal length.

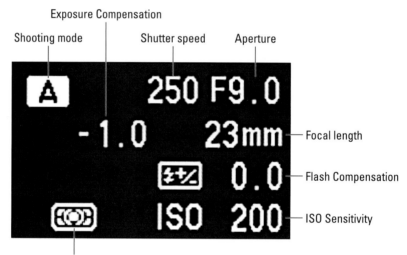

Figure 4-20: In this section of the display, you can inspect major exposure settings along with the lens focal length.

Flash information doesn't appear for pictures taken without flash.

 ✔ **Color and Picture Mode settings:** Figure 4-21 labels the picture options revealed in this area of the display. These options relate to how the camera renders the image colors. The Picture Mode setting also affects image contrast and sharpness. Check out Chapter 7 for the scoop on color and Picture Mode settings.

 ✔ **File data:** The remaining items, labeled file data in Figure 4-19, also appear in the Simplified display mode: You see the image aspect ratio, file type, folder number, the last four digits of the filename, and the frame number. See the preceding section for more details.

White Balance setting White Balance adjustment

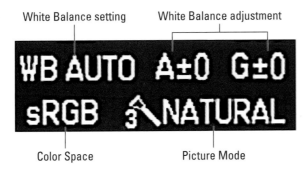

Color Space Picture Mode

Figure 4-21: These settings affect color, contrast, and sharpness.

Interpreting a brightness histogram

A *brightness histogram* is a graph that indicates the distribution of shadows, high-lights, and *midtones* (areas of medium brightness) in an image. Photographers use the term *tonal range* to describe this aspect of their pictures.

The brightness histogram appears underneath the image thumbnail in Overall display mode (refer to Figure 4-19). For a larger view, you can switch to Histogram display mode, as outlined a couple sections later. You also can enable a histogram display during shooting; Chapter 1 explains how to enable that feature.

In any case, the horizontal axis of the histogram represents the possible picture brightness values, from the darkest shadows on the left to the brightest highlights on the right, as shown in Figure 4-22. In a digital image, possible brightness values range from 0 (black) to 255 (white).

Shadows (0) Highlights (255)

Figure 4-22: The brightness histogram indicates the tonal range of an image.

The vertical axis of the histogram shows how many pixels fall at a particular brightness value. A spike indicates a heavy concentration of pixels. For example, in Figure 4-22, which shows the histogram for the floral image in Figure 4-19, the histogram indicates that most pixels fall in the middle range of the brightness scale, with few light or white pixels and few very dark pixels.

Keep in mind that there is no "perfect" histogram that you should try to duplicate. Instead, interpret the histogram with respect to the amount of shadows, highlights, and midtones that comprise your subject. For example, the histogram in Figure 4-22 makes sense for this particular image because the subject comprises mainly midtones — there simply aren't many black or white areas in the scene.

Pay attention, however, if you see a very high concentration of pixels at the far right end of the histogram, which can indicate a problem known as *blown highlights* in some circles and *clipped highlights* in others. In plain English, both terms mean that *highlights* — the brightest areas of the image — are so overexposed that areas that should include a variety of light shades are instead totally white. For example, in a cloud image, pixels that should be light to very light gray become white because of overexposure, resulting in a loss of detail in those clouds. On the flip side, a large mass of pixels at the left end of the histogram may indicate clipped shadows and a loss of detail in the darkest areas of the scene.

Reading an RGB histogram

When you view images in Overall display mode, you see two histograms: the brightness histogram, covered in the preceding section, and an RGB histogram. Figure 4-23 shows the RGB histogram for the flower photo shown in Figure 4-19.

Figure 4-23: The RGB histogram can indicate problems with color saturation and exposure.

To make sense of an RGB histogram, you first need to know that digital images are called *RGB images* because they're created out of three primary colors of light: red, green, and blue. Whereas the brightness histogram reflects the brightness of all three color components, or *channels,* RGB histograms enable you to view the values for each channel.

When you look at the brightness data for a channel, though, you're really evaluating color *saturation.* I don't have space in this book to provide a full lesson in RGB color theory, but the short story is that when you mix together red, green, and blue light and each component is at maximum brightness, you get white. Zero brightness in all three channels gives you black. But if you have maximum red and no blue or green, you have fully saturated red. If you mix together two channels at maximum brightness, you also get full saturation. For example, maximum red and blue produce fully saturated magenta. And wherever colors are fully saturated, you can lose picture detail. For example, a rose petal that should have a range of tones from partially saturated red to fully saturated red may instead be one flat blob of full-on red.

The upshot is that if all the pixels for one or two channels are slammed to the right end of the histogram, you may be losing picture detail due to overly saturated colors. If all three channels show a heavy pixel population at the right end of the histograms, you may have blown highlights — again, because when you have maximum red, green, and blue, you get white. Either way, you may want to adjust your exposure settings and try again.

A savvy RGB histogram reader can also spot color balance issues by looking at the pixel values. But frankly, color balance problems are fairly easy to notice just by looking at the image itself. And understanding how to translate the histogram data for this purpose requires more knowledge about RGB color theory than I have room to present in this book.

For information about manipulating color, see Chapter 7.

Histogram display

In this mode, you can get a larger, uncluttered look at the brightness histogram, as shown in Figure 4-24. See the earlier section "Interpreting a brightness histogram," in this chapter, to find out how to interpret what this display tells you.

In this view, you can get a slightly more detailed look at the distribution of pixels in the image than in the small display available in the Overall display

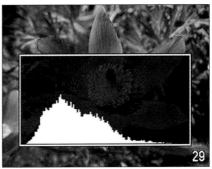

Figure 4-24: Histogram display mode gives you a better view of the brightness histogram.

mode. For that reason, I prefer this mode when I really want to evaluate the histogram.

Highlight and Shadow display

In Overall display mode (refer to Figure 4-19), areas that the camera thinks may be overexposed are replaced with blinking red pixels. Underexposed areas are indicated by blinking blue pixels. Highlight and Shadow display mode lets you see the same blinking alerts in full-frame view to get a better look at the problem areas. For example, Figure 4-25 shows you an image that contains both over-exposed and underexposed pixels.

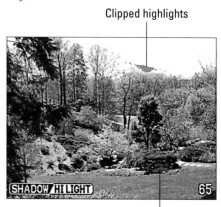

Clipped highlights

Clipped shadows

Figure 4-25: Blinking red areas indicate overexposure; blinking blue areas indicate underexposure.

If you read the section "Interpreting a brightness histogram" earlier in this chapter, you may recall that a fully white pixel has a brightness value of 255 and a black pixel has a value of 0. Normally, the camera reserves the blinking red warning for pixels that measure 255 on the brightness scale and flashes the blue warning only for pixels with a value of 0. But you can adjust this threshold so that the warning also appears for pixels that are almost black or almost white. This option is especially useful for photographer submitting pictures to publications that require images stay within a brightness spectrum that's a little narrower in range than the full 0 to 255 — 5 to 250, for example.

To adjust the warning threshold, summon Custom Menu D and then select Histogram Setting, as shown in Figure 4-26. Press OK to display the right screen in the figure. Press the left- or right-arrow key to highlight the value you want to change and then press the up- or down-arrow key to change the value. You can set the Highlight alert value as low as 245 and the Shadow alert value as high as 10.

One more comment on this feature: Just because you see the flashing alerts doesn't mean that you should adjust exposure — the decision depends on where the alerts occur and how the rest of the image is exposed. Consider the photo in Figure 4-25, for example. Yes, small white areas are in the sky, and a few black areas are in the shadowed areas of the tree and the ground. Yet exposure in the majority of the photo is fine. If you increased exposure to bring out the deepest shadows, more sky pixels would be blown out, as would some of the lighter areas of the foliage. Conversely, if you darkened

the exposure to eliminate blown pixels in the sky, you'd send more shadow pixels to black. In other words, sometimes you simply can't avoid a few clipped shadows or highlights when the scene includes a broad range of brightness values.

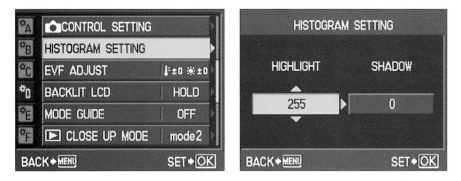

Figure 4-26: You can adjust the threshold at which the blinking highlight and shadow alerts appear.

Light Box display

When you're shooting in difficult lighting, it's a good idea to take several pictures of a subject, using different exposure settings for each, as I did when photographing the sundial images in Figure 4-27. That way, you make sure that you end up with at least one good exposure. I also try to take multiple shots of each subject when shooting portraits to up the odds that I'll get a picture in which the subject has a great expression and isn't blinking.

Figure 4-27: I shot these sundial images using different exposure settings to create two plays on the light and shadow in the scene.

During playback, you can compare the various shots of the subject by simply scrolling back and forth between them or checking them out in index display. But for an even better way to compare images, the E-PL1 offers Light Box display, which lets you inspect the details of two pictures side-by-side, as shown in Figure 4-28.

A couple reminders before I explain how to view the photos:

Figure 4-28: In Light Box display, you can compare two images side-by-side.

✔ This mode is hidden by default; see the section "Viewing Picture Data" for details on how to enable it.

✔ You can't enable this mode unless you switch the Close Up Mode setting on Custom Menu D from the default, Mode 1, to Mode 2. See the section "Zooming in for a closer view" to find out how to make this adjustment.

After taking these two setup steps, display and compare your pictures as follows:

1. **Set the camera to single-image playback mode and display one of the pictures you want to check.**

 To keep the upcoming steps a little clearer, I call this Picture A.

2. **Press the Info button to cycle through the display modes until you see a split-screen view, as shown in Figure 4-28.**

 How many times you need to press the Info button depends on how many display modes you enable. Each press cycles from one display mode to the next.

 Picture A appears in the left half of the frame. The photo taken immediately after — I call it Picture B — appears in the green frame on the right side of the monitor. Note that the frame number appears in the lower-right corner of each image (45 and 46, in the figure). The value in the lower-left corner of the monitor indicates the current magnification value (1x, or no magnification, in the figure).

3. **To display a different comparison photo, press the right- or left-arrow key to scroll through your pictures.**

 Just keep scrolling until the picture that you want to compare with Picture A appears in the Picture B frame.

Now that you have the basics down, try these other tricks:

🖉 **Compare magnified views of both images.** First, press the Zoom button. You see green navigation triangles appear on the right image. Now press Zoom again to display the navigation triangles on the left image as well, as shown in Figure 4-29. The second Zoom button press is critical; otherwise, only the comparison image gets magnified.

Next, press the Info button to activate the magnification value in the left corner of the screen, as shown in Figure 4-30. Press the up arrow to zoom in; press the down arrow to zoom out. Both images appear at the same magnification. Don't worry if the display doesn't show the area of the frames you want to inspect, you can scroll the display to view those areas later. For now, just press Info again to lock in the magnification value and return to the normal split-screen view and redisplay the navigation arrows. Now you can use the arrow keys to scroll both displays simultaneously to inspect details, as shown in Figure 4-31.

To return to normal side-by-side view, reset the magnification level to 1x and then press the Zoom button.

🖉 **Hide Picture A and compare Picture B with another photo.** If you think you like Picture B better than A, you can send A packing and then bring up another picture to compare with Picture B. To do so, press OK. Picture B scoots over to the left side of the frame, and Picture A slinks away in shame. You then see Picture B on both sides of the frame. Press the right or left arrows to scroll the right-side display to the other picture that you want to view.

Figure 4-29: Press the Zoom button twice to display the zoom navigation triangles on both frames.

Figure 4-30: Press Info and then use the up- and down-arrow keys to set the zoom level.

Figure 4-31: After you zoom, use the arrow keys to scroll both images simultaneously to check fine details.

Protecting Photos

You can safeguard pictures and movies from accidental erasure by giving them *protected status.* After you take this step, the camera doesn't allow you to delete a picture by using any of the image-erasing options explained earlier in this chapter.

Formatting your memory card, however, *does* erase even protected files. In addition, when you protect a picture or movie, it shows up as a read-only file when you transfer it to your computer. You still can edit the photo or movie, but you must save the edited file under a new name — you can't overwrite the original. You can unlock the files in the camera, if they're still on the memory card. Or you can ask a computer wiz to show you how to remove the protection using the computer's file-management tools (you can use Windows Explorer on a PC or Finder on a Mac to do the job).

Protecting a picture or movie file is easy. You can get the job done in two ways:

- **Protecting photos in single-image view:** Display the picture or movie you want to protect and press the Movie button, labeled in Figure 4-32.

 See the little key symbol above the button? That's your reminder that you use the button to lock a file as well as for its movie-recording functions. The same symbol appears on protected photos and movies during playback, as shown in Figure 4-32.

Protected icon Press to protect picture

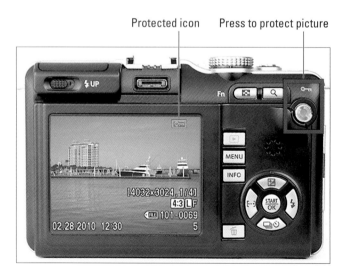

Figure 4-32: Press the Movie button to protect a file from accidental deletion.

✓ **Protecting files in thumbnails view:** Use this option to protect several files at once. Use the arrow keys to move the high-light box over the first image or movie you want to protect, and then press OK. A red check mark appears over the frame, as shown in Figure 4-33. Repeat the pro-cess to highlight and tag the rest of the files you want to protect. Then press the Movie button.

✓ **Remove protection:** To remove protection from a single file, dis-play it and press the Movie button. The key symbol disappears from the display. To unlock all files on your memory card, display the Playback menu and choose Reset Protect, as shown in Figure 4-34. Press OK, highlight Yes on the con-firmation screen that appears, and then press OK again.

Figure 4-33: In thumbnails view, select a file and press OK to tag it as one you want to protect.

Figure 4-34: You can unlock all protected files at once with Reset Protect.

Deleting Photos

You can erase pictures from a memory card when it's in your camera in three ways. Upcoming sections give you the lowdown. (Or is it the down low? I can't seem to keep up.)

First, though, the next section explains an option that enables you to tell the camera how to handle trash pickup when it encounters a pair of images that you shot using the dual-format Image Quality option (Raw+F/N or one of the other Raw/JPEG combos).

None of the delete methods described later erases protected pictures. If you want to erase a protected picture, either follow the steps outlined in the pre-ceding section to remove the protection or format the card, which wipes out all data on the card, including protected pictures. Chapter 1 shows you how to take that step.

Setting Raw+JPEG delete preferences

Chapter 2 discusses the Image Quality setting, which determines the picture resolution (pixel count) and the type of file the camera creates. You can

choose from two formats: JPEG (the default) or Raw. Or you can capture the image in both formats by selecting one of the Raw+JPEG settings, such as Raw+L/N.

During playback, you see the JPEG version of the photo. By default, if you delete the JPEG file, you also delete its Raw companion. If you prefer to delete just one or the other, head for Custom Menu H and select Raw+JPEG Erase, as shown in Figure 4-35. Press OK to display the available options. Select JPEG to delete only the JPEG copies of files; select Raw to dump only the Raw files. To return to the default, select Raw+JPEG.

No matter what setting you select in the menu, both files are deleted when you erase files using the All Erase or Erase Selected options. For details on these features, see the sections "Deleting all photos" and "Deleting a batch of selected photos," later in this chapter.

Figure 4-35: This option controls whether erasing a picture captured at one of the Raw+JPEG Image Quality settings deletes both files.

Deleting images one at a time

The Erase button is key to erasing single images. But the process varies a little depending on which playback display mode you're using, as follows:

- **Single-image view:** Press the Erase button.

- **Index view (displaying 4, 9, 25, or 100 thumbnails):** Use the arrow keys to move the highlight box over the picture you want to delete and then press the Erase button.

- **Calendar view:** Highlight the date on which you shot the photo and then press OK to view the first image from that day. Scroll to the picture you want to trash and then press the Erase button.

After you press the Erase button, you see a confirmation screen like the one shown in Figure 4-36. To move forward with deleting the picture, highlight Yes and then press OK.

Figure 4-36: The confirmation screen gives you a chance to reconsider deleting the photo.

Or, to cancel out of the process, press the Menu button, or select No and press OK.

Deleting all photos

You can use the following technique to quickly delete all photos on the current memory card. Note, though, that any photos that you protect are left alone. You can find out more about protecting photos earlier in this chapter.

1. **Open Shooting Menu 1 and choose Card Setup, as shown on the left in Figure 4-37.**

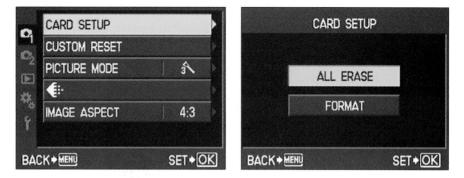

Figure 4-37: Use the All Erase option to quickly delete all photos (except protected ones).

2. **Press OK.**

 You see the right screen in Figure 4-37.

3. **Highlight All Erase and press OK.**

 A confirmation screen appears.

4. **Highlight Yes and press OK.**

Deleting a batch of selected photos

Here's a quick way to handle deleting chores when you want to erase several — but not all — pictures on the memory card:

1. **Display photos in index (thumbnails) mode.**

 Fn ▦ If you're currently looking at a single image, press the Fn button to switch to index mode. How many thumbnails appear depends on the thumbnails views you enable through Custom Menu D; by default, you see 25 thumbnails, as shown in Figure 4-38. (See the section "Viewing multiple images at a time," earlier in this chapter, to find out more about enabling other thumbnails views.)

 2. **Use the arrow keys to select the first image you want to delete.**

 Remember, the yellow box indicates the selected image.

 3. **Press OK.**

 A red check mark appears on the thumbnail, as shown in Figure 4-38.

 4. **Repeat Steps 2 and 3 to tag the remaining photos you want to erase.**

 5. **Press the Erase button.**

 You see the same confirmation screen that appears when you delete photos one by one.

 6. **Select Yes and press OK.**

 The tagged photos are zapped into oblivion; protected photos remain behind.

04.14.2010 10:42 37

Figure 4-38: In thumbnails view, highlight a picture and press OK to mark it as ready for the digital dumpster.

Playing Movies

In playback mode, movie files appear surrounded by a frame that's designed to resemble the sprocket holes in traditional movie film, as shown in Figure 4-39. The thumbnail shows you the first frame of your movie.

Sound recorded

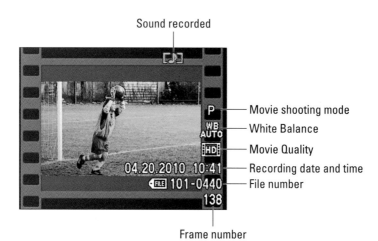

Movie shooting mode
White Balance
Movie Quality
Recording date and time
File number

Frame number

Figure 4-39: The sprocket holes indicate that you're looking at the first frame of a movie file.

By default, you also see the recording data labeled in the figure when you're viewing files in full-frame mode. (The frame number in the lower-right corner indicates the number of the movie file with respect to all files on the card, as with still picture playback, and not the number of an individual frame in the movie.) To hide the data, press the Info button. For movie files, you can choose from only these two playback displays.

Whether you're using single-frame or thumbnails view, you also see the little key symbol if you used the Protect feature to prevent the file from being erased. A movie-camera symbol also appears atop the movie thumbnail in thumbnails view.

To play a movie, display it in single-frame view. You can then control playback as follows:

- **Start playback:** Press OK to shift to the display you see on the left in Figure 4-40. Select Movie Play and then press OK again. (The other option is related to playing slide shows, a feature that you can explore in the next section.)

 When the movie begins, a little bit of data appears at the bottom of the screen, as shown on the right in Figure 4-41. The numbers in the lower-right corner indicate the elapsed time. The other symbols relate to the playback functions described next. These symbols change depending on whether you're playing movies on the camera or have it connected to a TV for playback. When you play movies on the camera, you see a volume-control symbol in the lower-right corner instead of the symbols shown in the figure.

 Either way, the symbols disappear after a few seconds of playback but reappear when you perform any playback functions.

- **Pause playback:** Press OK. Press OK again to resume playback.

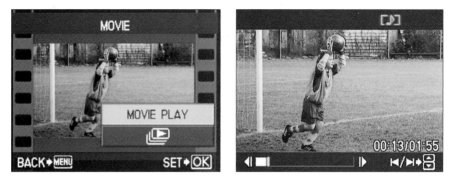

Figure 4-40: Select Movie Play and press OK to start viewing your movie.

Figure 4-41: This menu option sets the initial playback volume.

- **Advance frame by frame when playback is paused:** Press the right-arrow key to go forward one frame; press the left-arrow key to go backward one frame. Press and hold the keys to advance or rewind through additional frames.

- **Jump to the first or last frame when playback is paused:** Press the up-arrow key to jump to the first frame; press the down-arrow key to go to the last frame.

- **Fast-forward or fast-rewind during playback:** Press and hold the right-arrow key to fast-forward; press the left-arrow key to rewind.

- **Adjust sound volume:** During playback, press the up- or down-arrow keys to adjust the speaker volume. Again, this applies only if you're viewing movies on the camera; if the camera is connected to a TV, use the TV volume control.

You can also adjust the camera's speaker volume any time you're viewing photos in single-image view. Just press the up- or down-arrow key to display the little volume control and then press up or down to set the level. This option is designed for pictures that you annotate with a voice recording, a feature covered in Chapter 9.

To set the initial playback volume, open Custom Menu D and scroll to the final screen of the menu to highlight Volume, as shown on the left in Figure 4-41. Press OK to display the volume scale, as shown on the right in the figure, and then use the up or down keys to adjust the setting. Press OK to exit the menu. If you adjust volume during playback, the camera automatically sets the menu option to the new volume setting.

To find out how to connect the camera to a TV for playback, see "Viewing Your Photos on a Television," later in this chapter.

Creating an In-Camera Slide Show

Many photo-browsing and photo-editing programs offer a tool for creating digital slide shows that can be viewed on a computer or (if copied to DVD) on a DVD player. You can even add music, special transition effects, and the like to jazz up your presentations.

If you just want a simple slide show — that is, one that just displays all the photos on the camera memory card one-by-one — you don't need a computer at all, though. You can create and run the slide show right on your camera. And, by connecting your camera to a television, as outlined in the next section, you can present your show to a roomful of people.

You can access the Slide Show feature in two ways:

↳ Display the Playback menu and select the slide show icon, as shown on the left in Figure 4-42, and press OK.

↳ Set the camera to playback mode and press OK. You then see the menu shown on the right in the figure (or a variation of it, depending on whether you captured the picture in the JPEG, Raw, or JPEG+Raw format or are looking at a movie file). Again, select the slide show icon and press OK.

Slide show icon

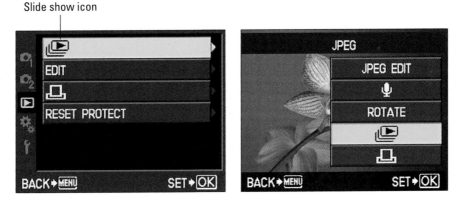

Figure 4-42: You can access the Slide Show feature from the Playback menu (left) or by pressing OK after displaying a picture in full-screen view (right).

On the next screen, as shown in Figure 4-43, you can set up your show. One by one, set your preferences for each of the following options:

✔ **BGM (Background Music):** You can choose from three musical accompaniments, Melancholy, for sad pictures; Joy, for happy pictures; and Cool, for hip pictures. I have to say, though, that Melancholy doesn't sound all that morose to me, and Joy doesn't sound that ecstatic — I guess music is in the ear of the beholder. Cool delivers a jazz sound so that label depends on your definition of the word Cool. As you choose each option, the camera plays a clip of the audio so you can come to your own

Figure 4-43: Set your slide show preferences and then select Start and press OK to begin playback.

conclusions. Choose Off if you don't want any music played with the show.

✔ **Slide:** Through this option, you tell the camera to include just still pictures, just movies, or both in the show.

✔ **Slide Interval:** This option affects display time for still pictures. By default, photos are displayed for three seconds, but you can choose any interval from 2 to 10 seconds.

✔ **Movie Interval:** To play movies in their entirety, select Full for this option. If you select Short, only the opening frames of each movie play.

After setting up your show, use these button-pushing techniques to control playback:

✔ **Start the show:** On the menu shown in Figure 4-43, select Start and press OK.

✔ **Adjust volume:** If you're viewing the show on the camera monitor, press the up- or down-arrow key to display two volume controls. The vertical meter controls the overall volume of the show. Above that meter is another control, marked with a little musical note, which adjusts the volume of the background music with respect to movie sound or audio clips that you add to still photos. (Chapter 9 explains that feature.)

Press the up- or down-arrow key to adjust overall volume; press the right- or left-arrow key to adjust the background music only.

If you connect your camera to a TV for playback, you control the overall volume using your TV remote, but you still adjust the balance of the background music and the movie or picture audio using the arrow keys on the camera.

✔ **Stop the show:** Press OK.

Viewing Your Photos on a Television

Your camera is equipped with a feature that allows you to play your pictures and movies on a television screen. In fact, you have three playback options:

- **Regular video playback:** Haven't made the leap yet to HDTV (high-definition television)? No worries: The camera can send a standard-definition audio and video signal to the TV. In fact, the cable you need to connect the two devices is included in the camera box. Look for the cable that has a yellow plug and a white plug at one end. The yellow plug carries the video signal; the white plug, the audio signal.

- **HDTV playback:** If you have an HDTV, you can set the camera to high-def playback. However, you need to purchase an HDMI (High-Definition Multimedia Interface) mini-cable to connect the camera and television.

- **For HDMI CEC TV sets:** If your television is compatible with HDMI CEC (Consumer Electronic Control), you can use the TV's remote control to rule your playback operations.

Before connecting the camera to the TV, check the Video Out option and, for HD playback, the HDMI option on Custom Menu D, as shown in Figure 4-44. The options offer the following settings:

Menu		
A	HDMI	
B	VIDEO OUT	NTSC
C	SLEEP	1MIN
D	LIVE VIEW BOOST	OFF
E	☺ FACE DETECT	OFF
F	▦/INFO SETTING	
BACK➔MENU		SET➔OK

HDMI	
HDMI OUT	1080i
HDMI CONTROL	OFF
BACK➔MENU ▤✦▯	SET➔OK

Figure 4-44: Set the HD playback and video mode options through Custom Menu D.

- **HDMI:** For HD playback, select this option and press OK to display the options shown on the right in Figure 4-44:

 - *HDMI Out:* Controls the resolution of the video signal; you can choose from 1080i, 720p, or 480p/576p. (Check your TV manual to find out the correct setting.)

 - *HDMI Control:* When set to On, this enables you to control playback by using the TV remote control — again, only if the TV is compatible with HDMI CEC.

⊭ **Video Out:** This option controls the format of the video signal. You have just two options: NTSC and PAL. Select the video mode used by your part of the world. (In the United States, Canada, and Mexico, NTSC is the standard.) If you select PAL, the 480p HDMI option isn't available; the camera sets the signal to 576p if you choose the 480p/576p HDMI option.

With the right cable in hand and the camera turned off, open the little rubber door on the right side of the camera. There you find two *ports* (connection slots): the top port is a dual-purpose port for connecting the camera to a computer through a USB connection, as explained in Chapter 5, and for sending a standard audio/video (A/V) signal. The lower port is used for the HDMI connection. Figure 4-45 labels the two ports.

For A/V playback, put the yellow plug into your TV's video jack and the white one into your audio jack. For HDMI playback, a single plug goes to the TV.

At this point, I need to point you to your specific TV manual to find out exactly which jacks to use to connect your camera. You also need to consult your manual to find out which channel to select for playback of signals from auxiliary input devices.

After you sort out that issue, turn on your camera to send the signal to the TV set. You can control playback using the same camera controls as you normally do to view pictures on your camera monitor. You can also run a slide show by following the steps outlined in the preceding section. And, if you have that latest and greatest HDMI CEC capability, you can relax, using your TV's remote to direct the show.

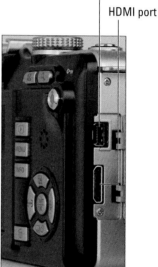

USB/AV port

HDMI port

Figure 4-45: You can connect your camera to a television, VCR, or DVD player.

Downloading, Printing, and Sharing Your Photos

For many novice digital photographers, the task of moving pictures to the computer is one of the more confusing aspects of the art form. Unfortunately, providing you with detailed downloading instructions is impossible because the steps vary widely depending on which computer software you use to do the job.

To give you as much help as possible, however, this chapter starts with a quick review of photo soft-ware, in case you aren't happy with your current solution. Following that, you can find information about downloading images, converting pictures that you shoot in the Raw (ORF; Olympus Raw Format) format to a standard format, and preparing your pictures for print and e-mail.

Choosing the Right Photo Software

Programs for downloading, archiving, and editing digital photos abound, ranging from entry-level software designed for beginners to high-end options geared to professionals. The good news is that if you don't need serious photo-editing capabilities, you can find free programs that should provide all the basic tools you require, including two offerings from Olympus. The next

two sections offer a look at the Olympus programs along with two other free-bies; following that, I offer some advice on four popular programs to consider whether the free options don't meet your needs.

Four free photo programs

If you don't plan on doing a lot of retouching or other manipulation of your photos but simply want a tool for downloading, organizing, printing, and sharing photos online, one of the following four free programs may be a good solution:

✓ **Olympus [ib] (Windows only):** This program is on the CD that shipped in your camera box. *ib* stands for *image browser,* in case you're wondering. And as the name implies, the program provides a simple photo organizer and viewer, as shown in Figure 5-1, plus a few basic photo-editing features, including red-eye removal and exposure and color adjustment filters. You also can use the program to download pictures and to convert Raw files to a standard format. (See Chapter 2 for an explanation of file formats.)

Figure 5-1: Olympus [ib] offers a basic photo viewer and some limited editing functions for Windows users.

✔ **Olympus Master 2 (Windows and Mac):** Olympus provides this program
free via download from its Web site (www.olympus.com). Olympus
Master 2 provides a more sophisticated interface, as shown in Figure 5-2,
plus a larger assortment of editing tools.

Metadata

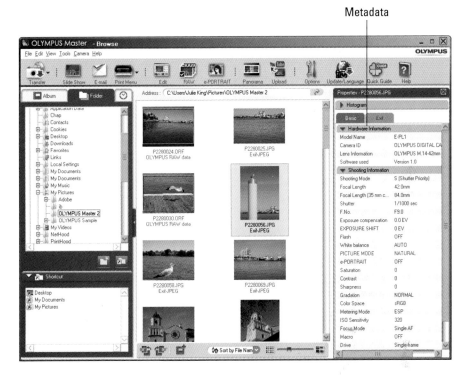

Figure 5-2: Olympus Master 2, also free, provides a more advanced option for both Windows
and Mac users.

In both programs, you can view camera *metadata* — the data that
records the camera settings you used to take the picture, as follows:

- *Olympus [ib]:* Right-click a picture thumbnail and choose File⮫
 Display Media File Information to display a metadata window. You
 must close the metadata window and then repeat the process to
 view data for another image.

- *Olympus Master 2:* Choose View⮫Properties to display the meta-
 data in the right side of the program window, as shown in Figure 5-2.

Many other photo programs also can display camera metadata, but some-
times can't display data that's very camera-specific, such as the Picture
Mode. Every camera manufacturer records metadata differently, so it's a
little difficult for software companies to keep up with each new model.

✓ **Apple iPhoto:** Most Mac users are very familiar with this photo browser, built into the Mac operating system. Apple provides some great tutorials on using iPhoto at its Web site (www.apple.com) to help you get started if you're new to the program.

✓ **Windows Photo Gallery:** Some versions of Microsoft Windows also offer a free photo downloader and browser — in Windows 7 and Vista, it's called Windows Photo Gallery.

Only Olympus Master 2 can display all the photo files on your computer right away. With the other three programs, you must ask the software to search for and catalog your photos. However, if you use the program to handle the picture downloads, it catalogs pictures as part of the process. Check the program's Help system for details on taking the cataloging step and setting up the program as the default download tool.

One other important note: As of press time, Olympus just announced a new browser, Olympus Viewer, available for both Mac and Windows users. You can download a free copy from the Olympus Web site. Also know that other free programs are available online, so if none of these suits you, you have other options.

Four advanced photo-editing programs

Any of the programs mentioned in the preceding section can handle simple photo downloading and organizing tasks. But if you're interested in serious photo retouching or digital-imaging artistry, you need to step up to a full-fledged photo-editing program.

As with software in the free category, you have many choices; the following list describes just the four that are most widely known.

✓ **Adobe Photoshop Elements (www.adobe.com, about $100):** Elements has been the best-selling consumer-level photo-editing program for some time, and for good reason. With a full complement of retouching tools, onscreen guidance for beginners, and an assortment of templates for creating photo projects such as scrapbooks, Elements offers all the features that most consumers need. Figure 5-3 offers a look at the Elements editing window.

✓ **Apple Aperture (www.apple.com, about $200):** Aperture is geared more to shooters that need to organize and process lots of images but typically do only light retouching work — wedding photographers and school-portrait photographers, for example.

✔ **Adobe Photoshop Lightroom (www.adobe.com, about $300):** Lightroom is the Adobe counterpart to Aperture, although in its latest version, it offers some fairly powerful retouching tools as well. Many pro photographers rely on this program or Aperture for all their work, in fact.

✔ **Adobe Photoshop (www.adobe.com, about $700):** This program is for serious image editors only, not just because of its price but because it doesn't provide the type of onscreen help that you get with an entry-level editor, such as Elements. As you can see from Figure 5-4, which shows the Photoshop editing window, this isn't a program for the easily intimidated. Photoshop also doesn't include the creative templates and other photo-crafting tools that you find in Elements. What you get instead are the industry's most powerful, sophisticated retouching tools, including tools for producing HDR (high dynamic range) and 3D images.

Not sure which tool you need, if any? Good news: You can download 30-day free trials of all these programs from the manufacturers' Web sites.

Figure 5-3: Adobe Photoshop Elements offers excellent retouching tools plus templates for creating scrapbooks, greeting cards, and other photo gifts.

Figure 5-4: Adobe Photoshop is geared toward pros and heavy-duty photo-editing enthusiasts.

Sending Pictures to the Computer

Whatever photo software you choose, you can take two approaches to downloading images to your computer: Connect the camera directly to the computer, using the USB cable that came in your camera box, or use a memory-card reader. With a card reader, you simply pop the memory card out of your camera and into the card reader instead of hooking the camera to the computer. Many computers and printers now have card readers, and you also can buy standalone readers for under $30. **Note:** If you're using the new SDHC (Secure Digital High Capacity) cards, the reader must specifically support that type.

Using a card reader offers one important advantage: You don't waste camera battery power. For camera transfers, the camera must be powered up during the entire download process.

If you do want to transfer directly from the camera, the next section explains some important steps you need to take to make that option work. If you choose to use a card reader, skip ahead to "Starting the transfer process," in this chapter.

Connecting your camera to a computer

To download pictures directly from the camera to the computer, you need to dig out the USB cable that came in the camera box. This cable has a regular USB plug like the one shown on the left in Figure 5-5 and a tiny, camera-specific plug at the other. The smaller plug on the cable goes into the camera's USB/AV port, as shown on the right in the figure.

USB port USB/AV port

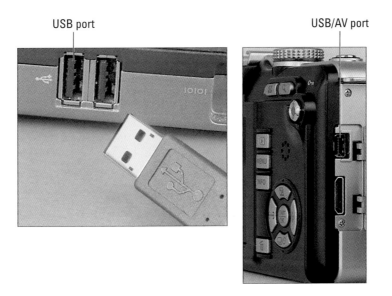

Figure 5-5: Connect the camera to the computer with the supplied USB cable.

For direct camera-to-computer downloading to work, your computer must run one of the following operating systems:

- **Microsoft Windows:** Windows 7, Windows Vista, Windows XP Home or Professional, or Windows 2000 Professional
- **Mac:** Mac OS X 10.3 or later

If you use another *OS* (*operating system,* in case you're a nongeek), check the support pages on the Olympus Web site (www.olympus.com) for the latest news about updates to system compatibility. You can always simply transfer images with a card reader, too.

The camera offers two USB *protocols* (communication methods): MTP (Media Transfer Protocol) or Storage. Most operating systems and download programs are geared to the Storage option. However, if you want to download using Microsoft Photo Gallery in Windows Vista, Olympus recommends the MTP option. By default, the camera is set to suss out the correct setting but

then display a confirmation screen to get your approval. After you connect the camera to the computer, the camera monitor displays a menu showing both options — the correct one should be displayed — and then you must press OK to move forward.

However, this behavior depends on the setting of the USB Mode option on Custom Menu D, as shown in Figure 5-6. By default, the option is set to Auto, as shown in the figure, and things work as just described. But if you always want to use one protocol, you can change the setting from Auto to either Storage or MTP. Then the camera and computer will start talking automatically, and you don't have to take the step of verifying the protocol selection and pressing OK. Just remember that you took this step: Otherwise, you can't transfer pictures onto a computer that doesn't use the protocol you selected.

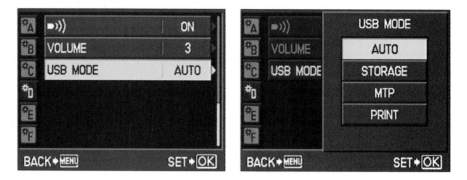

Figure 5-6: At the Auto setting, the camera displays a screen asking you to confirm its choice of USB mode after you connect it to a computer.

With that preamble out of the way, the next steps show you how to get your camera to talk to your computer:

1. **Assess the level of the camera battery.**

 If the battery is low, charge it before continuing. Running out of battery power during the transfer process can cause problems, including lost picture data.

2. **If your computer isn't already on, turn it on and give it time to finish its normal startup routine.**

3. **Turn off the camera.**

4. **Open the port cover on the right side of the camera and insert the smaller of the two plugs on the USB cable into the USB/AV port.**

 It's the top port on the right side of the camera, as shown in Figure 5-5.

5. **Plug the other end of the cable into the computer's USB port.**

Plug the cable into a port that's built into the computer, as opposed to one that's on your keyboard or part of an external USB hub. Those accessory-type connections can sometimes foul up the transfer process.

When you connect the two devices, the camera automatically turns on. If you chose the Auto setting for the USB Mode option on Custom Menu D, you see a menu asking you to verify the selected transfer mode — MTP or Storage. Press OK to go forward. If you set the USB Mode option to a specific protocol, the camera bypasses the menu display, and you don't have to press any other buttons.

Move to the next section for help with the process of transferring images after your camera and computer are communicating.

After you finish downloading, tell the computer that you're ready to disconnect the camera. In Windows, use the Safely Remove Hardware feature (the exact process varies depending on your version of Windows, so check the Windows Help system if you have problems). On a Mac, drag the camera drive icon to the Trash. Then remove the USB plug from the camera. The camera turns off automatically.

Starting the transfer process

After you connect the camera to the computer or insert a memory card into a card reader, your next step depends on the software installed on your computer.

Here are the most common possibilities and how to move forward:

Figure 5-7: Windows may display this initial boxful of transfer options.

- **On a Windows-based computer, a Windows dialog box (like the one shown in Figure 5-7) appears.** (The figure features the Windows 7 version of the dialog box.) This dialog box suggests different programs you can use to download picture files. Which programs appear depends on what you have installed on your system. To proceed, click the transfer program you want to use. (In older versions of Windows, you may need to click OK as well.)

- **An installed photo program automatically displays a photo-download utility.** For example, on a Mac computer, the iPhoto downloader may leap to the forefront. Usually, the downloader that appears is associated with the software you most recently installed.

If you don't want a program's auto downloader to launch whenever you insert a memory card or connect your camera, you can turn off that feature. Check the software manual to find out how to disable the auto launch and how to use other downloading features.

✔ **Nothing happens.** Don't panic; all is probably well. Someone — maybe even you — simply may have disabled all automatic downloaders on your system. Just launch your photo software and then transfer your pictures using whichever command starts that process.

In Olympus [ib], for example, choose File⇨Transfer Images from Camera; in Olympus Master 2, choose File⇨Transfer Images⇨Transfer Images from Camera. The [ib] downloader automatically transfers all pictures on the camera that haven't already been downloaded, but the Olympus Master 2 downloader lets you view image thumbnails and choose the ones you want to transfer.

Another option is to use Windows Explorer or Mac Finder to drag and drop files from your memory card to your computer's hard drive. The process is exactly the same as when you move any other file from a CD, DVD, or another storage device onto your hard drive — the computer sees the camera or memory card as just another drive on the system.

Again, I can't give step-by-step instructions for using all the various photo downloaders that may be sprinkled over your hard drive. So if you feel lost and don't have a computer-savvy friend to help you, open the program's Help system, typically found under the Help menu. (For some Help systems, you must have an active internet connection because the Help files are actually stored online.)

Processing Raw (ORF) Files

Chapter 2 introduces you to the Raw file format, which enables you to capture images as raw data. One advantage of capturing Raw files, named ORF files on Olympus cameras, is that *you* make the decisions about how to translate raw data into actual photographs. You can specify attributes such as color intensity, image sharpening, and contrast — which are all handled automatically by the camera if you use its other file format, JPEG.

The bad news: You have to specify attributes, such as color intensity, image sharpening, and contrast, before you can do anything with your pictures. Although you can print them immediately if you use the Olympus software, you can't take them to a photo lab for printing, share them online, or edit them in your photo software until you process them using a tool known as a *raw converter.* At the end of the process, you save the finished file in a standard file format, such as JPEG or TIFF.

If you decide to shoot in the Raw format, you can process your images by using either of the free Olympus programs, [ib] (Windows only) or Olympus

Master 2 (Windows and Mac), or doing a simple conversion using the Raw Data Edit option in the camera. Although I don't have room in this book to provide complete step-by-step instructions for software Raw conversions, the next sections provide a quick overview to the [ib] and Olympus Master 2 processes to get you started. Following that, you can find details on doing in-camera Raw conversions.

Processing Raw images in Olympus [ib]

To start the Raw conversion process in Olympus [ib] (Windows only), click a Raw image thumbnail and choose Edit⇨Open Raw Development Window. The development window appears, as shown in Figure 5-8. You can access the Raw processing tools either from the Image menu or by clicking the icons along the bottom of the window. Don't overlook the tiny triangle at the end of the row of icons, labeled in the figure: Clicking the triangle displays a pop-up menu that enables you to open two editing panels, Basic Settings and Camera Settings, as shown side-by-side in Figure 5-9. (Again, you also can open the panels from the Image menu.)

Click to display settings palette

Figure 5-8: Click this arrow in the Raw Development window to access the Raw-processing palettes.

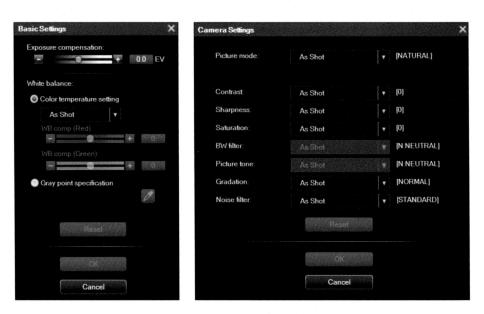

Figure 5-9: Controls found on the Basic Settings palette (left) and the Camera Settings palette (right).

A couple other tips about the processing options:

- **Art Filter:** By clicking the Art Filter icon, you can display a palette that lets you apply any art filter except the Gentle Sepia filter to the image. (See Chapter 9 for a look at the filters.) The program's regular editing window contains a sepia-effect filter, though, so you can apply it to the processed image after you save the file if you want.

- **Distortion:** The Distortion icon opens a palette that contains tools designed to automatically adjust the image to compensate for image distortion that can occur with some lenses, especially wide-angle lenses. If you use an Olympus Micro Four Thirds lens, you can set the tool to Auto mode, and the program uses data about the lens to correct the image automatically. Or you can select Manual mode and adjust the image by dragging a slider.

After adjusting the image, choose File➪Export to display the Export Image dialog box, as shown in Figure 5-10. Pay attention to the following settings:

- **Export To:** Use the folder area at the top of the window to choose the folder where you want to store your processed copy of the Raw file. Click the Browse button to display a complete folder list if you don't see the one you want to use in the display area.

- **File Name:** By default, the processed file is given the same name as the original, but you can rename the file if you prefer. Don't worry that keeping the original filename will overwrite the original picture, though — you're

saving the image in a new file format, so even if you keep the same file-name, your original Raw file is retained.

✔ **Format:** You can choose from TIFF, JPEG, or BMP. As Chapter 2 explains, JPEG is a *lossy format* — it dumps some image data to create smaller file sizes. So if you want your processed file to have the highest image quality, choose TIFF (*Tagged Image File Format,* pronounced *tiff,* as in little spat). TIFF is a *lossless* format — it retains all the original picture data. TIFF is also the standard format for professional print production, and most publishing and word processing programs can accept TIFF files. The other lossless format, BMP (Windows bitmap), is an older format that's rarely used today; in other words, ignore it.

Figure 5-10: To retain the original image quality, select TIFF as the file format.

For the JPEG and TIFF formats, the Format menu offers a couple variations, as follows:

- *JPEG or EXIF-JPEG:* With EXIF-JPEG, the file retains the image metadata (camera-settings information). With regular JPEG, the metadata isn't included in the file.

In case you're curious, EXIF stands for Exchangeable Image File Format, which is the standard specification for storing extra data in a picture file. Wonks r' us, yes indeed.

Retaining the metadata creates a slightly larger file, but it enables you to view the picture information without referring to the original Raw file. Perhaps most important is retaining the original shooting date so that you can find the file easily by running a file-search based on the date. If you strip the metadata, the software records the date on which you do the Raw processing as the file date.

- *TIFF or EXIF-TIFF:* You get the same two options for TIFF — one with and one without metadata.

- *TIFF 16-bit or EXIX-TIFF 16-bit:* A *bit* is a unit of computer data; the more bits you have, the more colors your image can contain. The number of bits in an image is its *bit depth.*

The standard TIFF format creates an 8-bit file, whereas this setting produces a 16-bit file. (Technically, you get 8 bits for each color channel — red, green, and blue — for a total of 24 bits, or 16 bits per channel for a total of 48 bits. But many programs, including [ib], indicate bit depth on a bits-per-channel basis.)

On the plus side, choosing one of the 16-bit TIFF options means that you retain all the bits in your Raw file, which contains 12 bits per channel (or a total of 36 bits). On the down side, many photo-editing programs can't open these so-called *high bit-depth* files, or else they limit you to a few editing tools. So stick with standard, 8-bit TIFF unless you know that your software can handle the higher bit depth.

- ✔ **Resize:** If you want to dump some pixels from the original, use this feature to set the new pixel dimensions.

- ✔ **Crop Using Aspect Ratio Information:** If you captured the Raw image using any aspect ratio except the default, 4:3, select this check box to automatically crop the processed file to that aspect ratio (3:2, 16:9, or 6:6). But you have a lot more cropping flexibility if you save the processed file at the original 4:3 proportions and then crop in your photo editor. When you crop using the dialog box option, you can't specify which part of the image you want to retain or how much of the photo you want to keep. The software just sets the crop boundary to retain as much of the original photo as will fit the new aspect ratio.

Click the Export button when you finish setting all the dialog box options. The program makes a copy of your Raw original using the specifications you selected.

Processing Raw images in Olympus Master 2

In Olympus Master 2, the steps for processing a Raw file are pretty much the same as outlined for Olympus [ib], in the preceding section. Start by clicking a thumbnail and choosing Edit⇨Open Raw Development Window. You then see the window shown in Figure 5-11.

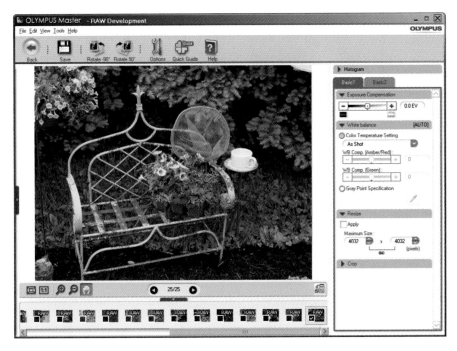

Figure 5-11: Olympus Master 2 offers similar Raw processing options as Olympus [ib], but in a different layout.

The Raw processing controls are grouped into two panels on the right side of the screen, Basic 1 and Basic 2, both shown in Figure 5-11. The controls are essentially the same as are found in the [ib] software, but in Olympus Master 2, you set the dimensions of the processed file on the Basic 1 tab instead of the file-saving dialog box as in [ib].

After you adjust settings, choose File⇨Develop and Save. You see the dialog box shown in Figure 5-12. Select a storage location for the processed file from the folder area at the top of the window. If you want to give the file a name different from the original Raw file, enter it into the File Name box.

Figure 5-12: The Resolution value affects only the default print resolution; you can always change that value later.

As for file format, you get the same options as in [ib] except the choice to create 16-bit TIFF files. To avoid repeating all the format information, I refer you to the bulleted list in the preceding section.

The final option, Resolution, *does not* adjust the pixel count of your image, as you might imagine. The option sets only the default output resolution that will be used if you send the photo to a printer. Most photo-editing programs enable you to adjust this value before printing, however, or automatically set the resolution based on the print size you select. In other words, you can ignore this option unless you have some specific need for setting output resolution of the file.

Click the Save button to wrap up the Raw processing process.

Processing Raw images in the camera

For the quickest, most convenient Raw processing, you can do the job before you download images, by using the Raw Data Edit function in the camera — no computer or other software required.

Before I spell out the specifics, I want to share two reservations:

✔ **You can save processed files only in the JPEG format.** As discussed in Chapter 2, that format results in some quality loss because of the file compression that JPEG applies. You determine the level of JPEG compression applied to the processed file by setting the Image Quality option to Super Fine, Fine, Normal, or Basic before you choose the Raw Data Edit menu option.

Chapter 2 details the JPEG options, but, long story short, choose Super Fine for the best JPEG quality. And if you want to produce the absolute best quality from your Raw images, use a software solution and save your processed file in the TIFF format instead.

✔ **Files are processed according to the current picture settings.** When you convert Raw files using computer software, you can control such picture characteristics as exposure, white balance, and Picture Mode. But for in-camera processing, the JPEG file is created using whatever picture settings are currently in force. That means that you must set all the picture characteristics *before* you start the process of creating your JPEG copy. You don't have a chance to alter the settings after you put in your request for the Raw conversion.

In short, consider in-camera Raw processing only as a solution for times when you need JPEG copies of your Raw images for immediate online sharing. (JPEG is the standard format for online use.) Otherwise, do the job after downloading, using your photo software. Not only do you have more control over the final image, but it's easier to evaluate the results on a large monitor than on the smaller camera screen.

When you do need to use the in-camera processor, follow these steps:

1. **Set the camera to shooting mode and select the picture options you want applied to your Raw file.**

 The following settings affect the processing of the file:

 • *Image Quality:* Your choice determines both the resolution of the JPEG copy and the amount of JPEG compression applied. Chapter 2 has details.

 • *Picture Mode and White Balance:* These affect image color, sharpness, saturation, and gradation (exposure adjustment). Chapter 6 has details.

 • *Image Aspect (4:3, 3:2, 16:9, or 6:6):* Unless you select 4:3, the Raw photo will be cropped to match the aspect ratio you choose. Chapter 2 explains this setting as well.

 You can't manipulate the exposure or focus of the image, which are determined by the Raw original. (If you need to tweak exposure, use your photo software for this task.) However, after you create the JPEG copy, you can use the JPEG Edit options outlined in Chapter 9 to tweak the picture a little.

2. **Press the Playback button to shift to playback mode.**

3. **Display the Raw photo in full-frame display.**

 Chapter 4 explains playback options.

4. **Press OK.**

 You see a menu similar to the one shown in Figure 5-13.

5. **Choose Raw Data Edit and press OK.**

Figure 5-13: Select Raw Data Edit and press OK to create a JPEG copy of a Raw original.

 A progress bar appears on the monitor as the camera creates your JPEG copy. The finished image then appears on the monitor.

The camera assigns the JPEG copy a filename automatically, and the file number isn't the same as the Raw original. (The camera just uses the next available file number.) So if you need to link your Raw and JPEG versions later, make note of their respective file numbers.

Planning for Perfect Prints

Images from your E-PL1 can produce dynamic prints, and getting those prints made is easy and economical, thanks to an abundance of digital printing services in stores and online. For home printing, today's printers are better and less expensive than ever, too.

That said, getting the best prints from your picture files requires a little bit of knowledge and prep work on your part, whether you decide to do the job yourself or use a retail lab. To that end, the next three sections offer tips to help you avoid the most common causes of printing problems.

Allow for different print proportions

At the default Image Aspect setting, the E-PL1 produces images that have a 4:3 aspect ratio, which matches the proportions of a standard computer monitor or television (that is, not a wide-screen model).

To print your photo at traditional sizes — 4 x 6, 5 x 7, 8 x 10, and so on — you need to crop the photo to match those proportions. Alternatively, you can reduce the photo size slightly and leave an empty margin along the edges of the print as needed. As a point of reference, Figure 5-14 shows you how much of a 4:3 original can fit within a 4-x-6- and 5-x-7-inch frame. The entire width of the photo is retained at those print sizes, but not the entire height. Note that

the same type of cropping is necessary when you shoot cameras that create 3:2 digital originals (35mm film cameras and some digital cameras) if you print at any frame size other than 4 x 6.

4 x 6 crop height 5 x 7 crop height

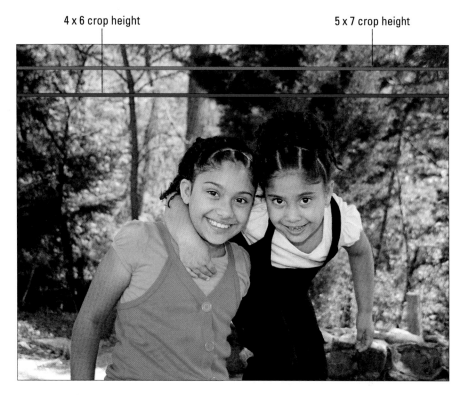

Figure 5-14: Compose shots with a little head room so you can crop to different frame sizes.

Depending on the aspect ratio of the print you want to make, you may be able to crop right in the camera. You can create a copy of your original image at an aspect ratio of 3:2 (to fit a 4-x-6-inch print), 16:9 (for display on a wide-screen monitor or TV), or 6:6 (for a square frame). Use either of these options:

 ✔ **Select the aspect ratio before you shoot.** Chapter 2 explains how to choose this setting. Pictures that you capture in the JPEG format are cropped automatically as the image is saved to the memory card. For pictures taken in the Raw format, the aspect ratio information is embedded in the picture file. If you then use the Raw Data Edit feature to create a JPEG copy of the image, the camera applies the crop to make the copy. (See the earlier section "Processing Raw images in the camera," in this chapter, for details.

✔ **Use the Aspect Ratio option on the JPEG Edit menu.** Chapter 9 shows you how to use this feature to create a copy of your original 4:3 JPEG image at one of the other three aspect ratios.

Most photo programs, including the free Olympus offerings, provide cropping tools as well and normally let you crop to any aspect ratio. You also can usually crop pictures using the software provided at online printing sites and at retail print kiosks. If you plan to simply drop off your memory card for printing at a lab, find out whether the printer automatically crops the image without your input. If so, crop the photo yourself, save the cropped image to your memory card, and deliver that version of the file to the printer.

To allow yourself some printing flexibility, leave at least a little margin of background around your subject when you shoot (refer to Figure 5-14). That way, you don't clip off the edges of the subject, no matter what print size you choose. (Some people refer to this margin padding as *head room*, especially when describing portrait composition.)

Check the pixel count before you print

Resolution — the number of pixels in your digital image — plays a huge role in how large you can print your photos and still maintain good picture quality. You can get the complete story on resolution in Chapter 2, but here's a quick recap as it relates to printing:

✔ **Choose the right resolution before you shoot:** Set resolution via the Image Quality option, accessible via the Live Control and Super Control Panels as well as Shooting Menu 1.

You must set the resolution *before* you capture an image, which means that you need some idea of the ultimate print size before you shoot. When you do the resolution math, take any cropping you plan to do into account.

✔ **Aim for a minimum of 200 pixels per inch (ppi):** Depending on your printer, you may get acceptable results even at a lower resolution. On the other hand, some printers do their best work when fed 300 ppi, and a few request 360 ppi as the optimum resolution. However, using a resolution higher than that typically doesn't produce any better prints.

Unfortunately, because most printer manuals don't bother to tell you what image resolution produces the best results, finding the right pixel level is a matter of experimentation. (Don't confuse *ppi* with the manual's statements related to the printer's dpi. *Dots per inch (dpi)* refers to the number of dots of color the printer can lay down per inch; many printers use multiple dots to reproduce one image pixel.)

If you're printing photos at a retail kiosk or at an online site, the software you use to order prints should determine the resolution of your files and then suggest appropriate print sizes. If you're printing on a home printer, though, you need to be the resolution cop.

What do you do if you find that you don't have enough pixels for the print size you have in mind? You just have to decide what's more important — print size or print quality.

If your desired print size exceeds the photo's pixel supply, you have the following two choices, neither of which provides a good outcome:

- **Keep the existing pixel count and accept lower photo quality.** In this case, the pixels simply get bigger to fill the requested print size. When pixels grow too large, they produce a defect known as *pixelation:* The picture starts to appear jagged, or stairstepped, along curved or oblique lines. Or, at worst, your eye can make out the individual pixels and your photo begins to look more like a mosaic than, well, like a photograph.

- **Add more pixels and accept lower photo quality.** In some photo programs, you can use a process called *resampling* to change the pixel count. Adding pixels is known as *upsampling;* removing pixels is *downsampling.* Some other photo programs even resample the photo automatically for you, depending on the print settings you choose.

Although adding pixels might sound like a good option, it actually doesn't help. You're asking the software to make up photo information out of thin air, and the resulting image usually looks worse than the original. You don't see pixelation, but details turn muddy, giving the image a blurry, poorly rendered appearance.

300 ppi

To hammer home the point, Figures 5-15 through 5-17 show you the same image as it appears at 300 ppi (the resolution required by the publisher of this book), at 50 ppi, and then upsampled from 50 ppi to 300 ppi. As you can see, there's just no way around the rule: If you want the best-quality prints, you need the right pixel count from the get-go.

Figure 5-15: A high-quality print depends on a high-resolution original.

50 ppi

Figure 5-16: At only 50 ppi, there aren't enough pixels to render details smoothly.

50 ppi upsampled to 300 ppi

Figure 5-17: Adding pixels in a photo editor doesn't rescue a low-resolution original.

Get print and monitor colors in sync

Ah, your photo colors look perfect on your computer monitor. But when you print the picture, the image is too red or too green or has another nasty color tint. This problem, which is probably the most prevalent printing issue, can occur because of any or all the following factors:

✔ **Your monitor needs to be calibrated.** If the monitor isn't accurately calibrated, the colors it displays aren't a true reflection of your image colors. The same caveat applies to monitor brightness: You can't accurately gauge the exposure of a photo if the brightness of the monitor is cranked way up or down.

To ensure that your monitor displays photos on a neutral canvas, you can start with a software-based *calibration utility,* which is just a small program that guides you through the process of adjusting your monitor. The program displays various color swatches and other graphics and then asks you to provide feedback about the colors you see onscreen.

Mac users have a free calibration tool — the Display Calibrator Assistant; Windows 7 also offers a built-in calibration utility, Display Color Calibration. You can find more free calibration software for both Mac and Windows systems online; just enter the term *free monitor calibration software* into your favorite search engine. (This recommendation presumes that your system is protected from malicious downloads by a good antivirus program.)

Software-based tools, though, depend on your eyes to make decisions during the calibration process. For a more reliable calibration, you may want to invest in a hardware solution, such as the Pantone huey (www. pantone.com) or the Datacolor Spyder3Express (www.datacolor.com). These products, which both retail for less than $100, use a device known as a *colorimeter* to accurately measure display colors.

Whichever route you take, the calibration process produces a monitor *profile,* which is simply a data file that tells your computer how to adjust the display to compensate for any monitor color casts or brightness and contrast issues. Your Windows or Mac operating system loads this file automatically when you start your computer. Your only responsibility is to perform the calibration every month or so because monitor colors drift over time.

✔ **One of your printer cartridges is empty or clogged.** If your prints look great one day but are way off the next, the number-one suspect is an empty ink cartridge or a clogged print nozzle or head. Check your manual to find out how to perform the necessary maintenance to keep the nozzles or print heads in good shape.

If black-and-white prints have a color tint, a logical assumption is that your black ink cartridge is to blame, if your printer has one. But the truth is that images from a printer that doesn't use multiple black or gray cartridges always have a slight color tint. Why? Because to create

gray, the printer instead has to mix yellow, magenta, and cyan in perfectly equal amounts, and that's a difficult feat for the typical inkjet printer to pull off. If your black-and-white prints have a strong color tint, however, a color cartridge might be empty, and replacing it may help somewhat. Long story short: Unless your printer is marketed for producing good black-and-white prints, you'll probably save yourself some grief by simply having your black-and-whites printed at a retail lab.

When you buy replacement ink, by the way, keep in mind that third-party brands (though perhaps cheaper) may not deliver the same performance as cartridges from your printer manufacturer. A lot of science goes into getting ink formulas to mesh with the printer's ink-delivery system, and the printer manufacturer obviously knows most about that delivery system.

✏ **You chose the wrong paper setting in your printer software.** When you set up a print job, be sure to select the right setting from the paper type option — glossy or matte, for example. This setting affects the way the printer lays down ink on the paper.

✏ **Your photo paper is low quality.** Sad but true: Cheap, store-brand photo papers usually don't render colors as well as the higher-priced, name-brand papers. For best results, try papers from your printer manufacturer; again, those papers are engineered to provide top performance with the printer's specific inks and ink-delivery system.

Some paper manufacturers, especially those that sell fine-art papers, offer downloadable *printer profiles,* which are simply little bits of software that tell your printer how to manage color for the paper. Refer to the manufacturer's Web site for information on how to install and use the profiles. And note that a profile mismatch can also cause incorrect colors in your prints, including the color tint in black-and-white prints alluded to earlier.

✏ **Your printer and photo software are fighting over color management duties.** Some photo programs offer *color management* tools, which enable you to control how colors are handled as an image passes from camera to monitor to printer. Most printer software also offers color management features. The problem is, if you enable color management controls in both your photo software and printer software, you can create conflicts that lead to wacky colors. Check your photo software and printer manuals for color management options and ways to turn them on and off.

Even if all the aforementioned issues are resolved, however, don't expect perfect color matching between printer and monitor. Printers simply can't reproduce the entire spectrum of colors that a monitor can display. In addition, monitor colors always appear brighter because they are, after all, generated with light.

Finally, be sure to evaluate print colors and monitor colors in the same ambient light — daylight, office light, whatever — because that light source has its own influence on the colors you see. Also allow your prints to dry for 15 minutes or so before you make any final judgments.

Preparing Pictures for E-Mail and Online Sharing

How many times have you received an e-mail message that looks like the one in Figure 5-18? A well-meaning friend or relative sent you a digital photo that's so large you can't view the whole thing on your monitor.

The problem is that computer monitors can display only a limited number of pixels. The exact number depends on the monitor's resolution setting and the capabilities of the computer's video card, but suffice it to say that the average photo from one of today's digital cameras has a pixel count in excess of the number the monitor can handle. A good rule of thumb is to limit a photo to no more than 640 pixels wide by 480 pixels tall. That number ensures that people can view the entire picture without scrolling, as in Figure 5-19.

Figure 5-18: The attached image has too many pixels to be viewed without scrolling.

Figure 5-19: Keep e-mail pictures to no larger than 640 x 480 pixels so they can be viewed easily.

By using an Image Quality option explained in Chapter 2, you can capture images at 640 x 480 pixels, but that's not a good idea unless you know that you never want to print the image — you won't have enough resolution to generate a good print. Instead, choose a resolution appropriate for print and then create a low-res copy of the picture for e-mail sharing. Some new e-mail programs have a photo-upload feature that creates a temporary low-res version for you, but if not, creating your own copy is easy. (Details later.) If you're posting to an online photo-sharing site, you may be able to upload all your original pixels, but many sites have resolution limits.

In addition to resizing high-resolution images, check their file types; if the photos are in the Raw (ORF) or TIFF format, you need to create a JPEG copy for online use. Web browsers and e-mail programs can't display Raw or TIFF files.

You can tackle both bits of photo prep in a couple ways:

- **Create a JPEG copy of a Raw image:** Use the camera's Raw Data Edit feature or the Raw-processing tools found in the free Olympus software. The earlier section "Processing Raw (ORF) Files" has details on both options.

- **Create a JPEG copy of a TIFF image:** If you take my suggestion to select the TIFF format when you process your Raw images, you can create your small JPEG copy in your photo software. Some programs even have a tool that prepares a photo for e-mail sharing and then automatically produces a mail message window, with the photo already attached.

(In Olympus Master 2, choose Tools⇨Email to explore that feature.) Note, though, that most of these e-mail assist features don't store the small copy on your hard drive but simply create a temporary copy just for attaching to the current e-mail message.

In most programs, including the Olympus offerings, you can specify how much JPEG compression you want to apply to the file when you do the TIFF to JPEG conversion. The greater the amount of compression, the smaller the file size, but the lower the picture quality.

✔ **Create a low-resolution version of a JPEG image:** You can create a low-resolution copy of a JPEG picture right in the camera. Display the picture in full-frame view, press OK, and then select JPEG Edit from the menu that appears. Press OK again and then scroll to the Resize option, highlighted on the left in Figure 5-20. Press OK to display the second screen shown in the figure. You can choose from three sizes: 1280 x 960, 640 x 480, or 320 x 240. (For pictures that you originally captured at a low resolution, all three options may not be available.) Highlight your choice and press OK to make the copy. Note that if you resize an original that has an aspect ratio other than 4:3, the dimensions of the small copy will vary. For example, if you choose 1280 x 960 when resizing a 16:9 original, the small copy measures 1280 x 720 pixels.

Figure 5-20: This option on the JPEG Edit menu creates a low-resolution copy of a picture.

For images already transferred to your computer, use your photo software to create a copy of the original with a lower pixel count. In Olympus [ib], choose File⇨Export to File and use the Resize option in the resulting dialog box. (Refer to Figure 5-10.) In Olympus Master 2, choose Tools⇨Resize and Convert Format instead. If you use other software, check the Help system to find out how to resize the picture.

When the program displays the file-saving dialog box, be sure to give the small copy a different name from the original file, or you overwrite the original. I like to add the tag "for Web" onto the end of my small copies — as in P1011000ForWeb.jpg — so I can tell at a glance that it's the low-resolution version.

Part III
Taking Creative Control

*A*s nice as it is to be able to set your camera to one of its automatic modes and let it handle most of the photographic decisions, I encourage you to also explore the advanced exposure modes (P, A, S, and M). In these modes, you can make your own decisions about the exposure, focus, and color characteristics of your photo, which is key to capturing an image as you see it in your mind's eye. And don't think that you have to be a genius or spend years to be successful — adding just a few simple techniques to your photographic repertoire can make a huge difference in how happy you are with the pictures you take.

The first two chapters in this part explain everything you need to know to do just that, providing some necessary photography fundamentals and details about using the advanced exposure modes. Following that, Chapter 8 helps you draw together all the information presented earlier in the book, summarizing the best camera settings and other tactics to use when capturing portraits, action shots, landscapes, and close-up shots.

Getting Creative with Exposure and Lighting

*B*y using the iAuto and SCN modes, both covered in Chapter 3, you can enjoy point-and-shoot photography with the E-PL1. But to fully exploit your camera's capabilities — and, more importantly, to exploit *your* creative capabilities — you need to explore your camera's advanced exposure modes, represented on the Mode dial by the letters P, A, S, and M.

This chapter explains everything you need to know to start taking advantage of these four modes. First, you get an introduction to three critical exposure controls: aperture, shutter speed, and ISO. Adjusting these settings enables you to not only fine-tune image exposure but also affect other aspects of your image, such as *depth of field* (the zone of sharp focus) and motion blur. In addition, this chapter explains other advanced exposure features, such as Exposure Compensation and metering modes, and discusses the flash options available to you in the advanced exposure modes.

Kicking Your Camera into High Gear

Each of the advanced shooting modes highlighted in Figure 6-1 offers a different level of control over two critical exposure settings: aperture and shutter speed. Later in this chapter, I explain these controls fully, but here's a quick introduction:

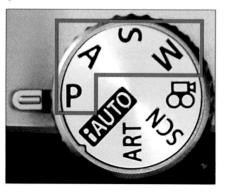

Figure 6-1: To fully control exposure and other picture properties, choose one of these exposure modes.

- ✔ **P (programmed autoexposure):** In this mode, the camera selects both the aperture and shutter speed for you, but you can choose from different combinations of the two.

- ✔ **A (aperture-priority autoexposure):** In this mode, you select the aperture setting, and the camera then selects the appropriate shutter speed to properly expose the picture.

- ✔ **S (shutter-priority autoexposure):** This mode, the opposite of aperture-priority autoexposure, enables you to set the shutter speed and rely on the camera to select the aperture setting.

- ✔ **M (manual exposure):** In this mode, you specify both shutter speed and aperture. But even in M mode, the camera assists you by displaying a meter that tells you whether your exposure settings are on target.

Again, these modes won't make much sense to you if you aren't schooled in the basics of exposure. To that end, the next several sections provide a quick lesson in this critical photography subject.

One point of clarification before you move on, though: The ART shooting mode, which applies special effects to images, gives you approximately the same control as the P mode. The result you get from a particular setting may be different in ART mode, however, because of the special effect being applied. See Chapter 9 for a detailed discussion of shooting in ART mode.

Introducing the Exposure Trio: Aperture, Shutter Speed, and ISO

Any photograph, whether taken with a film or digital camera, is created by focusing light through a lens onto a light-sensitive recording medium. In a film camera, the film negative serves as the medium; in a digital camera, it's the image sensor, which is an array of light-responsive computer chips.

Between the lens and the sensor are two barriers, the *aperture* and *shutter,* which together control how much light makes its way to the sensor. The actual design and arrangement of the aperture, shutter, and sensor vary depending on the camera, but Figure 6-2 offers an illustration of the basic concept.

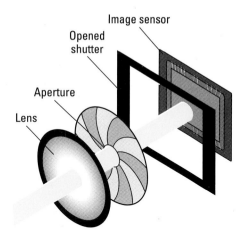

Figure 6-2: The aperture size and shutter speed determine how much light strikes the image sensor.

The aperture and shutter, along with a third feature, ISO, determine exposure — what most people would describe as the picture's overall brightness. This three-part exposure formula works as follows:

▸ **Aperture (controls amount of light):** The *aperture* is an adjustable hole in a diaphragm set inside the lens. By changing the size of the aperture, you control the size of the light beam that can enter the camera. Aperture settings are stated as *f-stop numbers,* or simply *f-stops,* and are expressed with the letter *f* followed by a number: f/2, f/5.6, f/16, and so on. The lower the f-stop number, the larger the aperture, as illustrated in Figure 6-3.

The range of possible f-stops depends on your lens and, if you use a zoom lens, on the zoom position (focal length) of the lens. For the kit lens sold with the E-PL1, you can select apertures from f/3.5 to f/22 when zoomed all the way out to the shortest focal length (14mm). When you zoom in to the maximum focal length (42mm), the aperture range is from f/5.6 to f/22. (See Chapter 7 for a discussion of focal lengths.)

▸ **Shutter speed (controls duration of light):** Set behind the aperture, the shutter works something like, er, the shutters on a window. When you press the shutter button, the shutter opens briefly to allow light that passes through the aperture to hit the image sensor.

The length of time that the shutter is open is the *shutter speed* and is measured in seconds: 1/60 second, 1/250 second, 2 seconds,

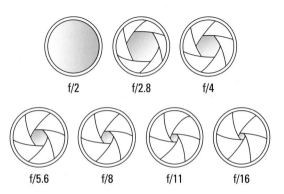

Figure 6-3: The lower the f-stop number, the larger the aperture.

and so on. Shutter speeds on the E-PL1 range from 60 seconds to 1/2000 second when you shoot without flash. If you want a shutter speed longer than 60 seconds, manual exposure mode also provides the *bulb* exposure feature. At this setting, the shutter stays open as long as you press the shutter button. See the bullet point related to the M exposure mode in the section "Adjusting aperture and shutter speed," later in this chapter, for details on bulb exposures.

If you use the built-in flash, the fastest available shutter speed is 1/160 second. With some compatible external flash units, you can use shutter speeds as fast as 1/2000 second, however.

✔ **ISO (controls light sensitivity):** ISO, which is a digital function rather than a mechanical structure, enables you to adjust how responsive the image sensor is to light.

The term *ISO* is a holdover from film days, when the International Organization for Standardization (thus ISO) rated each film stock according to light sensitivity: ISO 100, ISO 200, ISO 400, ISO 800, and so on. On a digital camera, the sensor doesn't actually get more or less sensitive when you change the ISO value — rather, the light "signal" that hits the sensor is either amplified or dampened through electronic wizardry, sort of like how raising the volume on a radio boosts the audio signal. But the upshot is the same as changing to a more light-reactive film stock: A higher ISO means that less light is needed to produce the image, enabling you to use a smaller aperture, faster shutter speed, or both. (In other words, from now on, don't worry about the technicalities and just remember that ISO equals light sensitivity.) The E-PL1 offers ISO settings ranging from 100 to 3200.

The image-exposure formula is this simple when distilled to its essence:

✔ Aperture and shutter speed together determine the quantity of light that strikes the image sensor.

✔ ISO determines how much the sensor reacts to that light.

The tricky part of the equation is that aperture, shutter speed, and ISO settings affect your pictures in ways that go *beyond* exposure. You need to be aware of these side effects, explained in the next section, to determine which combination of the three exposure settings will work best for your picture.

Understanding exposure-setting side effects

In terms of image brightness, you can produce the same results with different combinations of aperture, shutter speed, and ISO. For example, I varied aperture and shutter speed for the two shots shown in Figure 6-4, yet they're equally bright. Although the figure shows only two variations of settings, your choices are limited only by the aperture range the lens allows and the shutter speeds and ISO settings the camera offers.

f/5.3, 1/250 second, ISO 200 f/20, 1/60 second, ISO 200

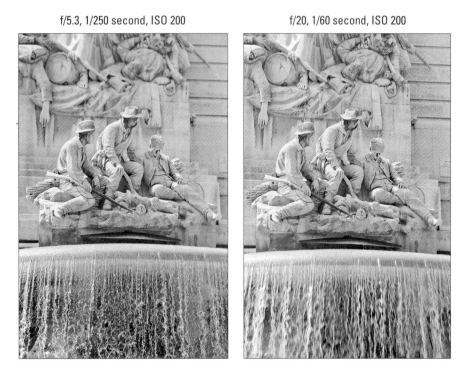

Figure 6-4: Aperture and shutter speed affect depth of field and motion blur.

But the settings you select affect your image beyond exposure, as follows:

✔ **Aperture affects depth of field.** The aperture setting, or *f-stop,* affects *depth of field,* or the distance over which sharp focus is maintained. With a shallow depth of field, your subject appears more sharply focused than faraway objects; with a large depth of field, the sharp focus zone spreads over a greater distance.

When you reduce the aperture size — or *stop down the aperture,* in photo lingo — by choosing a higher f-stop number, you increase depth of field. For example, notice that the background in the left image in Figure 6-4, taken at f/5.3, appears more softly focused than the right image, taken at f/20.

Aperture is just one contributor to depth of field, however. Your camera-to-subject distance and the focal length of your lens also play a role in this characteristic of your photos. Depth of field is reduced as you move closer to your subject or increase the focal length of the lens (moving from a wide-angle lens to a telephoto lens, for example). See Chapter 7 for the complete story on how these three factors combine to determine depth of field.

✓ **Shutter speed affects motion blur.** At a slow shutter speed, moving objects appear blurry, whereas a fast shutter speed captures motion cleanly. Compare the fountain water in the photos in Figure 6-4, for example. At a shutter speed of 1/250 second (left photo), the water droplets appear more sharply focused than at 1/60 second (right photo). The additional blur created at the slower shutter speed gives the water an almost misty appearance. The shutter speed you need to freeze action depends on the speed of your subject.

If your picture suffers from overall image blur, like you see in Figure 6-5, in which even stationary objects appear out of focus, the camera moved during the exposure — which is always a danger when you handhold the camera at slow shutter speeds. The longer the exposure time, the longer you have to hold the camera still to avoid the blur caused by camera shake.

Figure 6-5: Slow shutter speeds increase the risk of allover blur caused by camera shake.

How slow is too slow? It depends on your physical capabilities and your lens. For reasons that are too technical to get into, camera shake affects your picture more when you shoot with a lens that has a long focal length. For example, you may be able to use a much slower shutter speed when you shoot with a lens that has a maximum focal length of 42mm, like the kit lens, than if you switch to a 200mm telephoto lens. The best idea is to do your own tests so that you know when you need to use a tripod to steady the camera. Remember, too, that you can improve your odds of capturing a sharp photo when handholding the camera by turning on image stabilization. Chapter 2 explains how to take advantage of this feature.

✓ **ISO affects image noise.** When you select a higher ISO setting, making the image sensor more reactive to light, you risk creating *noise.* This defect looks like sprinkles of sand and is similar in appearance to film *grain,* a defect that often mars pictures taken with high ISO film.

On the flip side, dropping to the very bottom of the ISO scale available on the E-PL1 isn't the best choice, either. Every image sensor has a sweet spot that captures the greatest tonal range (the range of shadows to highlights) at the best image quality. On the E-PL1, that sweet spot is ISO 200. Drop below that setting, and noise level is slightly diminished, but you also can sacrifice some tonal range because you're reducing the sensor's ability to detect light.

Sometimes, lighting conditions simply don't permit you to use ISO 200 and still use the aperture and shutter speeds you need, however. For example, I took the daffodil pictures in Figure 6-6 at an indoor flower show on a day when I didn't have a tripod with me. My goal was to blur the background but to keep the flower sharp from the tip of the pistil and stamen to the petals. Because I was very close to the flower, I needed an f-stop of f/8 to accomplish that depth of field. At ISO 200, the shutter speed required to expose the scene was 1/30 second. Although I turned on image stabilization and made every effort to hold the camera as still as possible, I wasn't successful, as the blurry result on the left in the figure shows. Raising the ISO to 400 enabled me to increase the shutter speed to 1/60. At that speed, I could (with the help of image stabilization) squeeze off a sharp shot, as shown on the right in the figure.

f/8, 1/30 second, ISO 200 f/8, 1/60 second, ISO 400

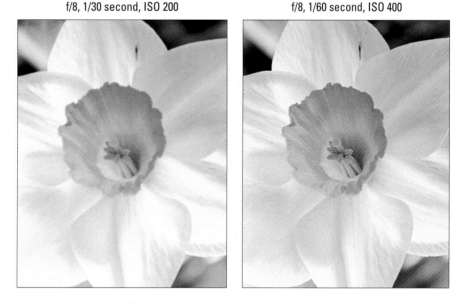

Figure 6-6: Raising the ISO enabled a higher shutter speed to ensure a blur-free shot while handholding the camera.

Fortunately, you usually don't encounter serious noise with the E-PL1 until you climb to the upper rungs of the ISO ladder. It's difficult to detect any noise in the ISO 400 image in Figure 6-6, for example. In fact, you may get away with much higher ISO settings if you keep the print or display size of the picture small. As with other image defects, noise becomes more apparent when you enlarge the photo. Noise also is more problematic in areas of flat color and in shadowed areas.

To give you a better look at how ISO affects noise, Figure 6-7 offers magnified views of the daffodil at several ISO settings ranging from 100 to 3200. As you look at these examples, keep one other critical fact about noise in mind: A long exposure time — say, 1 second or more — also can produce this defect. So after you cross that 1 second threshold, expect to see more noise than appears in these examples.

Your camera offers two noise-reduction features, named Noise Reduction and Noise Filter, that aim to compensate for this image defect. For the record, the examples in Figure 6-7 were captured with the filters at their default settings (Auto and Standard, respectively). For details about both filters, see the sidebar "Dampening noise," later in this chapter.

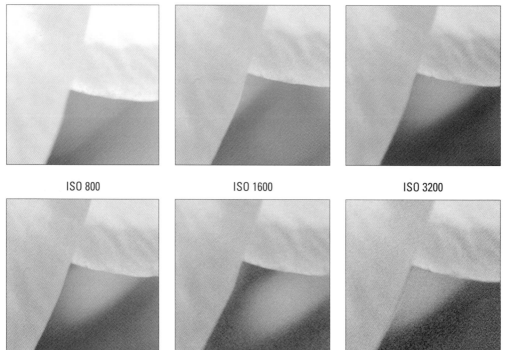

Figure 6-7: Noise in your images becomes more visible when you enlarge them.

TIP

Putting the f (stop) in focus

One way to remember the relationship between f-stop and depth of field, or the distance over which focus remains sharp, is simply to think of the *f* as *focus:* The higher the *f*-stop number, the larger the zone of sharp *focus.*

Please *don't* share this tip with photography elites, who will roll their eyes and inform you

that the *f* in *f-stop* most certainly does *not* stand for focus but, rather, for the ratio between aperture size and lens focal length — as if *that's* helpful to know if you aren't an optical engineer. (Chapter 7 explains focal length, which *is* helpful to know.)

Long story short: Understanding how aperture, shutter speed, and ISO affect an image enables you to have much more creative input over the look of your photographs — and, in the case of ISO, to also control the quality of your images. (Chapter 2 discusses other factors that affect image quality.)

Doing the exposure balancing act

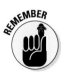

When you change any of the three exposure settings — aperture, shutter speed, or ISO — one or both of the others must also shift to maintain the same image brightness.

Say you're shooting a soccer game and you notice that although the overall exposure looks great, the players appear slightly blurry at the current shutter speed. If you raise the shutter speed, you have to compensate with either a larger aperture, to allow in more light during the shorter exposure, or a higher ISO setting, to make the camera more sensitive to the light. Which way should you go? Well, that answer depends on whether you prefer the shorter depth of field that comes with a larger aperture or the increased risk of noise that accompanies a higher ISO. Of course, you can also adjust both settings if you choose to get the exposure results you need.

All photographers have their own approaches to finding the right combination of aperture, shutter speed, and ISO, and you'll no doubt develop your own system when you become more practiced at using the advanced exposure modes. In the meantime, here are some handy recommendations:

 ✔ **Keep ISO at 200 unless the lighting conditions are such that you can't use the aperture and shutter speed you want at that setting.** Remember that raising the value brings the possibility of noise, whereas going below ISO 200 may sacrifice some shadow and highlight detail.

✐ **If your subject is moving (or might move, as with a squiggly toddler or an excited dog), give shutter speed the next highest priority in your exposure decision.** Choose a fast shutter speed to ensure a blur-free photo or, on the flip side, select a slow shutter speed to intentionally blur that moving object, an effect that can create a heightened sense of motion. When shooting waterfalls, for example, consider using a slow shutter speed to give the water that blurry, romantic look.

✐ **For images of stationary subjects, make aperture a priority over shutter speed, setting the aperture according to the depth of field you have in mind.** For portraits, for example, try using a wide-open aperture (a low f-stop number) to create a short depth of field and a nice, soft background for your subject.

Keeping all this information straight is a little overwhelming at first, but the more you work with your camera, the more the whole exposure equation will make sense to you. You can find tips in Chapter 8 for choosing exposure settings for specific types of pictures; keep moving through this chapter for details on how to monitor and adjust aperture, shutter speed, and ISO settings.

Reading the Meter and Other Exposure Data

In the default shooting information display, the f-stop, shutter speed, and ISO settings appear onscreen, as labeled in Figure 6-8. If you don't see this data, press the Info button to cycle through the different shooting display styles until it appears. (Chapter 1 has more information on the various display modes.)

You need to know a few details about how the camera presents exposure data:

✐ **Shutter speed values:** For shutter speeds less than one second, only the denominator of the fractional value appears. (In case you're as fuzzy on grade-school math as I am: The denominator is the second part of the value — the 60 in 1/60, for example.) For example, the shutter speed value in Figure 6-8 indicates 1/60 second. When the shutter speed slows to one second or more, you

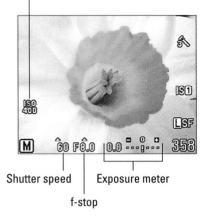

ISO

Shutter speed
f-stop
Exposure meter

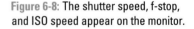

Figure 6-8: The shutter speed, f-stop, and ISO speed appear on the monitor.

see quote marks after the number — 1" indicates a shutter speed of 1 second, 4" means 4 seconds, and so on.

✓ **Exposure meter in M (manual) shooting mode:** If you set the Mode dial to M, which enables you to control aperture and shutter speed, the camera displays an exposure meter to help you gauge the accuracy of your settings, as shown in Figure 6-8. You also see a numeric readout to the left that indicates the amount of under- or overexposure.

Exposure is measured in *stops.* To increase exposure by one stop means to choose aperture or shutter speed settings that permit twice as much light into the camera as the previous settings. To decrease exposure by one stop, you select settings that cut the light by half. You also can produce the equivalent shifts in exposure by adjusting ISO: Doubling the value produces an exposure increase of one stop.

Each bar on the exposure meter represents a whole stop. The bar(s) under the meter tell you where on the scale the camera considers your exposure to be. Take a look at the enlarged meter illustrations in Figure 6-9, for example. When you see a single bar positioned in the middle of the meter, and the value at the end of the meter is 0.0, as in the top illustration, the current settings will produce a proper exposure. If you see bars extending toward the minus side of the scale, and the exposure value is negative, as in the middle illustration, the image will be underexposed. And if the bars go the other direction and the exposure value is positive, as in the bottom illustration, the image will be overexposed.

Good exposure

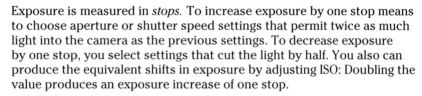

Underexposed

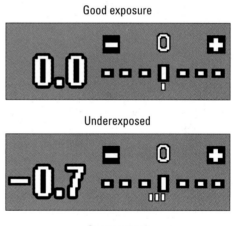

Overexposed

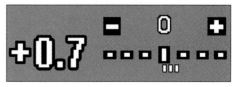

Figure 6-9: By default, the meter reflects under- or over-exposure in increments of one-third of a stop.

By default, the camera enables you to adjust exposure in increments of one-third of a stop, so the meter also uses that system to indicate exposure problems. In the middle meter illustration in Figure 6-9, for example, the readout suggests that the picture will be underexposed by 2/3 stop. (0.3 equals 1/3 stop, 0.7 equals 2/3 stop, and 1.0 equals a full stop.) The farther the indicator moves toward the plus or minus sign, the greater

the potential exposure problem. When you exceed three stops of exposure badness, the exposure value and meter blink to get your attention.

✏ **Exposure meter in P, S, and A modes:** In these modes, the meter plays a different role. Instead of telling you whether your exposure will be too dark or too bright, it indicates whether you applied *Exposure Compensation.* This feature, explained later in this chapter, enables you to tell the camera to produce a brighter or darker image than its auto-exposure brain thinks is correct. If you apply the adjustment, the meter tells you the amount and direction of the exposure shift. See the later section "Tweaking autoexposure results with Exposure Compensation," in this chapter, for details.

✏ **Exposure warnings in P, A, and M modes:** Because the meter is designated as an Exposure Compensation guide when you shoot in these modes, the camera uses different exposure-warning alerts than in M mode. Here's what happens in each mode if the camera thinks you're headed for a lousy exposure:

- *P (programmed autoexposure):* In this mode, the camera chooses both the f-stop and shutter speed for you. If the lighting conditions are such that the camera can't select a combination that will produce an optimum exposure, both values blink. Your only recourse is to either adjust the lighting or change the ISO setting.

 The camera doesn't warn you when the shutter speed drops so low that using a tripod is necessary to avoid camera shake. So you must check the shutter speed whether or not it blinks. Depending on the lighting, you may be able to choose a different combination of aperture and shutter speed by taking advantage of *programmed autoexposure shift.* (See the section "Setting ISO, f-stop, and Shutter Speed," later in this chapter.)

- *S (shutter-priority autoexposure):* In this mode, you select the shutter speed and the camera chooses the f-stop needed to expose the picture at that speed. If the camera can't open or stop down the aperture enough to expose the image at your selected shutter speed, the f-stop value blinks. Your options are to change the shutter speed or ISO. (Remember that the range of f-stops available depends on the lens.)

- *A (aperture-priority autoexposure:* The opposite of shutter-priority autoexposure, this mode lets you set the f-stop and rely on the camera to select the appropriate shutter speed. If the camera can't select a shutter speed that will produce a good exposure at the aperture you selected, the shutter speed value blinks. Choose a different f-stop or adjust the ISO.

 The warning I raised with regard to monitoring the shutter speed in P shooting mode applies in this case, too.

✓ **Histogram display:** You can add a live histogram to the display, as shown in Figure 6-10. After enabling the histogram view through Custom Menu D (see Chapter 1 for details), press the Info button to cycle to the histogram display. If you're not familiar with histograms, Chapter 4 helps you make sense of the information they provide.

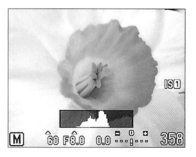

Figure 6-10: You can choose to add an exposure histogram to the mix.

✓ **Live preview of exposure:** By default, the exposure preview in the monitor is *live* — meaning that if you select a setting that changes exposure, such as adjusting shutter speed in manual exposure mode, the scene gets darker or brighter on the monitor. You lose this feature, however, if you turn on the Live View Boost feature on Custom Menu D.

Keep in mind that the camera's take on *proper* exposure may not always be the one you want to follow. First, the camera bases its exposure decisions on the current exposure *metering mode.* You can choose from five metering modes, as covered next, and each one calculates exposure differently. Second, you may want to purposely choose exposure settings that leave parts of the image very dark or very light for creative reasons. In other words, the meter and the blinking alerts are guides, not dictators.

Choosing an Exposure Metering Mode

The *metering mode* determines the method the camera uses to calculate exposure. In Movie, iAuto, and SCN modes, the camera chooses the metering mode for you. But in P, A, S, and M modes, you can choose from three standard modes and two special-purpose modes.

Take any of these routes to adjust the metering setting:

✓ **Live Control or Super Control Panel displays:** Figure 6-11 shows both screens with the metering mode option highlighted. (See Chapter 1 if you need help accessing and using the displays.)

✓ **Custom Menu E:** Select the Exposure/Metering/ISO setting, as shown on the left in Figure 6-12, press OK, and select Metering, as shown on the right in the figure. Press OK again to access the screen where you can select the mode you want to use.

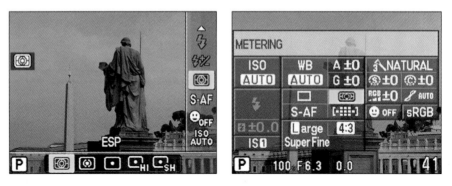

Figure 6-11: You can adjust the metering mode quickly through the Live Control display (left) or Super Control Panel display (right).

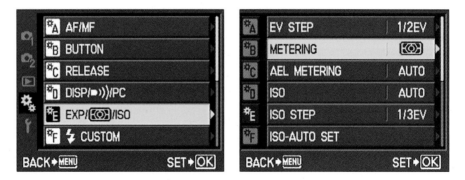

Figure 6-12: Custom Menu E also provides access to the metering options along with other exposure settings.

Whichever method you prefer, you can choose from these settings:

 ✓ **Digital ESP (whole frame) metering:** The camera analyzes the entire frame and then selects exposure settings designed to produce a balanced exposure. This setting, commonly referred to as *matrix* or *pattern* metering, is the default.

 However, whole-frame metering on the E-PL1 is implemented a little differently than on some cameras, and that's the basis of the Digital ESP name. *ESP* stands for *electro-selective pattern.* Not helpful? Okay, how about this: In this mode, the camera analyzes patterns of light and dark in the scene and then consults an internal database to try to figure out what type of picture you're trying to take. Then the camera adjusts exposure accordingly. So I think of ESP in the way people use those initials in common conversation: The camera intuits what type of picture you're trying to take without needing you to dial in a specific scene type as you do in SCN mode.

One helpful upshot of the technology comes into play when you're shooting portraits. If Face Detection is enabled, the camera assumes that you care most about the faces of your subjects. So if the camera detects faces in the frame, it calculates exposure solely on them rather than the entire frame. Check out Chapter 2 for more information about Face Detection.

✔ **Center-Weighted Averaging metering:** In this mode, the camera considers the entire frame but puts extra emphasis — *weight* — on the center of the frame when calculating exposure.

✔ **Spot metering:** Choose this mode to base exposure on the center of the frame only. The actual area metered equals about 2 percent of the frame.

[•]HI

✔ **Spot metering with Highlight Control:** When you shoot a scene that's dominated by white objects or areas, standard metering modes often result in those whites being rendered as light grays because the camera wants to avoid blowing out highlights. This mode is designed to address that issue; it increases exposure slightly over what you get with regular Spot metering to make sure that whites are truly white.

If you shoot in P, S, or A mode and discover that you need an exposure midway between the result produced in Spot metering and Spot with Highlight Control — Spot isn't bright enough and Spot with Highlight Control is too bright — just stick with Spot metering and then use Exposure Compensation, discussed later in this chapter, to refine the exposure.

[•]SH

✔ **Spot metering with Shadow Control:** The opposite of the Spot metering with Highlight Control mode, this option is meant for photographing scenes dominated by black — a close-up of a black cat, for example. The camera's normal inclination is to brighten the exposure to avoid underexposing the scene, but the result is that blacks appear muddy, dark gray. So this mode ratchets down exposure a notch so that black is really black in the photo.

In most cases, Digital ESP metering does a good job of calculating exposure, but it can get thrown off when a subject is set against a very bright background or vice versa. For example, in Figure 6-11, the bright blue sky caused the camera to choose an exposure that left the foreground statue too dark for my taste. Switching to Center-Weighted Averaging metering brightened things up a little, as shown on the left in Figure 6-13, because the camera gave extra importance to the center of the frame when calculating exposure. But I still thought the exposure a tad too dark, so I switched to Spot metering, after which the camera based exposure only on the statue, as it was in the center of the frame. The result appears on the right in Figure 6-13.

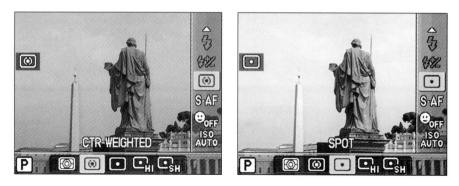

Figure 6-13: Switching to Center-Weighted Averaging (left) or Spot metering (right) can result in a better exposure of backlit subjects.

Here are a couple other points to note about the E-PL1 metering modes:

- After you select Center-Weighted Averaging or Spot metering, a metering-area indicator appears onscreen, as shown in Figure 6-14. The marking is black on the camera monitor; I painted it red in the figures to make it easier to see.
- The monitor shows you how exposure will be affected at different metering modes, as in my example figures, only if you set the Live View Boost option to Off (the default setting). To adjust the setting, head for Custom Menu D.

Center-Weighted Averaging metering area Spot metering area

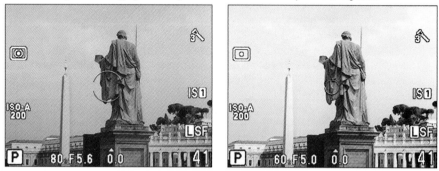

Figure 6-14: These indicators tell you the area being used by Center-Weighted Averaging and Spot metering.

- You can take advantage of Center-Weighted Averaging or Spot metering even if you don't want your subject to appear in the center of the picture. Just frame the scene initially so the subject is under the metering-area circle and then press and hold the shutter button halfway. By default, both autofocus and autoexposure are locked at that time. Keep the shutter button down halfway, reframe to your desired composition, and then press the button the rest of the way to take the picture. You also can set the camera to lock exposure and focus separately; this involves some button configuration and other menu adjustments that I cover in Chapter 10.

- When subjects are backlit, the exposure that does the best job on the subject typically overexposes the background. Unfortunately, there's no way around this photographic challenge other than applying exposure modifications in a photo-editing program. You also can try using the Shadow Adjustment feature on the JPEG Edit menu to bring backlit subjects out of the shadows. Chapter 9 shows you how.

- For scenes that feature a distinct break between shadow and highlight areas — for example, a dark vineyard that meets a bright sky at the horizon line — you also can use a type of lens filter called a *graduated neutral density filter.* Think of these filters like sunglasses with lenses that are dark at the top but fade to clear glass at the bottom. They darken the top half of the scene so that you can expose the shadowed foreground without blowing out the sky. (The neutral part of the filter name refers to the fact that the filter doesn't alter image colors, unlike most sunglasses.) You don't have to use the filter with the dark portion at the top and the clear portion at the bottom, however — you can orient it in any direction you like.

- If you think the camera consistently over- or underexposes images at a certain metering mode, you can tweak the meter's brain through the Exposure Shift option on Custom Menu J. This step isn't to be taken lightly, however; you're in essence recalibrating the meter. The change isn't reflected on the monitor, so assessing your actual exposures will be difficult. Second, using the Exposure Shift feature also reduces the range of exposures that you can produce at either the high or low end of the brightness spectrum. So stay away from this option or ask a qualified camera service tech to assist you in figuring out whether the change is really needed or whether something else is going on with the camera.

In theory, the best practice is to check the metering mode before each shot and choose the mode that best matches your exposure goals. But in practice it's a pain, not just in terms of having to adjust yet one more capture setting but also in terms of having to *remember* to adjust one more capture setting. So my advice is that until you're comfortable with all the other controls on your camera, just stick with the default setting (Digital ESP metering). That mode produces good results in most situations, and, after all, you can check your picture right after shooting to see whether you like the exposure or want to make some adjustments before your next shot. This option makes the whole metering mode issue a lot less critical than it is when you shoot with film.

Exposure stops: How many do you want to see?

In photography, *stop* refers to an increment of exposure. To increase exposure by one stop means to adjust the aperture or shutter speed to allow twice as much light into the camera as the current settings permit. To reduce exposure a stop, you use settings that allow half as much light. You can also affect exposure by adjusting ISO; for example, doubling the ISO value results in a one-stop exposure increase.

By default, all the major exposure-related settings on the E-PL1 are based on one-third stop adjustments. If you prefer, you can tell the camera to present exposure settings in other increments via the following options, both found on Custom Menu E:

✔ **EV Step:** This setting affects the adjustment increments for aperture, shutter speed, Exposure Compensation, Flash Compensation, and auto bracketing. You can choose 1/3-stop, 1/2-stop, or 1-stop increments. The setting also affects the exposure meter's under- or overexposure value, displayed when you use M (manual) shooting mode.

✔ **ISO Step:** For this option, which affects only the increments used for ISO settings, you can choose only 1/3 stop or 1 full stop.

Obviously, the default setting provides the greatest degree of exposure fine-tuning, so I stick with that option. In this book, all instructions also assume that you're using the defaults.

Additionally, if you don't like the exposure results you get in P, S, and A modes, changing the metering method isn't the only way to address the issue. You also can use Exposure Compensation to tell the camera that you want a darker or brighter exposure. I find that option easier than fooling with metering modes; check out the upcoming section "Tweaking autoexposure results with Exposure Compensation," in this chapter, to make up your own mind.

Setting ISO, f-stop, and Shutter Speed

To begin the process of selecting these exposure settings, initiate exposure metering by pressing the shutter button halfway. The camera meters the scene according to the metering mode you selected. What happens next depends on the shooting mode:

✔ **P (programmed autoexposure):** The camera displays its recommended aperture and shutter speed.

✔ **A (aperture-priority autoexposure):** The camera adjusts the shutter speed as needed to expose the picture at the current f-stop.

✔ **S (shutter-priority autoexposure):** The camera adjusts the f-stop as needed to expose the picture at the current shutter speed.

✔ **M (manual exposure):** The meter updates to reflect the camera's opinion of the shutter speed and f-stop you selected.

In all cases, the camera considers the current ISO setting when calculating exposure.

To lock in the current autoexposure settings in P, A, and S modes, keep the shutter button pressed halfway. If you're using autofocusing, focus is locked at the same time.

If you want to lock focus and exposure separately in P, A, or S mode, you have a couple of options:

- ✓ **Set focus manually.** Then only exposure is locked when you press and hold the shutter button halfway. See Chapter 7 to find out how to use manual focusing.

- ✓ **Set the Fn or Movie button to lock exposure.** You then press the shutter button to lock autofocus and press the other button to lock exposure. You also can choose from a bunch of other configurations for locking exposure and focus; Chapter 10 has details.

In manual exposure mode, the camera sticks with whatever exposure settings you dial in, no matter if it thinks you're absolutely crazy to have chosen them. So there's no need to lock exposure — it's locked already. Pressing and holding the shutter button simply locks focus, assuming that you're using autofocusing.

Controlling ISO

To recap the ISO information presented at the start of this chapter: Your camera's ISO setting controls how sensitive the image sensor is to light. At a camera's higher ISO values, you need less light to expose an image correctly.

Remember the downside to raising ISO, however: The higher the ISO, the greater the possibility of noisy images. Refer to Figure 6-7 for a reminder of what that defect looks like. Nor should you use ISO settings below 200 on a regular basis because although those low settings do reduce noise, they also make it harder for the camera to hold onto the entire tonal range.

In the fully automatic exposure modes (iAuto and SCN), the camera selects the ISO setting for you. In Movie mode, ISO control varies upon the Mode setting; see Chapter 3 for details.

In the P, A, S, and M modes, you can select an ISO setting via the Live Control or Super Control Panel display, as shown in Figure 6-15 or through Custom Menu E, as shown in Figure 6-16. You can select a specific ISO value from 100 to 3200, as shown in the figures, or choose the Auto setting and let the camera select the ISO for you. (When you drop below ISO 200, the label Low Noise Priority appears to remind you that you may be sacrificing some tonal range; when you select ISO 3200, the label Extension appears as an added reminder of the possibility of noise.)

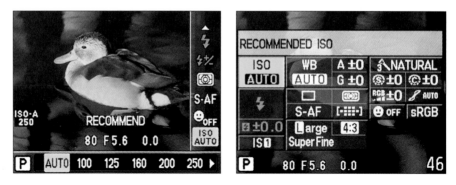

Figure 6-15: You can select a specific ISO value or stick with auto ISO adjustment.

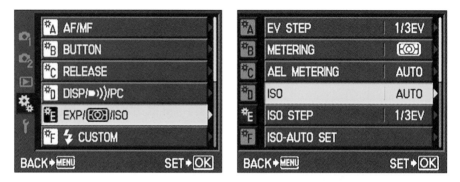

Figure 6-16: Custom Menu E also takes you to the ISO setting plus some related options.

Notice in Figure 6-15 that the shutter speed, f-stop, and amount of Exposure Compensation — or in M mode, the amount of under- or overexposure — remain visible in the displays (1/80, f/5.6, and 0.0 in the figures). The values update as you change the ISO setting so that you can see how your exposure will be affected.

In Auto mode, the camera selects an initial ISO of 200 and raises the value as high as 1600 as needed. But you can change both the default initial setting and the high limit. To set preferences for Auto ISO adjustment, choose Custom Menu E (refer to the left screen in Figure 6-16) and press OK. Then work your way through each of the following options:

✔ **Setting Auto ISO limits:** Choose ISO-Auto Set, as shown in Figure 6-17, to set the range of ISO settings the camera can select for automatic ISO adjustments. The High Limit value sets the maximum ISO; the Default value determines the initial ISO setting the camera selects any time you choose Auto as your ISO setting.

Figure 6-17: This option limits the maximum ISO the camera can use in Auto ISO mode.

✔ **Enabling Auto ISO for M (manual) shooting mode:** By default, Auto appears as an ISO option only when you shoot in the P, S, or A modes. But there's no rule that says you can't take advantage of the feature when using manual (M) exposure mode. Just change the ISO-Auto option, featured in Figure 6-18, from P/A/S to All. The camera then adjusts ISO as needed to expose the photo at the aperture and shutter speed you select, respecting the limits you set through the ISO-Auto Set menu option.

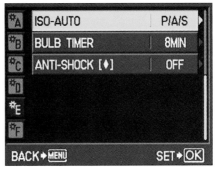

Figure 6-18: To take advantage of Auto ISO adjustment in M (manual) shooting mode, change this setting to All.

TIP

You can refine one additional aspect of ISO control: By default, the camera offers settings that adjust exposure in increments of one-third of a stop. But you can limit the number of available settings to those that produce a full stop of exposure change. See the sidebar "Exposure stops: How many do you want to see?" in this chapter, for details on this feature.

Adjusting aperture and shutter speed

For still photography, you can adjust aperture and shutter speed only in P, A, S, and M exposure modes. To get started, press the up-arrow key, labeled in Figure 6-19. As soon as you press the arrow, all the current camera settings that are adjustable via the Live Control display appear, as shown in the figure. What happens next and the technique you use to adjust f-stop and shutter speed depends on the exposure mode:

Dampening noise

Noise, the digital defect that gives your pictures a speckled look (refer to Figure 6-7), can occur for two reasons: a long exposure time and a high ISO setting.

By default, the E-PL1 attacks both causes of noise by applying the following corrective filters:

✔ **Noise Reduction:** This filter attempts to remove noise caused by long exposures. You can choose from three settings, Auto, On, and Off, by calling up Custom Menu G, as shown in the following figure. At the default setting, Auto, the camera decides when the shutter speed is slow enough to warrant the noise reduction — usually about one-half second or more. But you'll know when noise reduction happens because the filtering process occurs after the shot and doubles the time the camera needs to record the image. For this reason, the filter isn't applied if you set the shutter-release mode to Sequential (burst mode) shooting. If you set the option to On, the filter is applied after every shot, regardless of shutter speed. If the Auto setting slows you down too much when you're shooting long exposures, set the filter to Off.

✔ **Noise Filter:** Located just below the Noise Reduction filter on the menu, this filter addresses the type of noise caused by a high ISO setting, typically ISO 800 and up. You can choose from four settings: Standard, Low, Off, or High. The default is Standard, but you can select Low to request a lighter application of the filter or High to get a greater filter impact. Whatever level you choose, noise reduction kicks in only if the camera detects ISO-style noise, which looks a little different from long-exposure noise.

For long exposures, the Noise Reduction feature can do a pretty good job of cleaning up the photo if you have time to wait between shots for the image-scrubbing to occur. (The delay occurs because the camera actually records a second image with the shutter closed, analyzes that image to see where the noise occurred, and then uses that information as a reference to reduce long-exposure noise in the actual image.)

The Noise Filter, however, uses a type of noise reduction that can lead to the softening of image details as well as noise. If you're a photo-editing enthusiast, you may want to disable this feature in the camera and then do your own noise-removal in your photo software. That way, you can apply the correction just to parts of the image where noise is most noticeable — usually in areas of flat color or little detail, such as skies.

✒ **P (programmed autoexposure):** In this mode, the display appears as shown on the left in Figure 6-20 after you press the up-arrow key. Along with the camera's recommended combination of aperture and shutter speed, you see the current Exposure Compensation setting, as labeled in the figure. *Exposure Compensation,* covered in the next section, gives you a way to produce a brighter or darker exposure than the camera initially selects when you shoot in the P, A, or S modes.

Press to activate exposure settings

Figure 6-19: The first step in adjusting f-stop and shutter speed is to press the up-arrow key.

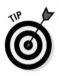

In addition to applying Exposure Compensation, you can ask the camera to display other possible combinations of aperture and shutter speed that will produce the same exposure as the one it originally suggested. Notice that in the lower-left corner of the screen, tiny up/down arrows appear next to the shooting mode icon. That's your reminder that to see other exposure combinations, you press the up- or down-arrow key. As soon as you do, the shooting mode icon changes from P to Ps, as shown on the right in Figure 6-20. The *s* refers to the official name of this feature, called *programmed autoexposure shift.*

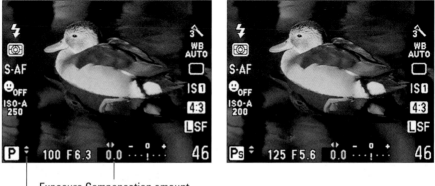

Exposure Compensation amount

Autoexposure shift

Figure 6-20: Press the up-arrow key and then press up or down to view other combinations of aperture and shutter speed.

Press up to stop down the aperture (higher f-stop number) and reduce the shutter speed; press down to open the aperture and increase the shutter speed. To return to the settings the camera suggested initially, press the up- or down-arrow keys until the s disappears from the shooting mode icon. The camera also returns to the default P exposure combo — that is, exits programmed autoexposure shift mode — if you turn the Mode dial to any other exposure setting or turn off the camera.

If the aperture and shutter speed values blink, the camera can't choose any combination of settings that expose the picture properly at the current ISO setting. You can either adjust the ISO or modify the lighting conditions.

✔ **A (aperture-priority autoexposure):** When you set the camera to A mode, a little green arrow appears above the f-stop to remind you that you control that exposure setting. After you press the up-arrow key, the f-stop and Exposure Compensation value both become highlighted, as shown in Figure 6-21. Press the up- or down-arrow key to change the f-stop setting; when you do, the camera automatically adjusts the shutter speed to maintain the equivalent exposure.

Figure 6-21: In A or S modes, press the up-arrow key and then press up or down to change the f-stop (A mode) or shutter speed (S mode).

Pressing the left- or right-arrow key changes the Exposure Compensation value, so be careful not to inadvertently tap one of those keys unless that's really what you have in mind. (See the next section to find out more.) Also, if you're handholding the camera, be careful that the shutter speed doesn't drop so low when you stop down the aperture that you run the risk of camera shake. And if your scene contains moving objects, make sure that when you dial in your preferred f-stop, the shutter speed that the camera selects is fast enough to stop action (or slow enough to blur it, if that's your creative goal). Finally, remember that if the shutter speed value blinks, the camera can't expose the picture properly at your chosen f-stop.

If you see only a single arrow above the f-stop value instead of two, as shown in Figure 6-21, you've reached the minimum or maximum aperture. An up arrow and no down arrow, for example, means that you can't lower the f-stop value beyond the current setting.

✔ **S (shutter-priority autoexposure):** Things work exactly the same as in A mode, except that you control the shutter speed instead of the f-stop. Press the up-arrow key to activate the shutter speed value and then

press up or down to change the setting. As in A mode, pressing the right- or left-arrow key adjusts the Exposure Compensation setting instead, so be careful about those button presses.

As you change the shutter speed, the camera automatically adjusts the aperture as needed to maintain the proper exposure. Remember that changing the aperture also changes depth of field. So even though you're working in shutter-priority mode, keep an eye on the f-stop, too, if depth of field is important to your photo. *Note:* In extreme lighting conditions, the camera may not be able to adjust the aperture enough to produce a good exposure at the current shutter speed — again, possible aperture settings depend on your lens. So you may need to compromise on shutter speed (or, in dim lighting, raise the ISO). A blinking aperture value tells you that you're in the danger zone.

✏ **M (manual exposure):** In this mode, you start by pressing the up-arrow key, as in the other exposure modes. But this time, both the aperture and shutter speed values become active, as shown in Figure 6-22. Adjust those settings as follows:

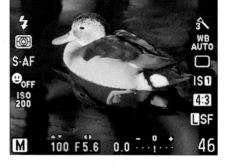

Figure 6-22: In M mode, press up and then use the up/down keys to set shutter speed and the left/right keys to adjust the f-stop.

- *To adjust shutter speed:* Press the up- or down-arrow key.

 In manual mode, you can select the *bulb* exposure setting in addition to the normal range of shutter speeds. (*Bulb* is one notch below the slowest regular shutter speed, 60 seconds.) At this setting, the shutter remains open as long as you hold down the shutter button, enabling you to use an exposure time of up to eight minutes by default. You can adjust the bulb-exposure cutoff time through the Bulb Timer option on Custom Menu E; settings range from 1 minute to 30 minutes.

- *To adjust aperture:* Press the right- or left-arrow key. Again, when you reach the maximum or minimum aperture, one of the two directional arrows above the f-stop value disappears to let you know that you can adjust aperture only in the direction of the arrow.

In M mode, the meter display indicates whether your shot will be under- or overexposed at the current aperture and shutter speed settings. See the earlier section "Reading the Meter and Other Exposure Data," in this chapter, to find out how to interpret the meter.

Regardless of the shooting mode, simply press and hold the shutter button halfway to lock exposure after choosing your exposure settings. You don't need to press OK or take any other action to lock in the settings you selected.

Keep in mind that when you use P, A, and S modes, the settings that the camera selects are based on what it thinks is the proper exposure. If you don't agree with the camera, you have two options. Switch to manual exposure (M) mode and simply dial in the aperture and shutter speed that deliver the exposure you want; or, if you want to stay in P, A, or S mode, you can tweak the autoexposure settings by using Exposure Compensation, described in the next section.

Be sure to also visit the sidebar "Exposure stops: How many do you want to see?," elsewhere in this chapter, to find out how to specify whether you want shutter speed and aperture values to be presented in increments of one-third stop (the default setting), a half-stop, or a full stop.

Tweaking autoexposure results with Exposure Compensation

When you set your camera to the P, A, or S shooting modes, you can enjoy the benefits of autoexposure support but retain some control over the final exposure. If you think that the image the camera produced is too dark or too light, you can use the Exposure Compensation feature, which is sometimes called *EV Compensation.* (The *EV* stands for *exposure value.*)

Whatever you call this feature, it enables you to tell the camera to produce a darker or lighter exposure than what its autoexposure mechanism thinks is appropriate. Best of all, this feature is probably one of the easiest on the camera to understand. Here's all there is to it:

- ✓ Exposure Compensation is stated in EV values, as in EV +2.0. Possible values range from EV +3.0 to EV –3.0.
- ✓ A setting of EV 0.0 results in no exposure adjustment.
- ✓ For a brighter image, raise the EV value.
- ✓ For a darker image, lower the EV value.

Each full number on the EV scale represents an exposure shift of one stop. By default, the exposure is adjusted in 1/3-stop increments; see the sidebar "Exposure stops: How many do you want to see?" in this chapter, to find out how you can modify that increment of change to 1/2 stop or a full stop.

Exposure Compensation is especially helpful for scenes like the one in Figure 6-23, where the light comes from behind the subject and the foreground and background are very different in brightness. For this photo, the camera was set to Digital ESP metering, which analyzes the entire scene to calculate exposure. Most times, this metering mode works fine. But in this photo, the brightness of the sky and the clock caused the camera to select an exposure that left the part of the scene that was my main interest — the red letters of the sign and the flowers underneath — underexposed.

One option for adjusting exposure in the autoexposure modes (P, A, and S) is to switch to Center-Weighted Averaging or Spot metering. But this scene features such a complex pattern of bright and dark areas at the center of the frame that positioning the metering-area circle in just the right spot to get the exposure I had in mind would have been a hit-or-miss proposition.

Press to access Exposure Compensation settings

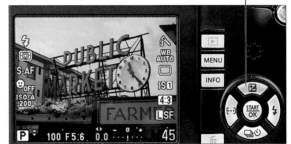

As I mentioned in my earlier discussion about metering modes, I usually find it easier to simply adjust the Exposure Compensation value, and that's the route I took in this instance.

To adjust Exposure Compensation, press the up-arrow key. The key is labeled with the universal symbol for this feature, a little plus/minus sign, as shown in Figure 6-23. After you press up, press the right- or left-arrow

Exposure Compensation value

Figure 6-23: Press the up-arrow key to access the Exposure Compensation setting.

key to adjust the Exposure Compensation value. I used a value of EV +0.7 to achieve the brighter image you see in Figure 6-24. After you set the Exposure Compensation value, press the shutter button halfway to exit the adjustment screen and return to shooting.

While you're adjusting Exposure Compensation, be careful not to press the up or down keys instead of the left or right keys, or you change aperture, shutter speed, or both, depending on which shooting mode you're using. Also note that when you power off the camera, it doesn't return you to a neutral setting (EV 0.0). The setting you last used remains in force.

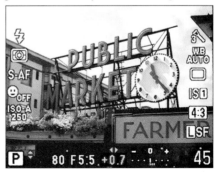

Figure 6-24: Then press right or left to set the amount of Exposure Compensation.

Most digital cameras offer Exposure Compensation, but the E-PL1 offers two cool twists on the feature: Not only can you preview on the monitor how your setting will affect the exposure, but you can also compare the effects of four EV values at once through the Multi View display option, as shown in Figure 6-25. Chapter 1 explains how to enable this view. After switching to Multi View display, press right or left to view thumbnails at additional Exposure Compensation settings. Remember that Live View Boost, an option on Custom Menu D, must be turned Off, as it is by default, in order for the monitor to display exposure adjustments.

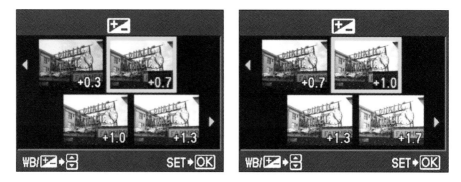

Figure 6-25: In Multi View display mode, you can compare exposure at four Exposure Compensation settings.

One more critical point to note: How the camera arrives at the brighter or darker image you request depends on the exposure mode:

- ✓ **In A (aperture-priority autoexposure) mode,** the camera adjusts the shutter speed but leaves your selected f-stop in force.

- ✓ **In S (shutter-priority autoexposure) mode,** the opposite occurs. The camera opens or stops down the aperture, leaving your selected shutter speed alone.

- ✓ **In P (programmed autoexposure) mode,** the camera decides whether to adjust aperture, shutter speed, or both to accommodate the Exposure Compensation setting.

These explanations assume that you have a specific ISO setting selected rather than Auto ISO. If you do use Auto ISO, the camera may adjust that value instead.

Keep in mind that the camera can adjust the aperture only so much, according to the aperture range of your lens. The range of shutter speeds is limited by the camera. So if you reach the end of those ranges, you have to compromise on either shutter speed or aperture or adjust ISO.

Correcting lens vignetting with Shading Compensation

Because of some optical science principles that are too boring to explore (well, to me, anyway), some lenses produce pictures that appear darker around the edges of the frame than in the center, even when the lighting is consistent throughout. This phenomenon goes by several names, but the two heard most often are *vignetting* and *light fall-off*. How much vignetting occurs depends on the lens, your aperture setting, and the lens focal length. (Chapter 7 explains focal length.)

The Shading Compensation feature can help correct vignetting by adjusting the light around the edges of the frame during the final processing of the image. Figure 6-26 shows an example. In the left image, just a slight amount of light fall-off occurs at the corners, most noticeably at the top of the image. The right image shows the same scene with Shading Compensation applied.

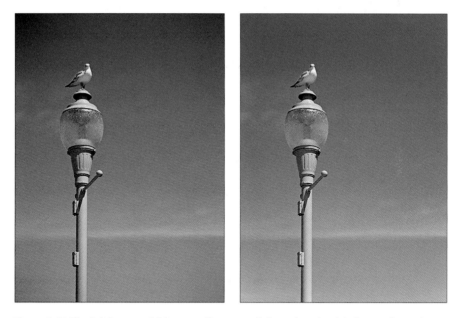

Figure 6-26: The left image exhibits a small amount of vignetting; the right image shows the result of applying Shading Compensation.

This "before" example hardly exhibits serious vignetting — it's likely that most people wouldn't even notice if it weren't shown next to the "after" example. And, frankly, you're not likely to notice significant vignetting with the 14–42mm kit lens bundled with the camera, either. But if your lens suffers from stronger vignetting, it's worth trying Shading Compensation.

You need to know a few specifics about the feature, however:

✔ **You can enable Shading Compensation only in P, A, S, and M modes.** Turn the feature on or off via Custom Menu G, as shown in Figure 6-27.

✔ **The correction is available only for photos captured in the JPEG file format.** For Raw files, you can find automatic vignette correction tools in many Raw conversion programs as well as in some photo-editing programs.

*G	◄►/COLOR/WB	►
*H	RECORD/ERASE	►
*I	MOVIE	►
*J	☐ UTILITY	►

BACK ➡ MENU SET ➡ OK

*G	NOISE REDUCT.	AUTO
*H	NOISE FILTER	STD.
*I	WB	AUTO
*J	ALL WB±	
	COLOR SPACE	sRGB
	SHADING COMP.	ON

BACK ➡ MENU SET ➡ OK

Figure 6-27: Enable Shading Compensation via Custom Menu G.

✔ **In some circumstances, you may see increased noise at the corners of the photo because of the correction.** This problem occurs because the exposure adjustment can make noise more apparent. See the first part of this chapter for an understanding of noise.

✔ **Shading Compensation isn't compatible with extension tubes and tele-converters.** If you use these lens modifiers, you need to correct vignetting in your photo software.

Using Flash in P, A, S, and M Modes

Sometimes, no amount of fiddling with aperture, shutter speed, and ISO produces a bright enough exposure — in which case, you simply have to add more light. The built-in flash on your E-PL1 offers the most convenient solution. To raise the flash, slide the Flash Up button, labeled in Figure 6-28, to the right and release it. You also

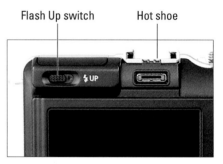

Flash Up switch Hot shoe

Figure 6-28: Slide the Flash Up button to the right and then release it to raise the built-in flash.

can attach an external flash to the camera, either via the flash hot shoe or through a flash-bracket cable. (If you do attach a flash, you can't use the optional electronic viewfinder, which covers the hot shoe when attached. Chapter 1 talks more about the viewfinder.)

Because the features available with external flash units vary depending on the specific flash, this book concentrates on using the built-in flash. However, note that some camera settings also affect the performance of an external flash as well as the built-in flash. For example, by enabling the Flash RC Mode option on Shooting Menu 2, you can use the built-in flash to trigger up to three compatible wireless flash heads. The camera manual has more information about wireless flash photography; check your flash manual for additional details about its operation.

The next several sections provide details on flash photography features available when you shoot in the P, A, S, and M shooting modes. For help with flash in iAuto or SCN mode, see Chapter 3, and check out Chapter 9 for the scoop on ART mode.

Understanding the flash modes

After raising the flash, set the *flash mode.* This setting determines the timing of the flash and also affects how much of the picture is exposed by ambient light and how much is lit by the flash.

As with most features on the E-PL1, you can adjust the flash mode in a couple ways:

- **Right-arrow key:** The little flash symbol on the key indicates the button's function. Press the key, and the available flash modes appear at the bottom of the screen, as shown in Figure 6-29. Press the right- or left-arrow keys to select the mode and then press OK or give the shutter button a quick half-press and release it to exit the screen.

Press to access flash modes

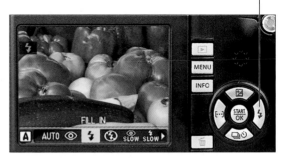

Figure 6-29: The right-arrow key offers the fastest way to access the flash modes.

- **Live Control and Super Control Panel displays:** Figure 6-30 shows you where to locate the flash mode setting in these displays.

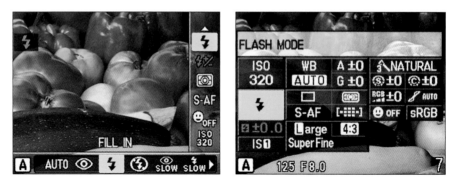

Figure 6-30: You also can access the flash mode via the Live Control and Super Control Panel displays.

Which flash mode is best? That answer depends on the lighting effect you want to create. To help you choose, the next several sections explain all the flash modes.

Note that which flash modes you can choose, and the order they appear when you go to adjust the setting, depends on your shooting mode (P, A, S, or M). The section headlines indicate which shooting modes enable each flash mode.

Auto flash (P and A shooting modes)

AUTO This mode hands over all flash control to the camera. If the camera thinks the scene needs more light, the flash goes off (although you still have to raise the built-in flash). If the light is bright, the flash doesn't fire.

Automatic flash is fine for beginners — which is why it's the mode used by the iAuto and SCN modes. But in many cases, you can get better results by adding flash in situations where the camera thinks the ambient light is fine, and the opposite is also true. So do yourself a favor and skip past Auto and choose one of the other modes.

Fill-in flash (P/A/S/M)

 Now you're starting to think like a photographer. In this mode, you control whether the flash fires. If you want flash, you raise the flash unit. Don't want flash? Close the flash unit. Simple as that.

The name of this flash mode is derived from the generic term *fill flash,* which refers to the fact that the flash is used to fill in shadows. You may also hear this mode called *force* flash because the flash fires even in the brightest light — something that doesn't occur in Auto flash modes.

Using flash outdoors in bright sunlight, by the way, is often an excellent idea. The small pop of light provided by the built-in flash is perfect for filling in shadows that can occur when your light source — the sun — comes from above. Flash can also help bring out the details in flowers and other outdoor subjects. As an example, compare the no-flash and flash shots in Figure 6-31. I took these pictures at a farmer's market on a brilliantly sunny day. In the first shot, half the frame is lost in a shadow cast by an awning on the farmer's stall. Adding fill flash virtually eliminated the shadow.

No flash Fill flash

Figure 6-31: When you're shooting in bright sun, try using flash to fill in shadows.

You do need to beware of a couple complications of using fill flash:

- **Colors may need tweaking when you mix light sources.** When you combine multiple light sources, such as flash with daylight, you may also notice that colors appear slightly warmer or cooler than neutral. To find out how to address this issue, see the Chapter 7 section related to the White Balance control.

- **Keep an eye on shutter speed.** Because of the way the camera needs to synchronize the firing of the flash with the opening of the shutter, the range of shutter speeds available when you use flash is more limited than when you go flash-free. Here's the scoop:

 - *P and A modes:* In these two shooting modes, the camera automatically selects a shutter speed ranging from 1/60 second to 1/160 second. You can control the lower limit of the shutter speed range through the Flash Slow Limit option on Custom Menu F, however. For example, if you set that value to 1/125, you force the camera to stick within a shutter speed range of 1/125 to 1/160 second. You may want to make this change if you're shooting a moving subject, for example. You can set the limit between 1/30 second and 1/160 second.

- *S and M modes:* You can use shutter speeds ranging from 60 seconds to 1/160 second.

The top end of the shutter speed range depends on the Flash X-Sync setting, also found on Custom Menu F. You can lower the top speed from 1/160 to as low as 1/60 second. This setting affects the range of shutter speeds available in all four shooting modes. To give yourself the maximum shutter speed flexibility, leave this option at 1/160 unless you have some specific reason for capping the shutter speed.

In bright sun, you may need to stop down the aperture significantly or lower ISO, if possible, to avoid overexposing the image even at 1/160 second. As another option, you can place a neutral density filter over your lens; this accessory simply reduces the light that comes through the lens.

If you use some external flash units, you can use higher shutter speeds through a feature that Olympus calls Super FP and is known generically as *high-speed flash.* (Check your flash manual for details on using this option.)

Red-eye reduction: Auto (P/A) or fill-in (S/M) flash

Red-eye is caused when flash light bounces off a subject's retinas and is reflected back to the camera lens. Red-eye is a human phenomenon, though; with animals, the reflected light usually glows yellow, white, or green.

Man or beast, this issue isn't nearly the problem with the type of pop-up flash found on your E-PL1 as it is on most point-and-shoot cameras. Your camera's flash is positioned in such a way that the flash light usually doesn't hit a subject's eyes straight on, which lessens the chances of red-eye. However, red-eye may still be an issue when you use a lens with a long focal length (a telephoto lens) or you shoot subjects from a distance.

If you do notice red-eye, you can enable the camera's red-eye reduction feature. The flash then emits a brief burst of light in advance of the actual flash and shutter opening. The subject's pupils constrict in response to the light, allowing less flash light to enter the eye and cause that glowing red reflection. Be sure to warn your subjects to wait for the flash, or they may step out of the frame or stop posing after they see the preflash.

In the P and A shooting modes, the red-eye reduction feature is combined with Auto flash — meaning that the camera decides whether flash is needed. So if you want to control flash firing and enable red-eye reduction, shoot in S or M mode. My warnings related to shutter speed in the preceding section apply to this flash mode as well.

When you display the flash mode settings (by pressing the right-arrow key or using the Live Control or Super Control Panel displays), the mode icon varies to indicate whether you should expect Auto or fill-in flash behavior. In P and A modes, you see just an eyeball, as in left side of the icon attached to the beginning of this section. In S and M modes, a flash symbol appears with the eye, as shown in the right side of the icon. The flash symbol means fill-in flash.

Also keep in mind that in both cases, the term is red-eye *reduction.* The feature can't eliminate all risk of red-eye. For a better solution, try the flash-free portrait tips covered in Chapter 8. If you do a lot of portrait work that requires flash, you may also want to consider an external flash unit that offers a rotating head. You then can aim the flash toward the ceiling and "bounce" the light off the ceiling instead of aiming it directly at your subject. That technique produces softer lighting and also virtually eliminates the possibility of red-eye.

If all else fails, check out Chapter 9, which shows you how to use the built-in red-eye removal tool on your camera's JPEG Edit menu. Sadly, though, this feature removes only red-eye, not the yellow/green/white eye that you get with animal portraits.

Flash-off (P/A/S/M)

This flash mode is provided simply to give you a way to disable flash between shots without continually raising and closing the built-in flash.

Slow-sync flash (P/A/S/M)

Slow-sync flash enables you to use flash with a slower-than-normal shutter speed. The idea is to give the camera a longer time in which to soak up ambient light so that the flash power needed to light the scene is reduced. Pictures taken with slow-sync flash typically feature softer, more even lighting than regular flash.

As an example, take a look at Figure 6-32. For the first shot, I used normal fill flash. The flash did a good job in terms of making the scene bright, but the light is harsh, casting a strong shadow and overexposing the pocket watch. For the second shot, I used slow-sync flash, using a shutter speed of 1.3 seconds. Because the camera could use more of the available light to expose the scene, the flash output was greatly reduced, producing more even lighting and a visual mood more in keeping with the subject.

Regular flash (1/60 second exposure) Slow-sync flash (1.3 second exposure)

Figure 6-32: Slow-sync flash exposes the image using more ambient light and less flash power, creating a softer look.

Slow-sync flash also can produce much better portraits than regular flash because of the softer light output. (Chapter 8 has an example.) But remember that a slow shutter means that your subject needs to be able to remain absolutely still during the exposure to prevent motion blur. You must keep the camera still as well. So for best results, use a tripod and don't try this technique with young children or pets (unless they're sleeping).

How you take advantage of slow-sync flash depends on the exposure mode. Here's the deal:

 ✔ **S and M shooting modes:** Just set the shutter to the speed you have in mind and set the flash mode to fill-in flash. You can choose shutter speeds as slow as 60 seconds.

 ✔ **P and A modes:** To use slow-sync flash in these modes, choose one of the following two flash settings:

- *Slow sync:* By default, the camera automatically drops the shutter speed to a setting as low as 60 seconds, depending on the ambient light. Note that the Flash Slow Limit option on Custom Menu F does not apply when you're using slow-sync flash, and the shutter speed can drop as low as 60 seconds.

- *Slow sync with red-eye reduction:* As its name implies, this mode combines a longer exposure time with the same preflash that occurs with regular red-eye reduction mode.

As when you use red-eye reduction flash in the P and A modes, the flash operates with its Auto-flash brain in both these slow-sync modes. In other words, the flash fires only if the camera thinks the existing lighting isn't sufficient. So to precisely control the flash, use the S or M shooting mode for slow-sync photography.

Slow sync with second-curtain sync (P/S/A/M)

When you use regular slow-sync flash, the flash fires at the beginning of the exposure. This flash behavior is called *first-curtain sync or front-curtain sync.* (*Curtain* refers to a part of the shutter mechanism.) You also can set the flash to use rear-curtain sync, also known as *second-curtain sync,* in which the flash fires at the end of the exposure.

The classic use of second-curtain slow-sync flash is to create trailing-light effects like the one you see in Figure 6-33. With rear-curtain sync, the light trails extend behind the moving object (my hand, and the match, in this case), which makes visual sense. If instead you use regular, first-curtain slow-sync flash, the light trails appear in front of the moving object.

To use this flash option, select one of the following two settings, depending on the shooting mode:

- ✓ **P and A modes:** Set the flash to the Slow 2 setting. But the same limitation applies as for regular slow-sync flash in these modes: The flash still only fires if the camera finds the ambient light insufficient. Shutter speed is controlled by the camera, as outlined in the preceding section, and can drop as low as 60 seconds.

Figure 6-33: With second-curtain slow-sync flash, motion trails follow the moving object.

⚡
2nd-C

✔ **S and M modes:** Select the 2nd Curtain flash setting. You control the shutter speed as usual, and the flash fires regardless of the existing light. You can choose shutter speeds from 60 seconds to 1/160 second.

Note that all the slow-sync modes are somewhat tricky to use successfully. So have fun playing around, but at the same time, don't feel too badly if you don't have time right now to master these modes plus all the other exposure options presented to you in this chapter. In the meantime, do a Web search for slow-sync and rear-sync image examples if you want to get a better idea of the effects that other photographers create with these flash modes.

Manual flash

In all the flash modes described so far, the camera calculates the correct flash power for you, basing its decision on the shutter speed, aperture, ISO, and current lighting conditions. But the E-PL1 also offers the four manual flash-exposure settings shown in Figure 6-34. You can fire the flash at its maximum power (Full), 1/4 power, 1/16 power, or 1/64 power.

To use these settings successfully, you need to understand the science of calculating flash exposure. If you fall into that category, it may help you to know that the guide number (GN) of the built-in flash is 10 at ISO 200.

Figure 6-34: The manual flash settings are designed for those experienced in calculating flash exposure.

If, like me, you prefer to let the camera set the flash exposure but you're not happy with the amount of light the flash added to the scene, you can modify flash output by using Flash Compensation, explained next.

Adjusting flash output

Assuming you stay away from the manual flash-exposure settings described just inches prior to this text, the camera uses *through-the-lens (TTL)* metering to calculate the correct flash exposure. You can tweak the flash power through a feature known as Flash Compensation or, in the language of your camera manual, *flash intensity control.*

Whatever you call this feature, it works just like Exposure Compensation, discussed earlier in the chapter, except that it enables you to tweak flash power instead of the overall exposure. As with Exposure Compensation, the flash intensity control settings are stated in terms of EV *(exposure value)* numbers. A setting of 0.0 indicates no flash adjustment; you can increase the flash power to EV +3.0 or decrease it to EV –3.0.

The photos in Figure 6-35 offer an example. Normally, I find that the E-PL1 flash does a pretty good job of picking the right flash power. But for this subject, I found the flash output slightly hot at normal power (EV 0.0). So I notched the Flash Compensation down one stop, to EV –1.0 to take the second shot. Now the shading of the interior of the bowl becomes visible, and more detail is retained in the chopsticks and mat.

Flash EV 0.0 Flash EV –1.0

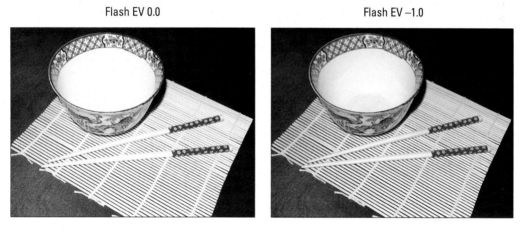

Figure 6-35: When normal flash output is too strong, dial in a lower Flash Compensation setting.

As for boosting the flash output, well, you may find it necessary on some occasions, but don't expect the built-in flash to work miracles even at a Flash Compensation of +3.0. Any built-in flash has a limited range, and you simply can't expect the flash light to reach faraway objects. In other words, don't even try taking flash pictures of a darkened recital hall from your seat in the balcony — all you'll wind up doing is annoy everyone.

With that preface in mind, you can adjust flash power through either the Live Control or Super Control Panel display, as shown in Figure 6-36, or from Shooting Menu 2, as shown in Figure 6-37.

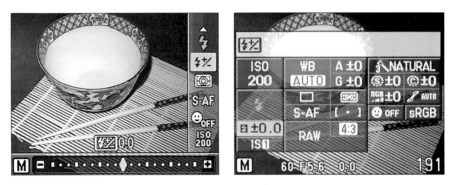

Figure 6-36: Access the setting from the Live Control or Super Control Panel screens.

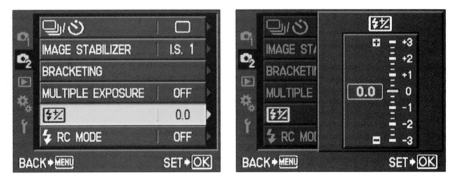

Figure 6-37: Flash intensity can also be adjusted through Shooting Menu 2.

Keep these additional bits of related information in mind:

✔ **Setting flash and Exposure Compensation together:** Normally, Flash Compensation and Exposure Compensation are independent entities. You use the Exposure Compensation setting to control the ambient exposure and you use Flash Compensation to affect flash power.

You can choose to link the two adjustments, however. If you then tap the up-arrow key to set an Exposure Compensation value, the camera adjusts both flash and ambient exposure. I prefer the default setup, but if you want to experiment with the difference, head for Custom Menu F and select the option shown in Figure 6-38. Change the setting to On and press OK. Note that you don't see the Flash Compensation value change on the displays, however.

✔ **Disabling Flash Compensation:**
As with Exposure Compensation, any flash-power adjustment you make remains in force, even if you turn off the camera, until you reset the control. So be sure to check the setting before you next use your flash.

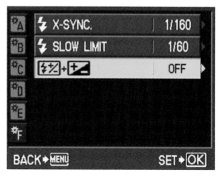

Figure 6-38: Keep this option set to Off if you want to control Flash Compensation and Exposure Compensation separately.

Bracketing Exposure, ISO, and Flash

Many professional photographers use a strategy called *bracketing* to ensure that at least one shot of a subject is properly exposed. They shoot the same subject multiple times, slightly varying the exposure settings for each image.

To make bracketing easy, your E-PL1 offers *automatic exposure bracketing,* or *AEB* in popular photo lingo. When you enable this feature, the camera takes one shot at your selected exposure settings, a second shot using settings that produce a darker image, and a third shot using settings that produce a brighter image. You can vary the exposure by as much as one stop.

The E-PL1, however, takes things further than most cameras that offer automatic bracketing, enabling you to bracket not just basic exposure, but also flash power, ISO, and white balance.

Chapter 7 details white-balance bracketing; to take advantage of exposure, flash, or ISO bracketing, follow these steps:

1. **Set the Mode dial to P, A, S, or M mode.**

 You can't use auto bracketing in the other modes, including ART mode.

2. **Display Shooting Menu 2 and highlight Bracketing, as shown in Figure 6-39.**

3. **Press OK.**

 You see the Bracketing screen shown on the left in Figure 6-40.

Figure 6-39: Enable bracketing through Shooting Menu 2.

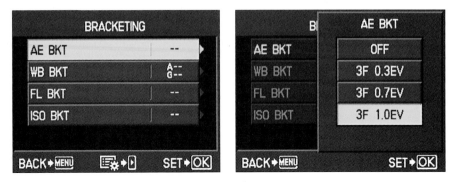

Figure 6-40: Select the option you want to bracket and press right to set the increment of adjustment.

4. Select the picture setting that you want to bracket.

Again, your options are AE (for exposure bracketing), WB (for white-balance bracketing), FL (for flash bracketing), and ISO (for ISO bracketing).

See the bulleted list of tips following these steps for details about each option.

5. Press the right-arrow key.

For exposure, flash, and ISO bracketing, you see a screen that contains the options shown on the right in Figure 6-40.

6. Set the bracketing amount.

In other words, how much change do you want to see between frames? By default, you can adjust exposures by one-third stop (0.3), two-thirds stop (0.7), or a whole stop (1.0).

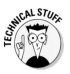

If you vary the setting of the EV Step option on Custom Menu E, your exposure and flash bracketing increments become more limited. For example, if you set the EV Step option to 1/2 stop, you can apply exposure or flash bracketing shifts of either 0.5 or 1.0, and if you set the EV Step value to 1.0, you're limited to bracketing exposures only by one full stop. Adjusting the ISO Step value doesn't change the increments available for ISO Bracketing, however. See the sidebar "Exposure stops: How many do you want to see?" for details on both menu options.

7. Press OK to exit the menu.

BKT appears at the top of the monitor, as shown in Figure 6-41. You also see a variation of the exposure meter, regardless of whether you're shooting in M, A, S, or P mode. Beneath the meter, you see three bars,

one representing each of the three shots of the bracketing series. The positions of the bar represent the bracketing amount; for example, if you set exposure bracketing to vary one stop between exposures, you see a bar at the middle of the meter (0.0), one at the –1.0 position, and one at the +1.0 position.

Figure 6-41: The white BKT symbol tells you that you're set to snap the first picture in the bracketed series.

You can combine Exposure Compensation with bracketing. For example, if you set the Exposure Compensation setting to EV +1.0 and set the exposure bracketing amount to 1.0, you get one exposure at EV +1.0, setting, one at EV +2.0, and one at EV +0.0. The three bracketing indicator bars shift along the meter to show you the setting at which each shot will be taken: The middle bar appears at the +1.0 spot on the meter, the left bar at 0.0, and the right bar at +2.0.

8. **Record your bracketed series.**

The shutter-release mode determines how you take this step. In single-frame (regular) release mode, press the shutter button fully for each shot. But in Sequential mode, press and hold the button down and wait for the camera to record all three shots. To record another series in Sequential mode, lift up on the button and press again.

Note, too, that the BKT symbol on the monitor turns green after you take the first shot in the series. After you shoot the third image, it turns white again to let you know that your next shutter-button press will start a new series.

If you forget which shot you're on, just take a close look at the meter. After you take the first shot, the middle bar under the meter remains white but the other two turn green. Take the second shot, and the bar on the negative side of the scale turns white. Take the third shot, and the bar on the right side of the meter turns white. Figure 6-42 gives you a close-up look at this meter display scheme.

9. **To disable bracketing, return to Shooting Menu 2 and set the selected bracketing option to Off.**

How the camera achieves the variations between frames depends on the type of bracketing, as follows:

✏ **Exposure bracketing:** The camera adjusts either shutter speed or f-stop, depending on the shooting mode. In P and S modes, f-stop changes between shots to produce the brighter and darker exposures. In M and A modes, the shutter speed is adjusted instead. So if you want to maintain the same depth of field between shots, bracket in M or A modes. And if you want a moving subject to be recorded at the same speed throughout the series of shots, bracket in S mode. (You could also use P mode, but S mode enables you to select a specific shutter speed.)

✏ **ISO bracketing:** The camera uses the currently selected ISO setting for the first shot and then ramps ISO up or down, according to the bracketing amount you set, for the other two shots. If you bracket shots while Auto ISO is in force, the initial shot is taken at the ISO the camera considers optimal, and the other two shots are taken at the higher and lower ISO settings.

✏ **Flash bracketing:** Flash power is adjusted between frames, and other exposure settings are left unchanged.

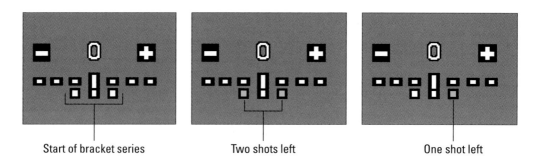

Start of bracket series Two shots left One shot left

Figure 6-42: The little bars under the meter also tell you which shot you're about to take.

7

Manipulating Focus and Color

In This Chapter

▷ Controlling the camera's autofocusing performance

▷ Focusing manually

▷ Understanding focal lengths, depth of field, and other focus factors

▷ Exploring white balance and its affect on color

▷ Investigating other advanced color options

*T*o many people, *focus* has just one interpretation when applied to a photograph: Either the subject is in focus or it's blurry. But an artful photographer knows that there's more to focus than simply getting a sharp image of a subject. You also need to consider *depth of field,* or the distance over which objects remain sharply focused. This chapter explains all the ways to control depth of field as well as how to take best advantage of the myriad focusing options on your camera.

In addition, this chapter dives into the topic of color, explaining your camera's White Balance control, which compensates for the varying color casts created by different light sources. You also can get my take on the other color features, including the Color Space option and Picture Mode settings, in this chapter.

Understanding Focusing Basics

One of the most important advantages you gain from stepping up to a camera like the E-PL1 is access to an array of focusing features. Although I cover all the focusing options in this chapter, the two most critical to understand are the following:

✏ **AF Mode:** Use this setting to specify whether you want to focus manually, take advantage of autofocusing, or enjoy both together, using autofocusing to set the initial focus point and then fine-tuning focus manually. The only shooting mode that doesn't let you select an AF Mode is SCN; in that mode, the camera selects the most appropriate setting.

✏ **AF Target:** If you go with autofocusing, use this setting to tell the camera what area of the frame to analyze when establishing focus. You can ask the camera to consider all 11 of its autofocusing points or to base focus on a single point that you select. This option is available in all shooting modes.

Together, these two options set the foundation for focusing with the E-PL1, so make learning them your priority. The next several sections detail each option individually.

Whichever autofocusing options you choose, you must take a two-stage approach to pressing the shutter button. Press halfway to initiate autofocusing and then press the rest of the way to take the picture. If you just jab down the shutter button in one motion, you don't give the camera a chance to put its focusing system to work. And speaking of jabbing the button — don't. Press gently to avoid introducing camera shake that can blur the image.

Choosing an AF Mode: MF, S-AF, or C-AF?

The first step in controlling focus with the E-PL1 is to select an AF Mode, which sets the camera to either manual focusing or autofocusing. How you get to the AF Mode depends on whether you're setting up for still photography or movie recording:

✏ **Setting the AF Mode for still photography:** You can adjust the setting by using the Live Control or Super Control Panel displays, as shown in Figure 7-1. Again, you don't have control over the option in SCN mode, but you can see which mode the camera selected for you by bringing up the displays.

If you like to do things the hard way, you also can set the AF Mode through Custom Menu A. Select AF Mode, as shown on the left in Figure 7-2, and press OK to display the screen shown on the right. From there, select Still Picture and press right to display the menu of AF Mode settings.

✏ **Setting the AF Mode for movie recording:** You can use either the Live Control panel or the menu-driven approach. The Super Control Panel isn't available for movie recording.

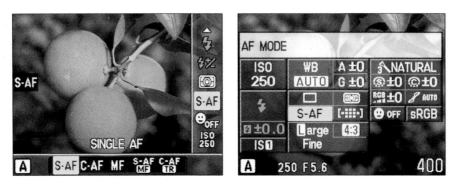

Figure 7-1: The Control panels offer the fastest ways to change the AF Mode setting.

Figure 7-2: You also can access the setting through Custom Menu A.

No matter how you get to the AF Mode, you can choose from five settings. Upcoming sections explain the step-by-step process for using each mode, but here's a quick overview of how each is designed to work:

✔ **S-AF (single autofocus):** With this option, the camera locks focus when you depress the shutter button halfway. This mode is designed for shooting stationary subjects. (Think *S* for *still, stationary.*) This mode is the default for all shooting modes except some SCN modes.

✔ **C-AF (continuous autofocus):** In this mode, which is designed for moving subjects, the camera sets focus initially at the time you press the shutter button halfway but then continually adjusts focus as necessary up to the time you take the picture. (Think *C* for *continuous motion.*)

This mode works only with Micro Four Thirds lenses (such as the kit lens sold with the camera). If you mount a regular Four Thirds lens, the camera uses single autofocus even if you select one of the continuous options as the AF Mode.

✓ **MF (manual focusing):** Choose this option to abandon autofocus and set focus manually, by twisting the focusing ring on the lens.

✓ **S-AF+MF (single autofocus with manual override):** In this mode, you press the shutter button halfway to set focus, as in regular S-AF mode. But you then can fine-tune focus by twisting the lens focusing ring without having to switch to MF mode. This option is great for shooting situations that traditionally prove troublesome for autofocusing mechanisms: subjects behind fences, highly reflective objects, and low-contrast scenes. If the autofocus system can't quite find its target, you can easily step in and give the focusing ring a twist to set focus. But be careful because it's easy to forget that the manual-focus option is enabled and accidentally move the focusing ring and change focus when you don't mean to.

✓ **C-AF+TR (continuous autofocus with subject tracking):** This mode, which also works only with Micro Four Thirds lenses, is an updated, more sophisticated continuous autofocusing feature, capable of more precisely tracking a subject's movement through the frame.

Your choice of autofocus mode also affects whether the camera lets you take a picture if focus can't be achieved. By default, the camera refuses to release the shutter in S-AF mode until focus is locked. No way, no how; the camera isn't going to take an out-of-focus picture no matter how hard you press the shutter button. With C-AF or C-AF+TR, the opposite occurs: The camera assumes that because this mode is designed for shooting action, you want to capture the shot at the instant you press the shutter button, regardless of whether it had time to set focus. You also are free to record an out-of-focus picture with S-AF+MF; in this case, the camera assumes that you know what you're doing with that manual focus ring and it doesn't interfere.

Because Olympus figures you didn't buy a camera as advanced as the E-PL1 to be limited to only one way of doing things, though, you can adjust this behavior through two *release-priority options.* These two options live all by themselves on Custom Menu C, as shown on the left in Figure 7-3. Select Release and press OK to view the settings, visible on the right in the figure. The two options work as follows:

Figure 7-3: These settings determine whether the camera lets you take a picture if focus hasn't been achieved.

> ✓ **RLS Priority S:** This one controls the shutter-release behavior for S-AF mode. If you want the camera to take a picture regardless of whether focus is achieved, change the option from its default setting, Off, to On. Now the camera knows that your priority is on shutter release over focus.
>
> ✓ **RLS Priority C:** To prevent the camera from releasing the shutter unless focus is achieved when you use continuous autofocusing (C-AF or C-AF+TR), change this setting from its default, On, to Off.

AF Area: One focus target or 11?

If you opt for autofocusing, the second critical setup step is to select an AF Area setting, which determines which part of the frame the camera uses to calculate focus distance.

On the E-PL1, autofocusing is based on an 11-point grid. If you tap the left-arrow key, you see the grid on the monitor, as shown in Figure 7-4. Either all the little boxes are green, as in the figure, or a single box is lit, as in Figure 7-5.

The green boxes indicate active focus areas. When all 11 boxes are green, all areas are active, and the camera chooses which one to use when setting the focus distance. Usually, the object closest to the lens wins. If only a single box is green, the camera bases focusing distance only on that specific area of the frame.

Olympus terminology refers to the mode that uses all the available focus points as All Targets mode. The single-point option is dubbed Single Target mode.

Upcoming sections explain the exact steps you use in either mode to set autofocus — they vary a little depending on whether you use continuous autofocusing or single autofocusing. In addition, when you shoot in Movie mode and set the AF Mode to one of the continuous autofocus settings, you can only use the single-target AF Area mode.

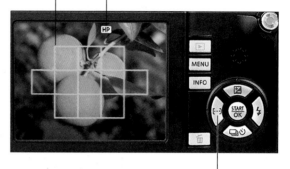

All Targets focus grid

Home Position icon

Press to set AF Mode

Figure 7-4: When all the AF targets are green, the camera looks at all 11 points to choose a focusing distance.

For now, set the mode dial to a setting other than Movie and familiarize yourself with these techniques, which provide the fastest ways to switch between the All Targets and Single Target modes and to choose a focus area in Single Target mode:

Selected focus target

- ✓ **Switch from All Targets mode to Single Target mode:** After displaying the focus grid, press any arrow key.

- ✓ **Select a focus area in Single Target mode:** Use the arrow keys to light up the target you

Figure 7-5: In Single Target mode, use the arrow keys to select the active focus area.

want to use. Press OK or give the shutter button a half-press and then release it to return to shooting.

If you look closely, you now can see a black focus frame representing the selected target area on the monitor, as shown in Figure 7-6. Use that outline as a reference when composing your shot, making sure that your subject falls within the selected target area before you press the shutter button halfway to initiate autofocus.

✔ **Switch from Single Target mode to All Targets mode:** Use the arrow keys to highlight a target at the very top, bottom, left, or right of the focusing grid. One more press in the same direction lights up all the targets. For example, if the active target is on the bottom row of the grid, as in Figure 7-5, press the down-arrow key to cycle back to All Targets mode.

Focus frame mark

Figure 7-6: In Single Target mode, an outline representing the selected target area appears.

You also can select the AF Area mode and focus target from Custom Menu A, although the process is more tedious. Select AF Area, as shown on the left in Figure 7-7, and press OK to display the second screen in the figure. For All Targets autofocusing, choose the top option, as shown in the figure, and press OK. For Single Target autofocus, select the second option, as shown in Figure 7-8, and press the right-arrow key. You then see the second screen in the figure. Use the arrow keys to light up the focus point you want to use and then press OK again.

Figure 7-7: You can also select an AF Area mode through Custom Menu A.

You have one additional target-selection option: In P, A, S, M, and ART modes, you can change the function of the Fn button or Movie button so that pressing the button selects a specific focus target or the All Targets setting. The AF target that you link to the button is your *home position*. Chapter 10 has details on button customization, but here's the short story: First, display Custom Menu B and set the button function to Home. For example, in

the left screen in Figure 7-9, I set the Fn button to Home. Next, specify which AF Target setting you want to use as your home position via the Set Home option on Custom Menu A, as shown on the right in the figure. Now when you press the assigned button, your home-position focus target flashes briefly to let you know that it's been activated. You still can select any focus target by pressing the left-arrow key. As you cycle through the various targets, a little HP (home position) icon appears when you reach your home position. (Refer to Figure 7-4.)

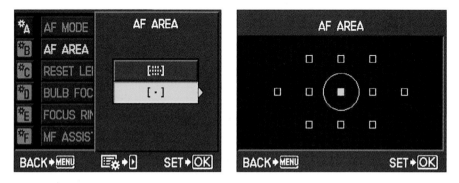

Figure 7-8: For Single Target autofocus, press right to access the screen where you can select the target you want to use.

Figure 7-9: You can assign the Fn or Movie button to select a favorite AF Target, known as your *home position.*

Matching autofocus settings to your subject

The key to getting the best performance out of the E-PL1's autofocus system is to select the right combination of AF Mode and AF Area settings for the job at hand.

I like to keep my world simple, so I boil down things like this:

✔ **For stationary subjects:** Use S-AF for the AF Mode and Single Target for the AF Area option. These combinations enable you to quickly lock focus on a specific part of the frame without worrying that the camera will mistakenly focus on something in the foreground or background instead of your subject. You also can use S-AF+MF to enable manual focus fine-tuning, but there are some danger points to doing so, as outlined in the next section, so I don't advise it for those not experienced with manual focusing.

✔ **For moving subjects:** For any picture in which the subject might move, whether it's a flower blowing in the breeze or a tennis player about to serve, things get a little more complicated. The ideal combination of settings depends on the subject, the setting, and your photographic goal.

 • *Focusing on a specific subject in a group:* Suppose that you're shooting a bike race, and you're interested in photographing one specific cyclist. You care only whether that cyclist is in focus. For this type of shot, I use C-AF+TR and select a single focus target. Those settings enable the camera to lock focus exactly on one subject and track that subject through the frame.

 • *Focusing on a solitary subject:* If your subject is the only significant thing in the frame, the camera can typically do a good job with either C-AF or C-AF+TR. And you usually don't have to select a specific target; you can rely on the camera to pick out the right subject in All Targets mode. So back to the cyclist example, these setups would work to capture a single rider on a track. Remember, though, that in Movie mode, you must select a focus target; All Targets mode is disabled for continuous autofocusing for movie shooting.

 • *Focusing on a group of moving subjects:* Now suppose that your goal is to capture a group shot of all the cyclists at the start of the race, and you aren't interested in singling out any one subject. For this type of group action, choose C-AF and All Targets mode. That combination offers the easiest continuous autofocusing and should work well for most scenes. Again, this tip applies only to still photography; for Movie mode, you must select a focus target.

The actual process you use to focus varies slightly depending on which of these combinations you choose. So the next sections show you the ropes. But keep in mind that manual focusing in some cases is just as easy, if not easier, than using autofocus. So don't rule out that option for either still or moving subjects. See the section "Using manual focus," later in this chapter, for tips.

Autofocusing on stationary subjects: S-AF and Single Target

For stationary subjects, whether it's a portrait subject or a landscape, I recommend the following approach to autofocusing:

1. **Set the AF Mode to S-AF, as shown on the left in Figure 7-10.**

 The fastest way to adjust the setting is via the Live Control display, as shown on the left in the figure, or the Super Control Panel.

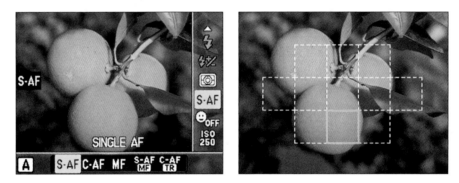

Figure 7-10: I prefer these settings for autofocusing on stationary subjects.

2. **Set the AF Area mode to Single Target and select a specific target area.**

 As outlined in the preceding section, start the process of choosing this setting by pressing the left-arrow key. Then press any arrow key to select the focus target you want to use. The target that's green is the current focus target.

3. **After setting the focus target, press OK to return to shooting.**

 Or you can just give the shutter button a quick half-press and release it. Either way, the little black target indicator appears on the monitor, as shown in Figure 7-11.

4. **Frame the shot so that the focus target is over the subject.**

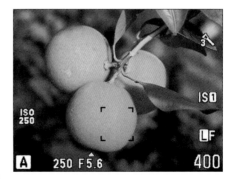

Figure 7-11: Make sure that your subject falls under the black target marks.

5. **Press and hold the shutter button halfway to initiate autofocusing and exposure metering.**

If the camera successfully achieves focus, the selected focus target turns green for an instant and the focus lamp lights in the upper-right corner of the screen, as shown in Figure 7-12. You also hear a tiny beep from the camera's speaker.

Both focus and exposure are now locked and remain locked as long as you keep the shutter button pressed halfway.

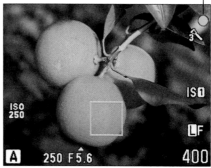

Focus light

Figure 7-12: If the camera achieves focus, you see the green focus lamp and hear a beep.

6. **Press the shutter button the rest of the way to take the shot.**

Don't forget that by default, the camera doesn't let you take the picture when focus isn't set. To modify that behavior, see the earlier section "Choosing an AF Mode: MF, S-AF, or C-AF?"

Now for a few nuances of this autofocus technique:

✒ **Positioning your subject outside a focus point:** Having to select a focus point before each shot can get a little tedious. So try this timesaver: Set the center target as the active focus point. Compose the shot initially so that your subject is under the center target, press the shutter button halfway to lock focus and exposure, and then reframe and press the button the rest of the way down. After you master this technique, you can simply use the center target for all shots, no matter where you ultimately want the subject to appear in the frame.

✒ **Fine-tuning autofocus manually with S-AF+MF mode:** If you change the AF Mode from S-AF to S-AF+MF, you can press the shutter button halfway to lock focus and then twist the lens focusing ring to fine-tune focus if needed. On the surface, this option sounds like the best of both worlds, and it can be, for those experienced in manual focusing. But you need to use this focusing option with caution. You can easily inadvertently move the focusing ring and muck up focus without realizing it. Additionally, although the monitor on the E-PL1 is really good, it's not always easy to determine exact focus from the display. There's no visual indication that you have achieved focus once you twist the focusing ring, and the camera will take the picture in this mode regardless of the release-priority option you set through Custom Menu C.

To try out this method of focusing, set the AF Mode to S-AF+MF, position your subject under the focus target, and press and hold the shutter button halfway. Keep pressing the button and then twist the lens focusing ring, labeled in Figure 7-13, to adjust focus. Press the button the rest of the way down to take the picture.

It's critical that you keep the shutter button pressed halfway as you adjust the focus manually. Otherwise, when you go to take the picture, the camera goes through the initial auto-focusing step as soon as you press the shutter button halfway again, thus sending you back to square one.

Focusing ring

Figure 7-13: If you use autofocus with manual override, be careful not to accidentally move the focusing ring.

Should you have trouble getting precise focus in S-AF mode, you have a really cool alternative to using S-AF+MF: You can zoom the live display and then tell the camera to focus on the zoomed part of the frame. This feature is pretty amazing, so I dedicate a separate section of the chapter to it. Look for the upcoming section "Taking advantage of zoom-frame autofocus," in this chapter.

Focusing on moving subjects

When you need to autofocus on a moving target, choose one of the two continuous autofocus modes, C-AF or C-AF+TR. (**Remember:** Neither option is available if you aren't using a Micro Four Thirds lens, though.)

As explained earlier, which mode works best — and which AF Area mode you should choose to go with it — depends on the subject. If you want to focus on a specific subject in a group shot, using C-AF+TR and a single AF target works best. But for group action shots where it's not critical for a specific subject to be sharply focused, C-AF and All Targets mode is easier and, often, faster. However, Movie mode requires you to select a specific target for either continuous autofocus option.

If all this seems a little confusing . . . well, it is. The best thing to do is to experiment. The difference in how the two modes operate is much clearer when you try them. To that end, the next two sections detail autofocusing steps for both continuous autofocusing modes, explaining when and how to switch the AF Area mode to your advantage.

Using tracking autofocus (C-AF+TR)

To recap earlier information, the C-AF+TR autofocus mode is a newer, more advanced form of continuous autofocusing than plain old continuous auto-focus (C-AF) mode. C-AF+TR can lock focus on a subject and then track that subject as it moves through the frame. All you need to do is pan the camera as needed to keep the subject within the bounds of the frame.

To try out tracking autofocus, take these steps:

1. **Set the AF Mode to C-AF+TR.**

 Your quickest option is to use the Live Control display, as shown on the left in Figure 7-14.

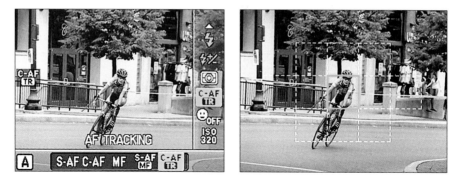

Figure 7-14: Continuous autofocus with subject tracking works best for most action shots.

2. **Set the AF Area mode to Single Target mode and select a focus target.**

 If you're not sure where in the frame the subject will be when it's time to focus, select the center target, as shown on the right in Figure 7-14.

3. **Frame the shot so that your subject appears under the selected focus target and press and hold the shutter button halfway.**

 The camera initiates autofocusing and exposure metering. When the camera locks focus, you hear the normal focus-achieved beep. You also

see the green focus light in the upper-right corner of the screen, as in S-AF mode, but it disappears after a second.

The critical focusing symbol to notice is the green target, labeled on the left in Figure 7-15, which indicates the subject that the camera will try to track. If the target isn't over your subject, release the shutter button and try again.

When the target is, er, on target, you can reframe the shot if needed — focus remains locked on the subject as long as you keep the shutter button pressed halfway. As your subject moves, the green target follows it across the frame, as shown on the right in Figure 7-15. You may need to pan the camera to make sure the subject doesn't leave the frame, as I did for this shot.

Focus tracking target

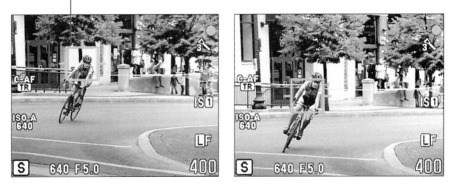

Figure 7-15: The green target follows your subject through the frame.

4. **If the target turns red, release the shutter button and reset focus.**

The red target is the camera's ways of telling you that it lost track of the subject. Sometimes you can wait for the camera to find the focus point again — in which case the target turns green again — but it's usually better to just release the shutter button and establish focus again. Either way, when focus is reset, you hear the usual focus-locked beep and see the green focus lamp.

5. **Press the shutter button the rest of the way to take the shot.**

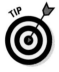

I want to clarify one point with regard to this example photo: I selected this image because it makes seeing the onscreen focus markings and settings easy. But this example may cause some confusion given that earlier, I suggested that for a solitary subject such as this, the C-AF and All Targets

autofocusing options could also work well. They would have, too — but just for this moment in time. The cycling event at which I took this shot involved a large group of riders completing multiple laps on a small route through town. So although the cyclist in the example photo was apart from the rest of the riders when I caught this frame, she was just as often riding in close proximity to other competitors. And when you're shooting action, you don't want to waste precious seconds between frames fiddling with your camera settings. So I chose the pairing that would work whether the cyclist was alone or not — C-AF+TR and Single Target AF Area mode. Remember that for Movie shooting, you must specify a single target no matter what continuous autofocus mode you choose.

Using regular continuous autofocusing (C-AF)

Like the C-AF+TR autofocus mode, C-AF continuously adjusts focus up to the time you take the shot, but without tracking a specific target subject. In that regard, this mode is a little less sophisticated than C-AF+TR. But the C-AF mode works fine for times when you don't need the focus system to pick out one moving subject from a crowd or when there isn't anything in the frame to confuse the camera. Photographing a flock of birds or capturing a solitary sailboat gliding across the water are just two subjects that would prove easy tasks for the C-AF autofocusing system.

For Movie mode, you must select a focus target. But for still photography, I typically pair C-AF with the All Targets mode simply to enable faster shooting: Letting the camera select the focus target means I don't have to stop and select a specific target. For shooting scenes like the flock of birds in Figure 7-16, even a few seconds' delay can cause you to miss capturing the height of the action.

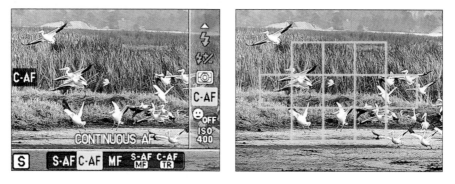

Figure 7-16: Choosing C-AF (left) and All Targets mode (right) works well for scenes like this one.

Here's the technique I use when pairing these two autofocus settings — again, for still photography only:

1. **Set the AF Mode to C-AF, as shown on the left in Figure 7-16.**

 You can use the Live Control screen, as shown in the figure, or adjust the setting through the Super Control Panel or Custom Menu A.

2. **Set the AF Area mode to All Targets, as shown on the right in the figure.**

 Remember, you can adjust the mode by tapping the left-arrow key.

Figure 7-17: The focus lamp appears when focus is achieved, but focus is adjusted up to the time you take the shot.

3. **Frame the subject and press the shutter button halfway.**

 When the camera establishes focus, you see the green focus confirmation light and hear the focus-lock beep, as shown in Figure 7-17. However, in this mode, no green focus target appears.

 If the subject moves, the camera attempts to adjust focus appropriately. You can sometimes hear the autofocus motor doing its thing and see the focus adjustment on the monitor.

4. **Press the shutter button the rest of the way to take the picture.**

If the camera has trouble picking out your subject, you can switch to Single Target mode and provide a focusing assist. If you do, frame the shot with the selected focus point over the subject and press the shutter button halfway. You see the focus frame flash green for an instant when initial focus is set in this case.

Shutter speed and blurry photos

A poorly focused photo isn't always related to the issues discussed in this chapter. Any movement of the camera or subject can also cause blur. Both of these problems are related to shutter speed, an exposure control that I cover in Chapter 6. Be sure to also visit Chapter 8, which provides some additional tips for capturing moving objects without blur.

Taking advantage of zoom-frame autofocus

Chapter 1 explains an E-PL1 feature that enables you to magnify the live view display so that you can check the details in a scene. But you can do more than get a close-up view: You can tell the camera to set autofocus on an object in that zoomed frame. Follow these steps to use zoomed autofocusing:

1. **Press the Zoom button.**

 A green focus frame appears, as shown on the left in Figure 7-18.

Figure 7-18: Press Zoom and then position the green frame over the subject.

2. **Use the arrow keys to move the focus frame over the spot where you want to set focus.**

3. **Press Zoom again.**

 Now the live view becomes magnified, with the display centered on the subject that was under the green focus frame, as shown on the right in Figure 7-18.

4. **To scroll the display, press the arrow keys.**

5. **To change the magnification level, press the Info button and then press the up- or down-arrow key.**

 The magnification value, labeled on the left in Figure 7-19, becomes active after you press Info. You can set the zoom level to 7x (the default setting), 10x, or 14x. I changed the value to 10x in Figure 7-19. Press Info again to lock in the magnification level.

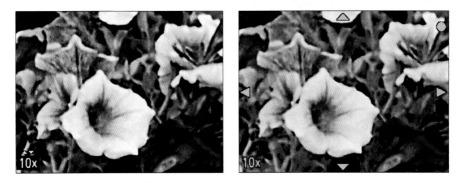

Figure 7-19: To change the magnification level, press Info.

6. **Press the shutter button halfway to set focus.**

 Focus is set on the object in the zoomed frame, and the focus lamp appears, as shown on the right in Figure 7-19.

7. **Press the shutter button the rest of the way to take the picture.**

 Remember that the camera captures the entire scene in front of the lens, not just the area in the preview.

8. **To exit the zoomed preview, press the Zoom button.**

 The green zoom reappears on the monitor so that you can take additional shots; just repeat Steps 2–7.

9. **To return to normal focusing, press OK.**

Using manual focus

Whenever possible, I rely on autofocusing. I find today's autofocus systems amazingly accurate, and letting the camera do the focusing frees me to concentrate on composition and other aspects of the shot. However, even the best autofocus system can have trouble picking out some focusing targets. At the zoo, for example, the focus system sometimes tries to lock focus on the fence or cage instead of the animal. Dark scenes like the one in Figure 7-20 also can be problematic because the camera needs light to find its focus target.

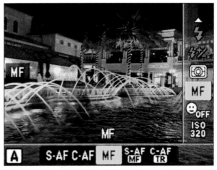

Figure 7-20: To use manual focusing, you must set the AF Mode to MF.

Preventing autofocus reset

By default, the camera resets focus to infinity (the farthest focusing distance) every time you power down the camera. That resetting can be annoying in some situations. For example, suppose that you're photographing a bride-to-be opening presents at a wedding shower. You turn off the camera during breaks in the action to save battery power, and then must refocus each time you get ready to shoot again — even though the focusing distance between you and the party's star hasn't changed. You can even miss a great moment during the time it takes to refocus.

To stop the camera from resetting focus, travel to Custom Menu A and change the Reset Lens option from On to Off, as shown in the figure here. Now the last focusing distance you used will be retained even if you turn off the camera.

#A	AF MODE	
#B	AF AREA	[·]
#C	RESET LENS	OFF
#D	BULB FOCUSING	OFF
#E	FOCUS RING	↻
#F	MF ASSIST	OFF

BACK➔MENU SET➔OK

So even if you use autofocusing 99 percent of the time, you need to understand how to step in and focus manually when needed. On the E-PL1, all you do is set the AF Mode to MF, as shown in Figure 7-20, and then twist the lens focusing ring (refer to Figure 7-13). You don't need to worry about selecting a focus target — those targets are purely an autofocusing tool.

You have a couple ways to customize the manual focusing process:

✓ **Change the focusing direction of the focus ring:** Normally, twisting the focus ring away from the shutter button shifts focus toward *infinity* — the farthest possible focus point. If you're used to a lens that works in the other direction, you can change the setup so that the lens adjusts focus in the other direction. To make this change, select the Focus Ring option on Custom Menu A, as shown in Figure 7-21, and then set the option to the one highlighted on the right in the figure. (The arrow indicates the direction you turn the lens to shift focus toward infinity.)

✓ **Enable automatic magnification during manual focusing:** In the preceding section, I explain how you can magnify the live image preview to base autofocus on a small area of the frame. You can also magnify the view during manual focusing to see whether you turned the focusing ring to the right position. Use the same zooming steps as when autofocusing.

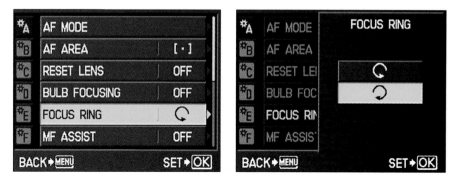

Figure 7-21: Select this option to reverse the focusing direction of the focusing ring.

If you like this feature, you can opt to have the magnified view appear automatically when you rotate the focusing ring during manual focusing. Look for the MF Assist option on Custom Menu A, as shown in Figure 7-22. The feature is turned off by default, and I prefer that setting. Maybe it's because I'm just not used to it, but I find it jarring to suddenly be thrown into magnified view every time I turn the focus ring. I'd rather set the focus as best I can and then use the live view zoom technique if I need a closer look.

Figure 7-22: If you turn on this option, the live view automatically becomes magnified as soon as you turn the focus ring.

If you disagree, just set the MF Assist option to On. The zoomed preview uses the magnification level you last set for regular live-view zooming (7x, by default). You can't adjust the magnification level while using MF Assist.

✏ **Bulb focusing:** In Manual (M) exposure mode, you can select a special shutter speed — *bulb*. At this setting, the shutter remains open for as long as you hold down the shutter button. If you set the Bulb Focusing option on Custom Menu A to On, as it is by default, and set the AF Mode to MF, you can twist the focus ring during the exposure and create some focusing special effects. Obviously, this is a special technique that requires some practice, and I suggest that most people disable it for bulb shooting. That way, you don't accidentally adjust focus during the exposure. (The option is just two rows up from the MF Assist option, as shown in Figure 7-22.)

Manipulating Depth of Field

Getting familiar with the concept of *depth of field* is one of the biggest steps you can take to becoming a more artful photographer. Chapters 3 and 6 introduce the concept; here's a quick recap just to hammer home the lesson:

✔ *Depth of field* refers to the distance over which objects in a photograph appear sharply focused.

✔ With a shallow, or small, depth of field, distant objects appear more softly focused than the main subject (assuming that you set focus on the main subject, of course).

✔ With a large depth of field, the zone of sharp focus extends to include objects at a distance from your subject.

Which arrangement works best depends on your creative vision and your subject. In portraits, for example, a classic technique is to use a short depth of field, as I did for the photo in Figure 7-23. This approach increases emphasis on the subject while diminishing the impact of the background. Landscapes and architectural shots, such as the one in Figure 7-24, however, typically feature a large depth of field, keeping the foreground and background sharply focused to give them equal weight in the scene.

Shallow depth of field

Figure 7-23: A shallow depth of field blurs the background and draws added attention to the subject.

Figure 7-23 illustrates an important point about using very shallow depth of field: Objects in front of the subject may blur as well as objects in the background. Notice that the cyclist's glove and the fence are both in soft focus, for example.

So exactly how do you adjust depth of field? You have three points of control: aperture, focal length, and camera-to-subject distance, as spelled out in the following list:

Large depth of field

Figure 7-24: A large depth of field keeps both foreground and background subjects in focus.

- **Aperture setting (f-stop):** The aperture is one of three exposure settings, all explained fully in Chapter 6. Depth of field increases as you stop down the aperture (by choosing a higher f-stop number). For shallow depth of field, open the aperture (by choosing a lower f-stop number). Figure 7-25 offers an example; in the f/11 version, the background is much more sharply focused than in the f/4.7 version. I snapped both images using the same focal length and camera-to-subject distance, so aperture was the only variable. Focus was set on the foreground orange for both shots.

If you're a seasoned photographer used to manipulating depth of field through f-stop settings, it's important to note that at any aperture setting, the E-PL1 achieves *twice* the depth of field as would be produced using the same setting on a 35mm film single-lens reflex (SLR) camera. This difference stems from the lens being closer to the image sensor on the Micro Four Thirds cameras than it is on an SLR. See the sidebar "Lens math: Micro Four Thirds versus 35mm film," in this chapter, for more details on this subject.

- **Lens focal length:** In lay terms, *focal length* determines what the lens "sees." As you increase focal length, measured in millimeters, the angle of view narrows, objects appear larger in the frame, and — the important point for this discussion — depth of field decreases. Additionally, the spatial relationship of objects changes as you adjust focal length. As an example, Figure 7-26 compares the same scene shot at a focal length of 84mm and 28mm. I used the same aperture, f/16, and camera-to-subject distance for both examples.

f/11 f/4.7

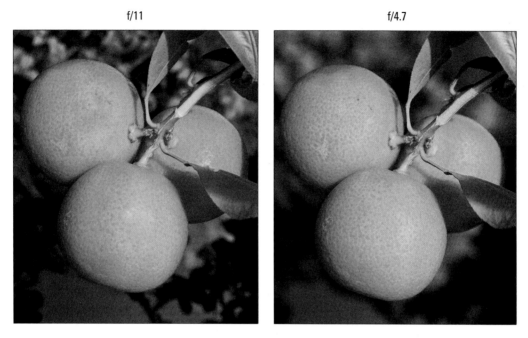

Figure 7-25: A lower f-stop number (wider aperture) decreases depth of field.

28mm 84mm

Figure 7-26: Zooming to a longer focal length also reduces depth of field.

Whether you have any focal length flexibility depends on your lens: If you have a zoom lens, you can adjust the focal length — just zoom in or out. If you don't have a zoom lens, the focal length is fixed, so you can manipulate depth of field only by changing aperture and camera-to-subject distance.

As with aperture, a given focal length produces different results on the E-PL1 than on a 35mm film camera. The aforementioned sidebar explains the issue in detail, but the short story is that the angle of view at any focal length is twice what you get on a 35mm film camera. For example, I shot the pictures in Figure 7-26 using the 14–42mm kit lens, which produces a focal length equivalent of a 28–84mm lens on a film camera. As is the custom in the photo industry, the focal lengths you see attached to pictures in this book represent the 35mm equivalent focal lengths.

✔ **Camera-to-subject distance:** As you move the lens closer to your subject, depth of field decreases. This assumes that you don't zoom in or out to reframe the picture, thereby changing the focal length. If you do, depth of field is affected by both the camera position and focal length.

Together, these three factors determine the maximum and minimum depth of field that you can achieve, as illustrated by my clever artwork in Figure 7-27 and summed up in the following list:

Greater depth of field:
Select higher f-stop
Decrease focal length (zoom out)
Move farther from subject

Shorter depth of field:
Select lower f-stop
Increase focal length (zoom in)
Move closer to subject

Figure 7-27: Your f-stop, focal length, and shooting distance determine depth of field.

✔ **To produce the shallowest depth of field:** Open the aperture as wide as possible (the lowest f-stop number), zoom in to the maximum focal length of your lens, and get as close as possible to your subject.

✔ **To produce maximum depth of field:** Stop down the aperture to the highest possible f-stop number, zoom out to the shortest focal length your lens offers, and move farther from your subject.

Here are a few additional tips and tricks related to depth of field:

✔ **Aperture-priority autoexposure mode (A) enables you to easily control depth of field while enjoying exposure assistance from the camera.** In this mode, detailed fully in Chapter 6, you set the f-stop, and the camera selects the appropriate shutter speed to produce a good exposure. The range of aperture settings you can access depends on your lens.

Even in aperture-priority mode, keep an eye on shutter speed as well. To maintain the same exposure, shutter speed must change in tandem with aperture, and you may encounter a situation where the shutter speed is too slow to permit handholding of the camera. You can raise the ISO setting to enable the camera to select a faster shutter speed.

✔ **For greater background blurring, move the subject farther from the background.** The extent to which background focus shifts as you adjust depth of field also is affected by the distance between the subject and the background. For increased background blurring, move the subject farther in front of the background.

✔ **You can set the Fn button or Movie button to display a depth-of-field preview in any mode except SCN and Movie.** When you press the shutter button halfway, you can get only a partial indication of the depth of field that your current camera settings will produce. You can see the effect of focal length and the camera-to-subject distance, but because the aperture is always fully open until you actually take the picture, the monitor doesn't show you how your selected f-stop will affect depth of field.

The E-PL1 offers a depth-of-field preview feature that enables you to see the impact of your selected f-stop, but to use the preview, you must dedicate the Fn button or the Movie button to that task. If you're interested, Chapter 10 shows you how. If you then press the assigned button, the camera temporarily sets the aperture to your selected f-stop so that you can preview depth of field. At small apertures (high f-stop settings), the display may become quite dark, but this doesn't indicate a problem with exposure — it's just a function of how the preview works.

Personally, I don't use this feature. After a while, you just come to learn what to expect at different apertures, so being able to preview the effect of changing the setting becomes unnecessary, and you can use the Fn and Movie buttons for other tasks.

Lens math: Micro Four Thirds versus 35mm film

A camera lens can be characterized by its *focal length,* measured in millimeters. Focal length determines angle of view (the area the lens can "see"), the apparent size and distance of objects in the scene, and depth of field. To choose the right lens for the type of pictures you want to take, you need to do a little math to convert stated focal lengths, which are based on 35mm-film camera standards, to the Micro Four Thirds camera design. Both the angle of view and depth of field differ from what you'd get from a given focal length on a 35mm film camera. (Spatial relationships between objects aren't affected.)

First, a little background on focal length. According to photography tradition, a focal length of about 50mm is a "normal" lens. A lens with a focal length less than 35mm is typically known as a *wide-angle* lens because at that focal length, the camera has a wide angle of view and produces a long depth of field, making it good for landscape photography. A short focal length also has the effect of making objects seem smaller and farther away. At the other end of the spectrum, a lens with a focal length longer than about 80mm is considered a *telephoto* lens (often referred to as a *long lens*). With a long lens, angle of view narrows, depth of field decreases, and faraway subjects appear closer and larger, which is ideal for wildlife and sports photographers.

Now here's the rub, and the reason for the first bit of arithmetic you need to do when comparing lenses: The angle of view you get at a given focal length depends on the size of the recording medium — the film negative or the image sensor, in a digital camera. The size of the E-PL1 sensor

means that to predict that angle of view that a lens will produce, you multiply the focal length by two. For example, the widest focal length on the kit lens — 14mm — delivers the angle of view you get from a 28mm lens on a 35mm film camera.

The proportions of the frame also differ: A 35mm film negative has a 3:2 aspect ratio, whereas the E-PL1 sensor has a 4:3 ratio. In the figure here, the background image shows the area captured by a 100mm lens on a 35mm film camera. The red outline indicates the area captured by the same focal length on a Micro Four Thirds camera. The resulting image area is roughly equivalent to that produced by a 200mm lens on a 35mm film camera, but with a 4:3 aspect ratio.

Additionally, when you use a Micro Four Thirds lens, the E-PL1 can achieve twice the depth of field as a 35mm film camera at a given focal length and aperture. For example, the depth of field at a focal length of 50mm and an aperture of f/2.8 on the E-PL1 is equal to a 50mm lens at f/5.6 on a 35mm film camera. The shift in this case occurs because depth of field varies according to the distance between the lens and *focal plane* — the position of the film negative or digital image sensor. The small form factor of a Micro Four Thirds camera and lens puts the lens much closer to the sensor than it is on a 35mm film camera. If you use lenses other than Micro Four Thirds lenses, you need to use an adapter ring to mount the lens, and that adapter changes the lens-to-sensor distance. So the depth-of-field calculation also changes depending on the size of that adapter ring.

If all this lens science has you perplexed, my best advice is to visit your local camera store, where you can get expert advice and try different lenses to see which one best suits your needs. You can find out more about the Micro Four Thirds technology and how it affects lens performance at www.four-thirds.org, and the Olympus Web site also has tools to help you match lenses to your photographic interests.

Controlling Color

Compared with understanding some aspects of digital photography — resolution, aperture and shutter speed, depth of field, and so on — making sense of your camera's color options is easy-breezy. First, color problems aren't all that common, and when they are, they're usually simple to fix with a quick shift of your camera's White Balance control. And getting a grip on color requires knowing only a couple new terms, an unusual state of affairs for an endeavor that often seems more like high-tech science than art.

The rest of this chapter explains the aforementioned White Balance control, plus a couple menu options that enable you to fine-tune the way your camera renders colors.

Correcting colors with white balance

Every light source emits a particular color cast. The old-fashioned fluorescent lights found in most public restrooms, for example, put out a bluish-greenish light, which is why your reflection in the mirrors in those restrooms always looks so sickly. And if you think that your beloved looks especially attractive by candlelight, you aren't imagining things: Candlelight casts a warm, yellow-red glow that is flattering to the skin.

Science-y types measure the color of light, officially known as *color temperature,* on the Kelvin scale, which is named after its creator. You can see the Kelvin scale in Figure 7-28.

When photographers talk about "warm light" and "cool light," though, they aren't referring to the position on the Kelvin scale — or at least not in the way most people usually think of temperatures, with a higher number meaning hotter. Instead, the terms describe the visual appearance of the light. Warm light, produced by candles and incandescent lights, falls in the red-yellow spectrum you see at the bottom of the Kelvin scale in Figure 7-28; cool light, in the blue-green spectrum, appears at the top of the Kelvin scale.

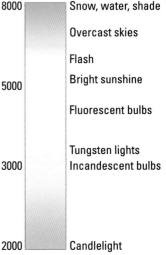

Figure 7-28: Each light source emits a specific color.

At any rate, most people don't notice these fluctuating colors of light because their eyes automatically compensate for them. Except in very extreme lighting conditions, a white tablecloth appears white no matter whether people view it by candlelight, fluorescent light, or regular house-lights.

Similarly, a digital camera compensates for different colors of light through white balancing. Simply put, *white balancing* neutralizes light so that whites are always white, which in turn ensures that other colors are rendered accurately. If the camera senses warm light, it shifts colors slightly to the cool side of the color spectrum; in cool light, the camera shifts colors the opposite direction.

The good news is that, as with your eyes, your camera's Auto White Balance setting tackles this process remarkably well in most situations, which means that you can usually ignore it and concentrate on other aspects of your picture or movie. But if your scene is lit by two or more light sources that cast different colors, the white balance sensor can get confused, producing an unwanted color cast like the one you see in the left image in Figure 7-29.

I shot this product image in my home studio, which I light primarily with photo lights that use tungsten bulbs, which have a color temperature similar to regular household incandescent bulbs. The problem is that the windows in that room also permit strong daylight to filter through. In Auto White

Balance mode, the camera reacted to that daylight — which has a cool color cast — and applied too much warming, giving my original image a yellow tint. No problem: I used the E-PL1 One Touch White Balance feature to precisely measure the color temperature of the light and create a customized White Balance setting that rendered the colors perfectly. The right image in the figure shows the corrected image.

Mixed lighting, Auto WB Mixed lighting, One Touch custom WB

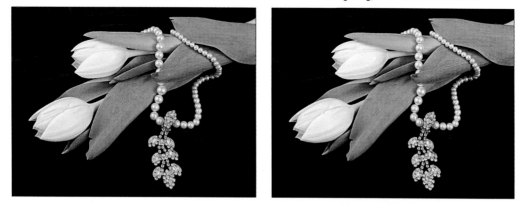

Figure 7-29: Multiple light sources resulted in a slight color cast in Auto White Balance mode (left); creating a custom White Balance setting solved the problem (right).

The next section explains how to make a simple white balance correction; following that, you can explore some advanced white balance options, including the One Touch feature I used when shooting Figure 7-29.

Changing the White Balance setting

In the iAuto and SCN shooting modes, you have no control over white balance, although you can make colors slightly warmer or cooler through the Live Guide Change Color Image feature in iAuto mode. In other modes, you can access the White Balance setting through the Live Control display, as shown on the left in Figure 7-30, or the Super Control Panel, as shown on the right. (See Chapter 1 for help enabling and using these displays; remember that the Super Control Panel isn't available in Movie mode.) Or you can change the setting via Custom Menu G, as shown in Figure 7-31. The various White Balance settings are represented by the icons you see in Table 7-1. In the menus, the specific color temperature for each setting is shown.

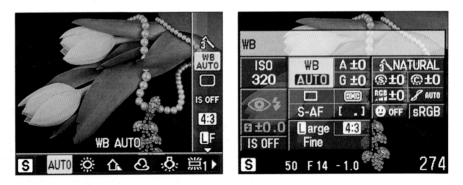

Figure 7-30: Use the Live Control or Super Control Panel displays to quickly change the White Balance setting.

Figure 7-31: Going through the menus gives you access to tools for fine-tuning white balance.

Table 7-1	White Balance Settings
Symbol	*Light Source*
AUTO	Auto
☀	Sun
⌂	Shade
☁	Cloudy
🔆	Incandescent

Symbol	Light Source
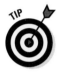1	Fluorescent 1
2	Fluorescent 2
3	Fluorescent 3
WB⚡	Flash
🖵	One Touch White Balance
CWB	Custom

TIP

If you're not sure which setting will work best, using the Live Control panel is the best route to go because you can see the effect of the change on the monitor.

Here are a few other tips about adjusting white balance:

🖊 **Previewing four settings at once:** For still photography in P, A, S, and M modes, you can switch the live display to Multi View and compare the current White Balance setting with three other options, as shown in Figure 7-32. You first must enable the Multi View display; Chapter 1 shows you how. Then just press the Info button as needed to cycle through all the other displays until you get to Multi View display. Press the right-arrow key to see how the picture looks at additional White Balance settings.

Figure 7-32: You can compare the result of White Balance settings in the Multi View display.

REMEMBER

Multi View is also used to compare four Exposure Compensation settings; to switch from that comparison screen to the White Balance screen, press the up- or down-arrow key. (Note the helpful little reminder displayed in the lower-left corner of the screen.)

✔ **Using One Touch White Balance:** This very nifty White Balance option enables you to set the white balance to precisely match the current lighting conditions — a great help when your subject is lit by different types of light. See the next section for details.

✔ **Selecting a specific Kelvin temperature:** If you work with professional photography lights, whether constant lighting or strobe (flash) units, you may find it easiest to use the Custom WB option, which lets you select a specific Kelvin temperature. You can then just select the temperature that most closely matches that of your lights.

To take advantage of this option through the Live Control display, highlight CWB, as shown on the left in Figure 7-33. Then press the Info button to activate the Kelvin value, as shown in the right. Press the up- or down-arrow key to adjust the value and press Info again to finish. You can select the temperature through the Super Control Panel in the same way. But there's one little quirk: If you want to switch between the two displays — which you also do by pressing Info — you have to first select a different White Balance setting or another picture option altogether. Otherwise, you just keep toggling the Kelvin adjustment setting on and off.

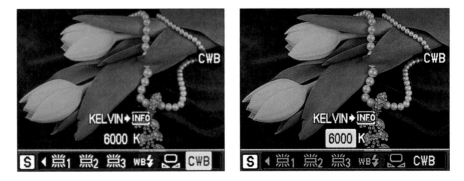

Figure 7-33: To select a specific Kelvin temperature, use the Custom White Balance (CWB) setting.

You also can select a specific Kelvin temperature through the menus. Just select Custom White Balance and then press the right-arrow key to display the screen where you can select the temperature value.

✔ **Fine-tuning white balance:** If you want to permanently shift how the camera renders colors at a specific White Balance setting, you can do some fine-tuning through the White Balance Compensation option, explained later in this chapter. You can even adjust all the White Balance settings in one step if you're so inclined.

✏ **Bracketing white balance:** For a color safety net, you also can ask the camera to record three versions of each image, using different White Balance settings for each image. You can find details a short drive from here.

Your selected White Balance setting remains in force until you change it. So you may want to get in the habit of resetting the option to the Auto setting after you finish shooting whatever subject it was that caused you to switch to manual White Balance mode.

Using One Touch White Balance

If none of the preset White Balance options produces the right amount of color correction, you can ask the camera to directly measure the current light and then adjust the white balance accordingly. Most advanced digital cameras offer this option, but few make it as easy as the E-PL1 — you really can accomplish the white balance customization with just one touch. (Well, okay, a couple touches, but trust me, it's still much simpler than on most cameras.)

To use this technique, you need a piece of paper or card stock that's either neutral gray or absolute white — not eggshell white, sand white, or any other close-but-not-perfect white. (You can buy reference cards made just for this purpose in many camera stores for less than $20.) Position the reference card so that it receives the same lighting you'll use for your photo and fills the frame.

You can establish your One-Touch White Balance setting only in P, A, S, M, and ART modes. However, after you create the setting, you can select it as the white-balance option in Movie mode. (SCN and iAuto modes don't enable you to control White Balance at all.) So after setting the Mode dial to P, A, S, M, or ART, follow these steps:

1. **Use the Live Control display to select the One Touch White Balance setting, as shown in Figure 7-34.**

 You also can use the Super Control Panel if you prefer, but not the menus.

2. **Press the Info button.**

 You see the screen shown on the right in Figure 7-34, asking you to fill the screen with your white or gray reference card.

3. **Take a picture.**

 Now you see one of two screens: If the camera could measure the light and create your White Balance setting, the confirmation screen shown in Figure 7-35 appears. Select Yes and press OK to move on.

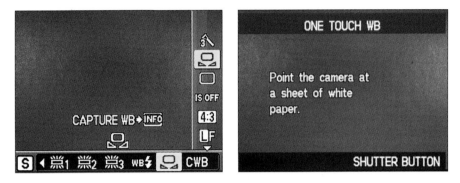

Figure 7-34: To base white balance on a direct measurement of the current light, use the One Touch setting.

If the camera has trouble capturing the image — which can happen in very bright or very dim lighting or if your reference card is actually not neutral but tinted — you instead see the message "WB NG RETRY." That's code for, "Sorry, but that white balance measurement was no good, so give it another go, will you?" Adjust the lighting or select a different reference card and try again until you get the confirmation screen shown in Figure 7-35.

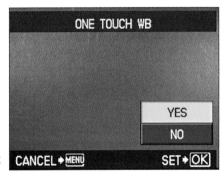

Figure 7-35: When you see this confirmation screen, select Yes and press OK.

Your customized White Balance setting is recorded and stored until you perform another direct measurement, even if you turn off the camera. So any time you shoot in the same light, whether for a still photo or a movie, you can just select the One Touch White Balance option, either through the control displays or menus. You don't have to go through the process of recording the reference picture each time.

Fine-tuning White Balance settings

You can fine-tune any White Balance setting — even the Auto setting — through the White Balance Compensation feature. The adjustment is based on two pairs of opposite colors: blue/amber and green/magenta. By increasing the amount of one color, you decrease the amount of the opposite color. For example, if you shift colors toward amber, blue is reduced.

To perform this trick, you must set the Mode dial to a setting other than iAuto or SCN — this kind of advanced color flexibility isn't available in those modes. Then follow these steps:

1. **Display Custom Menu G and select WB, as shown on the left in Figure 7-36. Press OK.**

 The screen shown on the right in Figure 7-36 appears.

Figure 7-36: Start by selecting the White Balance setting you want to fine-tune.

2. **Select the White Balance setting you want to fine-tune.**

 The settings are listed by their icons (refer to Table 7-1) and color temperature, as shown on the right in Figure 7-36. To the right of each setting, you can see the current amount of White Balance Compensation applied. A value of 0 indicates that no adjustment has been applied.

3. **Press the right-arrow key to display the adjustment screen shown in Figure 7-37.**

 On the right side of the screen are two sliders, A and G, representing amber and green, respectively. Not labeled — except in Figure 7-37 — are the color opposites for each pair, blue and magenta.

4. **Select the slider for the color pair you want to adjust: A (amber/blue) or G (green/magenta).**

 The active slider is white; press the right- and left-arrow keys to toggle between the two sliders.

5. Press the up- or down-arrow key to move the bar and adjust the balance of the colors.

For more amber and less blue, move the bar toward the top of the A scale; go the opposite direction to strengthen blues and reduce amber.

For more green, move the slider on the G scale up; to instead weaken greens and strengthen magentas, move the slider down.

By default, you're sort of working in the dark — you can't see the effect of the adjustments in the live preview. But you can press the Movie button to take a test shot at the current settings. The picture appears in the preview but isn't permanently recorded to the memory card.

More green
More amber

AUTO WB±/

A ▸ G
0 0

WB PREVIEW ▸ ◉

BACK ▸ MENU SET ▸ OK

More blue
More magenta

Figure 7-37: Press right/left to toggle between the scales; press up down to adjust the balance of the amber/blue and green/magenta color pairs.

6. Press OK to finalize the adjustment.

Values indicating the current amount of White Balance adjustment appear both on the menus and the Super Control Panel. (For the latter, refer to Figure 7-30 and note the A and G values right next to the WB Auto icon.) But the Live Control panel doesn't offer any indication that you adjusted the setting. So if you tweak the white balance for a particular set of shooting conditions that you won't encounter often, it's a good idea to reset everything to the neutral White Balance Compensation settings after you take your last picture of the day. Otherwise, you may forget about the adjustment and then wonder why colors aren't turning out right.

If you want to use the same adjustment settings for *all* White Balance settings, you can follow these same steps but select All WB instead of WB in Step 1. (The All option is one row down from the WB option, as shown in Figure 7-36.) Why would you do this? Well, frankly, I wouldn't, because I prefer colors to be rendered accurately — and if the camera started consistently

having trouble rendering colors at all White Balance settings, my first solution would be to march to the camera store for a service check. But different strokes for different folks, as they say. And some folks like all their strokes a little warmer than neutral — portrait photographers, for example, often warm colors to give a rosy glow to the skin. Some landscape-photographer folks, on the other hand, prefer stronger blues and greens. Film photographers slap tinted filters over their lenses to achieve warmer or cooler colors; digital photographers can get the job done through white-balance adjustments.

Bracketing white balance

Chapter 6 introduces you to your camera's automatic bracketing feature, which enables you to easily record the same image at several exposure settings. In addition to being able to bracket autoexposure, flash, and ISO settings, you can use the feature to bracket white balance.

Note a couple things about this feature:

- **You must use the P, A, S, or M shooting mode.** You can't apply white-balance bracketing in any of the other modes.

- **Each bracketed series includes three frames.** The first frame uses your current White Balance settings; the other two are adjusted in specific directions and amounts along the amber/blue and green/magenta color scales. (The upcoming steps show you how to set the amount of adjustment for each shot.)

- **You take just one picture to record each bracketed series.** Each time you press the shutter button, the camera records a single image at your current White Balance setting. Then your camera creates two copies, each using the requested bracketing settings.

- **You can shift colors by two, four, or six steps between frames.** A higher value produces greater differences between the images, obviously.

Figure 7-38 shows three variations of the same scene that I created using white-balance bracketing. The first shot shows the image captured using Auto White Balance, which produced the most accurate colors. For the warmer colors featured in the second image, I shifted the colors the maximum amounts (six steps) toward amber and magenta. For the third image, I went the other direction, applying six steps of correction in the blue and green direction to produce cooler colors.

Auto White Balance +6 Amber/+6 Magenta

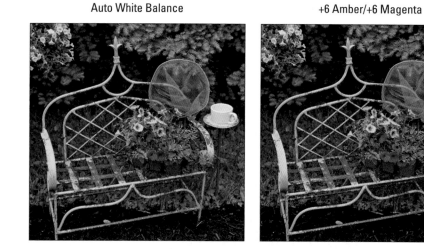

+6 Green/+6 Blue

Figure 7-38: I used white-balance bracketing to create these three variations on a garden scene.

To apply white-balance bracketing, take these steps:

1. **Display Shooting Menu 2, as shown on the left in Figure 7-39, and press OK.**

 You see the Bracketing menu, shown on the right in the figure.

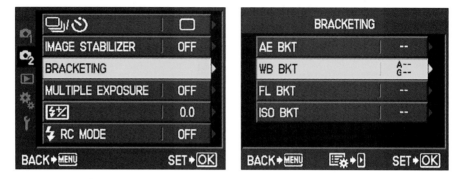

Figure 7-39: Enable white-balance bracketing through Shooting Menu 2.

2. **Select WB BKT, as shown on the right in Figure 7-39, and press the right-arrow key.**

 You see the screen shown in Figure 7-40.

3. **Specify the amount and type of bracketing adjustment.**

 You can choose to bracket just along the blue-to-amber color ramp, along the green-to-magenta ramp, or both. Press the right- or left-arrow key to select the color pair you want to bracket and then press the up- or down-arrow key to change the amount of shift you want the camera to apply between frames. You can choose 2 for minimal adjustment, 4 for medium adjustment, or 6 for maximum adjustment. (The *3F* part of the settings refers to the fact that each bracketed series contains three frames, with one being at the neutral setting.)

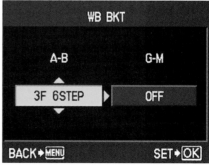

Figure 7-40: You can set the amount of amber-to-blue bracketing independently of the amount of green-to-magenta bracketing.

4. **Press OK.**

5. **Take the picture.**

 After you take the shot, the camera creates two copies and applies the bracketed settings to each.

When the camera is set to the maximum resolution, recording the two bracketed copies can take some time. So bracketing white balance isn't something you want to try when you need rapid shot-to-shot capture times. Instead, set the Image Quality setting to Raw and disable bracketing. When you process your Raw files, you can set white balance as part of the process, so you don't need to use bracketing as a safety net. You can even create different copies from the Raw file, using different color settings for each if you want to experiment or need to present a client with different renderings of a scene.

To disable bracketing, return to Shooting Menu 2, select Bracketing, and then set both the A-B and G-M options to Off (refer to Figure 7-40).

Choosing a Color Space: sRGB versus Adobe RGB

By default, your camera captures images using the *sRGB color mode,* which simply refers to an industry-standard spectrum of colors. (The *s* is for *standard,* and the *RGB* is for *red, green, blue,* which are the primary colors in the digital color world.) The sRGB color mode was created to help ensure color consistency as an image moves from camera (or scanner) to monitor and printer; the idea was to create a spectrum of colors that all these devices can reproduce.

However, the sRGB color spectrum leaves out some colors that *can* be reproduced in print and onscreen, at least by some devices. So as an alternative, your camera also enables you to shoot in the Adobe RGB color mode, which includes a larger spectrum (or *gamut*) of colors. Figure 7-41 offers an illustration of the two spectrums.

Some colors in the Adobe RGB spectrum can't be reproduced in print. (The printer just substitutes the closest printable color, if necessary.) Still, I usually shoot in Adobe RGB mode because I see no reason to limit myself to a smaller spectrum from the get-go.

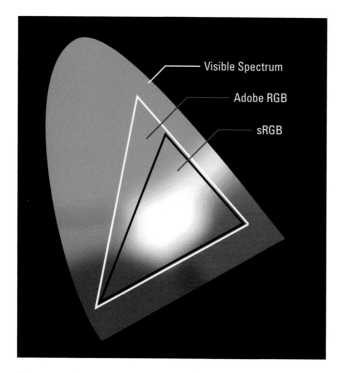

Figure 7-41: Adobe RGB includes some colors not found in the sRGB spectrum.

However, just because I use Adobe RGB doesn't mean that it's right for you. First, if you plan to print and share your photos without making any adjustments in your photo editor, you're usually better off sticking with sRGB because most printers and Web browsers are designed around that color space. Second, know that in order to retain all your original Adobe RGB colors when you work with your photos, your editing software must support that color space — not all programs do. You also must be willing to study the whole topic of digital color a little bit because you need to use some specific settings to avoid really mucking up the color works.

You can opt for Adobe RGB only in the P, A, S, and M shooting modes. Make the change either via Custom Menu G or the Super Control Panel, as shown in Figure 7-42.

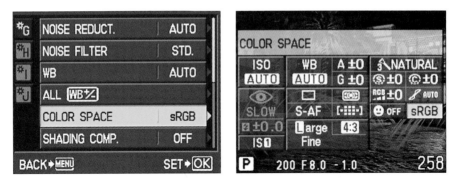

Figure 7-42: You can choose from two color spaces: sRGB and Adobe RGB.

You can tell whether you captured an image in the Adobe RGB format by looking at its filename: Names of pictures taken in the sRGB color space start with the letter P; for pictures taken in the Adobe RGB space, the P is replaced with _ (underscore).

Taking a Quick Look at Picture Modes

The Picture Mode feature offers one more way to tweak image contrast, sharpness, color saturation, and tonal range when you shoot in the JPEG formats. Olympus refers to these options as picture-processing options, and that's an apt term: They apply adjustments to your picture after you press the shutter button to render the scene in different ways.

Sharpening, in case you're new to the digital meaning of the term, refers to a software process that adjusts contrast in a way that creates the illusion of slightly sharper focus. I emphasize, "slightly sharper focus." Sharpening produces a subtle *tweak,* and it's not a fix for poor focus.

The E-PL1 offers the following Picture Modes:

 ✓ **i-Enhance:** At this setting, the camera tries to decide what type of scene you're shooting and adjust the image accordingly. For example, a landscape is rendered more vividly than a portrait.

 ✓ **Vivid:** In this mode, the camera amps up color saturation for a bolder look.

 ✓ **Natural:** The default for the P, A, S, and M modes, this option produces the most natural rendering of the scene.

 ↙ **Muted:** This mode delivers what its name implies: Tones are more flat, or *muted.*

 ↙ **Portrait:** Also fairly self-explanatory, this one is geared to rendering soft, warm skin tones.

 ↙ **Monochrome:** This setting produces black-and-white photos. Only in the digital world, they're called *grayscale images* because a true black-and-white image contains only black and white, with no shades of gray.

 I'm not keen on creating grayscale images this way. I prefer to shoot in full color and then do my own grayscale conversion in my photo editor. That technique just gives you more control over the look of your black-and-white photos. Assuming that you work with a decent photo editor, you can control what original tones are emphasized in your grayscale version, for example. Additionally, keep in mind that you can always convert a color image to grayscale, but you can't go the other direction.

 ↙ **Custom:** If none of the preset Picture Modes suits you, you can create your own.

In iAuto mode, the camera uses the i-Enhance Picture Mode. In SCN mode, the camera selects the Picture Mode based on the scene type, and in ART mode, the Picture Mode is set to Natural, but colors and other attributes are applied by the art filter you select. In P, A, S, and M modes, you can choose from all Picture Modes; in Movie mode, you can select any mode but i-Enhance.

To give you an idea of how Picture Modes affect your picture, Figure 7-43 shows the same image rendered at the six preset modes. In the example, the Vivid image is much the same as the i-Enhance version because the camera automatically boosts colors when it detects a landscape scene in i-Enhance mode.

With the exception of the Monochrome option, the extent to which a change of Picture Mode will affect your image depends on the subject as well as the exposure settings you choose and the lighting conditions. But as you can see from Figure 7-43, the differences are pretty subtle.

If you want to experiment with Picture Modes in the P, S, A, and M modes, you can change the setting quickly via the Live Control display or Super Control Panel, as shown in Figure 7-44. The modes are represented by the little paintbrush and number symbols you see in the preceding list. (Fortunately, the name of the setting appears with the symbol on the displays.)

i-Enhance

Vivid

Natural

Muted

Portrait

Monochrome

Figure 7-43: Picture Modes apply preset adjustments to color, sharpening, and other photo characteristics to images you shoot in the JPEG format.

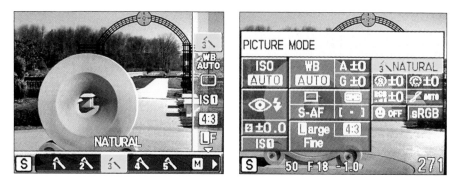

Figure 7-44: For quickest access to the Picture Mode option, use the Live Control or Super Control Panel display.

You also can adjust the setting via Shooting Menu 2, as shown in Figure 7-45; use this option in Movie mode, as you can't access the setting via the Live Control panel in that mode. Additionally, after selecting a Picture mode from the menu, you can press the right-arrow key to display the screen shown on the left in Figure 7-46, which lets you change the level of contrast, sharpness, saturation, and gradation (tonal range) adjustment for the mode. You also can modify these values through the Super Control Panel by choosing the four options labeled on the right in the figure.

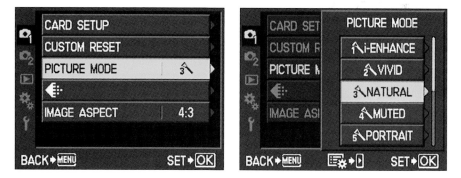

Figure 7-45: You also can choose a Picture Mode via Shooting Menu 1.

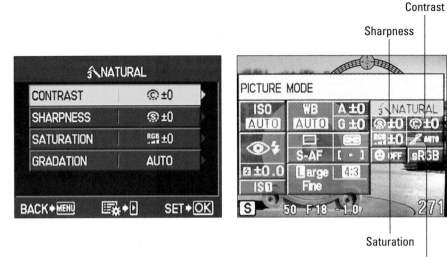

Figure 7-46: You can modify the four characteristics of each Picture Mode.

To create a custom style, the best method is to use the menus. Start by choosing the Custom mode, as shown on the left in Figure 7-47, and then press the right-arrow key to display the screen shown on the right. Use the top option on the screen to choose the existing Picture Mode you want to use as the starting point for your custom style. Then adjust the other four settings as usual.

Figure 7-47: These options enable you to create and store your own Custom Picture Mode.

Personally, I stick with the Natural option and just ignore the others. First off, you have way more important camera settings to worry about — aperture, shutter speed, autofocus, and all the rest. Why add one more setting to your list, especially when the impact of changing it is minimal?

Second, if you really want to mess with the characteristics that the Picture Mode options affect, you're much better off shooting in the Raw (ORF) format and then making those adjustments on a picture-by-picture basis in your raw converter. In the Raw format, the camera uses your selected Picture Mode for the image you see during playback and for the thumbnail previews in your photo browser, but you can adjust all the picture attributes as you like in the converter. In the Olympus software, you can even apply any of the camera's Picture Mode settings to the image. For these reasons, I opt in this book to present you with just this brief introduction to Picture Modes so that I can go into more detail about functions that I see as more useful (such as the white balance customization options presented earlier).

8

Putting It All Together

In This Chapter

▷ Reviewing the best all-around picture-taking settings

▷ Adjusting the camera for portrait photography

▷ Discovering the keys to super action shots

▷ Dialing in the right settings to capture landscapes and other scenic vistas

▷ Capturing close-up views of your subject

*E*arlier chapters of this book break down each and every picture-taking feature on the E-PL1, describing in detail how the various controls affect exposure, picture quality, focus, color, and the like. This chapter pulls together all that information to help you set up your camera for specific types of photography.

The first few pages offer a quick summary of critical picture-taking settings that should serve you well no matter what your subject. Following that, you get my advice on which settings to use for portraits, action shots, landscapes, and close-ups. But I want to stress that although I offer specific recommendations, there is no one "right way" to shoot a portrait, a landscape, or whatever. Don't be afraid to wander off on your own, tweaking this exposure setting or adjusting that focus control, to discover your creative vision. Experimentation is part of the fun of photography, after all — and thanks to your camera monitor and the Erase button, it's an easy, completely free proposition.

Recapping Basic Picture Settings

For certain picture-taking options, such as aperture and shutter speed, the best settings vary depending on the subject, lighting conditions, and your creative goals. But for the options shown in Table 8-1, you can rely on the same settings in almost every shooting scenario. The table shows you my

recommended settings for these options and lists the chapter where you can find details about each setting. Note that these settings, and the other tips in this chapter, relate to still photography. Chapter 3 provides information on shooting movies.

Table 8-1	All-Purpose Picture-Taking Settings	
Option	*Recommended Setting*	*See This Chapter*
Image Quality	Large/Super Fine (JPEG), Medium/Super Fine (JPEG), or Raw (ORF)	2
Shutter-release mode	Single	2
ISO	200	6
Metering mode	Digital ESP (whole frame)	6
AF mode	S-AF for stationary subjects; C-AF+TR for moving subjects	7
AF Target	Single	7
White Balance	Auto	7
Picture Mode	Natural	7
Aspect Ratio	4:3	2

Whether you can control these settings depends on the exposure mode. You can find details about which modes let you do what in the chapters that explain each function.

For the most part, the settings detailed in Table 8-1 fall into the "set 'em and forget 'em" category. That leaves you free to concentrate on a handful of other camera settings that you can manipulate to achieve a specific photographic goal, of which the leading two players are aperture, which affects depth of field, and shutter speed, which affects motion blur. Figure 8-1 offers a reminder of where to view the current f-stop and shutter speed in the standard information display.

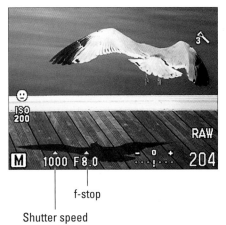

f-stop

Shutter speed

Figure 8-1: Use f-stop to affect depth of field and shutter speed to control motion blur.

The next four sections explain which of these additional options typically produce the best results when you're shooting portraits, action shots,

landscapes, and close-ups. I offer a few compositional and creative tips along the way — but, again, remember that beauty is in the eye of the beholder, and for every so-called rule, plenty of great images prove the exception. As Ansel Adams so wisely said, "There are no rules for good photographs; there are only good photographs."

Shooting Great Portraits

A classic portraiture approach is to keep the subject sharply focused while throwing the background into soft focus, as shown in Figure 8-2. This artistic choice emphasizes the subject and helps diminish the impact of any distracting background objects in cases where you can't control the setting. The following steps show you how to achieve this look:

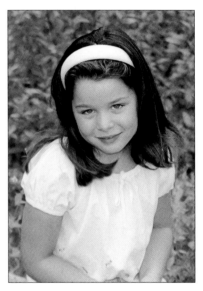

Figure 8-2: A blurred background draws more attention to the subject.

1. **Set the Mode dial to A (aperture-priority autoexposure) and then select the lowest possible f-stop value.**

 As Chapter 6 explains, a low f-stop number opens the aperture, which shortens *depth of field,* or the range of sharp focus. So, dialing in a low f-stop value is the first step in softening your portrait background. (The f-stop range available to you depends on your lens.) Keep in mind that the farther your subject is from the background, the more background blurring you can achieve at any one f-stop.

 I recommend aperture-priority autoexposure when depth of field is a primary concern because you can control the f-stop while relying on the camera to select the shutter speed that will properly expose the image. To adjust the f-stop, press the up-arrow key. Then press the up- or down-arrow key to adjust the value.

 If you aren't comfortable using this advanced exposure mode, try iAuto mode instead. Press OK to display the Live Guide screen and then use the Blur Background option to soften background focus. The Portrait Scene mode also results in a more open aperture, although the exact f-stop setting is out of your control and lighting conditions dictate the width of the aperture the camera will use. Chapter 3 details iAuto and Portrait modes.

2. **To further soften the background, zoom in, get closer, or both.**

As covered in Chapter 7, zooming in to a longer focal length also reduces depth of field, as does moving physically closer to your subject.

Avoid using a lens with a short focal length (a *wide-angle* lens) for portraits. A short focal length can cause features to appear distorted — similar to the way people look when you view them through a security peephole in a door.

3. **For indoor portraits, shoot flash-free, if possible.**

Shooting by available light rather than by flash produces softer illumination and avoids the red-eye problem. To get enough light to go flash-free, turn on room lights or, during daylight, pose your subject next to a bright window.

If flash is unavoidable, see the list of flash tips at the end of this step list to get better results.

4. **For outdoor portraits, use a flash.**

Even in bright daylight, a flash adds a beneficial pop of light to a subject's face, as discussed in Chapter 6 and illustrated in Figure 8-3.

Unfortunately, the camera doesn't let you use flash in very bright light in iAuto mode. In aperture-priority mode, raise the flash and then press the right-arrow key to access the flash mode settings. Select the Fill In flash mode to force the flash to fire.

Remember, though, that the fastest shutter speed you can use with the built-in flash is 1/160 second, and in extremely bright conditions, that speed may be

No flash

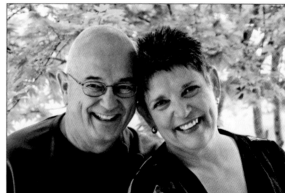

Fill flash

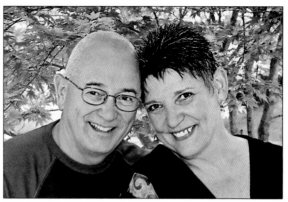

Figure 8-3: To properly illuminate the face in outdoor portraits, use fill flash.

too slow to avoid overexposing the image. If necessary, move your subject into the shade.

5. **If using autofocus, set the AF mode to S-AF (single mode) and select a specific AF Target (focus point).**

 You can adjust the AF mode through the Live Control screen; to adjust the AF Target, press the left-arrow key to display the grid of focus targets and then use the arrow keys to select the one you want to use. See Chapter 7 for details on this topic.

6. **Frame the picture with your subject under the focus point and press the shutter button halfway to lock autofocus and exposure.**

 As long as you keep the button pressed halfway, focus and exposure remain locked. That means that you can recompose the shot if needed, and focus and exposure will both be matched to your subject. (If you're focusing manually, only exposure is locked.)

7. **Press the shutter button the rest of the way to capture the image.**

Again, these steps give you only a starting point for taking better portraits. A few other tips can also improve your people pics:

✔ **Before pressing the shutter button, do a quick background check.** Scan the entire frame for intrusive objects that may distract the eye from the subject. If necessary (and possible), reposition the subject against a more flattering backdrop.

✔ **Frame the subject loosely to allow for later cropping to a variety of frame sizes.** Because your camera produces images that have an aspect ratio of 4:3, your portrait requires cropping to print at traditional frame sizes, such as 4 x 6 or 5 x 7. The printing section of Chapter 5 talks more about the aspect ratio issue; Chapter 9 explains how to use the crop function on the JPEG Edit menu to create a copy of your picture in the 3:2 aspect ratio, which matches that of a 4-x-6-inch print. Visit Chapter 2 to find out how to control the original aspect ratio of your picture.

✔ **Pay attention to white balance if your subject is lit by both flash and ambient light.** If you use the automatic White Balance setting (AWB), photo colors may be slightly warmer or cooler than neutral because the camera can become confused by mixed light sources. A warming effect typically looks nice in portraits, giving the skin a subtle glow. Cooler tones, though, usually aren't as flattering. Either way, if you aren't happy with the image colors, see Chapter 7 to find out how to fine-tune white balance.

✔ **For indoor portraits that require flash, try these tricks.** The following techniques can help solve flash-related issues:

 • *Turn on as many room lights as possible.* By using more ambient light, you reduce the flash power that's needed to expose the picture. This step also causes the pupils to constrict, further reducing the possibility of red-eye.

• *Try setting the flash to red-eye reduction or slow-sync mode.* If you choose the first option, warn your subject to expect both a preliminary pop of light from the flash, which constricts pupils, and the actual flash. And remember that slow-sync flash uses a slower-than-normal shutter speed, which produces softer lighting and brighter backgrounds than normal flash. (See Chapter 6 to find out how to enable both flash modes.)

Take a look at Figure 8-4 for an example of how slow-sync flash can really improve an indoor portrait. When I used regular flash, the shutter speed was 1/60 second. At that speed, the camera has little time to soak up any ambient light. As a result, the scene is lit primarily by the flash. That caused two problems: The strong flash created some "hot spots" on the subject's skin, and the window frame is much more prominent because of the contrast between it and the darker bushes outside the window. Although it was daylight when I took the picture, the skies were overcast, so at 1/60 second, the exteriors appear dark.

Regular fill flash, 1/60 second Slow-sync flash, 1/4 second

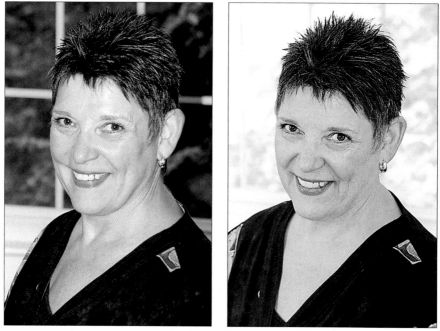

Figure 8-4: Slow-sync flash results in softer, more even lighting and brighter backgrounds.

In the slow-sync example, shot at 1/4 second, the exposure time was long enough to permit the ambient light to brighten the exteriors to the point that the window frame almost blends into the background. And because much less flash power was needed to expose the subject, the lighting is much more flattering. In this case, the bright background also helps to set the subject apart because of her dark hair and shirt. If the subject had been a pale blonde, this setup wouldn't have worked as well, of course. And note the color shift that occurred due to the different mixes of flash and ambient lighting — in this case, the slow-sync example exhibited much warmer tones. Again, you can adjust white balance if the colors aren't to your liking.

Any time you use slow-sync flash, don't forget that a slower-than-normal shutter speed means an increased risk of blur due to camera shake. So always use a tripod or otherwise steady the camera. And remind your subjects to stay absolutely still, too, because they'll appear blurry if they move during the exposure. I was fortunate to have both my tripod and a cooperative subject for my examples, but I probably wouldn't try slow-sync for portraits of young children or pets.

• *For professional results, use an external flash with a rotating flash head.* Then aim the flash head upward so that the flash light bounces off the ceiling and falls softly down on the subject. An external flash isn't cheap, but the results make the purchase worthwhile if you shoot lots of portraits. Compare the two portraits in Figure 8-5 for an illustration. In the first example, the built-in flash resulted in strong shadowing behind the subject and harsh, concentrated light. To produce the better result on the right, I bounced the flash light off the ceiling.

• *To reduce shadowing from the flash, move your subject farther from the background.* Moving the subject away from the wall helped eliminate the background shadow in the second example in Figure 8-5. The increased distance also softened the focus of the wall a bit (because of the short depth of field resulting from the f-stop and focal length).

Positioning subjects far enough from the background that they can't touch it is a good general rule. If that isn't possible, though, try going in the other direction: If the person's head is smack against the background, any shadow will be smaller and less noticeable. For example, less shadowing is created when a subject's head is resting against a sofa cushion than if he sits upright with his head a foot or so away from the cushion.

Direct flash Bounce flash

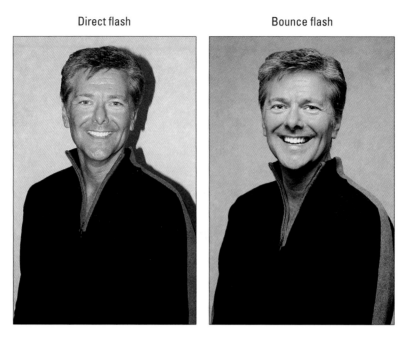

Figure 8-5: To eliminate harsh lighting and strong shadows (left), use bounce flash and move the subject farther from the background (right).

Capturing action

A fast shutter speed is the key to capturing a blur-free shot of any moving subject, whether it's a spinning Ferris wheel, a butterfly flitting from flower to flower, or, in the case of Figure 8-6, a seagull in lift-off mode. For this subject, I used a shutter speed of 1/1000. A slower shutter speed would probably have frozen the action as well, but I wanted to use a low f-stop setting to keep the background water a little blurry. In the bright sun, using a low f-stop setting (wider aperture opening) meant that I needed the faster shutter speed to properly expose the image.

Along with the basic capture settings outlined earlier (refer to Table 8-1), try the techniques in the following steps to set up the camera for photographing a subject in motion:

1. **Set the Mode dial to S (shutter-priority autoexposure).**

 In this mode, you control the shutter speed and the camera takes care of choosing an aperture setting that will produce a good exposure.

 If you aren't ready to step up to this advanced autoexposure mode, explained in Chapter 6, try using iAuto mode. Bring up the Live Guide by pressing OK and then use the Express Motions option to control

motion blur. You also can set the camera to SCN mode and select the Sport setting. Neither mode, however, gives you firm control over shutter speed or most other aspects of your picture, such as white balance and flash. So if you opt to use those settings, some of the following steps, including the next one, don't apply. See Chapter 3 for help going forward.

2. **Set the shutter speed.**

 Press the up-arrow key to highlight the shutter speed, and then press the up- or down-arrow key to adjust the value.

 After you select the shutter speed, the camera selects the aperture (f-stop) necessary to produce a good exposure.

 The shutter speed you need depends on how fast your subject is moving, so you have to experiment. Another factor that affects your ability to stop action is the *direction* of subject motion. A car moving *toward* you can be stopped with a lower shutter speed than one moving *across* your field of view. Generally speaking, 1/500 second should be plenty for all but the fastest subjects — speeding hockey players, race cars, or boats, for example. For slower subjects, you can even go as low as 1/250 or 1/125 second.

Figure 8-6: Use a fast shutter speed to freeze action.

If the aperture value blinks after you set the shutter speed, the camera can't select an f-stop that will properly expose the photo at that shutter speed. See Chapter 6 for more details about how the camera notifies you of potential exposure problems. Remember that you can raise the ISO setting, which makes the camera more sensitive to light, if needed, to allow the shutter speed you have in mind in dim lighting.

3. **If you want to use autofocusing, set the AF mode and AF Target mode.**

 Chapter 7 explains both of these settings, which determine whether the camera locks focus when you press the shutter button halfway and which part of the frame is used to establish focus. The pairings I recommend depend on the situation:

 - *To focus on a single subject in a crowded scene,* such a specific trumpet player in a marching band, use single AF Target mode and set the AF mode to C-AF+TR (continuous autofocus with subject tracking). In this mode, you frame the shot with the subject under the focus target and press and hold the shutter button halfway. A green target appears over the subject, and the camera tracks the subject as it moves through the frame. A red frame indicates that the camera lost track of the subject, in which case you need to release the shutter button and set focus again.

 - *To focus on a group of moving subjects,* such as a flock of birds, set the AF mode to C-AF and the AF Target to All Targets. The camera typically focuses on the closest subject in the group and continues to adjust focus as needed until you take the shot.

 - *To focus on a single subject against an empty background* — for example, the seagull in my example photo — you also can get good results by pairing C-AF and All Targets mode. In most cases, the camera successfully locks onto the subject automatically, which saves you the time of selecting a specific focus target. The camera continues to adjust focus as necessary until the time you take the shot.

 - *If you want to use Sequential release mode,* consider setting the AF mode to S-AF (single autofocus) instead. Why? Because the camera can achieve a faster frame rate than when you use continuous autofocusing. The difference is due to the fact that with S-AF, the camera uses the same focus point for all shots in the burst of frames, whereas in the continuous autofocus modes, it has to keep adjusting focus, which slows down things.

 The fastest way to adjust the autofocus (AF) mode is to use the Live Control screen; the quickest option for setting the AF Target is to press the left-arrow key.

4. **For fastest shooting, switch to manual focusing.**

 You then eliminate the time the camera needs to lock focus when you use autofocusing. To enable manual focusing, set the AF mode to MF. Chapter 7 shows you how to focus manually, if you need help.

5. **For rapid-fire shooting, set the shutter-release mode to Sequential.**

 In this mode, you can take up to 3 frames per second. As outlined in Step 3, you typically get the fastest frame rate when the AF mode is set to S-AF. The frame rate also can slow when you set the Image Quality setting to capture the file both in the Raw and JPEG format because it needs more time to save the files to the memory card.

 You can set the shutter-release mode quickly by pressing the down-arrow key.

6. **Don't use flash unless absolutely necessary.**

 With the built-in flash, the fastest shutter speed you can use is 1/160 second, which may not be fast enough to freeze action. The flash needs time to recharge between shots, which also can slow down your capture time. In addition, unless the subject is close to you, the flash won't reach far enough to do any good, anyway.

7. **Compose the subject to allow for movement across the frame.**

 You can always crop the photo later to a tighter composition. (Many examples in this book were cropped to eliminate distracting elements.) Chapter 9 shows you how to crop pictures via the JPEG Edit menu.

8. **Press and hold the shutter button halfway.**

 Exposure is now locked and remains locked as long as you keep the button pressed halfway. In S-AF mode, focus is locked as well. In the two continuous autofocus modes (C-AF and C-AF+TR), focus is adjusted up to the time you take the picture.

9. **Press the shutter button completely to record the shot.**

 If you use Sequential shutter-release mode, the camera continues recording images as long as you keep the shutter button down.

Using these techniques should give you a better chance of capturing any fast-moving subject. But action-shooting strategies also are helpful for shooting candid portraits of kids and pets. Even if they aren't running, leaping, or otherwise cavorting when you pick up your camera, snapping a shot before they move or change positions is often tough. So, if an interaction or scene catches your eye, set your camera into action mode and then just fire off a series of shots as fast as you can.

Capturing scenic vistas

Providing specific capture settings for landscape photography is tricky because there's no single best approach to capturing a beautiful stretch of countryside, a city skyline, or another vast subject. Depth of field is an example: One person's idea of a super cityscape might be to keep all buildings in the scene sharply focused. Another photographer might prefer to shoot the

same scene so that a foreground building is sharply focused while the others are less so, thus drawing the eye to that first building.

That said, here are a few tips to help you photograph a landscape the way *you* see it:

Figure 8-7: Use a high f-stop value (or Landscape mode) to keep foreground and background sharply focused.

- ✏ **Shoot in aperture-priority auto-exposure mode (A) so that you can control depth of field.** If you want extreme depth of field so that both near and distant objects are sharply focused select a high f-stop value; for a smaller zone of sharp focus, lower the f-stop. In Figure 8-7, I used an aperture of f/8. It was a foggy morning, so some of the distance blurring isn't due to the camera, but Mother Nature.

 As an alternative to using A mode, you can use iAuto mode and control depth of field some-what with the Blur Background Live Guide feature. Chapter 3 shows you how. The Landscape setting available in SCN mode also tries to produce a large depth of field by selecting a high f-stop number, but you have no control over the exact value.

 Whatever the shooting mode, the camera may need to use a slow shut-ter speed or raise the ISO setting to expose the image at a high f-stop.

- ✏ **For dramatic waterfall and fountain shots, consider using a slow shutter to create that "misty" look.** The slow shutter blurs the water, giving it a soft, romantic appearance. For the shot shown in Figure 8-8, I used a shutter speed of 1/30 second. Use a tripod to ensure that camera shake doesn't blur the rest of the scene.

- ✏ **At sunrise or sunset, base exposure on the sky.** The foreground will be dark, but you can usually brighten it in a photo editor, if needed. If you base exposure on the foreground, on the other hand, the sky will become so bright that all the color will be washed out — a problem you usually can't easily fix after the fact.

 This tip doesn't apply, of course, if the sunrise or sunset merely serves as a gorgeous backdrop for a portrait. In that case, enable the flash and expose for the subject.

For nighttime city pics, experiment with a slow shutter speed. Assuming that cars or other vehicles are moving through the scene, the result is neon trails of light, like those you see in Figure 8-9. Shutter speed for this image was ten seconds. The longer your shutter speed, the blurrier the motion trails. This technique also can produce some good results in city scenes that feature lighted fountains — flip back to Chapter 3 and take a peek at Figure 3-13 for an example shot at 1/10 second.

Because long exposures can produce image noise, you also may want to enable the Noise Reduction feature. You access this option via Custom Menu G. Chapter 6 discusses this option in more detail.

Figure 8-8: For misty water movement, use a slow shutter speed (and tripod).

In tricky light, bracket shots. *Bracketing* simply means to take the same picture at several different exposures to increase the odds that at least one captures the scene the way you envision. Bracketing is especially a good idea in difficult lighting situations, such as sunrise and sunset.

Your camera offers automatic exposure bracketing (AEB) when you shoot in the advanced exposure modes (P, A, S, and M). See Chapter 6 to find out how to take advantage of this feature.

Capturing dynamic close-ups

For great close-up shots, start with the basic capture settings outlined earlier, in Table 8-1. Then try the following additional settings and techniques:

Take control over depth of field by setting the camera mode to A (aperture-priority autoexposure) mode. Whether you want a shallow, a medium, or an extreme depth of field depends on the point of your photo.

Figure 8-9: A slow shutter also creates neon light trails in city-street scenes.

For floral close-ups like the one in Figure 8-10, for example, setting the aperture to f/5.6 blurred the background, helping the subject dominate the background. But if you want the viewer to clearly see all details throughout the frame — for example, if you're shooting a product shot for your company's sales catalog — go in the other direction, stopping down the aperture as far as possible.

Not ready for the advanced exposure modes? Try iAuto mode and use the Live Guide Blur Background slider to manipulate depth of field, a trick you can explore in Chapter 3. The Macro and Nature Macro Scene modes, also covered in Chapter 3, offer other alternatives.

Figure 8-10: Shallow depth of field helps set the subject apart from the similarly colored background.

- **Remember that both zooming in and getting close to your subject decreases depth of field.** Back to that product shot: If you need depth of field beyond what you can achieve with the aperture setting, you may need to back away, zoom out, or both. (You can always crop your image to show just the parts of the subject that you want to feature.) For the tulip shot in Figure 8-10, the focal length was 60mm and I was only about one foot away from the flower, all of which contributed to the extremely short depth of field.

- **Use fill flash for better outdoor lighting.** Just as with portraits, a tiny bit of flash typically improves close-ups when the sun is your primary light source. You may need to reduce the flash output slightly, via the camera's Flash Compensation control. Chapter 6 offers details about using flash.

Keep in mind that the maximum shutter speed possible when you use the built-in flash is 1/160 second. So, in extremely bright light, you may need to use a high f-stop setting to avoid overexposing the picture. You also can lower the ISO speed setting, if it's not already all the way down to ISO 100.

- **To get *very* close to your subject, invest in a macro lens or a set of diopters.** A true macro lens is an expensive proposition; expect to pay around $200 or more. If you enjoy capturing the tiny details in life, it's worth the investment and the only way you can begin to produce the kind of stunning, extreme close-ups you see in photography magazines.

For a less expensive way to go, you can spend about $40 for a set of *diopters,* which are sort of like reading glasses you screw onto your existing lens. Diopters come in several strengths: +1, +2, +4, and so on, with a higher number indicating a greater magnifying power. The downside to diopters is that they are very "soft" around the edges, so depth of field is extremely limited.

Coping with Special Situations

A few shooting situations pose some challenges not covered in earlier sections. So to wrap up this chapter, here's a quick list of ideas for tackling a few common tough-shot photos:

Figure 8-11: He's watching you . . .

- **Shooting through glass:** To capture subjects behind glass, set your camera to manual focusing — the glass barrier can give the auto-focus mechanism fits — and disable flash to avoid creating reflections. If you can get close enough, put the lens right up to the glass (be careful not to scratch your lens). If you must stand farther away, try to position your lens at a 90-degree angle to the glass. I captured the snake image featured in Figure 8-11 using these techniques.

- **Shooting fireworks:** Fireworks require a long exposure, so using a tripod is a must. Switch to manual focusing and set focus at infinity (the farthest focus point possible on your lens). Set the exposure mode to manual, choose a relatively high f-stop — say, f/16 or so — and start with a shutter speed of 1 to 3 seconds. From there, it's a matter of experimenting with different shutter speeds.

Be especially gentle when you press the shutter button — with a very slow shutter, you can easily create enough camera movement to blur the image. Also try using the 2-Second Self-Timer shutter-release mode or Anti-Shock features explained in Chapter 2 to delay the shutter release slightly, giving the camera time to stabilize after you press the shutter button.

✔ **Shooting in strong backlighting:** When the light behind your subject is very strong, the result is often an underexposed subject. You can adjust exposure settings or use flash to better expose the subject, but for another creative choice, purposely underexpose

Figure 8-12: Experiment with shooting backlit subjects in silhouette.

the subject to create a silhouette effect, as shown in Figure 8-12. Set your camera to an advanced exposure mode, disable flash, and then base your exposure on the brightest areas of the frame so that the subject remains dark.

✔ **Shooting reflective surfaces:** In outdoor shots, you can reduce glare from reflective surfaces by using a polarizing filter, which you can buy for about $40. But know for the filter to work, the sun, your subject, and your camera lens must be precisely positioned. Your lens must be at a 90-degree angle from the sun, and the light source must also reflect off the surface at a certain angle and direction. In addition, a polarizing filter also intensifies blue skies in some scenarios, which may or may not be to your liking.

For small objects, use a light tent or cube, such as the one shown in Figure 8-13 from Cloud Dome (www.clouddome. com). You place the object inside the tent or cube and then position your lights around the outside. The cube or tent acts as a light diffuser, reducing reflections. Prices range from about $50–$200, depending on size and features.

Cloud Dome, Inc.

Figure 8-13: A light cube or tent makes photographing reflective objects easier.

Part IV
The Part of Tens

The 5th Wave By Rich Tennant

"That's a lovely image of your sister's portrait. Now take it off the body of that pit viper before she comes in the room."

*I*n time-honored *For Dummies* tradition, this part of the book contains additional tidbits of information presented in the always popular "top ten" list format.

Chapter 9 introduces you to some tools designed to expand your creativity, including the ART shooting mode, and also discusses options that enable you to do some minor picture touchups, such as removing red-eye. Following that, Chapter 10 introduces you to ten camera functions that I consider specialty tools — bonus options that, although not at the top of the list of the features I suggest you study, are nonetheless interesting to explore when you have a free moment or two.

9

Ten Cool Creative (And Practical) Features

Many parts of this book are geared to your brain's left hemisphere — the half that scientists say is engineered to contemplate technical information. This chapter appeals to the other side of your noggin, presenting E-PL1 features designed to stimulate your creative side. You can have fun experimenting with the art filters, merge two images into one, and turn a full-color image into a black-and-white or sepia picture.

So that your left brain doesn't feel totally left out, however, this chapter also includes a couple practical features that I haven't yet covered, including in-camera red-eye removal and an option that lets you annotate a still picture with a voice recording. Additionally, the first section details the JPEG Edit menu, which serves up many of these photo-retouching and creative features.

Altering Your Photos through the JPEG Edit Menu

The JPEG Edit menu contains the majority of the in-camera editing functions. As the menu name implies, these features work only on JPEG picture files. If you only captured the image in the Raw format, you must create a JPEG copy before you can apply the JPEG Edit menu adjustments. (See Chapter 5 to find out how to use the Raw Data Edit menu option to take that step.)

You can access the JPEG Edit menu in two ways:

✏ **Display the photo in single-image view and press OK:** For pictures taken in the JPEG format, you then see the menu shown in Figure 9-1. For pictures taken using one of the Raw+JPEG options, the menu varies slightly and includes the Raw Data Edit option. Either way, choose JPEG Edit and press OK to get to the menu of editing functions.

Figure 9-1: Select JPEG Edit and press OK to access the in-camera editing pictures.

✏ **Take the long way and go through the Playback menu:** The Playback menu offers an option that gets you to the same place — eventually. From the menu, choose Edit and press OK. On the next screen, choose Sel Image, which stands for Select Image, and press OK again. The camera displays an image; press the right/left-arrow keys to scroll to the photo you want to edit and then press OK. On the next screen, choose JPEG Edit and press OK.

Examples throughout the rest of this chapter assume that you prefer the direct route covered in the first bullet point. Also note the following general details about how the E-PL1 approaches its photo-editing duties:

↙ **All alterations are made to a copy of your original image.** The camera assigns the edited image the next available image file number.

↙ **The copy uses the same Image Quality setting as the original.** See Chapter 2 for details on this setting, which controls resolution and the amount of JPEG compression.

↙ **Each time you edit and save the file, it undergoes another round of JPEG compression.** Too much compression destroys image quality, so if you want to make more than a couple changes to the photo, use your photo editor. Then you can apply all your edits at the same time and save the file once. You also can control the amount of compression applied when the file is saved.

↙ **If you used the Raw+JPEG Image Quality setting, the camera uses the JPEG image for editing.** But again, both the JPEG and Raw original are preserved.

Removing Red-Eye

If you spot a red-eye problem during playback, you may be able to remove it by following these steps:

1. **Display your photo in single-image view and press OK.**

2. **Highlight JPEG Edit and press OK.**

3. **Highlight Redeye Fix, as shown in Figure 9-2, and press OK.**

 The screen preview shown on the right in the figure appears.

4. **If you're happy with the correction, select Yes and press OK.**

5. **If you don't want to go forward, select No and press OK.**

 You also can press the Menu button to step back through the menu pages.

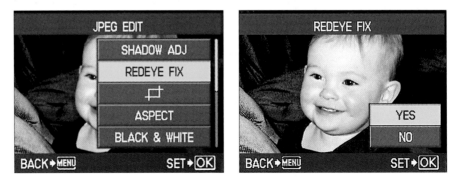

Figure 9-2: Choose Redeye Fix and press OK to apply the red-eye removal filter.

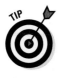

If the in-camera red-eye repair fails you, most photo-editing programs have red-eye removal tools that should enable you to get the job done. Unfortunately, no red-eye remover works on animal eyes. Red-eye removal tools know how to detect and replace only red-eye pixels, and animal eyes typically turn yellow, white, or green in response to a flash. The easiest solution is to use the brush tool found in most photo editors to paint in the proper eye colors.

Giving a Face the "Vaseline Lens" Treatment

If you explore the SCN mode options, covered in Chapter 3, you encounter the e-Portrait mode. After you take a shot in this mode, the camera creates a copy of your image and then applies a retouching filter that's engineered to soften and enhance skin tones to the copy. The filter is a digital version of the old trick of smearing Vaseline on a camera lens to create a soft-focus effect, thereby rendering skin lines, wrinkles, age spots, and other blemishes less noticeable.

Personally, I think the world has gone way overboard in trying to eliminate any signs that one's skin is more than a month old. And I would never recommend asking someone, "Do you want me to apply this filter to help hide all your age spots and crow's feet?" But because I'm here to tell you how to use all the features of your camera, I'll bite my tongue — okay, except for that little rant — and tell you that if you want to use the effect, you don't have to stick with the SCN mode. You can shoot the picture in any shooting mode and then apply the e-Portrait filter through the JPEG Edit menu.

After accessing the JPEG Edit menu (the first section of the chapter shows you how), scroll to the second page of the menu and highlight e-Portrait, as illustrated on the left in Figure 9-3. Press OK, and the camera creates a copy of your photo and applies the filter to the copy. You then see a side-by-side comparison of the two photos, as shown on the right in the figure.

Figure 9-3: The e-Portrait effect applies a filter that softens skin tones.

Note that this retouching filter is tied to the Face Detection feature. If the camera can't find a face in the picture, it displays the message "Face Detection Failed" instead of the side-by-side comparison. The failure can occur in extreme close-ups of faces or if the subject isn't facing the lens directly.

Tweaking Color Saturation

Saturation refers to the intensity and purity of color. The greater the saturation, the bolder the color. A fully saturated color contains no black, white, or gray.

On occasion, an image can benefit from a little saturation bump. Figure 9-4 offers an example. I was drawn to this scene by the deep purple veins running through the green leaves. But when I reviewed the original photo, shown on the left, it seemed a little lackluster in the rendering of those colors. So I increased the saturation slightly to produce the image shown on the right.

Original Saturation increased

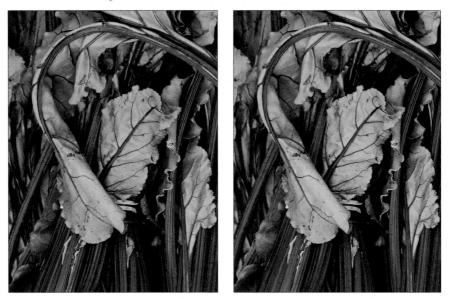

Figure 9-4: I slightly increased saturation to make the colors pop a little more.

Through the Saturation filter on the JPEG Edit menu, you can either increase or decrease color intensity. Follow these steps:

1. **Display your image in single-image view, and press OK.**

2. **Highlight JPEG Edit and press OK.**

 The JPEG Edit menu pulls into the driveway.

3. **Scroll to the second page of the menu and highlight Saturation, as shown in Figure 9-5.**

4. **Press OK.**

 You see the screen shown on the left in Figure 9-6.

Figure 9-5: The Saturation filter is on the second page of the JPEG Edit menu.

Figure 9-6: Press the up arrow to increase saturation, press down to reduce it.

5. **To increase saturation, press the up-arrow key.**

 As you press the arrow, the slider bar moves up the saturation scale that runs along the right side of the screen. Each notch boosts colors a little bit more. As you adjust saturation, the thumbnail on the right updates to show you the impact of the change. The smaller thumbnail on the left shows the original image.

6. **To decrease saturation, press the down-arrow key to move the slider toward the bottom of the scale.**

7. **Press OK.**

 The camera displays a preview screen, as shown on the right in Figure 9-6. If you're not satisfied with the result, highlight Reset and press OK to cycle back to Step 5 and try again.

8. **When you like the image displayed in the preview, select Yes and press OK.**

 The camera creates the copy of the image using your new saturation settings.

Be careful about increasing saturation too much. Doing so actually can destroy picture detail because areas that previously contained a range of saturation levels all shift to the fully saturated state, giving you a solid blob of color.

Bringing a Subject Out of the Shadows

When you shoot a scene like the one on the left in Figure 9-7, you face an exposure dilemma: If you select camera settings that will properly expose the bright areas, the shadowed areas will be too dark. Go the other direction, and you blow the highlights.

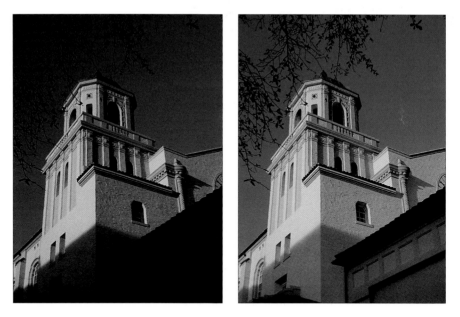

Figure 9-7: I applied the Shadow Adjustment filter to brighten the heavily shadowed areas of the picture without affecting the highlights.

In this scenario, opt for the first choice, exposing for the highlights. You can then use the Shadow Adjustment feature on the JPEG Edit menu to brighten some of the underexposed areas. I used that technique to produce the corrected image on the right in Figure 9-7.

Start the process by following the standard steps for using the JPEG Edit filters: Display your photo in full-screen view, press OK, choose JPEG Edit, and press OK again. Then highlight Shadow Adj (Adjustment) and press OK. The camera displays a progress bar for a few seconds as it works its magic, and then presents a confirmation screen. Select Yes and then press OK to complete the adjustment.

If you want more shadow brightening, you can apply the filter to the edited copy you just created, thereby doubling the shadow-recovery effort. Still not enough? Just keep repeating the process. For the record, I applied the filter three times to produce the final copy you see on the right in Figure 9-7. Remember, though, that each application of the filter results in another round of JPEG compression, which lowers image quality slightly. See Chapter 2 for details about compression.

Cropping to a New Composition

To *crop* a photo simply means to trim away some of its perimeter. Cropping can often improve an image, as illustrated by Figure 9-8. When shooting this scene, I was attracted to the way the sun was shining through the petals of the tulip. But I couldn't get close enough to fill the frame with the flower. So I just got as close as I could, selected the highest image resolution, and snapped the pic. Because of the high initial resolution, I had enough pixels left to crop the image to the composition, shown on the right in the figure.

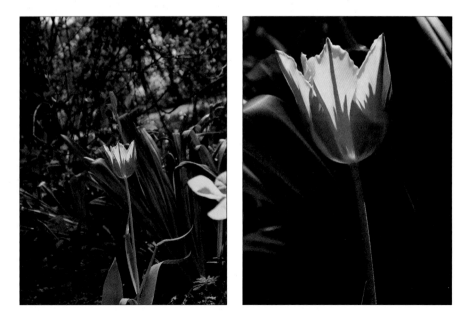

Figure 9-8: The original (left) contained too much extraneous background; cropping produces a much better composition (right).

The JPEG Edit menu offers two options for cropping a photo. But both work only on JPEG images shot at the default image aspect ratio — 4:3. Assuming that you do start with a 4:3 image, you can select the normal crop function, highlighted on the left in Figure 9-9, or the option just below it, Aspect. Here's the difference between the two:

✔ **Crop:** Select this option to keep the proportions of your cropped photo at 4:3. After you highlight the option and press OK, you see the screen shown on the right in Figure 9-9. The crop frame surrounds the area of the picture that will be retained. You can adjust the frame as follows:

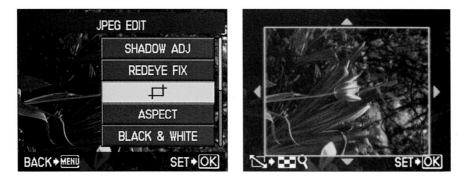

Figure 9-9: Select the Crop option to trim the image but retain a 4:3 aspect ratio.

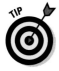

• *To change the size and orientation of the frame:* You can press either the Fn button or the Zoom button. Each press cycles you through a selection of four different crop frames: two with a vertical orientation and two with a horizontal orientation.

• *To reposition the frame:* Use the arrow keys to shift the crop frame into position.

Press OK to create the cropped copy of the image. You see a preview of the cropped photo; select Yes and press OK to finish the job.

If you can't achieve the crop you want using one of the four frame options, remember that you can do an initial crop and then crop the cropped copy, if you get my drift. For example, the boundary shown in Figure 9-9 was the smallest crop frame I could get that retained the picture's original orientation. So I created the cropped copy and then cropped *it* to produce the final version shown in Figure 9-8.

✔ **Aspect:** This option lets you crop to one of the camera's other available aspect ratios: 3:2, 16:9, or 6:6. But you can't control the size of the crop frame as you can with the crop tool — the camera automatically retains as much original image area as will fit the new proportions. Nor can you

apply the normal crop tool to the image after you apply the Aspect tool. You *can* crop first and then apply the Aspect tool to change the proportions of the cropped image, however.

To change the aspect ratio, highlight Aspect on the JPEG Edit menu and press OK. On the next screen, shown on the left in Figure 9-10, highlight your aspect ratio of choice and then press OK. (Choose 3:2 if you're cropping the picture to fit a 4-x-6-print size.) Now you see a crop frame, as shown on the right in the figure. Use the arrow keys to position the frame over the part of the picture you want to keep, and then press OK. The camera creates your cropped copy.

Figure 9-10: Use the Aspect option to crop to proportions of 3:2, 16:9, or 6:6.

For cropping to any aspect ratio other than the four standard proportions — or if you just find the in-camera cropping options too limited — you can do the job easily in most any photo program. Most retail print kiosks and online sites also offer easy-to-use crop tools and will even recommend the appropriate print size for the cropped photo.

Which brings me to one final reminder: Don't forget that cropping eliminates pixels from the image. For a decent print, you need at least 200 pixels per inch, so be careful about cropping too tightly. The extent to which I cropped the example photo retained enough pixels to produce a decent 4-x-6-inch print, but little more. Additionally, each time you edit and save the file, image quality is reduced slightly because the picture undergoes another round of JPEG compression. See Chapter 2 for more about pixels and compression.

Creating Monochrome and Sepia Tone Copies

With the Monochrome Picture Mode covered in Chapter 7, you can shoot black-and-white photos. Technically, the camera takes a full-color picture and then strips it of color as it's recording the image to the memory card, but the end result is the same.

As an alternative, you can create a black-and-white copy of an existing color photo through the JPEG Edit menu. You can also create sepia images, which give the photo sort of an antiqued look. Figure 9-11 shows you examples of both effects, created from the full-color original shown in the inset.

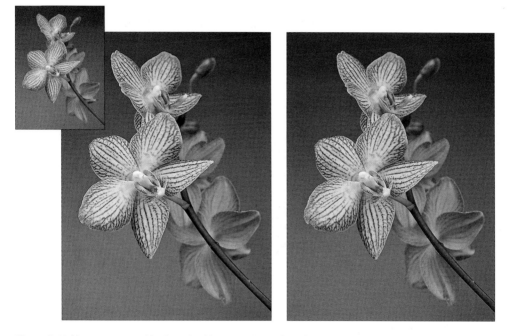

Figure 9-11: You can create black-and-white or sepia copies of your color photos through the JPEG Edit menu.

 I prefer to convert my color photos to black-and-white or sepia images in my photo editor; going that route simply offers more control. You can play with contrast and select which color tones you want to be dominant in the monochrome image, for example. Still, I know that not everyone's as much of a photo-editing geek as I am, so I present to you here the steps involved in creating in-camera black-and-white or sepia copies:

1. **Display the JPEG Edit menu.**

 The first section of the chapter explains how, if you need a reminder.

2. **Select either Black & White, as shown on the left in Figure 9-12, or Sepia, as shown on the right.**

 You need to scroll to the second page of the JPEG Edit menu to get to the Sepia option.

Figure 9-12: The Sepia effect is on the second page of the JPEG Edit menu.

3. **Press OK.**

 You see the usual confirmation screen.

4. **Highlight Yes and press OK.**

 The camera creates your black-and-white or sepia image.

Exploring the Art Filters

Through the ART shooting mode, you can add one of the following six special effects to photos or movies:

- **Pop Art (ART 1):** Choose this mode to ramp color saturation way, way up, creating the effect of a vintage pop-art poster.

- **Soft Focus (ART 2):** Throw the whole scene slightly out of focus to create a dreamy effect.

- **Grainy Film (ART 3):** Miss the look of old-fashioned film grain? You can use this effect to bring it back. (Try shooting your next movie in this mode to give it a film noir mood.)

- **Pin Hole (ART 4):** This mode mimics the effect you get when you shoot with pin-hole camera.

- **Diorama (ART 5):** Another mode that plays with focus, this one produces an effect sort of like what you can achieve with an expensive type of lens called a *tilt-shift lens*. This mode makes an ordinary scene appear as though it's actually a miniature created for a museum display (thus, diorama).

- **Gentle Sepia (ART 6):** This filter creates a monochrome image with a sepia tint, much like the Sepia option on the JPEG Edit menu (refer to Figure 9-11).

Figure 9-13 compares an unfiltered — no effects — version of a scene with the first five art filters to give you a better idea of the results you can expect.

If you've worked with other cameras that let you add special effects only to existing pictures, you may be surprised to discover that with the E-PL1, the effect is actually recorded as you shoot. What's more, the live preview shows you exactly how the filter will render the scene. That means that you can adjust exposure, white balance, and other settings to suit the filter — options you don't have if you shoot first and filter later.

No filter	Pop Art	Soft Focus

Grainy Film	Pin Hole	Diorama

Figure 9-13: Turn the Mode dial to ART to access the effects filters.

Here are a couple other details you need to know before using the filters:

✔ **Art filters can't be applied to Raw files.** If you set the Image Quality setting to Raw and then set the Mode dial to the ART setting, the camera automatically changes the Image Quality setting to Raw+LN (Large/Normal). Only the JPEG (LN) file receives the filter; the Raw file is recorded normally.

Assuming that you're comfortable working with Raw files, shooting in Raw+JPEG is the best option because it gives you the choice of using the regular image or the filtered one later, depending on which one you like best.

✔ **You can also add the art-filter effects during Raw processing.** Both of the free Olympus software tools, [ib] (Windows only) and Olympus Master 2 (Windows and Mac) let you select any art filter except the Gentle Sepia option as part of the Raw-processing stage. You can even create multiple copies of your original Raw file, applying a different filter to each one. (At press time, Olympus had just released another free program, Olympus Viewer, which does enable you to apply the Gentle Sepia filter.)

The following steps explain how to use the art filters for still photography:

1. **Set the Mode dial to ART.**

 As soon as you turn the dial, you see the menu screen shown on the left in Figure 9-14. Press the up- or down-arrow key to choose the mode you want to use and then choose OK. The live preview returns and the display shows you how the filter will affect the scene, as shown on the right in the figure. (The Pin Hole filter was active when I captured this figure.)

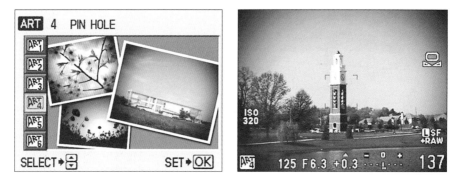

Figure 9-14: After you select a filter and press OK (right), the live preview shows the effect applied by the filter (right).

2. **To see how other filters affect the scene without returning to the menu, use the Live Control display. Press OK to display the Live Control screen.**

 The Art Filter setting appears in the location shown on the left in Figure 9-15. You also can change the setting via the Super Control Panel — the option resides in the lower-left corner of the screen, as shown in the second image in the figure. But of course, the panel pretty much obliterates your view of the image, so the Live Control display is better until you familiarize yourself with the different art effects.

 See Chapter 1 to find out how to use both control displays.

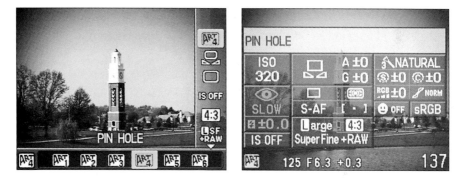

Figure 9-15: You also can choose a different filter through the Live Control or Super Control Panel displays.

3. **Adjust exposure, color, and other picture or movie-recording settings as needed.**

 You can adjust most of the same settings as you can in P (programmed autoexposure) mode. If a setting is unavailable, the camera needs to control that option in order to produce the art filter effect.

4. **Take the picture.**

5. **To exit ART mode, just set the Mode dial to any other setting.**

For movie recording, you can follow the same steps and then press the Movie button to begin recording; the movie is created using the most recently used recording settings. Or you can set the Mode dial to Movie and then select the art filter you want to apply through the Live Control panel. See Chapter 3 for more details about recording movies.

Creating a Multiple-Exposure Image

Now that the age of digital imaging and Adobe Photoshop has dawned, it's not unusual to see photo *composites* — pictures created by layering multiple digital pictures on top of each other. Sometimes the goal is outright trickery, as when a supermarket tabloid juxtaposes a picture of Celebrity A with a picture of Celebrity B, making it appear that the two are stepping out together instead of with their respective spouses. But many people use photo compositing not to deceive but to create surreal, dreamlike imagery that is simply about artistic expression.

The E-PL1 offers two tools that enable you to start experimenting with photo compositing:

- **Multiple Exposure:** After you enable this option, you shoot two pictures in a row, and the camera merges them into one image.

- **Image Overlay:** This option enables you to merge up to three existing Raw images into one.

In other words, Multiple Exposure and Image Overlay are two sides of the same coin. The first is a *composite as you shoot* tool, whereas the other lets you blend images after the fact.

Figures 9-16 and 9-17 provide two examples of the kind of images you can produce with either tool. For the first image, I combined a shot of some piano keys with a photo of a piece of sheet music. For the second example, I combined a picture of the watch face with one of interior of the case.

The example figures illustrate one key point to understand about Multiple Exposure and Image Overlay: Each image in the composite is set to 50-percent opacity, which means that the half-and-half effect you see in Figure 9-16 is the normal result. The only way that an object from one frame can appear at full opacity is when it's positioned in an area that's black in the other frame. For example, when shooting the images that I composited to create Figure 9-17, I placed the watch on the left side of the frame for the first picture and on the right side for the second picture. Because the watches don't overlap in the composite, both appear at full opacity. (You can see the steps I took to create the image in the next section.)

For product shots, you can simply use a black background, as I did. Or try the compositing trick that's often used for marketing this feature: Composite a shot of a full moon with a nighttime cityscape taken on a night when clouds obscured the moon — no need to wait for perfect conditions anymore! You do have to think ahead and compose both shots carefully so that when you put the two together, the moon doesn't overlap any of the buildings and vice versa.

Figure 9-16: I layered a picture of piano keys over a photo of sheet music to create this composite image.

Figure 9-17: If you want objects in composited images to appear at full opacity, shoot them against a black background.

To be honest, I don't use Image Overlay or Multiple Exposure for the purpose of serious photo compositing. Instead, I do this kind of work in my photo software, which enables me to precisely control how pixels in one image blend with another. In my photo program, for example, I could blend the piano and music images in a way that kept the keys fully opaque, with the music notes appearing at, say, 60-percent opacity over the white keys. Understand, too, that neither feature is designed to produce an HDR (high dynamic range) image, which lifts different brightness ranges from different images to create the composite. For HDR, you need software that can do tone mapping, not just whole-image blending.

But it's not really fair to blame these features for failing to accomplish a goal they're not designed to do. And the E-PL1 offers a really cool twist on the Multiple Exposure feature: After you take your first shot, the frame is superimposed on the live preview so that you can see how to frame the second shot for the best results.

If you're interested in comparing the two features, the next two sections give you the step-by-step process.

Shooting a multiple exposure

To try out the Multiple Exposure option, take these steps:

1. **Set the Mode dial to P, A, S, or M.**

 You can create a multiple exposure only in these modes.

2. **Set all picture-taking options.**

 You must set exposure, color options, Image Quality, and so on *before* turning on the Multiple Exposure feature. After you enable this feature, the camera automatically cancels it if you press the Menu button or the Playback button, or change the Mode dial. And you can't even access some options (such as Image Quality) after you enable the feature. So set all the photo options and take a test shot to make sure everything's dialed in before you go any further.

 Also note that Multiple Exposure is cancelled if you switch between the monitor display and the optional electronic viewfinder display or insert the USB cable, the AV cable, or the optional HDMI cable into the ports on the side of the camera. Be prepared to shoot right away and have a full battery charge: Enabling Multiple Exposure turns off the camera's Sleep function (which powers down the camera automatically after a period of inactivity).

3. **Display Shooting Menu 2, select Multiple Exposure, as shown on the left in Figure 9-18, and press OK.**

 You see the screen shown on the right in the figure, offering three options. To set each one, highlight it, press the right-arrow key, select the setting you want to use, and press OK. The options work as follows:

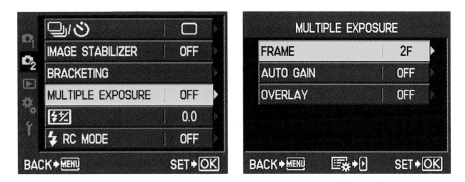

Figure 9-18: Wait to enable the Multiple Exposure option until *after* you set all other picture-taking options.

- *Frame:* Select 2F (two frames) to turn on the feature; select Off to disable it.

- *Auto Gain:* This option determines the opacity of each frame. If you choose On, each frame is set to 50 percent, and the resulting effect is similar to what you see in Figure 9-16. When Auto Gain is turned off, each frame is set to 100-percent opacity. On the surface, that sounds like it might be a good thing, but it usually isn't. When you layer two images, you're adding together the pixel brightness values of each image. So, for example, if a pixel in one image is medium gray, and the same pixel in the other image is also medium gray, the pixel in the merged image will be white. If you're in doubt, just shoot one pair of frames with the setting enabled and one with it turned off.

- *Overlay:* If your memory card contains images taken in the Raw (ORF) file format, you can choose to overlay your multiple exposure images on top of one of the Raw photos. In this way, you can actually combine three frames using Multiple Exposure: Your existing Raw image and your two Multiple Exposure shots.

 When you turn the setting On and press OK, an Overlay screen appears, showing thumbnails of Raw images on the card. Use the arrow keys to move the highlight box over the frame you want to use and press OK.

 To combine several existing Raw images, use the Image Overlay technique outlined in the next section.

4. **After setting your Multiple Exposure options, press OK and then press the shutter button halfway to return to shooting mode.**

 If you turned on Image Overlay, the image you selected is superimposed at reduced opacity over the live preview. Otherwise, the screen looks normal with the exception of the little icon at the top of the screen, labeled on the left in Figure 9-19. That icon tells you that Multiple

Exposure shooting is enabled. (And its absence tells you that you pressed a button or took some other action that inadvertently canceled the Multiple Exposure operation.)

To create the watch image in Figure 9-17, I set up the first shot as shown on the left in Figure 9-19, by the way.

Multiple Exposure symbol

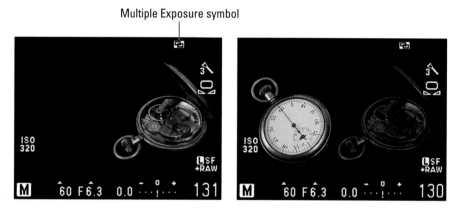

Figure 9-19: With Multiple Exposure, your first image (left) is superimposed on the live preview to help you compose the second shot (right).

5. **Take your first shot.**

 If you enabled instant review, the image appears for a few seconds on the monitor. (See Chapter 4 for more about instant review.) Then you see a faded version of your first shot in the live preview, as shown on the right in Figure 9-19, to guide you in composing your second shot. For example, when I was ready to shoot the face of the watch, I knew to position it as shown on the right in the figure to avoid having any part of it overlap the watch from the first shot. Remember, any objects that overlap appear at partial opacity — to keep them "solid," you must separate them and use a black background.

6. **Take the second shot.**

 This time, the instant review shows you the merged image.

 Neither of your original shots is stored as separate files on the memory card — you retain only the final, merged image. So if you need both shots as separate files, record them either before or after enabling Multiple Exposure. Or, as another option, shoot them in the Raw format and then use Image Overlay, explained next, to combine them.

Using Image Overlay

Image Overlay lets you combine three existing images, but only if they were shot in the Raw file format. (See Chapter 2 to get an understanding of file formats.) To try out Image Overlay, walk this way:

1. **Set the Image Quality option to the format you want the camera to use for the composite photo.**

 The composite image is saved in the Image Quality setting that was in force before you began the overlay process. Well, sort of, anyway. If you set the Image Quality to Raw, the camera actually steps in and uses the Raw+LN (JPEG Large/Normal) instead.

2. **Switch to playback mode and display the first image that you want to merge.**

 Again, you can only merge Raw photos.

3. **Press OK.**

 If you captured the image only in the Raw format, you see the Image Overlay option in the menu position shown on the left in Figure 9-20. If you captured the picture using one of the Raw+JPEG settings, the menu looks a little different. Scroll to the second page of the menu to uncover the Image Overlay option.

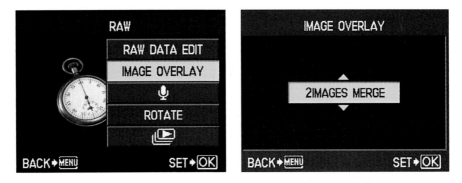

Figure 9-20: Select Image Overlay to composite existing Raw images.

4. **Select Image Overlay and press OK.**

 You see the screen shown on the right in Figure 9-20.

5. **Select the number of images you want to merge.**

 You can choose to merge two or three photos.

If you want to merge four images, you can, however. Just set the image quality to Raw or Raw+JPEG in Step 1. Create one overlay image using the first three pictures, and then repeat the process, this time selecting your composite Raw photo as the starting image in Step 1.

6. **Press OK.**

You're taken to the Image Overlay screen, which contains thumbnails of all Raw files on the memory card, as shown in Figure 9-21. A red check mark appears over the image you selected in Step 2 to show that it's selected to be used in the overlay image.

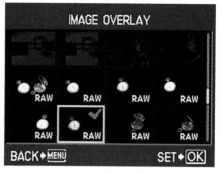

Figure 9-21: Select a thumbnail and press OK to tag it as one you want to merge.

7. **Select the images you want to merge with the original Raw file.**

Use the arrow keys to move the highlight box over the first image you want to merge and press OK to tag it with a red check mark as well. If you're merging three photos, select the second Raw thumbnail and press OK to tag it.

8. **Press OK to build the initial composite image.**

The camera displays a progress bar and then shows you a preview screen like the one in Figure 9-22.

9. **To modify the result, use the gain controls under each thumbnail.**

Press the right- or left-arrow key to highlight one of the gain controls and then press the up- or down-arrow key to adjust the value.

10. **Press OK.**

You're presented with a confirmation screen.

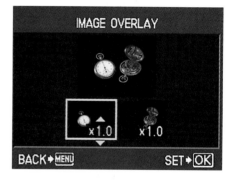

Figure 9-22: You can modify the mix of pixels in the image by using the gain controls under each thumbnail.

11. **Highlight Yes and press OK to create the final composite image.**

If the image quality was set to Raw+JPEG, you get two composite files, one in each format.

Adding a Voice Annotation to an Image

How many times have you looked at a picture and thought, "Now where was I when I took that shot — and who the heck is that I'm sitting with?" Well, those days are gone. Now you can add a little voice recording to any picture during playback to remind you of where you've been and what you've done.

Follow these steps to record your note:

1. **Display the photo in single-image playback mode.**

2. **Press OK.**

 If you shot the picture in the Raw format, you see the menu shown on the left in Figure 9-23. Otherwise, you see the standard JPEG Edit menu.

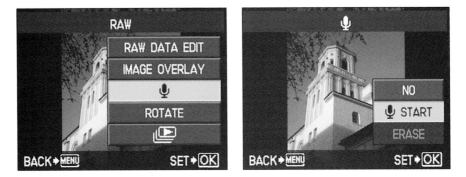

Figure 9-23: Choose this option to record a voice memo with your picture file.

3. **Choose the little microphone option, as shown on the left in Figure 9-23, and press OK.**

 (On the JPEG Edit menu, the option is the second one on the menu.) You see the screen shown on the right in the figure.

4. **Select Start and press OK to start recording.**

 The display changes to show the recording symbol and the elapsed recording time, as shown in Figure 9-24. The little green musical note tags the image as having a sound file attached.

 You can talk for as long as 30 seconds, at which time the recording stops automatically. To stop before that time, press OK.

During playback, annotated images are indicated with the same little green sound file icon that appears during recording. Your voice annotation begins playing as soon as you display the picture. You can adjust the speaker volume by pressing the up- or down-arrow key. To delete a recording, follow the same steps but choose Erase in Step 4.

TIP

After downloading images, you can listen to the audio file in the Olympus photo software (either [ib] or Olympus Master). Just choose File⇨Linked Sound⇨Play.

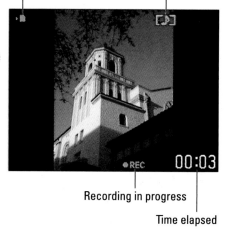

Writing to memory card Sound file icon

●REC 00:03

Recording in progress

Time elapsed

Figure 9-24: The music note indicates that a sound recording is attached to the photo.

Safeguarding your masterpieces

Computer hard drives — whether inside the computer case or external units — are mechanical beasts that are subject to failure. To protect yourself in the event of drive failure, always copy important pictures to DVD or CD. Regular backups also protect you in the event that your computer picks up a virus that requires you to wipe your hard drive clean to bring back your system to life. This warning goes double — heck, triple — if you store your pictures on a laptop computer; I can't tell you how many people have told me that they lost all their photos when their laptop was stolen or dropped.

For the best backup protection, buy archival-quality DVD or CD blanks. You'll pay more than the cheap store-brand discs, but there really is a difference in the longevity of the data you store. You may also want to consider adding a third layer of security by adding a second hard drive just for the purpose of image backup. Just don't forget that if the main system gets zapped by a power surge, anything connected to it is likely to get fried, too. Some people buy an external backup drive and then connect it to the main system only during the backup process. Online file-storage services offer yet another way to ensure the safety of your picture files.

10

Ten More Ways to Customize Your Camera

In This Chapter

▶ Changing the tasks assigned to the Fn and Movie buttons

▶ Storing groups of camera settings using the Reset and My Mode features

▶ Customizing picture filenames

▶ Streamlining the picture delete process

▶ Adding to your lens repertoire

Consider this chapter the literary equivalent of the end of one of those late-night infomercial offers — the part where the host exclaims, "But wait! There's more!"

The ten features covered in these pages fit the category of "interesting bonus." They aren't the sort of features that drive people to choose one camera over another, and they may come in handy only for certain users, on certain occasions. Still, they're included at no extra charge with your camera, so check 'em out when you have a few spare moments. Who knows; you may discover that one of these bonus features is actually a hidden gem that provides just the solution you need for one of your photography problems.

 Many features this chapter covers involve options accessible through the Custom menu, which is hidden by default. See Chapter 1 to find out how to display the menu if you haven't already done so.

Assign New Tasks to the Fn and Movie Buttons

By default, the Fn button, labeled in Figure 10-1, is set to toggle Face Detection on and off, and the Movie button is set to start and stop movie recording. But you can assign different tasks to each button if you like.

To start exploring your options, first set the Mode dial on top of the camera to P, A, S, or M. These modes give you access to all the available button functions. In other modes, you either can't adjust the button function at all or can't set the button to perform functions that work only in the P, A, S, and M modes. Then travel to Custom Menu B (*B* for *B*utton!), as shown on the left in Figure 10-2. To change the purpose of the Fn button, choose the first of the two Function options, as shown on the right in the figure. To set the function of the Movie button, choose the second Function option. (The little circle-inside-a-circle icon is how Olympus represents the Movie button on the menus and in the camera manual.)

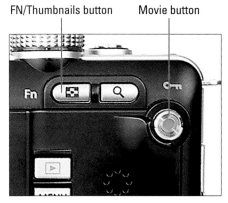

FN/Thumbnails button Movie button

Figure 10-1: You can assign different tasks to these two buttons.

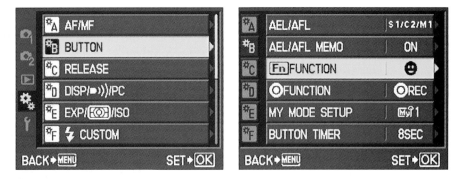

Figure 10-2: You can set either button to perform 1 of 12 functions or render it inactive for shooting.

After selecting the button you want to customize, press OK to display a screen similar to the one in Figure 10-3. Press the up- or down-arrow key to scroll to the function that you want to assign to the button and press OK.

Here's a list of the functions that you can use the buttons to access:

✔ **Face Detection on/off:** Again, this is the default setting for the Fn button. Press once to turn on Face Detection; press again to turn it off.

✔ **Preview:** Press and hold to preview depth of field at the current f-stop. Chapter 7 explains this feature.

✔ **One Touch White Balance:** Switch to One Touch White Balance, also covered in Chapter 7.

Figure 10-3: Press up or down to select the button function and then press OK.

✔ **Home AF Target:** Press once to use your home AF Area target; press again to switch back to the target that was previously being used. Chapter 7 covers this and other focus features.

✔ **MF:** Press once to toggle the AF mode to manual focus; press again to switch back to the previously selected setting.

✔ **Raw+JPEG:** Press to toggle the Image Quality setting between JPEG only and Raw+JPEG. See Chapter 2 for information about Image Quality options.

✔ **Test Picture:** Press to take a picture and display it in the monitor so that you can evaluate exposure, color, and focus without actually recording the image to the memory card.

✔ **My Mode:** Press and hold to take a picture using settings you store with the My Mode feature, explained later in this chapter.

✔ **Underwater shooting modes:** Of all the icons used on the E-PL1, the one that represents this setting, as shown in Figure 10-4, is my favorite (as well as perhaps the most cryptic). Here's the deal: If you buy the optional underwater camera housing, you can use the assigned button to switch between two automatic underwater shooting modes. The three-fish symbol represents the mode designed to capture a large group of subjects, such as a school of fish; the one fish icon represents the setting geared to shooting a single subject, such as a lonely little clownfish or a piece of coral.

Figure 10-4: This setting enables you to toggle between two underwater shooting modes when you use the optional underwater camera housing.

- ✓ **AEL/AFL:** Pressing the button locks focus, exposure, or both, according to the setting you select for the AEL/AFL option on Custom Menu B. See the next section for information about this advanced customization feature.

- ✓ **Movie Recording start/stop:** By default, you press the Movie button to start and stop recording and press the shutter button to record a still photo in the midst of the recording. If you don't set the Movie button or the Fn button to serve the Movie start/stop function, you use the shutter button to start and stop recording. (You must first set the Mode dial to Movie.) You can then capture a still photo at the end of the recording by turning on the Movie+Still option. See Chapter 3 for help with movie making.

- ✓ **Backlit LCD:** Press the assigned button to toggle the monitor on and off between shots to save battery power. Note that this feature is different from the option that goes by the same name on Custom Menu D. That option controls the timing of when the monitor shifts from full brightness to reduced brightness (again, to save battery power).

- ✓ **Off:** Choose this setting to prevent the assigned button from having any kind of useful life during shooting. The button still plays its normal roles during picture playback, however. See Chapter 4 for playback help.

If you adjust the functions assigned to the buttons, instructions in this book (as well as those in the camera manual) may not work as advertised. So remember that you may need to adapt steps involving the buttons if you changed their default assignments.

Adjust Focus and Exposure Locking

The warning given in the preceding paragraph goes double — nay, triple or even ten times — for the customization option I'm about to discuss. Don't take advantage of this option, which enables you to alter the way the camera locks focus and exposure, unless you really know what you're doing.

At the default camera settings, pressing the shutter button halfway initiates autofocusing and autoexposure. Exposure is then locked as you keep the shutter button down halfway. Focus is also locked if you use the S-AF autofocus setting, but in the continuous autofocus modes (C-AF and C-AF+TR), focus is adjusted up to the moment you depress the button fully to take the shot.

When the Mode dial is set to P, A, S, M, or ART mode, you can modify this behavior via the AEL/AFL option on Custom Menu B, as shown on the left in Figure 10-5. You can choose to lock focus only, for example, or exposure only, with a half-press of the shutter button. What's more, you can set different preferences for the S-AF autofocus mode, the C-AF mode, and manual focus mode.

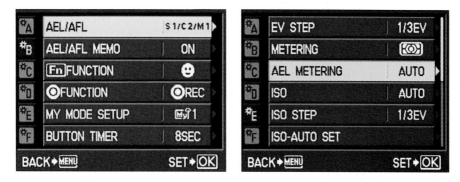

Figure 10-5: The AEL/AFL, AEL/AFL Memo, and AEL Metering options customize focus and exposure locking controls.

If you set the Fn button or Movie button to the AEL/AFL option, as outlined in the preceding section, the menu option also determines what happens when you press that button. You can set the shutter button to lock focus and the other button to lock exposure, for example.

To make everything even more complex, the setting of the AEL/AFL Memo option, which lives just below the AEL/AFL option on Custom Menu B, determines whether you end focus or exposure lock by releasing the Fn button or Movie button or by pressing it a second time. Finally, if you use the Fn or Movie button to lock exposure, you specify what metering mode you want the button to invoke through the AEL Metering option on Custom Menu E, as shown on the right in Figure 10-5.

Wowee, that's a brain-boggling bunch of customization options to sort through. Very experienced photographers may want to tweak these settings to suit their shooting habits and preferences — the camera manual spells out all the available focus and exposure locking possibilities. But my advice to anyone else is to leave all three options at their default settings and use the Fn and Movie buttons for performing other tasks.

Use Custom Resets to Store Picture Settings

Through the Custom Reset option on Shooting Menu 1, you can restore most default settings for the P, A, S, and M shooting modes. Select the option, press OK, and then choose Reset, as shown in Figure 10-6, and press OK again.

But there's more to the Custom Reset menu option than this basic default-restoring function. Through the Reset 1 and Reset 2 options, also shown on the right in Figure 10-6, you can create two of your own sets of defaults so that you can quickly revert to those settings at any time. For example, you might use Reset 1 to store settings you like to use for shooting sports, and then set up Reset 2 to hold your favorite portrait photography settings.

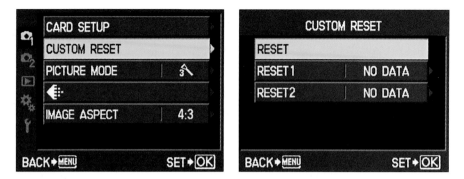

Figure 10-6: You can store two groups of frequently used picture settings through the Reset 1 and Reset 2 options.

Setting up your pair of custom defaults, or *presets,* in digital-camera vernacular, is easy:

1. **Set the camera to P, A, S, or M mode.**

2. **Select the settings you want to use when you call up your custom preset.**

 When you create your preset, the camera simply looks at the current settings and stores them. So you need to dial in all the important picture settings before you move on. The preset remembers such settings as shutter-release mode, Image Quality, image stabilization, AF Mode, and AF Area mode — in other words, all the biggies. Your camera manual has a complete list of all the settings that can be stored in the preset.

3. **Choose Custom Reset from Shooting Menu 1 and press OK.**

 You see the screen shown on the right in Figure 10-6. Until you register the settings you want to store, the Reset 1 and Reset 2 options show the No Data label, as in Figure 10-6.

4. **Highlight Reset 1, as shown on the left in Figure 10-7, and then press the right-arrow key.**

 Now you see the screen shown on the right in Figure 10-7.

5. **Highlight Set, as shown on the right in Figure 10-7, and press OK.**

 After you choose Set and press OK, your current camera settings are stored as Reset 1, and the screen shown on the left in the figure reappears. This time, Set appears next to Reset 1 instead of No Data to let you know that your settings were registered.

6. **Repeat the process to register settings for Reset 2.**

7. **Press the Menu button to exit the Custom Reset screen.**

8. **Press the shutter button halfway to return to shooting mode.**

Figure 10-7: Select Reset 1, press right, and then choose Set to store the current camera settings as your first custom preset.

To modify a preset, just repeat the steps. Your original preset is replaced with the new settings. If you want to completely wipe out a preset so that you can start over from scratch, choose Reset in Step 5. All settings for the preset then revert to the defaults for the P, A, S, and M modes.

After you create your custom presets, select the one you want to use as follows:

1. **Open Shooting Menu 1, select Custom Reset, and press OK.**

 You see the screen shown on the left in Figure 10-8. (This assumes that you created both presets.)

2. **Highlight the custom preset you want to use (Reset 1 or Reset 2).**

3. **Press OK to display the screen shown on the right in Figure 10-8.**

 Don't press the right-arrow key instead of OK or you bring up the screen that lets you register new settings. You can easily take a wrong turn and end up wiping out your current reset, especially because the different option names are so similar, so pay attention on this step.

Figure 10-8: To use a preset, select it, press OK, select Yes, and press OK again.

4. **Choose Yes and then press OK.**

 The camera automatically reconfigures itself to use all the settings stored in the custom reset.

Create Your Own Shooting Mode

A variation of the Custom Reset feature, the My Mode feature gives you another way to store and then easily return to a favorite group of picture-taking options. As with custom presets, you can store two groups of settings, My Mode 1 and My Mode 2. But the My Mode feature is a little more limited in the number of settings you can store and also a bit trickier to implement. Here's what you need to know:

- ✓ **Check the camera manual to compare the settings that can be stored in My Mode versus the Reset feature.** Both features enable you to store quite a long list of camera settings, but review the list to see whether My Mode is missing a setting that's critical to you.

- ✓ **You must assign the Fn or Movie button to recall your My Mode settings.** You can't call up a My Mode preset via menus. So before you explore the My Mode option any further, read the first section of this chapter to make sure you wouldn't prefer to use the button for some other task. (By default, the Fn button toggles Face Detection on and off, and the Movie button enables one-button movie recording.)

- ✓ **You can access only one My Mode preset at time.** You use an option on Custom Menu B to set your assigned button to recall My Mode 1 or My Mode 2. And in case you're wondering: You can't assign one button to call up My Mode 1 and use the other to access My Mode 2. As soon as you set one button to the My Mode function, that option is no longer available for the other button.

- ✓ **To take a picture with the stored settings, you press the assigned button and keep it pressed while you press the shutter button.** It's not that difficult to do, but you have to get in the habit of pressing both buttons at the same time. As soon as you let up on the assigned button, the camera no longer uses the My Mode settings but instead reverts to whatever settings were in place before you pressed the button.

 All these issues aside, the My Mode feature can come in really handy during occasions where you expect to be shooting two very different types of photos. Suppose that you're going to a family picnic, for example. One minute, you may need to use settings that enable you to take a nice portrait, and the next, you may need to use action-photography settings so that you can catch some pics of the kids playing badminton. If you store the action

settings as a My Mode preset, you can set up the camera for portrait shoot-ing and then press the assigned button to switch quickly over to your action settings. In this regard, My Mode makes switching to a collection of settings faster than using Reset 1 or Reset 2.

Enough preamble: Follow these steps to store camera settings using the My Mode feature:

1. **Assign either the Fn or Movie button to the My Mode setting.**

2. **Set the camera to P, A, S, or M mode and set all the camera options to the settings you want to store in the My Mode 1 preset.**

 You can't take advantage of the My Mode feature in any other shooting mode but P, A, S, or M. Even the ART mode is excluded from this buffet.

3. **Display Custom Menu B, as shown on the left in Figure 10-9, and select My Mode Setup.**

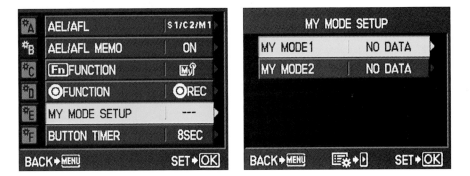

Figure 10-9: Register current settings as either My Mode 1 or My Mode 2.

4. **Press OK to display the screen shown on the right in the figure.**

5. **Select My Mode 1 and then press the right-arrow key.**

 You see the screen shown in Figure 10-10.

6. **Choose Set and then press OK.**

 You return to the My Mode Setup screen.

7. **To set up My Mode 2, exit the menus and then repeat Steps 2–6.**

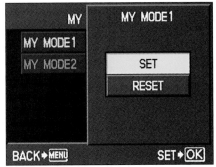

Figure 10-10: Choose Set to register the current settings; choose Reset to wipe out a stored My Mode preset.

8. **Specify which of the two modes you want the assigned button to access.**

 You start this process on My Mode Setup screen (the left screen in Figure 10-11). Select the mode and press OK to get to the second screen in the figure. Select Yes and press OK.

Figure 10-11: Even if you create only one My Mode preset, you must take this step to link it to the assigned button.

You're returned to Custom Menu B. The My Mode Setup option shows which mode you assigned to the button, as shown in Figure 10-12. Note that you must take Step 8 even if you create only one My Mode preset; otherwise, the button won't be linked to the function.

Figure 10-12: The menu now shows which My Mode preset the button calls up.

Although the setup steps are a little confusing, shooting a picture using your stored My Mode preset is easy. Press and hold the button you assigned to the My Mode function. When you do, you see a My Mode icon above the normal shooting mode icon (P, S, A, or M) in the lower-left corner of the screen. Keep holding the button as you take the picture and then release. Now the normal shooting mode is active again.

Create Personalized Filenames

Picture filenames contain eight characters and normally begin with the letter P and three numbers that indicate the folder number, as in P1010001.jpg. If you change the color space from the default, sRGB, to Adobe RGB, the P is replaced by an underscore, as in _1010001jpg. (Chapter 7 explains the Color Space option.)

You can customize the first four characters of the filename for sRGB files and the three characters following the underscore for pictures taken in the Adobe RGB space. You might set the characters to match your initials, for example, if you share the camera with other photographers so that you can tell at a glance who took the picture.

To customize filenames, choose Edit Filename on Custom Menu H, as shown on the left in Figure 10-13. Press OK to display the second screen in the figure. If the Color Space option is currently set to sRGB, the screen offers controls for changing the first four characters, as shown in the figure. If the Color Space is set to Adobe RGB, you can adjust only three characters. Either way, use the left- and right-arrow keys to select the character you want to change and then press the up- or down-arrow key to choose the character. In addition to alphabetic characters, you can choose a number from 1 to 9. Press OK to finalize the change. Your new filename is used for the next picture you shoot.

Figure 10-13: Use this option to customize the first characters of filenames.

To return to the default filenaming conventions, revisit the Edit Filename option and set all the character values to Off.

Speed Up the Image Delete Process

The normal image-delete feature provides you with some safety nets that help prevent you from unintentionally erasing a picture. However, if you like to live on the edge, you can speed up the deleting process through the following two options, both found on Custom Menu H and shown in Figure 10-14.

✔ **Priority Set:** When you delete photos using the normal processes (Chapter 4 has details) the camera presents you with a Yes/No confirmation screen, with No selected by default. To move ahead with deleting, you must select Yes and then press OK. But if you change the Priority Set option to Yes, as shown in the figure, Yes is selected by default. You then can delete a photo with just two button presses — press the Erase button (the one marked with the red trash can) and then press OK.

Note, though, that this setting affects all camera features that display a confirmation screen. If that's a concern, consider the next option for speedy picture deleting instead.

✔ **Quick Erase:** If you set this option to On, as shown on the right in Figure 10-14, you can delete with just a single press of the Erase button. The camera doesn't bother you — or warn you — with a confirmation screen, so use caution during picture playback to avoid accidentally deleting a photo.

QUICK ERASE	ON
RAW+JPEG ERASE	RAW+JPG
FILE NAME	AUTO
EDIT FILENAME	
PRIORITY SET	YES
dpi SETTING	AUTO

BACK ➔ MENU SET ➔ OK

QUICK ERASE	ON
RAW+JPEG ERASE	RAW+JPG
FILE NAME	AUTO
EDIT FILENAME	
PRIORITY SET	YES
dpi SETTING	AUTO

BACK ➔ MENU SET ➔ OK

Figure 10-14: Quick Erase and Priority Set give you two ways to speed up the process of deleting pictures.

Specify a Default Print Resolution

Chapter 2 explains how image resolution (pixel count) determines the size at which you can produce a good quality print. As a general rule, a resolution of about 200 ppi (pixels per inch) is sufficient, although you may need a higher resolution if submitting a photo for professional printing. The publisher of this book, for example, requires 300 ppi picture files.

If you print your photos from a professional photo-editing program, such as Adobe Photoshop, you can control the print size and print resolution. For example, if your original image contains 4032 x 3024 pixels — the maximum pixel count on the E-PL1, you can output an 8-x-6 print at 504 ppi or a 16-x-12 print at half that resolution, 252 ppi.

Olympus embeds a print resolution value into the image file so that if you set up a print job in a program like Photoshop that can read the data, the default print resolution is selected for you. The default print resolution also determines the default print size, of course. The embedded resolution value also is useful to photographers who need to deliver an image file to a publisher at a specified resolution.

By default, the camera embeds the print resolution data automatically, varying the value depending on what pixel count you use for the Image Quality setting. If you want to choose a specific default resolution, change the DPI setting, found on Custom Menu H (see Figure 10-15), from Auto to Custom and then set the value you want to use.

Figure 10-15: This value simply sets the default print resolution; it doesn't lock you into any set resolution or print size.

Note that the name of the option is slightly inaccurate: DPI is a measure of how many dots of ink or toner a printer can lay down per inch (*dots per inch*), which isn't the same thing as ppi (pixels per inch). Many printers use multiple dots to reproduce one image pixel.

Check for Faulty Pixels

It's not uncommon for a few pixels on a digital camera's image sensor to go bad over time. Usually, you can't detect any difference in the photo itself. But if a clump of pixels fails, the problem may show up as tiny black or white spots in your images.

If you experience this problem, the first step is to run the Pixel Mapping function, found on Custom Menu J and shown in Figure 10-16. (Wait a minute after taking a picture or adjusting the monitor before doing so.) The Pixel Mapping utility runs a diagnostic test on the sensor, mapping out any bad pixels. From this data, the camera can reset itself to compensate for the problem pixels, often eliminating any visual image defects. If the Pixel Mapping function doesn't take care of bad pixels, take the camera to an Olympus-certified repair shop.

Figure 10-16: Pixel Mapping runs a diagnostic sensor test to locate any bad pixels.

 Olympus suggests that you run the utility at least once a year even if you don't spot any image defects, in fact, just to make sure the sensor delivers the highest quality images that it can produce.

Change the Timing of the Battery Warning

Also found on Custom Menu J, the Battery Warning option lets you adjust the level of battery drain required before the low-battery icon appears in the upper-right corner of the monitor. After selecting the option, press OK and then use the up- or down-arrow key to adjust the setting. Figure 10-17 illustrates the process. The middle position on the slider bar represents the default setting; lower the value if you want the battery drain to be more severe before the warning occurs.

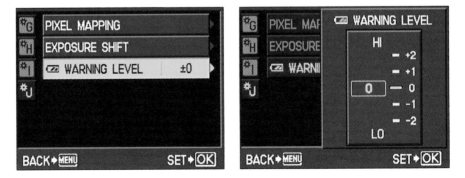

Figure 10-17: If you want the camera to wait until the battery is really, really low before displaying the warning icon, lower this value.

Expand Your Lens Kit

One final way to customize your camera — and an awfully fun, if expensive way — is to invest in additional lenses. You can use all types of lenses with your camera, including the following:

- **Micro Four Thirds lenses:** These are the lenses built from the ground up to mesh perfectly with the E-PL1.

- **Four Thirds lenses:** With an optional lens adapter, you can mount any lenses that fit on regular Four Thirds cameras (Olympus E-series dSLR cameras). This broadens your focal-length choices dramatically. However, you do give up some E-PL1 functions, including the tracking autofocus mode (C-AF+TR).

- **OM System lenses:** In the 1970s, Olympus introduced lenses with this specification for use with its OM line of 35mm-film SLR models. (*OM* is a variant of the original name of the first camera in line, the Olympus M-1.) As with Four Thirds lenses, you can use an OM lens with the help of an optional adapter. Mounting an OM lens also limits the range of camera functions you can access, too, but it's still great to be able to resurrect an old lens that would otherwise just be collecting dust.

For complete details about lens compatibility and a look at other camera accessories, visit the Olympus Web site (www.olympus.com).

Index

● *N* ●

Business/Accounting & Bookkeeping

Bookkeeping For Dummies
978-0-7645-9848-7

eBay Business
All-in-One For Dummies,
2nd Edition
978-0-470-38536-4

Job Interviews
For Dummies,
3rd Edition
978-0-470-17748-8

Resumes For Dummies,
5th Edition
978-0-470-08037-5

Stock Investing
For Dummies,
3rd Edition
978-0-470-40114-9

Successful Time
Management
For Dummies
978-0-470-29034-7

Computer Hardware

BlackBerry For Dummies,
3rd Edition
978-0-470-45762-7

Computers For Seniors
For Dummies
978-0-470-24055-7

iPhone For Dummies,
2nd Edition
978-0-470-42342-4

Laptops For Dummies,
3rd Edition
978-0-470-27759-1

Macs For Dummies,
10th Edition
978-0-470-27817-8

Cooking & Entertaining

Cooking Basics
For Dummies,
3rd Edition
978-0-7645-7206-7

Wine For Dummies,
4th Edition
978-0-470-04579-4

Diet & Nutrition

Dieting For Dummies,
2nd Edition
978-0-7645-4149-0

Nutrition For Dummies,
4th Edition
978-0-471-79868-2

Weight Training
For Dummies,
3rd Edition
978-0-471-76845-6

Digital Photography

Digital Photography
For Dummies,
6th Edition
978-0-470-25074-7

Photoshop Elements 7
For Dummies
978-0-470-39700-8

Gardening

Gardening Basics
For Dummies
978-0-470-03749-2

Organic Gardening
For Dummies,
2nd Edition
978-0-470-43067-5

Green/Sustainable

Green Building
& Remodeling
For Dummies
978-0-470-17559-0

Green Cleaning
For Dummies
978-0-470-39106-8

Green IT For Dummies
978-0-470-38688-0

Health

Diabetes For Dummies,
3rd Edition
978-0-470-27086-8

Food Allergies
For Dummies
978-0-470-09584-3

Living Gluten-Free
For Dummies
978-0-471-77383-2

Hobbies/General

Chess For Dummies,
2nd Edition
978-0-7645-8404-6

Drawing For Dummies
978-0-7645-5476-6

Knitting For Dummies,
2nd Edition
978-0-470-28747-7

Organizing For Dummies
978-0-7645-5300-4

SuDoku For Dummies
978-0-470-01892-7

Home Improvement

Energy Efficient Homes
For Dummies
978-0-470-37602-7

Home Theater
For Dummies,
3rd Edition
978-0-470-41189-6

Living the Country Lifestyle
All-in-One For Dummies
978-0-470-43061-3

Solar Power Your Home
For Dummies
978-0-470-17569-9

Internet
Blogging For Dummies,
2nd Edition
978-0-470-23017-6

eBay For Dummies,
6th Edition
978-0-470-49741-8

Facebook For Dummies
978-0-470-26273-3

Google Blogger
For Dummies
978-0-470-40742-4

Web Marketing
For Dummies,
2nd Edition
978-0-470-37181-7

WordPress For Dummies,
2nd Edition
978-0-470-40296-2

**Language & Foreign
Language**
French For Dummies
978-0-7645-5193-2

Italian Phrases
For Dummies
978-0-7645-7203-6

Spanish For Dummies
978-0-7645-5194-9

Spanish For Dummies,
Audio Set
978-0-470-09585-0

Macintosh
Mac OS X Snow Leopard
For Dummies
978-0-470-43543-4

Math & Science
Algebra I For Dummies
978-0-7645-5325-7

Biology For Dummies
978-0-7645-5326-4

Calculus For Dummies
978-0-7645-2498-1

Chemistry For Dummies
978-0-7645-5430-8

Microsoft Office
Excel 2007 For Dummies
978-0-470-03737-9

Office 2007 All-in-One
Desk Reference
For Dummies
978-0-471-78279-7

Music
Guitar For Dummies,
2nd Edition
978-0-7645-9904-0

iPod & iTunes
For Dummies,
6th Edition
978-0-470-39062-7

Piano Exercises
For Dummies
978-0-470-38765-8

Parenting & Education
Parenting For Dummies,
2nd Edition
978-0-7645-5418-6

Type 1 Diabetes
For Dummies
978-0-470-17811-9

Pets
Cats For Dummies,
2nd Edition
978-0-7645-5275-5

Dog Training For Dummies,
2nd Edition
978-0-7645-8418-3

Puppies For Dummies,
2nd Edition
978-0-470-03717-1

Religion & Inspiration
The Bible For Dummies
978-0-7645-5296-0

Catholicism For Dummies
978-0-7645-5391-2

Women in the Bible
For Dummies
978-0-7645-8475-6

Self-Help & Relationship
Anger Management
For Dummies
978-0-470-03715-7

Overcoming Anxiety
For Dummies
978-0-7645-5447-6

Sports
Baseball For Dummies,
3rd Edition
978-0-7645-7537-2

Basketball For Dummies,
2nd Edition
978-0-7645-5248-9

Golf For Dummies,
3rd Edition
978-0-471-76871-5

Web Development
Web Design All-in-One
For Dummies
978-0-470-41796-6

Windows Vista
Windows Vista
For Dummies
978-0-471-75421-3

Available wherever books are sold. For more information or to order direct: U.S. customers visit www.dummies.com or call 1-877-762-2974.
U.K. customers visit www.wileyeurope.com or call (0) 1243 843291. Canadian customers visit www.wiley.ca or call 1-800-567-4797.

DUMMIES.COM®

How-to?
How Easy.

Go to www.Dummies.com

From hooking up a modem to cooking up a casserole, knitting a scarf to navigating an iPod, you can trust Dummies.com to show you how to get things done the easy way.

Visit us at Dummies.com